GOING ONCE

GOING
ONCE

250 YEARS OF CULTURE,

TASTE AND COLLECTING

AT CHRISTIE'S

FOREWORD

BY

LORD ROTHSCHILD

I have had the great good fortune to have spent a large part of my
working life in an area of London synonymous with the art market,
dominated by the Royal Academy of Arts on Piccadilly to one side and
Christie's on the other on King Street, only a stone's throw from the
auction house's original premises on Pall Mall. Whether for paintings,
Old Master drawings, books, furniture, silver, jewellery, wine or
many other things besides, the salerooms at Christie's have acted as
a barometer of connoisseurship, desire, fashion, expertise and value
for 250 years, reflecting and often forming taste and trends. My family
has been deeply involved with them, since collecting has always been
and continues to be a passion for many of us.

A survey of the landmark sales recorded in this book reveals many
in which our family has featured, both as buyers and sellers, none
more notably than the famous Hamilton Palace sale of 1882 when the
collections of the Dukes of Hamilton went under the hammer (see
pp.366–7). Several members of the Rothschild family bought at the
sale, and then, as now, the press followed developments with keen
interest, astonished by Baron Ferdinand paying £6,000 for a table by
the great cabinetmaker Jean-Henri Riesener, made for Marie Antoinette,
and which is now at Waddesdon Manor, the Rothschild house in
Buckinghamshire. Not for the first or the last time, the art world focused
on Christie's in a manner that prefigured some of the great sales of
the twentieth and twenty-first centuries. The pivotal role played by
the auction house is similarly underlined by the number of paintings
at Waddesdon that have passed through Christie's hands, including
some of the greatest stars of the collection, such as the portrait of *David
Garrick between Tragedy and Comedy* (1760–1) by Joshua Reynolds and
Thomas Gainsborough's famous *Francis Nicholls 'The Pink Boy'* (1782).

This book illuminates a fascinating and complex story, and it seems
to me, from the vantage point of my association with the arts and
heritage world over many years – and as a collector – that the appetite for
collecting, for seeking out works of art and objects of the highest quality
and interest, remains as consuming now as it was when James Christie
started out in the 1760s. There is every indication that it will continue
as avidly through the next 250 years. The auction house he established
has remained at the heart of the collector's world, whether private or
institutional. Long may this continue.

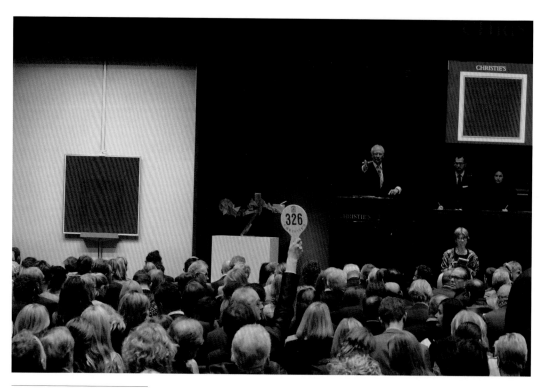

Honorary chairman
Christopher Burge's last
sale as an auctioneer on
8 May 2012 at Christie's
New York. Josef Albers's
*Homage to the Square:
Distant Alarm*, 1966, is in the
room and on the screen to
the right of the rostrum, and
sold for nearly $2m (almost
£800,000). Mark Rothko's
Orange, Red, Yellow, 1961,
sold for a record-breaking
$86.9m (£53.8m) at the
same sale (see pp.186–7).

UNDER THE HAMMER

250 OBJECTS, YEARS AND STORIES
FROM CHRISTIE'S AUCTION HOUSE

To judge by their appearance as they file into the saleroom, you would think the crowd at a Christie's evening auction was settling down for a performance in some venerable old theatre. In a sense, that is exactly what they are doing – because an auction is both a social occasion and a cultural event. It is one of the ways that art-lovers get together. However, this audience would be counted a badly behaved one in any playhouse. They fidget and they look at their phones; there is a constant low murmur of conversation; there are pings and rings as they receive texts and make calls. When the bids begin to roll in, there are shouts from the floor that sound like heckling. But the cat's cradle of communication that takes place in a saleroom is an essential element of this sport, in which the attendees are both players and audience. An auction tests the mettle of those who take part; it calibrates desire by insisting on an instant and very specific answer to the question: what's it worth to you?

James Christie, the founder of the firm, would understand most of what goes on in a saleroom today. He might be surprised by a few modern innovations – the giant display screens, the ranks of staff with phones pressed to their ears, the 'paddles' bearing a number on one side and Mr Christie's own profile on the other. However, everything about the mechanics of an auction, as well as the spectacle of it and the fraught air of competition, would be entirely familiar to him. Above all, he would be intrigued by the person of the auctioneer himself, since he more or less invented the profession in its modern form. His own style at the rostrum, we know from contemporary accounts, was loquacious and witty – like a music-hall master of ceremonies. In his own lifetime, his patter was parodied in several satirical pieces and cartoons that dubbed him the 'king of epithets' and 'the specious orator'. A kinder observer said of him that he had 'an easy and gentlemanlike flow of eloquence; he possessed, in great degree, the power of persuasion, and even tempered his public address by a gentle refinement of manners.'

Modern-day auctioneers are still required to have some of the charm of a showman, and they must be other things, too: an umpire, a corporate executive, a sharp judge of man-made artefacts and of human temperament. Perhaps the character that an auctioneer most resembles is that of the conductor of an orchestra, because both activities involve connecting through graceful gesture and movement.

Auctioneers might show a palm, as if to signal pianissimo, when the bid is against someone in the room; or incline their whole body towards the part of the room where the action is taking place; or lift the gavel, like a baton, to telegraph the fact that a coda is imminent. And, like a musical maestro, a good auctioneer has the ability to vary the pace, or at least to relish an opportunity to introduce an urgent rhythm into the proceedings – three-twenty! Three-forty! Three-sixty! Three-eighty! Four hundred! Fair warning! BANG! And the gavel is brought down. If the person on the rostrum resembles a conductor at the podium, then every auction – or, rather, each lot in an auction – is like Haydn's 'Farewell' symphony, in which one by one the players snuff out their candles and leave the stage. 'It's just the two of you now,' the auctioneer might say towards the end of a saleroom battle, but eventually it is always the two of somebody: that's the attritional name of the game, and it has always been that way, since Christie's began.

James Christie held his first sale in permanent rooms 250 years ago, in 1766. That is the anniversary that *Going Once* celebrates. He cannily chose rooms on Pall Mall, in the fashionable heart of London. At the same time, he was at pains to position his own outgoing personality close to the centre of the city's web of influence. Among his friends and clients were some of the leading political and cultural figures of the day: the orator and statesman Charles James Fox; the influential historian, collector, social commentator and man of letters Horace Walpole (whose father's collection Christie sold to Catherine the Great of Russia); the actor David Garrick; the playwright Richard Sheridan; and the artists Joshua Reynolds and Thomas Gainsborough. Christie saw to it that his London auction rooms became an essential stopping-point on the social carousel, a place where smart people gathered to look one another over – like so many walking lots. On a more businesslike level, Christie's was the place where executors converted the possessions of recently deceased noblemen into hard cash, and where foreign diplomats could easily and profitably divest themselves of cumbersome assets such as furniture and wine before leaving their posts and heading home.

So James Christie made himself indispensable to London high society, but in the first decades of his new venture he also benefited from the wider international situation. One effect of the French Revolution in 1789–99, and of the subsequent upheaval throughout the Continent, was to loose vast quantities of art from their secure moorings in European chateaux and castles. Some of that booty drifted like flotsam to Christie's shore, and was then dispersed via auction. European treasure continued to wash up after Christie was succeeded by his son, also James (the first Mr Christie died in 1803). The younger James was a very different character from his father – less of a ringmaster, quieter, an Eton-educated classical scholar.

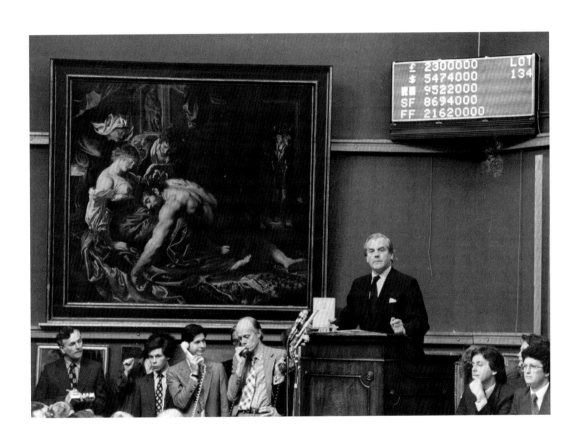

Senior picture director
Patrick Lindsay accepts
bids on Peter Paul Rubens's
Samson and Delilah, c.1609,
on 11 July 1980 at Christie's
London. It sold for £2.3m
($5.4m; see pp.292–4).

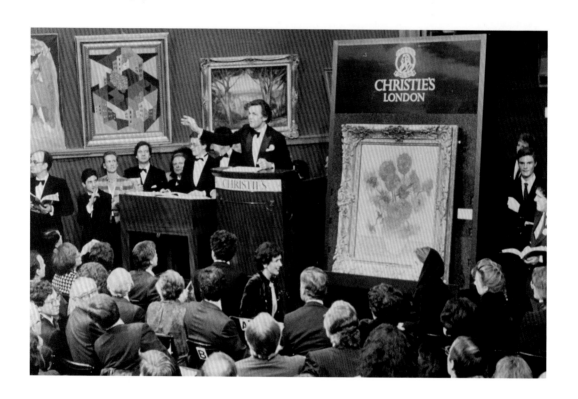

Chairman Charles Allsopp
conducts the sale of Vincent
van Gogh's *Sunflowers*, 1889,
at Christie's London on
30 March 1987. It set an
auction record for a painting
when it sold for £24.7m
(nearly $40m; see pp.80–1).

He was also a great auctioneer, oversaw many auctions and ran the firm in his own understated way, carrying it forward into the new century.

From the earliest days of Christie's, and well into the twentieth century, 'studio sales' were regular and important events in the life of the firm. These were auctions consisting of the contents of an artist's atelier, sold after his or her death. Reynolds and Gainsborough were the subject of studio sales; so too, decades later, were Dante Gabriel Rossetti, John Singer Sargent and Augustus John. Sales like these are a kind of valediction, in which the works of great artists are scattered like ashes. They also amount to a retrospective of sorts – and it remains true, no matter what the theme or location of an auction, that Christie's salerooms are the best free exhibitions in town.

But the sale is the thing. The art historian Dirk Boll, who is also Christie's managing director for Continental Europe, once remarked that 'when the hammer comes down it creates a moment of truth' – meaning that the price paid for a work of art at auction is a solid and useful piece of numerical data. That is why Christie's meticulously logs prices from its salerooms across the globe. They are the weather stations of art, design and taste, and the mass of prices they generate are like meteorological readings. Once the numbers have been carefully crunched, they allow analysts to study or even predict patterns in the art market. When the focus is narrowed, the prices paid over time for particular genres or individual artists can reveal the moments when fashions for certain kinds of collecting emerge or fade away. That is why, in this book, we have included sale prices alongside all the featured artworks and objects. It is not that, in Oscar Wilde's words, we are cynically interested in the price of everything and the value of nothing. Prices attained at auction matter primarily because they tell us something worth knowing (see the notes on prices on page 471 for further information). They are perhaps the only truly reliable way of pinning down that elusive quality in art: desirability.

Some of the objects in this book have their place because they have sold for record-breaking prices, and so have changed perceptions of a genre or an artist. Among the most costly items in their category are a Fabergé egg, Lucian Freud's painting of a benefits supervisor sleeping, and a dozen bottles of Château Pétrus 1945. But many of the objects have stories to tell that are more than merely fiscal. There are tales of romantic obsession – as when Lord Nelson stepped in to buy a portrait of his mistress Emma Hamilton, so that no other man could own her likeness. There are astonishing instances of accidental discovery: a priceless drawing brought to a church-hall valuation in a black bin bag; an ancient Assyrian bas-relief found behind the dartboard in a school tuck shop. And there are the many oddities and curiosities to illustrate the fact that Christie's – which is institutionally interested in everything – functions as a kind of commercial cabinet of curiosities, a pop-up gallery where (on the right day) you can acquire the skeleton

of a woolly mammoth, a little black dress once worn by Audrey Hepburn, a Spitfire Mark I or the golden typewriter on which Ian Fleming wrote the James Bond novels ...

The number of objects featured in *Going Once* – exactly 250 – reflects, of course, the 250 years of Christie's existence. That is not to say that each piece in the book is drawn from a different year. We have selected the objects that seemed to us to have the greatest significance – whenever or wherever they turned up on the auctioneer's block. So this book is not a biography of the firm, still less an academic or comprehensive history of collecting. You could say that it is itself a collection – a highly eclectic one, showcasing some of the beautiful, bizarre or blockbusting objects that have passed through the salerooms from London to New York, from Shanghai to Geneva. As with all good collections, our 250 objects are arranged for maximum serendipity. Turning a page of *Going Once* is like passing from one room to the next in some richly endowed but eccentric museum. Sometimes the piece you find yourself looking at will have a connection to the last object you saw; sometimes it will come as a surprising change of direction. This book is a sumptuous lottery of an exhibition that you can also dive into at random, always certain that you will encounter something worth knowing about.

The other thing that these diverse objects have in common, apart from the fact that Christie's has seen and sold them all, is that someone wanted them badly enough to put up a fight. Christie's has always been the world's leading stock exchange of human creativity, a trading floor of artistic excellence. It is a place where (to paraphrase William Morris) people can gain possession of the things that they believe to be beautiful. Or, as the art critic Herbert Furst once remarked: 'Christie's are a measure of what men and women have coveted in different periods. Not, be it said, the physical necessities of life – food, drink, raiment and so on – but metaphysical necessities; things which in themselves are of no practical use, but without which man ceases to be a civilized animal.'

Global president Jussi
Pylkkänen conducts the
sale of Amedeo Modigliani's
Nu couché, 1917-18, at
Christie's New York on
9 November 2015. The
painting sold for $170.4m
(over £112m), a new record
for Modigliani (see pp.141–3).

THE FIRST HOUSE SALE

First sale on Pall Mall

SALE
5 December 1766, London

SOLD
£ 174 16s 6d/$795

EQUIVALENT TODAY
£21,700/$31,500

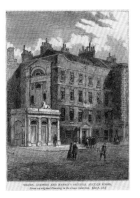

Top: James Christie's first
permanent salerooms at
83–84 Pall Mall, London.

Above: Christie on the
Chippendale rostrum in
an etching executed by
Robert Dighton in 1794.

In late 1766, James Christie (1730–1803) produced a sale catalogue, the first page of which announced that the objects going under the hammer consisted of 'Genuine Household Furniture, Jewels, Plate, Fire-Arms, China, &c. And a large Quantity of Maderia [*sic*] and high Flavour'd Claret. Late the Property of A Noble Personage (Deceas'd) ...' This, then, was a house clearance, albeit an upmarket one, and it was a workaday undertaking for Christie. The historical significance of this sale lies in the fact that it was the first to be held by the thirty-six-year-old auctioneer on permanent premises rather than in hired rooms. Christie had set up shop on Pall Mall in London, and he was there to stay.

The auction began at noon on 5 December 1766, and lasted for five days. We know from James Christie's own copy of the catalogue – the original was stolen, but a facsimile exists – precisely how much each lot fetched and also the names of individual buyers. Christie carefully inscribed this information on blank folios to the right or left of the printed page. So we can read in his own slightly scratchy copperplate hand that Lot no.1 – 'six breakfast pint basons [*sic*] and plates' – was bought by a Mr Sheppherd for 19 shillings, and that the marathon sale as a whole realized 174 pounds 16 shillings and sixpence.

The language of the catalogue is beguiling and sometimes obscure. In places, the descriptions of the lots read like fragments of free verse:

· A Dutch kitchen
· A pair of Nankeen embossed jars
· An octagon compotier and mellon and leafs for a desert
· A Pontipool tea-board and a waiter in birds ...

Elsewhere the articles for sale seem as mundane and ordinary today as they were then: 'cups and saucers and a teapot'; 'two rings'. So the catalogue, a lengthy inventory of one lifetime's bric-a-brac, goes to show how much has changed in 250 years, and also the extent to which the necessities of life remain largely the same.

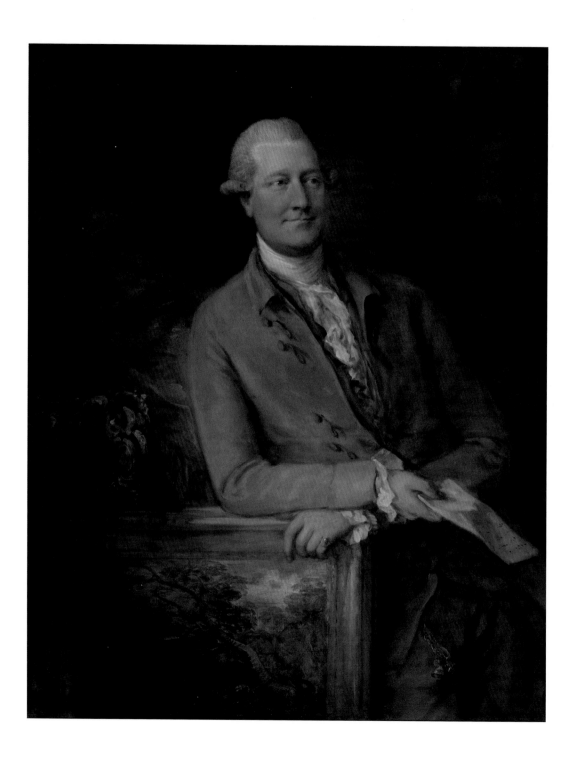

LIFE OF
A SALESMAN

Thomas Gainsborough
(1727–1788), *Portrait of James Christie*, 1778,
oil on canvas, 128 x 102 cm
(50½ x 40½ in)

SALE
20 May 1927, London

ESTIMATE
Not published

SOLD
7,200 guineas/£7,560/$35,380

EQUIVALENT TODAY
£403,000/$581,300

This handsome portrait of James Christie, painted in 1778 by Thomas Gainsborough, not only depicts the founder of Christie's auction house but also reflects the story of the eighteenth-century art market.

Gainsborough, the son of a cloth merchant, was interested in the great personalities in contemporary society, and many of his portraits are sympathetic towards entrepreneurial men. He depicts Christie, then aged forty-seven, as a cosmopolitan gentleman in formal wig and brown frock coat, sporting his signet ring and watch-fob with two seals, with his face an expression of affable openness. The portrait was completed twelve years after Christie moved the auction house into permanent rooms on Pall Mall, London.

Christie was born in Perth, Scotland; little is known of his childhood, but by the age of twenty he was working as an assistant to an auctioneer in London. 'Not exactly a connoisseur' of art, according to the magazine *Library of the Fine Arts* (March 1831), Christie depended on a 'certain coterie' of artists, 'who frequently partook of his venison and claret'. On such occasions they would advise him and even 'christen' some of the works of art destined for the saleroom.

Gainsborough was an associate of Christie, and from 1774 lived next door to his auction rooms on Pall Mall. The artist dined frequently with his neighbour, and a firm friendship was established between the two men. Certainly they drew mutual benefit through this picture, which went on to hang in a prominent position in Christie's saleroom. Through it, Christie could advertise his familiar bond with one of the country's leading portrait painters, while Gainsborough could quietly promote his landscape painting – an example of which is shown in the portrait. Landscape was Gainsborough's great passion, but he quickly found that his patrons preferred portraits. This picture implies Christie's admiration of the artist as a landscape painter. The portrait is now in the J. Paul Getty Museum in Los Angeles.

FROM GAMBLING DEN TO THE GREAT ROOM

'A small Library of Books, in
English and French Literature,
engraved copper plates, with
impressions from the same,
also, the household furniture,
the property of a gentleman,
and removed from his
residence in Great George
Street, Westminster'

SALE
18–19 December 1823, London

ESTIMATE
Not published

SOLD
£585 6s 6d/$2,800

EQUIVALENT TODAY
£47,400/$68,300

On 11 December 1823, James Christie, son of the auction house's
founder, announced a forthcoming sale in *The Times*: a 'Library
of Books, Engraved Copperplates, Household Furniture and Effects –
By Mr Christie at his Great Room, 8 King-street, St James's-square,
on Thursday, December 18, and the following day.' This sale is
significant because it was the first to take place at King Street, the
auction house's new location and still its headquarters today.

James Christie the younger (1773–1831) was a respected antiquarian
who wrote several papers on Classical antiquities, including Etruscan
vases and Greek sculpture. A connoisseur of the fine arts, he was
elected to the Dilettanti Society in 1824 and to the Athenaeum Club
in 1826. Originally destined for a career in the Church, he entered
the family auction business and took over the running of the firm after
his father's death in 1803.

Christie had made his first appearance on the rostrum in the spring
of 1794, when he relieved his father, who was fatigued after a six-day
sale. Onlookers commented that his language was elegant, but that
at times he was scarcely audible and spoke falteringly. He overcame
his initial diffidence, however, and became a very successful auctioneer.
During his lifetime he retained sole control of the firm.

George Cruickshank's
satirical take on a morning
drop-in at Christie's King
Street in 1831.

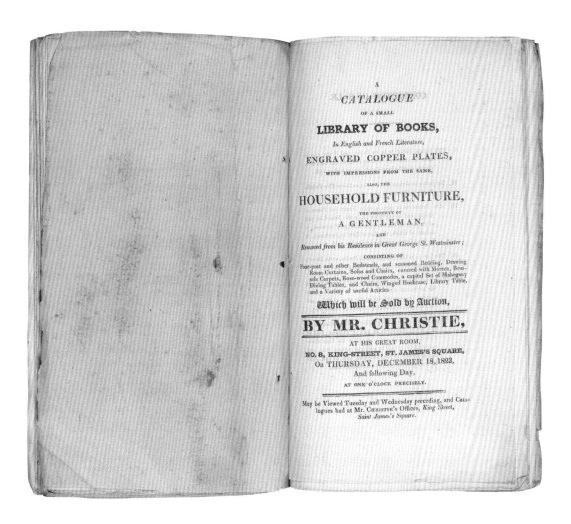

A
CATALOGUE
OF A SMALL
LIBRARY OF BOOKS,
In English and French Literature,
ENGRAVED COPPER PLATES,
WITH IMPRESSIONS FROM THE SAME,
ALSO, THE
HOUSEHOLD FURNITURE,
THE PROPERTY OF
A GENTLEMAN,
AND
Removed from his Residence in Great George St. Westminster;
CONSISTING OF
Four-post and other Bedsteads, and seasoned Bedding, Drawing
Room Curtains, Sofas and Chairs, covered with Moreen, Brus-
sels Carpets, Rose-wood Commodes, a capital Set of Mahogany
Dining Tables, and Chairs, Winged Bookcase, Library Table,
and a Variety of useful Articles:

Which will be Sold by Auction,

BY MR. CHRISTIE,
AT HIS GREAT ROOM,
NO. 8, KING-STREET, ST. JAMES'S SQUARE,
On THURSDAY, DECEMBER 18, 1823,
And following Day,
AT ONE O'CLOCK PRECISELY.

May be Viewed Tuesday and Wednesday preceding, and Cata-
logues had at Mr. CHRISTIE's Offices, *King Street,*
Saint James's Square.

Christie's saleroom at 8 King Street was formerly Wilson's European Emporium (a museum), and before that the premises were notorious as a gambling den. His opening sale, which included a library of books, may have been calculated to needle his rivals Sotheby's, who were considered specialist book auctioneers. The 'property of a gentleman', sold on 18–19 December 1823, comprised books, engravings and a range of household objects including 'Rosewood Commodes' and 'a capital Set of Mahogany Dining Tables'.

Top: The catalogue's title page for Christie's first sale at King Street, London, in 1823.

Above: Christie's King Street building today.

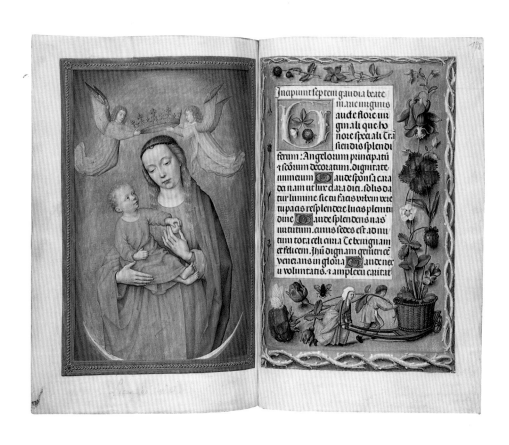

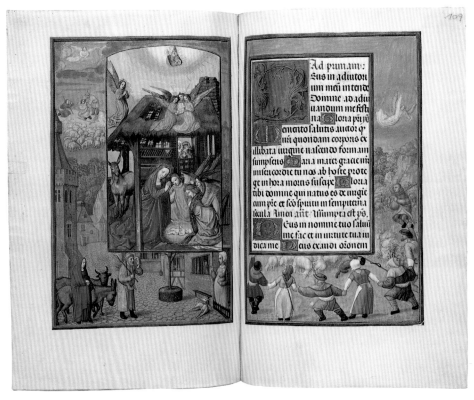

ILLUMINATIONS
OF THE HIGHEST ORDER

Gerard Horenbout,
Alexander and Simon Bening,
The Rothschild Prayerbook,
c.1505, illuminated
manuscript on vellum,
252 leaves,
23 x 16 cm (9 x 6½ in)

SALE
8 July 1999, London

ESTIMATE
£2m–3m/$3.1m–4.7m

SOLD
£8,581,500/$13,361,400

EQUIVALENT TODAY
£13,300,000/$19,273,200

This sumptuous book of hours – the most popular type of manuscript used for private prayer – was made in Bruges or Ghent in about 1505. The contributing artists were Alexander Bening and his son Simon, and Gerard Horenbout – the most renowned illuminators of the day. The commissioning patron was almost certainly connected to the Habsburg court in the Southern Netherlands.

Printing was widespread by the turn of the sixteenth century, so the prayerbook is a self-consciously handmade piece. Its value lies not just in the extensive and exquisite illumination – sixty-seven full-page miniatures survive, each surrounded by a painted border and with a complementary border on the facing page – but also in the countless man-hours they represent. There is something epic about this book; like a novel by Tolstoy, its aim is to focus on the spiritual yet it cannot help also revelling in the great and gaudy pageant of everyday life. The quotidian vignettes are completely integrated with the superlative religious art, so that across the page from a quiet Nativity, for example, sturdy peasants dance a merry round. There is an exquisite painting of the Madonna – Mary rises from a crescent moon holding a curly-headed Christ in the crook of her arm – and yet, just on the facing page, a weary woman wheels a laden barrow, a man drags a gigantic spray of roses, and – a surreal touch – a beautifully observed *trompe-l'œil* bluebottle sits on the page as if it has just landed there. You can imagine the book's owner absent-mindedly trying to brush it away.

After it was made, the prayerbook was out of public view for hundreds of years. For most of that time it must have been closed, since the pigments remain bright and unfaded. It surfaced again in the collection of the Viennese branch of the Rothschild family in 1868, but was later confiscated by the Nazis. The Austrian authorities returned it to the family in 1999. Soon afterwards the family sold it through Christie's, where the price fetched at auction was a world record for an illuminated manuscript. The manuscript was re-offered at Christie's, New York, on 29 January 2014, and sold for $13,605,000 (£8,215,350).

MASTER
OF THE HEAVENS

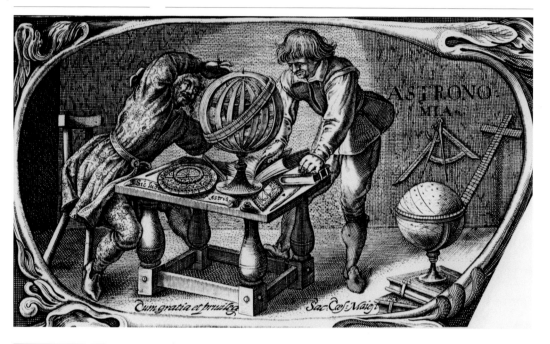

Muhammad Bin Sulayman
Al-Maghribi (1627–1683),
spherical astrolabe, 1662–3,
lacquered sphere, inked in red
and black, in a hemispheric
leather case, 11 cm (4½ in)
in diameter

SALE
8 October 2015, London

ESTIMATE
£100,000–150,000/
$153,000–230,000

SOLD
£722,500/$1,106,250

This rare spherical astrolabe was made in Medina, Saudi Arabia,
in 1662–3 by Muhammad Bin Sulayman Al-Maghribi, who signed
himself 'Al-Rudani'. A Moroccan-born astronomer who spent most
of his life in the Ottoman Empire, Al-Rudani is famous for his
invention of a particular type of astrolabe into which another sphere
with a different axis was placed. The second sphere was divided into
two parts, in which the zodiacal signs were drawn. The mechanism
of this astrolabe is complex and delicate, and it is the only extant
example of one of Al-Rudani's instruments.

The principles informing the astrolabe were known to classical
scholars before 150 BC, but the first astrolabes were not made until
the fifth century AD. Astrolabes were introduced into the Islamic world
in the middle of the eighth century, and the oldest existing example
dates from the tenth century. By the twelfth century, Islamic Spain
had become the conduit by which knowledge concerning astrolabes
returned to European halls of learning.

The astrolabe would have been an indispensable tool for its
stargazing owner, and is testimony to the ingenuity and knowledge

of Islamic craftsmen and scientists. It might be described as an early form of astronomical computer, which shows how the night looks at a given time in a specific place. The sky is drawn on the fixed face of the astrolabe, and moveable components, simulating the daily rotation of the Earth, are adjusted to reflect the place and time.

Astrolabes were used for determining the time of celestial events, for establishing celestial positions and for making astrological calculations and basic astronomical observations. Learning how to operate this complex instrument was part of a seventeenth-century gentleman's education, and its use was taught in universities throughout Europe.

All over the world, rulers looked to the heavens seeking celestial guidance, and the astrolabe found its way to the courts of Kublai Khan, the imperial capital in Beijing and the seat of the Holy Roman Empire. It was a particularly valuable instrument within Islam because it could be used both to determine prayer times and to find the direction of Mecca.

Islamic astrolabes such as this one are beautifully crafted objects, ornamented with floral decorations and scripts, and engraved with lines indicating the hours of devotion. This extremely rare survivor of an important period in Islamic science attracted great interest in the saleroom, reaching nearly five times its high estimate when it sold in 2015 for £722,500.

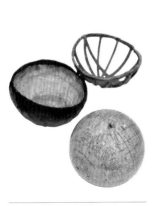

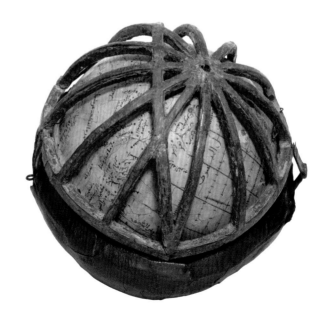

Left: Wood engraving showing astronomers at work in 1650. An astrolabe can be seen in the foreground.

6

A METAL-DETECTOR'S DISCOVERY

Crosby Garrett helmet
(Roman cavalry parade
helmet), c.2nd–3rd
century AD, bronze,
40.5 cm (16 in) high

SALE
7 October 2010, London

ESTIMATE
£200,000–300,000/
$319,000–478,000

SOLD
£2,281,250/$3,634,000

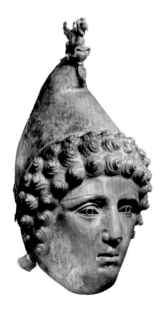

The Crosby Garrett helmet, named after the village in Cumbria, northern England, close to where it was found, is one of the greatest Roman-era finds of its kind, unparalleled in its combination of beauty, fine workmanship and completeness. The masked helmet is one of only three discovered in the country in a similar condition (the others are in the British Museum, London, and the National Museum of Scotland, Edinburgh), although the Crosby Garrett helmet, with its enigmatic facial features, shares qualities with those found in southern Europe.

The helmet was discovered in May 2010 by a young metal-detector enthusiast, a student in his early twenties from the north east, who made the astonishing find. Having searched the same set of fields with his father for seven years, finding only coins and small objects, he initially believed his latest find to be Victorian in age, a discovery of limited excitement. However, with the assistance of various experts, including Christie's antiquities specialists, the amazing truth soon became apparent – he had unearthed a unique Roman cavalry parade helmet dating to the imperial period.

This type of helmet was designed for cavalry sports events performed by garrisoned Roman soldiers, rather than for combat. The well-preserved tinned bronze face mask boasts high-quality detailing, with luxurious locks of curly hair and eyelashes, and is an extraordinary example of Roman metalwork at its zenith. The elaborate bronze griffin on the top of the Phrygian-style cap is unprecedented.

Many visitors travelled to Christie's South Kensington saleroom to gaze at the helmet's youthful visage before the auction in October 2010. The helmet's estimate of £200,000–300,000 swiftly proved to be conservative as six bidders – three on the telephone, two in the room and one online from California – competed in a frenzied auction that lasted for more than five minutes. The helmet eventually sold to an anonymous telephone buyer for more than seven times the high estimate. It has since been shown in public in Britain three times, including at the Tullie House Museum and Art Gallery, Carlisle, in the county where it was found, at the British Museum in London, and in the 'Bronze' exhibition at the Royal Academy of Arts, London, in 2012.

FLY ME
TO THE MOON

Omega (est. 1848), Apollo 17
Speedmaster chronograph
wristwatch, 1970, stainless-
steel watch with official
NASA Velcro strap,
4.2 cm (1.65 in) in diameter

SALE
15 December 2015, New York

ESTIMATE
Not published

SOLD
$245,000/£162,830

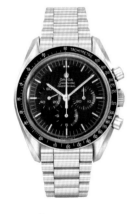

Few items auctioned at Christie's have travelled quite as far as the Omega Speedmaster watch (1970) worn by the American astronaut Ron Evans (1933–1990), the command module pilot on the Apollo 17 mission to the Moon. It is a timepiece that has clocked up well over half a million miles.

Evans was a navy pilot before he went into space, and he had served in Vietnam, where he flew combat missions from an aircraft carrier. NASA selected him for Astronaut Group 5 in 1966, and the Apollo 17 mission in December 1972 – the last manned Moon-shot – was Evans's first venture into space.

This watch was the one Evans used for timing a 'heat flow and convection' experiment carried out during the mission. He surely glanced at it often while his fellow astronauts were on the lunar surface and he circled above them in the command module (setting a record for time spent alone in lunar orbit).

When Evans and his fellow astronauts splashed down in the Pacific Ocean, the ship sent to retrieve them from the sea was the *Ticonderoga* – the very carrier on which Evans had served as a fighter pilot. Later, when he got home, he took an engraving tool and wrote on the back and side of the watch case. The abbreviated inscription in capital letters, like those found on Roman coins, reads: 'FLOWN IN C.S.M. TO THE MOON APOLLO 17'; then, on the side of the watch, 'HEAT FLOW EXPR 6–19 DEC 1972'. It represents Ron Evans's somewhat understated summary of his part in mankind's nascent exploration of the cosmos.

SET PHASERS TO STUN

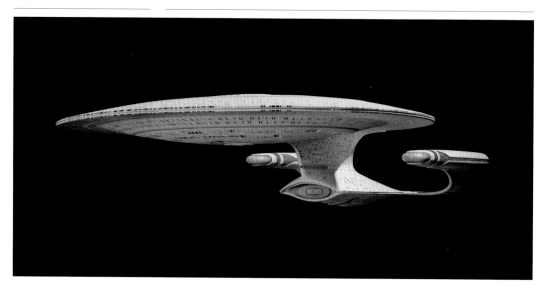

Built by the Industrial Light and Magic Model Shop, conceived by Andrew Probert, visual effects miniature of the Starship Enterprise-D from *Star Trek: The Next Generation*, c.1987–94, fibre-reinforced cast-resin construction with internal neon lighting on an aluminium armature, 198 x 150 x 36 cm (78 x 59 x 14 in)

SALE
5–7 October 2006, New York

ESTIMATE
$25,000–35,000/£13,300–18,700

SOLD
$576,000/£307,600

In October 2006, forty years after *Star Trek*'s television debut, Christie's boldly went where no auction house had gone before. With 1,000 lots beamed down to New York's Rockefeller Center from CBS Paramount Studios in Hollywood, '40 Years of Star Trek: The Collection' was the largest sale of *Star Trek* memorabilia ever held, as well as being the first official auction of genuine props, costumes and scripts from five television series and ten feature films.

Although a pair of Mr Spock's ears had sold at Christie's Los Angeles for $3,290 (£2,178) in 2000, and the actor William 'Captain Kirk' Shatner's kidney stone had raised $25,000 (£14,075) at a charity auction in January 2006, very little genuine studio memorabilia had come up for sale before this landmark auction.

Trekkies are famously devoted fans, with a level of knowledge that would make even a seasoned auctioneer quake. That much was in evidence during the three days of the sale, as members of the packed audience, which included a smattering of Dr Spocks and Captain Kirks in full Starfleet regalia, occasionally interrupted the auctioneer to correct mispronunciations of trickier *Star Trek* terminology.

As the first large-scale sale by any auction house to be streamed live on the Internet, '40 Years of Star Trek' represented a jump to warp speed for the industry, and the assembled Trekkies and collectors

lived up to the occasion. An isomagnetic disintegrator rifle sold for $19,800 (£10,550), well over twenty times its estimate; Captain Picard's chair from the Enterprise-E made $62,400 (£33,322) from a predicted $7,000 (£3,783), and a filming miniature of a Klingon Bird-of-Prey, valued at $12,000 (£6,408), hit $307,200 (£164,045). However, the stellar prize was a model of the Starship Enterprise-D from *Star Trek: The Next Generation* (1987–94), which sold for $576,000 against a high estimate of $35,000. In total, the sale achieved over $7m (£3.7m), well over double the estimate. As the Klingons might say: '*Qapla!*'



9

THE STONE FROM OUTER SPACE



A complete stony meteorite with almost complete fusion crust, from L'Aigle, Orne, France, which fell to Earth in 1803, 12.5 cm (5 in) wide

SALE
8 April 1998, London

ESTIMATE
£10,000–12,000/
$16,700–20,000

SOLD
£25,300/$42,225

EQUIVALENT TODAY
£39,800/$56,900

Those who gathered at Christie's South Kensington on 8 April 1998 would have been forgiven for thinking there was something a little otherworldly about the proceedings, at least where Lot 8 was concerned. Most of the objects for sale were scientific instruments, but this lot was a little different: the first meteorite ever to be sold by the auction house.

This small fragment from outer space spoke not just of the romance of other worlds, but also of a time when the mysteries of the galaxy were even less well understood than they are today. The meteorite had fallen to Earth in France on 26 April 1803, and its arrival rocked a scientific world that was still debating whether in fact it was possible for objects to fall from outer space.

The astronomer Jean-Baptiste Biot (1774–1862) visited the site, where he learned that a fireball had been seen in the sky, followed by a shower of stones weighing a total of about 37 kg (82 lb). He collected specimens, many of which are now in the National Museum of Natural History in Paris, and recorded eyewitness accounts. 'The freshly fallen stones taken into houses gave out such a disagreeable smell of sulphur that they had to be taken outside,' Biot noted. After he wrote a report on the incident and presented his evidence to the French Academy of Sciences in 1806, it was acknowledged, finally, that meteorites existed.

Lot 8 sold for £25,300, more than double its high estimate, and ever since that first sale Christie's has catered to a growing number of collectors. In 2014, the first dedicated meteorite sale was held in the United States: the most valuable lot, a Martian meteorite called 'Black Beauty', sold for $81,250 (£49,250).

WHERE RELATIVITY BEGAN

Albert Einstein (1879–1955) and Michele Besso (1873–1955), Einstein–Besso Manuscript, 1913, 54 (of 56) pages, quarto, ink and pencil on 37 sheets of foolscap and squared paper of various types, mostly 27.5 x 21 cm (10½ x 8½ in)

SALE
25 November 1996, New York

ESTIMATE
$250,000–350,000/
£150,000–210,000

SOLD
$398,500/£238,700

EQUIVALENT TODAY
$580,900/£400,000

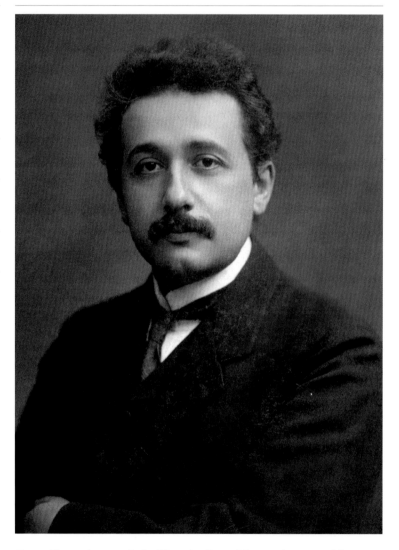

Co-writers of the Einstein–Besso Manuscript: Albert Einstein in 1912; and, on the opposite page, Michele Besso with his wife in 1898.

On 25 November 1996, the Einstein–Besso Manuscript was sold for $398,500 to the scientific book dealer Jeremy Norman & Co. This valuable working document, dating from June 1913, reveals the mathematical processes that underpin the general theory of relativity. It also illustrates vividly the genesis of one of the most important scientific ideas of the twentieth century.

Michele Besso was Albert Einstein's lifelong friend and collaborator. Besso had studied mechanical engineering at the Swiss Federal Polytechnic in Zurich, shortly before Einstein entered the college in 1896. When he finished his studies, Besso went on to work for an electrical machine factory in Winterthur, but he kept up regular visits to Zurich. It was during this period that he and Einstein became acquainted, subsequently enjoying long discussions about mathematics and physics. Einstein called Besso 'the best sounding board in Europe'.

The Einstein–Besso Manuscript consists of fifty-four loose pages, half in Einstein's hand, half in Besso's. It contains a series of calculations used in early versions of the field equations of Einstein's general theory of relativity, to test whether the theory could account for the anomaly in the motion of the perihelion of Mercury. This working paper reveals, in fascinating detail, the complex mathematics with which the general theory was conceived, expressed and tested. The theory appeared to pass the test using these calculations, but tiny errors – overlooked at the time – had been made. When Einstein redid the calculations – without the errors – two years later, he discovered to his dismay that the theory failed. Frustrated by this setback, he returned to earlier, rejected ideas outlined in the so-called Zurich Notebook of 1912. He reviewed his notes and used these ideas to complete the general theory of relativity – as we know it today – within a month.

Einstein's friend and collaborator died just three weeks before his great mentor, in 1955. Einstein commented: 'People like us, who believe in physics, know that the distinction between past, present and future is only a stubbornly persistent illusion.'

A LONG
LOST TIEPOLO

Giovanni Battista Tiepolo
(1696–1770), *An Allegory with
Venus and Time*, c.1754–8,
irregular oval ceiling painting,
292 x 190.5 cm
(115 x 75 in)

SALE
27 June 1969, London

ESTIMATE
Not published

SOLD
£409,500/$978,700

EQUIVALENT TODAY
£6,020,000/$8,643,000

Sometimes, all it takes to make a great discovery is to pick up the
phone. In 1964, David Carritt, a world-renowned expert in Christie's
Old Masters department, was browsing through Antonio Morassi's
recently published catalogue of works by Giovanni Battista Tiepolo,
the great eighteenth-century Italian virtuoso of fresco painting, when
one entry caught his eye. The detail that stopped him in his tracks
was the location given.

The entry in Morassi's catalogue for *An Allegory with Venus and
Time* quotes a nineteenth-century author who stated that it formed
'part of the ceiling of one of the grandest houses in Mayfair, London,
present whereabouts unknown'. Carritt was confident that he knew
– and the book in his hands seemed to confirm his hunch – that the
picture had once been in the collection of a German-Belgian banker
named Henri Louis Bischoffsheim (1829–1908). It was relatively
straightforward to establish that Bischoffsheim's London residence in
the 1870s had been at 75 South Audley Street, in the heart of Mayfair.
Ceiling paintings are notoriously difficult to relocate so, Carritt guessed,
there was every chance that the 'present whereabouts' of the Tiepolo
was not so much unknown as unchanged.

The house on South Audley Street no longer belonged to the
Bischoffsheim family. It had become the embassy of the United Arab
Republic (as Egypt was known at the time). Carritt telephoned the
cultural attaché, explained his theory, and asked if he might come and
look round the embassy. The attaché readily agreed, and when the
specialist arrived he was delighted to see the picture in situ in the main
drawing room: the melancholy Venus, loosely veiled in pink drapery
against a cerulean-blue sky, passing the quizzical child to the winged,
grey-bearded figure of Time.

The Egyptian ambassador realized that the Tiepolo was both
an asset and a risk: it would be impossible to save in the event of a fire.
So, five years later, he asked Christie's to remove the painting and
sell it on behalf of his government (a copy was made to replace it).
The Tiepolo was acquired at auction by the National Gallery in London
and the money raised was spent on the conservation of ancient
Egyptian temples in the Nile Valley.

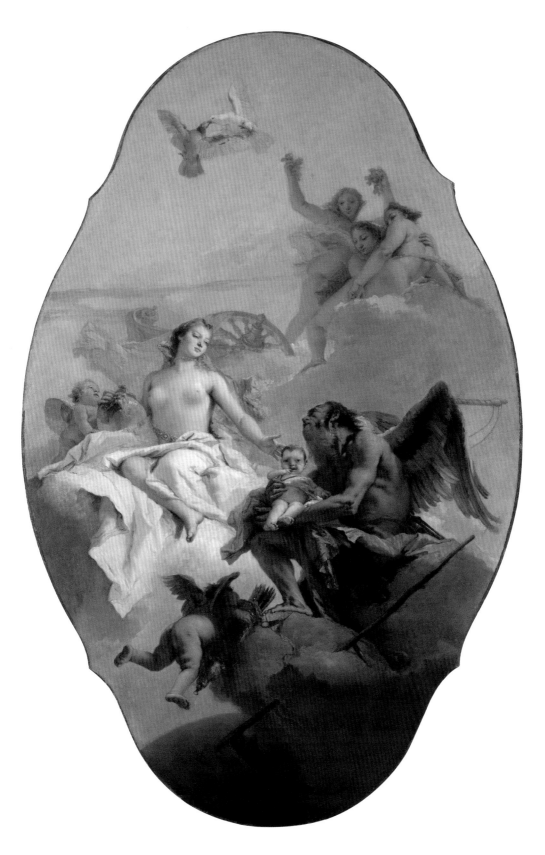

THE FASHION
FOR PHARAOHS

Cameo glass flask,
25 BC–AD 25, glass,
7.5 x 4.2 cm (3 x 1½ in)

SALE
5 March 1985, London

ESTIMATE
Not published

SOLD
£324,000/$421,000

EQUIVALENT TODAY
£877,000/$1,242,500

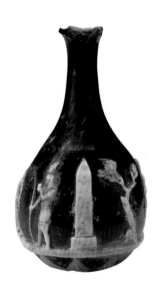

Pecunia non olet, as the Roman proverb goes – 'money has no smell.'
The original owner of this miniature glass perfume bottle might have
begged to differ.

In the age of Augustus, the increasingly wealthy elite of the
Roman Empire learned to display their wealth and sophistication
through exquisite, exotic objects that were labour-intensive to make.
The invention of cameo glass by the early Romans, a tour de force in
the glassmaker's art, is a case in point. Immigrant glass-blowers from
Syria are thought to have produced the cobalt-blue bottle that was then
encased in a layer of opaque white glass, and entrusted into the delicate
hands of the artisan who carved the image.

The Egyptian narrative depicted in the relief has intrigued modern
scholars. On one side of the flask a pharaoh, recognizable by his crown
and staff, stands next to an obelisk inscribed with hieroglyphs. As the
flask is rotated, the carving shows a naked boy approaching an altar
bearing the god Thoth in the form of a baboon, and then another nude
boy in front of an altar, holding up ears of corn before a flame.

Scholars refer to the practice of typically Roman artefacts being
given an Egyptian twist, as with this flask, as Rome's 'Egyptomania',
and the vessel is cited as one of the earliest examples of Orientalism
in art history. Roman 'Egyptomania' sometimes favours style over
substance – for example, the hieroglyphs on the flask spell out utter
nonsense, suggesting that they were merely stylistic devices. Why?
Egypt had become a province of Rome in 31 BC following one of
Augustus's chief military victories, the defeat of Cleopatra and Mark
Antony. 'Egyptomania' and the transposing of Egyptian motifs on
to traditional Roman objects reminded his subjects of this triumph,
and served as a subtle act of imperialistic propaganda.

The cameo glass technique was widely practised for only about fifty
years – the lifespan of one generation of artisans. It was consequently
a rarefied treasure in its day, and an even greater one in today's market.
Fifteen intact glass cameo objects are thought to exist, and this example
was the prize lot in the sale of the esteemed glass collection of the Swiss
couple Ernst Kofler and Marta Truniger in 1985. The flask was acquired
by the J. Paul Getty Museum in California.

THE LURE
OF THE EAST

John Duck (active late
17th century), a pair of
silver tankards, 1686,
silver, 22 cm (8½ in) high,
weight 3.5 kg (123½ oz)

SALE
29 May 1963, London

ESTIMATE
Not published

SOLD
£17,000/$47,600

EQUIVALENT TODAY
£318,000/$461,700

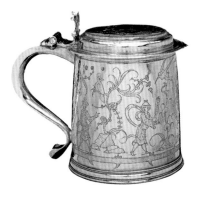
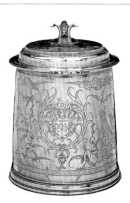

The Times described the audience for the sale of the Brownlow silver collection in 1963 as 'less poker-faced and more relaxed than is customary on these occasions, thanks perhaps to Derby Day euphoria'. It could be argued that the biggest drama of the day took place not at the famous racecourse in Epsom but in Christie's King Street saleroom, when on the morning of the 'greatest flat race in the world' a pair of silver tankards reached £17,000, a record at the time for such objects.

Made in 1686, these large silver tankards bear the arms of Sir John Brownlow of Belton and feature a maker's mark – a goose in a dotted circle – that is attributed to the English maker John Duck. Oriental scenes interspersed with exotic birds and trees decorate the tankards, reflecting the delight taken at the time for all things Oriental. An inventory taken in 1688 of the new house at Belton in Lincolnshire lists a great array of Oriental objects, including lacquer furniture, 'Japan' tables, and Japanese and Chinese porcelain. Three years later, in 1691, Sir John Brownlow commissioned a magnificent set of chinoiserie tapestries.

The plate collection at Belton, which was augmented by later members of the Brownlow family, was particularly noteworthy. A newspaper report of a ball there in 1833 comments: 'The decorations of the table were exceedingly beautiful and the display of costly plate superb.' In 1992 this pair of tankards reappeared on the market, selling in New York for $797,500 (£450,600; equivalent to $1,210,000/£833,000 today), and in June 2000 they were back in London, where they realized £938,750 ($1,417,500) at Christie's.

Late 17th-century English School portrait of Sir John Brownlow, 3rd Baronet (1659–1697).

INTO THE UNKNOWN

James Cook (1728–1779), logbook and journal of Captain Cook's first and second voyages, 1768–75, red morocco leather with gilt tooling, dimensions not available

SALE
28 November 1960, London

ESTIMATE
£4,000–7,000/$11,200–19,700

SOLD
£53,000/$148,930

EQUIVALENT TODAY
£1,090,000/$1,585,600

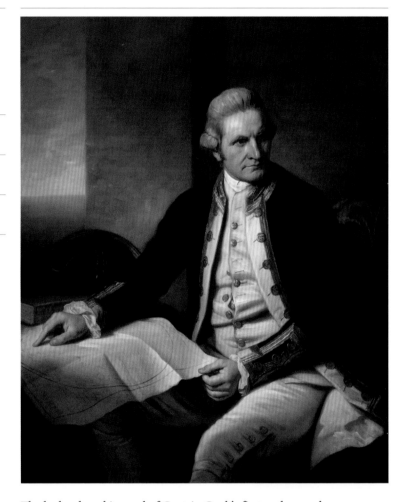

Captain James Cook, portrait by Nathaniel Dance, 1775–6, completed following Cook's second voyage.

The logbook and journal of Captain Cook's first and second voyages that were sold at auction in 1960 are virtually complete contemporary transcripts of Cook's own record of his exploratory journeys, and include annotations in his own hand. They tell the story of a crucial moment in the history of British global expansion: Cook's two extraordinary voyages of discovery, which opened up both Australia and New Zealand to European exploration, settlement and colonization.

On Cook's first expedition (1768–71), he commanded the *Endeavour* with a crew of ninety-four men, as well as scientists,

botanists (see p.84) and artists. He observed the Transit of Venus in Tahiti, and was the first European to explore and chart the eastern shores of Australia, and to circumnavigate and chart New Zealand. His second expedition (1772–5) took two ships, *Resolution* and *Adventure*, and a crew of 193 men further south than any European mariner had travelled before. Cook also discovered South Georgia Island and the South Sandwich Islands (the naming of these islands is recorded in Cook's own hand on the manuscript).

The manuscripts themselves are a testament to Cook's relationship with Comptroller Sir Hugh Palliser (1723–1796), his naval patron. Palliser greatly admired Cook and had recommended him to command these two important voyages. Cook subsequently presented these works, bound in decorative red morocco leather, to Palliser. They passed down through the generations to Palliser's descendant Commander P.A. Hudson RN, who sold the logbook and journal at auction in 1960.

Sir Hugh Palliser's admiration for his protégé is evident on the memorial dedicated to Cook in the grounds of Palliser's house in Buckinghamshire in 1781. It reads: 'Mild, just, but exact in discipline, he was a father to his people, who were attached to him from affection, and obedient from confidence.'

BRITISH SHIPS
ENTERTAIN THE EMPEROR

John Henry Borrell
(1757–1840), quarter-
chiming, musical
automaton 'Sailing Ships'
clock, 1760–1820, ormolu
and guilloché enamel,
74 x 38 x 30.5 cm
(29 x 15 x 12 in)

SALE
27 May 2008, Hong Kong

ESTIMATE
HK$4,500,000–6,500,000/
£290,000–420,000/
$577,000–833,000

SOLD
HK$36,167,500/
£2,339,265/$4,634,950

In the late eighteenth century, the increasing precision and reliability of timekeeping put clockmakers in the vanguard of Europe's scientific advancement. As such, clocks were presented as tributes to the Chinese imperial court by Western envoys hoping to establish trade links with the guarded empire.

Such timepieces, which were highly prized by the Chinese, included the most sophisticated automata and music-box mechanisms made at the time. They were originally introduced to the court as gifts from missionaries, a tradition that was continued by foreign dignitaries and Chinese high officials, who went on to commission increasingly complex designs for successive emperors. In time, such imports encouraged native craftsmen to create devices of similar richness.

Emperor Qianlong (r. 1735–96) displayed about 3,000 clocks in his court, which resonated with their chimes. This particular example is one of a pair reputedly presented by Lord Macartney (1737–1806) to the Emperor Qianlong on the occasion of the British first envoy's trade mission of 1793.

The pendulum and backplate of this clock are engraved with the name of its maker, John Henry Borrell. A Huguenot Swiss

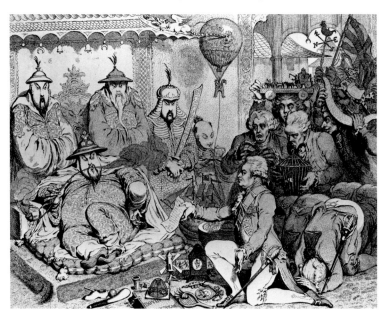

James Gillray's cartoon showing Britain's first envoy to China: George Macartney (later Lord Macartney), being received by the Emperor in Pekin (Beijing) in 1793.

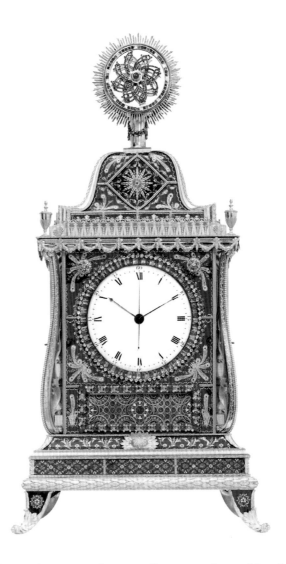

clockmaker working in London, Borrell was one of several horologists who specialized in export trade. What makes this particular piece exceptional is the automata: two painted metal ships appear on the hour from behind shutters, bobbing in a naturalistic manner between two spiral-twist glass rods that simulate the sea. Behind them, further rods turn to represent waterfalls, while music plays.

The clock's case was made of ormolu – a gold-coloured alloy – with panels of guilloché enamel embellished with metal foil peacock feathers. The piece later entered a collection of clocks owned by the Nezu Museum in Tokyo, held to be the finest outside Beijing's Palace Museum, and was offered at auction in 2008. Koichi Nezu, chairman and grandson of the founder of the Nezu Museum, stated: 'It has been difficult to find appropriate occasions to exhibit the clocks.' He continued: 'It is a pity to keep these exquisite clocks, with their strong historical value, hidden [from view] in the museum.' The sale of the collection raised funds to help finance the renovation of the museum.

A CELEBRATED BEAUTY

Élisabeth Vigée-Le Brun
(1755–1842), *Portrait of
Emma Hamilton as Ariadne*,
1790, oil on canvas,
135 x 158 cm (53 x 62 in)
(copy by Henry Bone,
1803, right)

SALE
27–28 March 1801, London
(private sale)

ESTIMATE
Not published

SOLD
£300/$1,315

EQUIVALENT TODAY
£20,400/$29,600

Emma, Lady Hamilton (1765–1815) – born Amy Lyon, the daughter of
a Cheshire blacksmith – became one of the most celebrated beauties
of her age. Her considerable allure was captured in paint by two of the
leading artists of the eighteenth century (see also pp.212–13).

In 1786, at the suggestion of her lover Charles Greville, Lyon
travelled to Naples to visit his elderly widowed uncle Sir William
Hamilton (1730–1803), English ambassador to Naples and a major
collector of antiquities and works of art. She did not realize that
Greville had engineered the sojourn because he wanted rid of his
mistress so that he could marry a wealthy heiress. Indeed, Greville
suggested to Sir William that he should take her as his mistress,
in an attempt to distract Sir William from remarrying, and to secure
his own place as the childless man's heir. Sir William fell in love with
Emma – who was thirty-five years his junior – and persuaded her
to marry him five years later.

Presiding over Sir William's salon in Naples, Lady Hamilton
developed her 'Attitudes', posing and dancing in flowing robes
to evoke figures from classical antiquity. Élisabeth Vigée-Le Brun's
three portraits of Emma all show her in the guise of a figure from Greek
mythology. In the first, *Portrait of Emma Hamilton as Ariadne* (1790),
she reclines coquettishly on the seashore, holding a wine cup as a ship
sails away in the background. Emma may represent either a Bacchante
or Ariadne, who was abandoned by her lover Theseus, just as Emma
had been by Greville.

Sir William's collecting habit had consequences, and in March
1801 Christie's held a sale of his possessions to help pay his huge
debts. This portrait of Emma was meant to be included in the sale,
but Admiral Lord Nelson (1758–1805), who was by then Emma's lover,
could not bear the thought of his favourite image of her being sold
publicly. 'How can any man sell your resemblance?' he thundered in
a letter to his mistress.

Writing from his ship in the Baltic as he prepared for battle, Nelson
arranged to buy it privately through James Christie for £300, asking
for the transaction to be conducted with the utmost discretion. 'If it
had cost me 300 drops of blood I would have given it with pleasure,'
he later declared. The painting was so close to his heart that he hung
it in his bedchamber at Merton Place in south-west London, the home

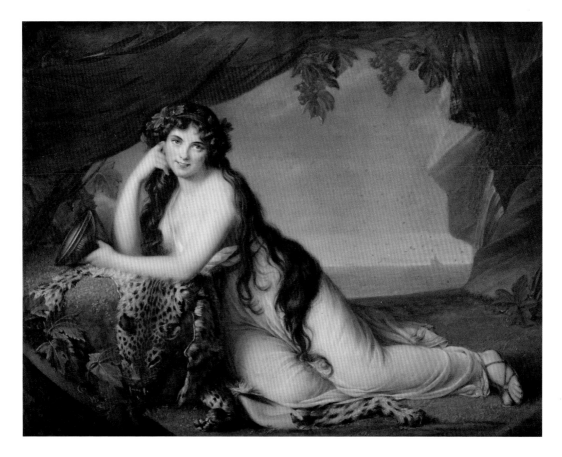

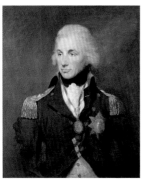

Left, top: Portrait of Sir William Hamilton, Emma Hamilton's husband, by William Hopkins Craft, c.1802.

Left, bottom: Charles Greville, portrait by George Romney, c.1770–99.

Above: Admiral Horatio Lord Nelson, Emma Hamilton's lover, as portrayed by Lemuel Francis Abbott, 1797.

he shared with Emma and her husband from 1801 until the latter's death two years later. Sir William, who seems to have tolerated the *ménage à trois* in which he found himself, commissioned the enamellist Henry Bone to copy the portrait (1803, above, now in the Wallace Collection, London), which he left to Nelson in his will.

After Sir William's death in 1803, his remaining possessions and household goods were auctioned by Christie's. Emma quickly exhausted the money he had left her. Following Nelson's death in 1805 at the Battle of Trafalgar, her struggle with debt increased, and in 1809 she authorized Christie's to sell the contents of Merton Place. The Vigée-Le Brun portrait was included in this sale, raising 130 guineas (£136 10s/$625; equivalent to £8,850/$12,850 today), and it has been in a private collection ever since. Emma, however, ended her days in Calais, on the run from her creditors.

A TALE OF
TWO MASTERS

J.M.W. Turner (1775–1851),
Sun Rising through Vapour:
Fishermen Cleaning and
Selling Fish, before 1807,
oil on canvas, 134 x 179.5 cm
(52 x 70 in)

SALE
7 July 1827, London

ESTIMATE
Not published

SOLD
480 guineas/£514 10s/$2,540

EQUIVALENT TODAY
£39,800/$57,700

When the artist J.M.W. Turner died in London in 1851, he left
thousands of works to the nation; they eventually became the Turner
Bequest, which is now largely housed at Tate Britain. For two paintings
in particular, however, Turner stipulated in his will special conditions
for their display. One of these works was *Sun Rising through Vapour:*
Fishermen Cleaning and Selling Fish (before 1807). He asked that this
painting, and his *Dido Building Carthage* (1815), be displayed alongside
Claude Lorrain's *Landscape with the Marriage of Isaac and Rebecca*
(1648, now known as *The Mill*) and *Seaport with the Embarkation*
of the Queen of Sheba (1648). Such a display would, Turner hoped,
serve as an enduring record of his association with and admiration
for the French seventeenth-century master. The pictures exhibited
are as Turner intended at the National Gallery in London.

Unusually for a painting by Turner, no specific location is
depicted in *Sun Rising through Vapour*, and while the debt to Claude
(1600–1682) is evident, there is, too, a clear sense of the influence
of Dutch painting. This work was included in a high-profile sale in
1827, of the 'very Distinguished and universally Admired Gallery of
that Accomplished and truly Spirited Patron of the Arts, The Rt Hon.
Lord de Tabley,' as trumpeted in the auction catalogue. De Tabley had
recently died, and the catalogue praised his collection, noting that it
was built 'with the finest Taste, and at the most liberal Expense, with
a view to displaying the perfection of the Fine Arts in this country,
and the Genius and Talent of British Artists'. It included 'favourite and
very popular specimens' of work by Thomas Gainsborough, Richard
Wilson and Joshua Reynolds, among many others. Four further works
by Turner were also included.

Sun Rising through Vapour was described in the catalogue thus:
'Dutch fishing boats with the sun rising. A busy group of figures
bargaining for fish, and others unloading a vessel, which is left dry
upon the shingles, occupy the front ground. In the distance the sun
is richly gleaming through a sultry morning vapour, with beautiful
effect.' It was received with applause in the saleroom, where Turner
himself bought it back. His affection for the painting is reflected
in the fact that he paid just over 480 guineas (£514 10s), the highest
price paid for any of his pictures during his lifetime and it remained
in his possession until his death.

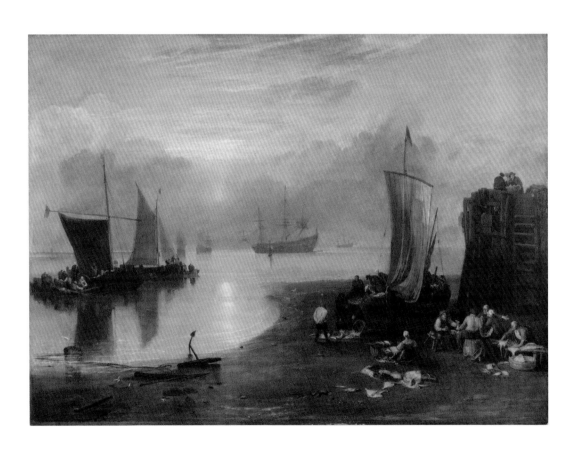

FROM SUNRISE
TO SUNSET

This pair of classical landscapes by Claude Lorrain was commissioned by the Swiss military engineer Hans Georg Werdmüller (1616–1678). By the early nineteenth century they formed part of the collection of Welbore Ellis Agar (1735–1805), Commissioner of His Majesty's Customs, who bequeathed them to his two illegitimate sons, Welbore Felix and Emmanuel Felix Agar. The collection included works by Peter Paul Rubens and Nicolas Poussin, but the stars were arguably the two landscapes by Claude.

'In the late eighteenth century, [the two paintings] were considered the most valuable Claudes in the entire collection,' wrote the scholar Michael Kitson in 1969. 'That this was so was probably due in part to their conventionality, for at that time the more eccentric of Claude's works were often not understood. They show that kind of execution which makes Claude's finest pictures expand in the mind irrespective of the composition or the subject.'

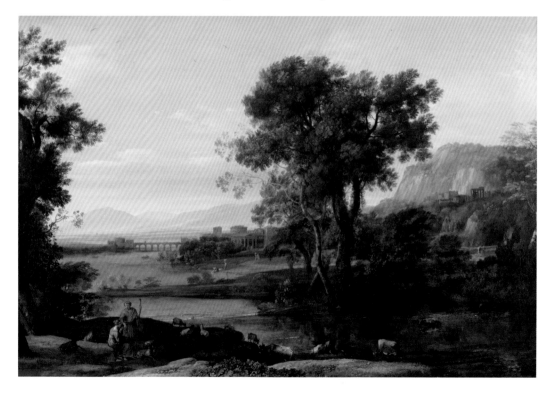

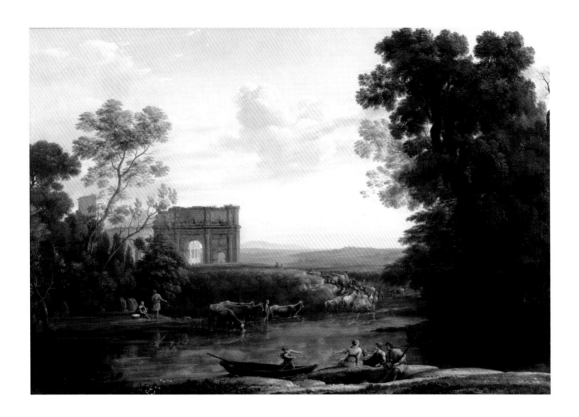

Claude Lorrain (1600–1682),
*Morning: A Pastoral
Landscape*, 1651 (left),
oil on canvas, 99 x 145 cm
(39 x 57 in), and
*Evening: A Pastoral Caprice
with the Arch of Constantine*,
1651 (above), oil on canvas,
99 x 145 cm (39 x 57 in)

SALE
2–3 May 1806, London

ESTIMATE
3,000 guineas/
£3,150/$14,000 (each)

SOLD
The entire collection
of Welbore Ellis Agar
(comprising sixty-five
pictures) was bought by
Lord Grosvenor for 30,000
guineas/£31,500/$140,000

EQUIVALENT TODAY
£2,280,000/$3,230,000

Despite these works having been consigned to auction following Ellis Agar's death, they were not sold publicly. A catalogue had been printed in preparation for an auction in 1806, but the collection was bought en bloc by the 2nd Earl Grosvenor, later 1st Marquess of Westminster, for 30,000 guineas. The two Claudes were valued at 3,000 guineas each.

From 1806 the dealer and restorer William Seguier (1771–1843) was appointed by the 2nd Earl Grosvenor to attend to his picture collection, for which Seguier was paid a retainer of £100 ($445) per year. He later became the first Keeper of the National Gallery, London, in 1824. The two Claude landscapes remain in the collection of the Duke of Westminster.

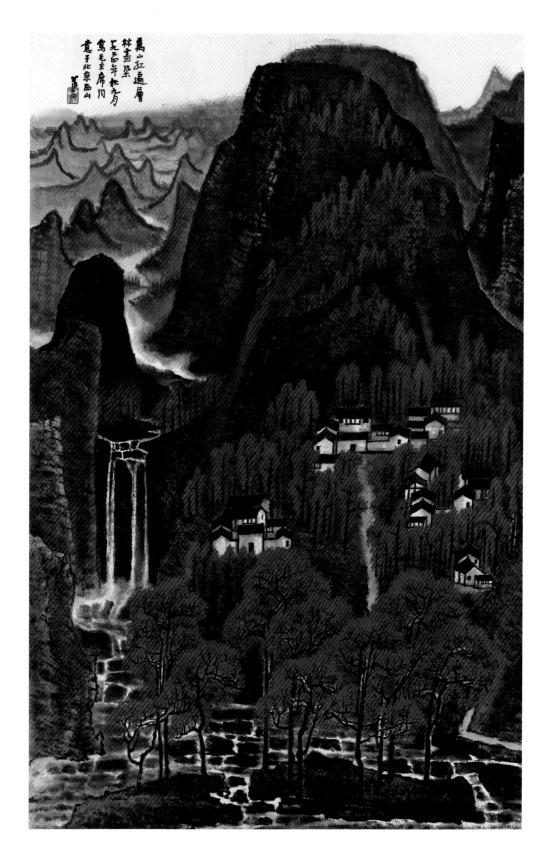

ALONE I STAND
IN THE AUTUMN CHILL

Li Keran (1907–1989), *All the Mountains Blanketed in Red*, 1964, scroll, ink and colour on paper, 133 x 84 cm (52 x 33 in)

SALE
28 May 2007, Hong Kong

ESTIMATE
Not published

SOLD
HK$35,040,000/
£2,259,760/$4,480,850

In Maoist China in the 1950s and 1960s, the painter and calligrapher Li Keran pioneered a new form of landscape painting that combined Western techniques with traditional Chinese aesthetics. In his own words, his objective was to 'delve into tradition with the utmost power, and break away from it with the utmost courage'.

At a time of social and political upheaval, Li steered a skilful course between personal artistic integrity and Maoist ideology. In September 1964, at a time when there was a strong political call for art to reflect class struggle, he painted *All the Mountains Blanketed in Red* (1964), which echoes a line from Mao Zedong's poem 'Changsha' (1925): 'All the mountains are blanketed in red and forests are totally dyed.' Changsha, the capital of central China's Hunan province, is the city where Mao began his political career.

Li's scroll is one of seven distinctly different landscapes that he painted on the theme between 1962 and 1964. His images do not depict Changsha as Mao describes it in his poem, but instead each presents an amalgam of different views that Li himself observed on his long sketching journeys through China. Besides introducing Western perspective and ideas of light and shade, Li's innovations included drawing from nature. In contrast to classical Chinese landscape painting, which conveyed the artist's inner mind 'landscape' rather than describing the visible world, Li believed in 'creating in front of scenery'. At the same time, his use of red was not only descriptive of autumn but also alluded to revolutionary fervour.

In 2007, the centenary of Li's birth, *All the Mountains Blanketed in Red* – the largest, most radiant and most monumental of his red landscapes – was sold in Hong Kong. It was anticipated that the lot would elicit furious bidding from collectors worldwide, and in a marathon afternoon sale that did not finish until nearly one o'clock the next morning, it was finally sold for more than HK$35m.

'DEGENERATE ART' IS REHOUSED

Alexander Archipenko
(1887–1964), *Carafe*, 1921,
oil and papier-mâché
on wood, 40 x 28.5 cm
(15¾ x 11¼ in)

SALE
29–30 October 1996, Vienna

ESTIMATE
ATS650,000–1,000000/
£38,000–59,000/
$61,000–94,000

SOLD
ATS4,535,000/
£265,070/$426,700

EQUIVALENT TODAY
€556,700/£503,300/$643,000

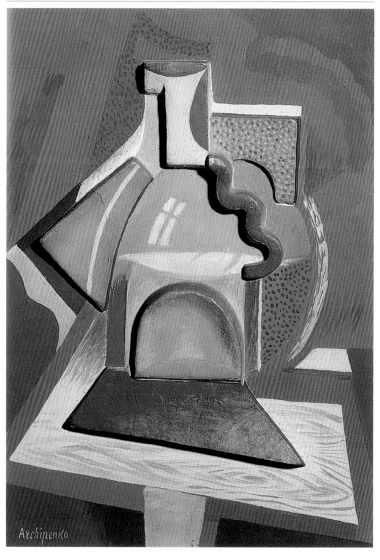

Works of art confiscated
during the Nazi regime
were stored at a monastery
in Mauerbach, Austria.
The store was photographed
in 1971, as the Austrian
government sought
to repatriate the work.

Looting and cultural destruction have always accompanied war, but the National Socialists' orchestrated actions and their consequences meant that between 1933 and 1945 confiscations, forced sales and the displacement of art occurred on an unparalleled scale. Towards the end of the Second World War some of this lost art – predominantly that taken from Jewish collections – was uncovered by the Allies, hidden in salt mines and depots in Germany and Austria (see pp.82–3, 202–3).

These finds were taken to 'collecting points', and a painstaking process began to identify this recovered art and its pre-war owners. Artworks with clear documentation were returned to their 'home' countries for restitution to their rightful owners, but for thousands of artworks the history of their ownership was lost in the turmoil of war. Thousands of these recovered but 'ownerless' artworks were transferred into the custody of national museums or collections. As official deadlines for claims passed, questions about their ownership and possible restitution tailed off. This was the case for nearly 8,500 objects transferred to the Austrian government at the end of the war and stored in a monastery at Mauerbach, near Vienna. Prompted by the intervention of Jewish writer Simon Wiesenthal in 1969, the Austrian government publicized the Mauerbach artworks, but few paintings had been returned by the deadline in 1972.

In 1984, however, *ARTnews* brought the subject back into sharp relief with an article on what it called Austria's 'legacy of shame', accusing the country's government of inefficiency and opacity in its handling of the heirless works in its charge. The ensuing international outcry reinvigorated the claims process for the remaining Mauerbach works. Over the next ten years, seventy-seven paintings and over 200 other works were restored to their rightful owners. In 1995 Austria transferred responsibility for the remaining works to the Federation of Jewish Communities of Austria.

The last 'ownerless' pieces were brought together in 1996 in the Mauerbach Benefit Sale, held on behalf of the Federation of Jewish Communities at the Museum of Applied Arts (MAK) in Vienna. Many of the works auctioned were financially modest but spoke of the pre-war homes from which they had been confiscated. The auction of these works raised a substantial $14.6m (£9m; equivalent to $21.4m/£15m today) for victims of the Holocaust and their families. The highlight of the sale was Alexander Archipenko's sculpto-painting *Carafe* (1921). For its conduct of the sale, Christie's was awarded the annual medal of Extraordinary Achievement to the Jewish Community by the Federation of Jewish Communities in Austria.

The Mauerbach monastery, near Vienna, in 1970.

FLORENTINE TOUR-DE-FORCE

Grand Ducal workshops in Florence, The Badminton Cabinet, 1726–32, Florentine *pietra dura*, ebony and ormolu, 386 x 232.5 x 94 cm (152 x 91½ x 37 in)

SALE
5 July 1990, London

ESTIMATE
Not published

SOLD
£8,580,000/$15,329,900

EQUIVALENT TODAY
£17,400,000/$25,100,500

The Badminton Cabinet was commissioned by the young Henry Somerset, 3rd Duke of Beaufort (1707–1745), from the Grand Ducal workshops in Florence. It was a flamboyant and grand act of patronage by a nineteen-year-old who would go on to become one of the inaugural governors of the Foundling Hospital, Britain's first institution for the care of abandoned children. In 1990, the cabinet became the most expensive work of European decorative art ever sold at auction when it realized more than £8.5m.

Made between 1726 and 1732, the piece is regarded as the greatest Florentine cabinet of its time. Nearly 4 metres (12½ feet) tall and crafted from *pietra dura* (a decorative technique in which highly polished and coloured stones are inlaid to create patterns or pictorial images), ebony and ormolu (gilt bronze), the cabinet features an extraordinary range of materials, including jasper, chalcedony, lapis lazuli, agate and amethyst quartz. A clock face is set into the top, surmounted by the gilt-bronze figures of Flora, Ceres, Bacchus and Saturn (symbols of the four seasons), and the Beaufort coat of arms appears at the apex.

The cabinet remained in the Beaufort family until 1990, when it was offered for sale at Christie's. The successful bidder was the American heiress Barbara Piasecka Johnson, although the export licence was delayed for eight months while a fundraising campaign attempted unsuccessfully to raise the money to purchase the cabinet for the British nation. Fourteen years later, on 9 December 2004, the Badminton Cabinet broke its own record when it was auctioned again at Christie's, this time being bought for £19,045,250 ($36,509,744) by Prince Hans-Adam II of Liechtenstein, and is now on display in the Liechtenstein Museum in Vienna.

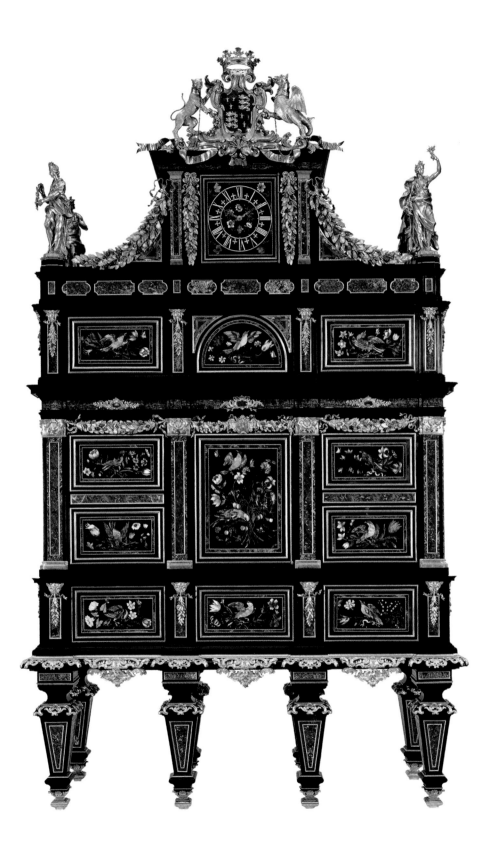

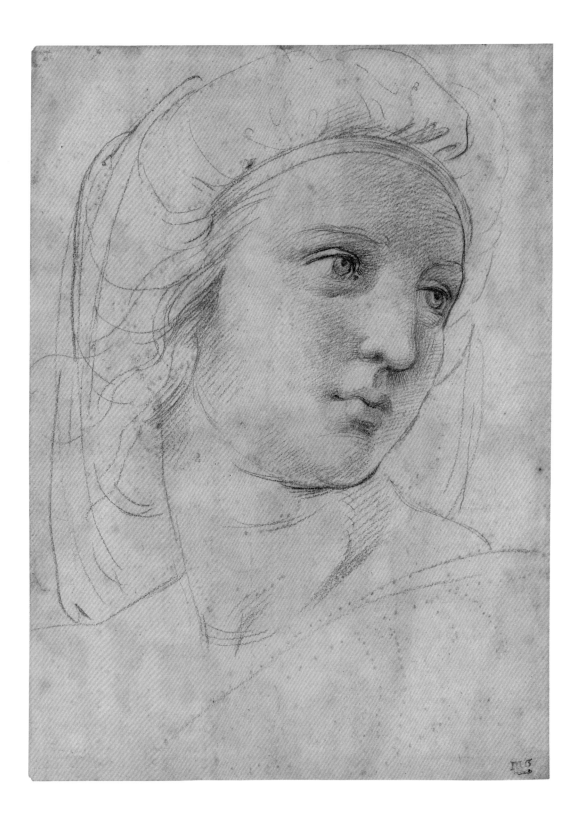

GOING ONCE

RAPHAEL'S MUSE

Raffaello Sanzio, called Raphael (1483–1520), *Head of a Muse*, c.1510, black chalk over pounce marks, traces of stylus, 30.5 x 22 cm (12 x 8½ in)

SALE
8 December 2009, London

ESTIMATE
£12m–16m/$19.7m–26.3m

SOLD
£29,161,250/$48,009,960

In 1508, as Michelangelo began working on the Sistine Chapel ceiling at the Vatican, the twenty-five-year-old Raphael was summoned to the court of Pope Julius II to help with the redecoration of the papal apartments. Part of his assignment was to paint frescoes for the Pope's library and private office, the Stanza della Segnatura. The series of four works that Raphael produced is widely considered to be his masterpiece. This drawing was for a section of a wall depicting Mount Parnassus, the home of Apollo and the nine Muses.

Raphael's exquisite *Head of a Muse* (c.1510) is an auxiliary cartoon, a type of preparatory drawing that allowed the artist to experiment with particularly important or tricky details of his design. It was made by pressing powdered chalk through the pricked outlines of the original drawn cartoon on to a fresh sheet of paper, leaving guiding lines that Raphael then drew over, adapting the design as his ideas evolved. Less cumbersome than the full-scale cartoon, which was probably 3 metres wide and 2 metres high (9¾ × 6½ feet), the small drawing acted as a reference tool during the painting of the fresco, and remains a unique record of Raphael's thinking during the final stages of creating Mount Parnassus.

When *Head of a Muse* was sold in 2009, it set a new world record for a work on paper, soaring beyond the £12m–16m estimate. As reported at the time, 'two bidders were clawing it out' in what was described as 'a knockdown fight'. When the gavel finally struck, the winner was an anonymous telephone bidder who paid more than £29m for the drawing.

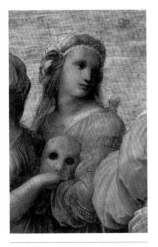

A detail from Raphael's Vatican fresco *The Parnassus*, 1511, showing the muse based on the drawing.

WITH STRINGS ATTACHED

Antonio Stradivari
(1644–1737), a violin known
as 'The Hammer', 1707,
alpine spruce and maple,
back 35.5 cm (14 in) long

SALE
16 May 2006, New York

ESTIMATE
$1.5m–2.5m/£0.8m–1.3m

SOLD
$3,544,000/£1,882,000

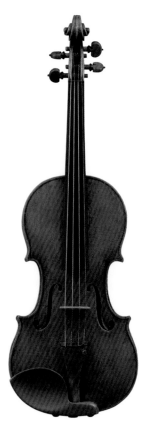

In May 2006, as the bidding for the violin known as 'The Hammer' surpassed the $3m mark, the crowd in the saleroom erupted into applause. When bidding closed at over $3.5m, history had been made. Created by one of the most important violin-makers ever to have lived, the Italian master craftsman Antonio Stradivari, The Hammer had achieved a sale price higher than any other musical instrument in history.

Stradivari lived and worked in Cremona, a small town in northern Italy that had been the centre of violin-making since the early sixteenth century, thanks to Andrea Amati (c.1505–1578), the man widely credited as the inventor of the modern violin. It was also home to the legendary craftsman Bartolomeo Giuseppe Guarneri (1698–1744), known as Guarneri del Gesù, whose violins were played by Niccolò Paganini (1782–1840), the most celebrated violin virtuoso of his time. Between them, these great craftsmen had created works of art as brilliant and beautiful as anything achieved by other Renaissance masters.

The violin sold at Christie's for the record sum was a Stradivarius named after its first recorded owner, the nineteenth-century Swedish collector Christian Hammer. The Hammer had been crafted in 1707 during Stradivari's 'Golden Period' (1700–20). These were the years when he produced some of the most famous violins and cellos ever made, instruments that went on to be owned and played by such great names as Napoleon Bonaparte, Yehudi Menuhin and Jacqueline du Pré. Until its sale, The Hammer had been on loan to the celebrated Japanese violinist Kyoko Takezawa, who used it as her main performance instrument.

Today, only 650 Stradivari are thought to survive, including fifty cellos, a dozen violas and three guitars. Those lucky enough to play them argue that each has a distinctive personality and tone that makes every instrument a unique masterpiece in its own right.

LOVE CHANGES EVERYTHING

John William Waterhouse
(1849–1917), *St Cecilia*, 1895
(overleaf), oil on canvas,
123 x 201 cm (48½ x 79 in)

SALE
14 June 2000, London

ESTIMATE
£2.5m–3.5m/$3.8m–5.3m

SOLD
£6,603,750/$9,984,500

When John William Waterhouse's *St Cecilia* sold for just over £6.6m in 2000, setting a new world auction record for a Victorian painting, it was a clear indication that this once overlooked category was becoming increasingly sought after. Much of this demand was being driven by a small group of passionate collectors including the musical impresario Andrew Lloyd Webber. On this occasion, it was the Andrew Lloyd Webber Foundation that managed to acquire the Waterhouse.

A respected teacher and much-loved painter who was fascinated by myths and literary themes, Waterhouse was at the height of his career when he painted *St Cecilia*, which was exhibited in the same year that he was elected a member of the Royal Academy. The subject of the painting was notable for her vow of chastity (despite her enforced marriage) and her martyrdom, and Waterhouse took as his inspiration lines from Tennyson's poem 'The Palace of Art' (1832): 'In a clear walled city on the sea/Near gilded organ pipes ... slept St Cecily.' The painting was instantly successful, and a reviewer in the *Art Journal* wrote: 'The feeling is entirely medieval ... The effect is decorative first, then somewhat ecclesiastic; entirely remote from realism and the world of our daily life.'

Waterhouse continued with the Pre-Raphaelite style several decades after the movement was first developed by Dante Gabriel Rossetti and John Everett Millais. The interest in nostalgia, hyperrealism and myth fell out of fashion around the turn of the twentieth century, to be supplanted by Post-Impressionism and modernism.

Andrew Lloyd Webber fell in love with the Pre-Raphaelites at a young age; in the 1960s his grandmother refused to lend him £50 (equivalent to about £900/$1,300 today) to buy Lord Frederic Leighton's *Flaming June* (1895), dismissing it as 'Victorian junk'. Undeterred, the composer went on to amass an extensive collection of Victorian paintings, sculptures and objets d'art, including works by Millais, William Holman Hunt, Edward Burne-Jones and Rossetti (see also pp.296–8, 444–5).

John William Waterhouse
at his easel, lithograph after
a sketch by Charles Paul
Renouard, c.1890.

MAJOR SYMPHONIC DISCOVERY

Giuseppe Verdi (1813–1901),
autograph manuscript score,
c.1834, paper, 62 pages,
landscape quarto,
23 x 28 cm (9 x 11 in)

SALE
13 December 2001, Rome

ESTIMATE
Lira 180m–200m/
£57,600–64,000/
$82,800–92,000

SOLD
Lira 183,750,000/
£58,800/$84,525

On 3 December 2001, Christie's sponsored the performance of a symphony by Giuseppe Verdi that had not been heard for 164 years. Before the sale of the score, the newly rediscovered work was played at the Auditorium di Milano by the Orchestra Sinfonica di Milano Giuseppe Verdi, conducted by Riccardo Chailly.

The auction of this remarkable find – a rare instrumental work from Verdi's early career – came during the centenary of the Italian composer's death. The nineteenth-century music specialist Andrea Cortellessa described its emergence as 'one of the most exciting musical discoveries of the last decades'.

The sixty-two-page score of a hitherto unpublished 'Symphony in D Major' was written mainly by the composer himself. The manuscript had been found in the Biblioteca Livia Simoni of the Museo Teatrale alla Scala in Milan, and featured two versions of a piece that had been heard for the first (and only) time on 17 February 1838 at Busseto, a town near where the composer was born.

The occasion was an Accademia, a typical musical event in nineteenth-century Lombard society, where young composers could showcase their works alongside those by more established names. That evening's programme boasted a duet by Gioachino Rossini, then the undisputed king of Italian opera thanks to such classics as *The Barber of Seville* (1816); and the third item on the bill was Verdi's symphony.

At the time, Verdi was struggling to establish himself as an operatic writer. He was director of Busseto's municipal music school and the local Philharmonic Society, but he was a year away from staging his first opera, *Oberto: Conte di San Bonifacio*, at Milan's celebrated opera house, La Scala. In his memoir the composer – who wrote such operas as *Rigoletto* (1851), *La Traviata* (1853) and *Aida* (1871) – remembers writing many such symphonies in his youth that were used in church, the theatre and at concerts, but few survive today.

26

CALLIGRAPHIC COMMUNION

Dong Qichang (1555–1636), *Poems in Running Script Calligraphy*, 1620, handscroll, ink on paper, 27.5 x 235 cm (11 x 92½ in)

SALE
28 May 2012, Hong Kong

ESTIMATE
HK$5m–7m/
£410,000–575,000/
$644,000–902,000

SOLD
HK$57,780,000/
£4,745,715/$7,443,095

Literacy and scholarly excellence traditionally invested the Chinese arts of the brush – calligraphy, poetry and painting – with great importance. In ancient times, China fostered the development of bureaucratic prowess, pioneered the invention and production of paper, and sustained codes of moral and aesthetic integrity. By Dong Qichang's lifetime, those arts had already been practised and valued for more than two millennia.

Dong's lifelong study of the masters of calligraphy and painting from as far back as the fourth century gave him a deep understanding of historic values and style, and an artistic philosophy which posited calligraphy as the means of expressing a scholar's own personality. Both the Kangxi (r. 1662–1722) and Qianlong (r. 1735–96) Emperors admired Dong's calligraphy, and the critical criteria he established remain influential to the present day.

For *Poems in Running Script Calligraphy* (1620), Dong uses running (*xingshu*) and cursive (*caoshu*) script, the two most effective styles for revealing the writer's mind. Both were derivatives of the more formal clerical script (*lishu*), and showed his admiration for great calligraphers of the Tang (618–907) and Song (960–1279) dynasties. The spontaneity and continuity of these scripts enabled the reader to trace the movement of the brush as it passed over the writing surface, giving a sense of communion with the artist. In this example of Dong's calligraphy, we can also see his preoccupation with balance and the spacing of strokes, characters and lines. Such conscientiousness corresponds well with the linguistic care of one of China's greatest poets, Li Bai (701–762), whose verses appear on this handscroll.

The scroll was sold at auction in 2012 by an American collector, and evidence of its earlier ownership added immeasurably to its value. Listed in a respected eighteenth-century catalogue of artworks possessed by the Qing Imperial Court (1644–1911), it bears two of Dong's own seals, six of the Emperor Qianlong, one of Qianlong's son Jiaqing (r. 1796–1820) and many more appended by subsequent owners known for their discerning taste. It is now part of the Guanyuan Shanzhuang Collection.

27 POETRY IN MOTION

Joan Miró (1893–1983),
*Painting-Poem ('Le corps de
ma brune puisque je l'aime
comme ma chatte habillée en
vert salade comme de
la grêle c'est pareil')*, 1925,
oil on canvas, 130 x 96.5 cm
(51 x 38 in)

SALE
7 February 2012, London

ESTIMATE
£6m–9m/$9.5m–14.3m

SOLD
£16,841,250/$26,757,625

Living in Paris in the 1920s, the Spanish artist Joan Miró spent a great deal of time with avant-garde poets and writers. A member of his circle was André Breton (1896–1966), the founder of the Surrealist movement. Miró's discovery of Surrealism marked a turning point in his career; he later wrote that it 'freed the unconscious, exalted desire, endowed art with additional powers ... I painted as if in a dream, with the most total freedom.'

Abandoning realism for the imaginary, Miró began creating lyrical free-form 'painting-poems' that fused abstracted imagery with handwritten stream-of-consciousness poetry. The most famous of this extraordinary group of paintings is *Le corps de ma brune*, the full text of which reads: *Le corps de ma brune puisque je l'aime comme ma chatte habillée en vert salade comme de la grêle c'est pareil* – 'the body of my dark-haired woman because I love her like my pussy-cat dressed in salad green like hail, it's all the same.'

le corps
de ma brune

puisque je l'aime

comme ma chatte
habillée
en vert salade

comme de la

grêle

c'est pareil

Vestiges of the 'dark-haired woman' appear in the painting as a spectral white streak punctuated by breasts. Breton saw the free association in painting-poems such as this as exemplars of 'pure psychic automatism,' and remarked that in the 1920s Miró appeared to be 'the most "surrealist" of us all.' Miró, for his part, explained that he painted without premeditation and that he made no distinction between painting and poetry: 'It therefore happens that I illustrate my canvases with poetic phrases and vice versa.' The artist regularly experienced hallucinatory episodes as a result of hunger, and saw shapes in the cracks in the walls and in the ceiling that he would record in his notebooks. These jottings would become the starting points for spontaneously painted forms and words that he superimposed on carefully prepared monochromatic grounds.

In 2012, *Le corps de ma brune* was sold in The Art of the Surreal sale in London to an anonymous telephone bidder for £16.8m ($26.7m), a record for Miró at the time. In 1985 the same work had sold in New York for $770,000 (£590,000; equivalent to $2.3m/£1.6m today).

28

GOLDEN FINGERS
AT GOLDENEYE

Royal Typewriter Company
(est. 1904), Royal Quiet
De Luxe portable typewriter
(once belonging to Ian
Fleming), c.1952, gold-plated
body and fittings, four-row
keyboard, 28 x 28 x 15 cm
(11 x 11 x 6 in)

SALE
5 May 1995, London

ESTIMATE
£5,000–8,000/$7,800–12,500

SOLD
£55,750/$86,750

EQUIVALENT TODAY
£96,000/$137,000

Ian Fleming in his study
at Goldeneye, his Jamaican
home, in 1964.

'My love,' wrote Ian Fleming (1908–1964) to his new wife, Ann,
in August 1952, 'this is only a tiny letter to try out my new typewriter
and to see if it will write golden words since it is made of gold.'

The gold-plated Royal Quiet De Luxe, made by the Royal
Typewriter Company of New York, was a gift that Fleming had bought
for himself as a reward for finishing a draft of the first James Bond
novel, *Casino Royale* (1953). The next draft of that book, and all the
subsequent Bond stories including *Goldfinger* (1959) and *The Man with
the Golden Gun* (1965), were written on the same golden typewriter at
Fleming's Jamaican retreat, Goldeneye. Clearly, Fleming had a fondness
for gold's glister and all that it signified.

The golden typewriter cost Fleming $174 (£62; equivalent to about
$2,000/£1,500 today). He asked a friend, Ivar Bryce, to pick it up
for him in New York and bring it back to England, adding mysteriously:
'I will not tell you why I am acquiring this machine.' Presumably, the
existence of James Bond was still something Fleming wanted to keep
under wraps at this stage. By the time the typewriter came up for
auction forty years later, 007 had become a global phenomenon.
The suave spy's every utterance and action had come to life on this
very machine, which made it one of the most exciting pieces of literary
memorabilia ever to be offered by Christie's. The golden typewriter
sold for £55,750, more than ten times its low estimate, making
it officially the most valuable typewriter in the world. The identity
of the buyer remained, appropriately enough, a secret.

LIVE AND LET DIE

Aston Martin (est. 1913),
Aston Martin DB5, 1965,
right-hand-drive car with
six-cylinder engine, five-
speed manual gearbox,
independent front suspension
and four-wheel servo-
assisted disc brakes

SALE
14 February 2001, London

ESTIMATE
£100,000–150,000/
$150,000–220,000

SOLD
£157,750/$230,000

Ever since 1962, when Sean Connery first picked up 007's Walther PPK in *Dr No*, James Bond has been the embodiment of cool luxury. While Bond's recent outings have highlighted his watch as product placement on his immaculately tailored arm, all twenty-four official Bond films have produced a vast and lucrative market in memorabilia.

Bond is a connoisseur of fine suits, fast cars, expensive watches and outlandish gadgets, but there is a collector's market for almost anything Bond-related, from underwear to film scripts. What's more, it's a market that is shaken (if not stirred) every few years by the release of a new Bond film, ensuring that prices keep rising.

Agent 007's cars are usually the star attraction of any Bond sale. Pierce Brosnan premiered his suave Bond to considerable acclaim behind the wheel of an Aston Martin DB5 in *Goldeneye* (1995). It was not the first time the fictional British Secret Service agent had driven this particular model, and its reappearance thirty years after Sean Connery had transformed it into one of the most famous cars in the world in *Goldfinger* (1964) was an affectionate tribute to previous films. In 2001 the Aston Martin DB5 belonging to Brosnan's Bond sold at auction for £157,750.

Other Bond cars have sold for even more: Daniel Craig's Aston Martin DBS from *Quantum of Solace* (2008), for example, reached

£241,250 ($374,500) in 2012. But Brosnan's DB5, harking back as it did to the early years of the franchise, is possibly the most iconic Bond car to have passed through Christie's salerooms.

In the last twenty years, Bond film posters by such 1960s and 1970s illustrators as Robert McGinnis and Mitchell Hooks have become almost as iconic and important to the Bond brand as the cars. In good condition, they can now sell for more than ten times what these posters achieved in the early twenty-first century, and at times can rise above £10,000 ($14,000).

However, it is the unique props and costumes that appeared in the original films that hold the real allure for collectors. Ursula Andress's iconic white bikini from *Dr No* sold in 2001 for £41,125 ($59,960); Daniel Craig's powder-blue La Perla swimming trunks from *Casino Royale* (2006) came up for sale in 2012 and raised £44,450 ($69,000) for charity. At the same sale in 2012, Christie's auctioned an Omega Seamaster watch worn by Craig in *Skyfall* (2012). Estimated at £6,000–8,000, it made £157,250 ($229,300) before the film was even released.

Far left: The Aston Martin DB5 first seen in *Goldfinger* (1964) returned in *Goldeneye* (1995) with Pierce Brosnan as James Bond.

Left: The Aston Martin DB10 from *Spectre* (2015) with Daniel Craig as Bond. The DB10 sold at Christie's on 18 February 2016 for over £2.4m ($3.5m).

DEADLY BIRDSONG

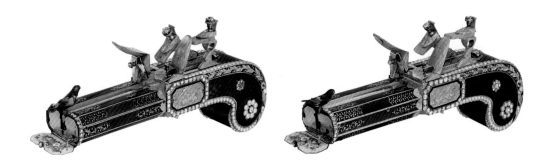

Attributed to Frères Rochat,
pair of mirror-image
singing bird pistols, c.1820,
gold, enamel, agate, pearl
and diamond, dimensions
not available

SALE
30 May 2011, Hong Kong

ESTIMATE
HK$20m–40m/
£1.6–3.1m/$2.56–5.1m

SOLD
HK$45,460,000/
£3,551,445/$5,843,100

Why should a pair of pistols – no matter how exquisite – appear in
a sale of watches? The reason lies in the complex clockwork mechanism
that allows birds hidden within the pistols to sing.

These ornamental weapons were made for imperial Chinese
patrons during a period when automata (moving objects) were
constructed especially for the Ottoman Empire and Indian royalty,
as well as European aristocrats and royal families. Swiss craftsmanship
and technology were highly prized, particularly that of the three Rochat
brothers of Geneva, who specialized in singing birds that appeared
in boxes or pistols, of which these examples were the most advanced.

Thanks to a mechanism made up of several hundred screws and
wheels, the tiny multicoloured feathered birds flip up from inside the
barrels when the triggers are pressed. The barrel covers open to reveal
bouquets of flowers over turquoise enamel. The exquisite creatures
turn, flap their wings and move their beaks and tails in time to lifelike
birdsong, automatically retreating into the barrels once the music has
finished. Elsewhere, the detailing is just as sumptuous. The pistols are
made of gold with scarlet enamel grips inset with pearls and diamonds,
and two plaques on each depict a stag and a lion. These pistols remain
in exceptional condition, with the mechanism in perfect working order.

Such artefacts were made in extremely limited numbers, and only
four other examples are known to exist, none of them in pairs. The
2011 sale prompted an epic bidding war between connoisseurs that
lasted for ten minutes before finally settling with one proud buyer.

THE
PYGMALION EFFECT

John Joseph Merlin
(1735–1803), Silver Swan,
1773, chased silver,
166 x 80 x 80 cm
(65 x 31 x 31 in)

SALE
26 May 1864, London

ESTIMATE
Not published

SOLD
£155/$1,545

EQUIVALENT TODAY
£13,600/$19,400

Built by John and Joséphine Bowes in the nineteenth century, the Bowes Museum in County Durham, north-eastern England, was commissioned to house the couple's wide-ranging collection of paintings, ceramics, furniture and textiles. Its impressive permanent collection includes works by Canaletto, Gustave Courbet and J.M.W. Turner, as well as Sèvres porcelain. Yet every day at 2 p.m., one object in particular can be relied upon to attract the biggest audience of the day.

What these visitors congregate around is the Silver Swan, a mechanical automaton created in 1773 in the workshop of the silversmith and clockmaker James Cox of London. Automata were at the forefront of eighteenth-century technological developments, and were created for the entertainment of the wealthy elite.

Three separate clockwork mechanisms enable the elegant life-size bird to move in time to music from a set of chimes. During the

thirty-two-second performance, the swan turns its neck from side to side as if grooming its plumage before scooping a fish from the surrounding 'water', fashioned from rods of twisted glass, and swallowing it whole. The movement in the head and neck is so lifelike that it is thought to be the work of the celebrated inventor John Joseph Merlin, who worked for Thomas Weeks, owner of London's Mechanical Museum, where the swan is recorded as being first displayed, in 1774. (Merlin is also credited with having invented roller skates.)

The Mechanical Museum was wound up after Weeks's death, and the automaton auctioned along with all the other exhibits. The swan was later shown in the Paris Exposition of 1867, where the American novelist Mark Twain praised it as having a 'living grace about his movement and a living intelligence in his eyes'. Paris was also where John and Joséphine Bowes first saw the swan, which was being exhibited by the jeweller Harry Emanuel. They eventually purchased it for £155 five years later, equivalent to £13,600 today.

32

TIME WAITS
FOR NO MAN

Thomas Tompion (1639–1713), The Mostyn Tompion clock, c.1695–1700, clock housed in an oak case with ebony veneer and gilded bronze and silver decorations, 71 cm (28 in) high

SALE
14 July 1982, London
(private treaty)

ESTIMATE
Not published

SOLD
£500,000/$712,380

EQUIVALENT TODAY
£1,576,000/$2,238,700

Britain's greatest horological treasure, the Mostyn Tompion clock (c.1695–1700), was acquired by the British Museum at the eleventh hour, on the eve of the planned Christie's sale, for the sum of £500,000. It was the highest price ever recorded for a clock.

This superb clock celebrates the coronation of William III and Mary II in 1689, and was kept in their royal bedchamber. It is housed in an oak case with ebony veneer and gilded bronze and silver decorations, and crowned by a statuette of Britannia, who bears a shield that combines the crosses of St George and St Andrew. The dial shows hours and minutes, as well as days of the week. Most notably, it is a 'year-going' clock, which means that it runs for a year on a single wind; it continues to keep excellent time to this day.

The clock was made by Thomas Tompion, the son of a Bedfordshire blacksmith who embarked on his clockmaking career at a time when London boasted many skilled goldsmiths, silversmiths, engravers and watchmakers, a large proportion of whom had fled religious persecution in France and the Netherlands. Tompion made two regulators for the new Royal Observatory at Greenwich in 1676, but was most famous for his domestic clocks, which were much in demand among royalty, merchants and aristocrats.

After the death of William III in 1702, the Tompion clock was bequeathed to the Earl of Romney and from him to the Mostyn family. The 5th Baron Mostyn sold the clock in 1982, and the British Museum has continued to honour the tradition adopted by his family, and holds a 'winding party' each year.

THE HOLY GRAIL
OF THE SEAS

John Harrison (1693–1776),
Harrison's second sea
watch or the H5 marine
chronometer, 1770, silver case,
dimensions not available

SALE
11 April–12 June 1877, London

ESTIMATE
Not published

SOLD
£168/$765

EQUIVALENT TODAY
£14,100/$20,100

The sale of the estate of the Scottish shipbuilder Robert Napier in April
1877 was one of the largest auctions of the decade. Spanning twenty
days, it contained everything from ormolu vases to Brescian pistols,
marquetry commodes and antique amphorae. Without doubt, though,
the sale's greatest treasure was Lot 2998, a 'chronometer, in silver case,
by J. Harrison, 1770', which was sold on the fourteenth day.

Only five marine timekeepers ever bore John Harrison's name.
In 1877 four of them lay half-forgotten in the Royal Observatory
at Greenwich, London. The fifth, which sold at Christie's that day
for £168, was the only Harrison marine chronometer in private
ownership. It represented one of the most important scientific
discoveries ever made.

Born in Yorkshire in 1693, Harrison – a self-taught clockmaker –
began crafting his precision timepieces in the 1720s, when maritime
navigation was still a hopelessly haphazard affair. Although methods
for measuring latitude had existed for centuries, to calculate longitude
required a timepiece capable of accurate timekeeping despite the
plunging physics of a ship at sea, and that was beyond contemporary
technology. So desperate had the situation become by 1714 that the

British government created the Board of Longitude, a panel of judges charged with awarding the sum of £20,000 – about £2.8m/$4m in today's money – to whoever could solve the longitude problem. For many years the Board was deluged by theories that purportedly held the solution. 'Discovering the longitude' soon entered common parlance as a byword for a scientific impossibility.

Between 1735 and 1770, Harrison submitted five marine chronometers to the Board: three large brass clocks and two silver watches. However, during the 1760s as the rival 'Lunar-distance' method of finding longitude neared a solution, certain members of the Board with vested interests tried to obstruct Harrison's bid for the prize. Finally, in 1770 he audaciously sidestepped this opposition by presenting his last chronometer, the H5, directly to George III to be tested at the king's private observatory. As a result of the parliamentary debate that followed, Harrison was finally recognized as the man who had solved the longitude problem.

After Harrison's death, memory of his achievement faded. Under the terms of the prize, his first four marine timekeepers became the property of the Board of Longitude and were stored at the Royal Observatory in Greenwich. The H5, however, remained in the Harrison family until Napier acquired it in 1869. Kept in immaculate condition by subsequent owners, it has been held by the Worshipful Company of Clockmakers since 1891.

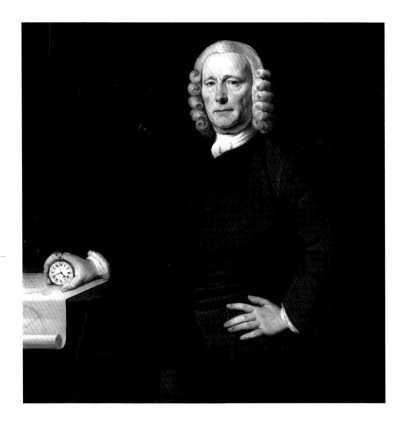

Clockmaker John Harrison, as portrayed by Thomas King in 1767 (detail). Harrison's H3 chronometer stands on the table behind him, and he is holding a watch built to his specifications by John Jefferys in 1751–2. This watch led Harrison to develop H4 and H5 and finally solve the longitude problem.

CITIES IN THE SKY

Liu Wei (b. 1972), *Purple Air*,
2009, oil on canvas,
180 x 300 cm (71 x 118 in)

SALE
24 October 2015, Shanghai

ESTIMATE
RMB1.5m–2.5m/
£154,000–257,000/
$236,000–$394,000

SOLD
RMB3,630,000/
£373,415/$571,840

In the 1980s and 1990s, Chinese contemporary art came to be
dominated by an unpicking of state propaganda and by the human
response to the profound changes happening in Chinese society,
as seen in the work of Zeng Fanzhi (see p.362). In more recent years,
urbanization and the extraordinary architectural growth of Chinese
cities have played an increasingly important role in informing new
practice, as can be seen in the work of Liu Wei. Liu makes sculptures
and paintings of soaring cityscapes, representing them as vital
contemporary spaces but also questioning how the structures that
underlie our cities affect our negotiation of urban existence.

Purple Air, in common with all Liu's works, does not represent
a particular place, but instead evokes the vertiginous dynamism of
modern cities and the ubiquitous and faceless 'grey' of the twenty-first-
century metropolis. Of the 'Purple Air' series, Liu has said that
it concerned 'purple air arriving from the East … an auspicious omen.
The purple air is covered in a mass of grey but [is] full of life.'

Liu's painting is representational to a degree, but he also engages with the history of abstraction: the surfaces of the 'Purple Air' series are mesmerizing up close, zinging with geometric rhythm. The images are created through the digital manipulation of landscape views, leading to an increasing fragmentation of the original image, and the final work is a product of the imagination rather than any form of observed reality.

If Liu's subject matter represents a significant shift in Chinese contemporary art, so does his practice as an artist. Unlike the early pioneers of the 1980s, he has emerged into a globalized art world in which demand for new Chinese art is high. This means that Liu can act, as can numerous Western artists, as a producer as much as a maker, working with numerous assistants.

This work was sold at the inaugural +86 auction (86 is the international dialling code for China), the first auction held by Christie's Shanghai to focus on a new generation of emerging Chinese artists.

35

THE TENSION BETWEEN CHANCE AND CONTROL

Gerhard Richter (b. 1932),
Abstraktes Bild, 1989,
oil on canvas,
259.5 x 200.5 cm
(102 x 79 in)

SALE
13 February 2014, London

ESTIMATE
Not published

SOLD
£19,570,500/$32,563,225

'When I paint an abstract picture,' Gerhard Richter has said, 'I neither know in advance what it is meant to look like, nor, during the painting process, what I am aiming at and what to do about getting there. Painting is consequently an almost blind, desperate effort, like that of a person abandoned, helpless, in totally incomprehensible surroundings.'

Abstraktes Bild is one of a large number of paintings that emerged from what is surely the German painter's most prolific period of making abstract works, between 1988 and 1992. Richter's process is well known: he applies layer after layer of colour, often wet into wet, using a squeegee to pull the paint across the surface in various directions. This is where he ventures into the unknown: he can predict the kind of mark he can create, but cannot be certain what forms and effects will emerge from each of the individual movements with the squeegee. He describes this as a form of chance 'that is always planned, but also always surprising'. With typical mischievous modesty, Richter adds that he is 'often astonished to find how much better chance is than I am'.

The tension between chance and control has been at the centre of Richter's work since he began to establish himself as a leading artist in the early 1960s. His memorable show at Tate Modern in London

in 2011, which subsequently toured to Berlin and Paris, emphasized this push and pull in his work, so that rooms full of abstracts would be punctuated by paintings based on photographs. Everything was ultimately a form of abstraction, even the most representational images.

Richter's abstracts inevitably inspire interpretations that stray into the figurative world, from molten lava to the Northern Lights and wooded landscapes. The artist has made it clear that he does not set out to depict anything, but neither does he discourage such readings, saying that the paintings show 'scenarios, surroundings and landscapes that don't exist, but they create the impression that they could exist'. It is this quality that makes them so beguiling and so enveloping, and by far the most popular of his paintings at auction: only one of his top ten highest prices was for a figurative painting.

Abstraktes Bild was sold for nearly £20m in 2014. In that same year Christie's staged a private selling exhibition featuring Richter alongside his compatriot and former collaborator Sigmar Polke (1941–2010), their first joint show in almost fifty years.

Gerhard Richter in front of *4900 Colours: Version II* at the Serpentine Gallery, London, in 2008.

THE COLD GREY LIGHT
OF DAWN

James Abbott McNeill
Whistler (1834–1903),
*Harmony in Grey: Chelsea
in Ice*, 1864, oil on canvas,
45 x 61 cm (18 x 24 in)

SALE
25 May 2000, New York

ESTIMATE
$2.5m–3.5m/£1.7m–2.4m

SOLD
$2,866,000/£1,946,000

In 1859, the American artist James Abbott McNeill Whistler moved from Paris to London and began working on a set of etchings of the River Thames. From that point on, London would be his home, and the river became a lifelong source of inspiration. The Thames was a major industrial thoroughfare. Whistler – who always lived within a short distance of its banks – drew and painted it in all seasons and in all kinds of weather. As the river changed over time, so Whistler's art evolved, becoming more poetic and more atmospheric.

Harmony in Grey: Chelsea in Ice is a view from Whistler's house in Chelsea, near Old Battersea Bridge. Whistler's mother records that it was painted during a period of 'very sharp frost' in February 1864, when they were able to see sheets of ice moving down the river. In the painting, the freezing fog muffles, flattens and smudges figures in the foreground and the view across the river, where the factory chimneys, warehouses and slagheaps of Battersea are transformed into a dreamscape of Venetian campaniles and Japanese mountain peaks. The only hint of nineteenth-century London, in fact, is the steam-powered tugboat that emerges from the mist. At the same time, the lack of detail, the subdued colour and the composition's slanting lines (suggesting movement downstream) all point to Whistler's interest in Japanese art, which was still a new discovery in Europe.

As was the case with other paintings by Whistler from this period, the work's subtlety was lost on many contemporary viewers, who were dismayed by what they saw as slightness and lack of finish. Even at the beginning of the twenty-first century, when *Harmony in Grey: Chelsea in Ice* was put up for sale, *The New York Times* voiced concerns that its muted colours might not make it a popular choice. In the event, the painting sold for $2,866,000, a record price at auction for the artist. It now resides in the Colby College Museum of Art in Waterville, Maine.

THE STORMY
OCEAN OF WISDOM

Katsushika Hokusai
(1760–1849), *Choshi in
Shimosa Province*, from
the series 'One Thousand
Pictures of the Ocean', c.1833,
woodblock print,
19 x 25.5 cm (7½ x 10 in)

SALE
22 September 1983, New York

ESTIMATE
$10,000–15,000/
£6,600–10,000

SOLD
$60,500/£39,800

EQUIVALENT TODAY
$144,000/£120,000

Utagawa Hiroshige, *View of
the Monkey Bridge in Kōshū
Province*, 1841–2.

The Japanese artist Katsushika Hokusai is today most famous for his woodblock print *Under the Wave off Kanagawa* (*c.*1830–2), one of the most commonly reproduced artworks in the world, depicting a giant wave looming over several wooden boats. Hokusai's prints influenced a wide range of nineteenth-century artists including James Abbott McNeill Whistler (see previous page), Paul Gauguin and Vincent van Gogh, all of whom drew inspiration from his flattened perspective and harmonious arrangement of forms.

The great wave is a recurring motif in Hokusai's work, and it appears again in his 'One Thousand Pictures of the Ocean' series, issued *c.*1833. The series features ten prints in total, and a complete set came on the market in 1983, with several prints carrying estimates of $10,000–15,000 each. Other items in the sale included paintings and ceramics, as well as such objects as traditional Japanese inrō (a small carrying case) and sculptures.

On the day, bidding was fierce, with American and Japanese collectors competing for nineteenth-century prints of landscapes, including Utagawa Hiroshige's *View of the Monkey Bridge in Kōshū Province* (1841–2), which fetched $60,500 (£39,800). In total, the 'One Thousand Pictures of the Ocean' prints realized nearly $200,000 (£131,500; equivalent to £396,300/$476,000 today), with one work – *Choshi in Shimosa Province*, which depicts a storm-tossed sea not dissimilar to that in *The Great Wave off Kanagawa* – fetching $60,500, over four times its estimate. This figure matched the then-record price paid for a Hokusai print at auction, for *Fuji in Clear Weather* (*c.*1830–4), sold in 1979.

SUNFLOWERS SET THE RECORD

Vincent van Gogh (1853–1890), *Still Life: Vase with Fifteen Sunflowers*, 1889, oil on canvas, 99 x 76 cm (39 x 30 in)

SALE
30 March 1987, London

ESTIMATE
Not published

SOLD
£24,750,000/$39,784,600

EQUIVALENT TODAY
£62,200,000/$90,360,600

In 1987, a small painting of sunflowers by the Post-Impressionist artist Vincent van Gogh became the most expensive picture ever bought at auction when it was sold for more than £24m (see also pp.202–3). The auction added yet another twist to the story of the poverty-stricken Van Gogh, who sold only one painting during his short lifetime.

Although the price of the painting was phenomenally high, there was a valid reason. It was highly likely that this was the last time a painting of sunflowers by Van Gogh would ever come up at auction. Although he had completed seven paintings of sunflowers in a vase, four were already owned by museums and another had been destroyed during a bombing raid on Japan in the Second World War. This still life had been part of a collection formed in the 1930s by the wife of the mining millionaire Sir Alfred Chester Beatty, and the painting was being sold to meet inheritance taxes.

All Van Gogh's sunflower paintings date from the last few years of the artist's life. The first were completed in Paris in 1887, and a further four were painted a year later during a frenzied burst of activity in Arles in southern France, while Van Gogh waited for his friend the artist Paul Gauguin to arrive. This painting is one of two versions by Van Gogh, completed the following January, based on the *Sunflowers* painting of 1888 that now hangs in the National Gallery in London.

When one of the sunflower paintings was first shown in an exhibition in Brussels in 1890, the year Van Gogh committed suicide, the Belgian artist Henry de Groux nearly came to blows with Paul Signac and Henri de Toulouse-Lautrec, Van Gogh's supporters, over the inclusion of the painting. De Groux called the painting 'laughable'. Today Van Gogh's sunflower paintings are celebrated for their expressive energy and for revealing the artist's creative powers in full bloom. As Van Gogh's brother Theo wrote after contemplating one of them, 'It has the effect of a piece of fabric embroidered with satin and gold; it's magnificent.'

This painting was bought by the Yasuda Fire and Marine Insurance Company of Tokyo, which sought to replace the version that had been destroyed by fire in the Yokohama City Art Museum in 1945.

Paul Gauguin's 1888 portrait of his friend Vincent van Gogh, painting sunflowers.

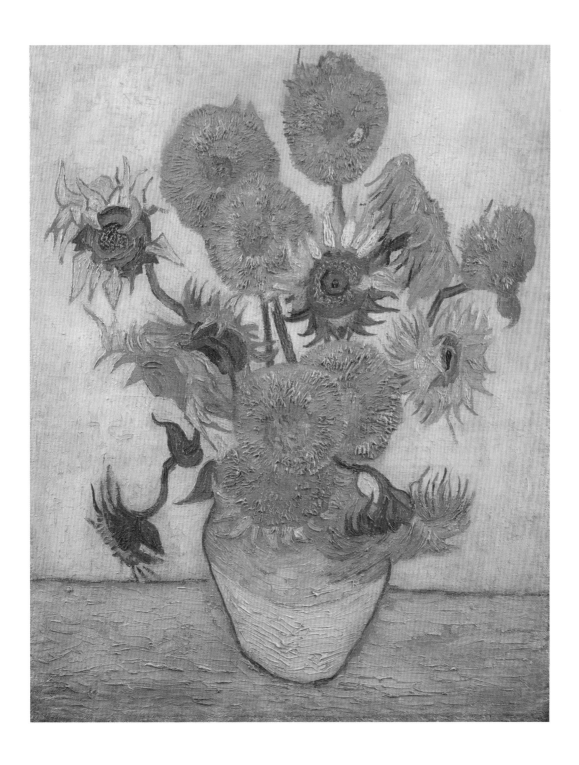

REDISCOVERY AND RESTITUTION OF A LOST MASTERPIECE

Egon Schiele (1890–1918),
Herbstsonne, 1914, oil on
canvas, 100 x 120.5 cm
(39½ x 47½ in)

SALE
20 June 2006, London

ESTIMATE
£4m–6m/$7.4m–11m

SOLD
£11,768,000/$21,651,150

Until the mid-2000s, *Herbstsonne* (*Sunflowers*) was thought to be among the many great paintings lost or destroyed during the Second World War. It had belonged to Karl Grünwald, a dealer in art, textiles and antiques who had befriended Egon Schiele during the First World War and who sat for a portrait in 1917. Grünwald began to amass a significant collection of Schiele's work after the artist's early death from influenza in 1918, and he bought *Herbstsonne*, which was prized as the 'jewel' in his collection, in the 1920s. It remained with him in Vienna until 1938, when Germany annexed Austria, and Grünwald fled to Paris.

While Grünwald himself escaped the Nazis, his collection did not. Although he managed to get some of his works by Schiele out of Vienna, *Herbstsonne*, which had been stored in Strasbourg, was confiscated by the occupying forces. The last time the painting was seen in public was at a sale of confiscated art held in 1942. From then on it was presumed lost, even though Grünwald and his son Frederic expended great energy in trying to trace and retrieve their appropriated art.

Remarkably, in 2005, *Herbstsonne* reappeared. Christie's was contacted by the owner of the painting in France, and the two Christie's experts who went to view it knew instantly they had rediscovered a truly seminal work in Schiele's oeuvre, describing the moment as 'an intense experience, a rare moment of magic'.

Herbstsonne is an anthropomorphic study of wilting sunflowers against a pale sunset. Schiele was inevitably mindful of Vincent van Gogh's masterpieces and Gustav Klimt's responses to them, and he brought his own profoundly melancholy world view to bear on these flowers, which – like so many of his figures – seem caught between life and death. The painting was created as much from Schiele's imagination as from observation, and, like so much of his best work, marries extraordinary elegance and expressionistic verve with an ominous bleakness of mood.

Through Christie's, an amicable agreement was reached to restitute the work to the Grünwald family, who then entrusted Christie's to bring it to auction. The successful resolution of the Grünwald heirs' claim was a significant illustration of how the art market is engaged in tackling the ongoing and complex issue of Nazi-era losses (see also pp.48–9, 202–3).

Portrait of Karl Grünwald
by Egon Schiele, 1917.

THE ALLURE
OF CONCHOLOGY

'An entire collection
of shells, corals, ores,
minerals, petrefactions
and other curious
subjects in natural history'

SALE
3 June 1771, London

ESTIMATE
Not published

SOLD
£83 8s/$380

EQUIVALENT TODAY
£9,800/$14,100

There have always been collectors of fossils and shells, people who are drawn in by the strange allure of things long dead. Christie's first sale of such objects took place in June 1771, five years after James Christie opened his permanent saleroom on Pall Mall, London (see p.17). It was advertised as a sale of 'an entire collection of shells, corals, ores, minerals, petrefactions and other curious subjects' and included 'a fine large onyx agate, the skin of a beautiful zebra, two curious birds of paradise &c. [The property] of an eminent collector, lately deceased.'

It transpired that this was a pivotal moment for natural history, and for the market in natural-history artefacts. A month after Christie held this auction, Captain James Cook returned to England from his first voyage (see pp.36–7). His ship, the *Endeavour*, was crammed with samples of flora and fauna from 'Terra Australis'. Some of it was gathered as part of Cook's scientific mission, but a great deal more – in particular, a vast haul of shells – was simply picked up on distant beaches by Cook's crewmen, who knew they could make money from such things when they got home. The return of the *Endeavour*, therefore, caused a buying frenzy among certain collectors. It seems highly likely that some of the gentlemen who bought fossils and seashells, such as devil's claws and bishop's mitres, at Christie's in June were, later that summer, vying to get their hands on exotic and desirable conchological finds from the South Seas.

Objects from eighteenth- and nineteenth-century collections and 'cabinets of curiosities' still find their way on to the market today. In recent years, Christie's has successfully sold dodo bones, iridescent ammonites and an egg of the extinct Mauritian elephant bird. Bidders are sometimes specialists in palaeontology, but many are buyers of furniture who are looking for something unique – the skull of a sabre-toothed tiger, say, or a striking conch shell – to display on their Louis XVI sideboard.

Hand-coloured copperplate
engraving of a mitre shell
from George Shaw and
Frederick Nodder's *The
Naturalist's Miscellany*, 1796.

THREE TONS OF TULIPS

Jeff Koons (b. 1955),
Tulips, 1995–2004 (overleaf),
high-chromium stainless
steel with transparent
colour coating,
203 x 457 x 520.5 cm
(80 x 180 x 205 in)

SALE
14 November 2012, New York

ESTIMATE
Not published

SOLD
$33,682,500/£21,250,290

In 2012, Jeff Koons hit the headlines with the sale of his sculpture *Tulips*, which set a world auction record for the artist at that time. The sculptural installation – created in five versions between 1995 and 2004, and comprising of seven stainless-steel blooms coated in bright colours – is part of Koons's 'Celebration' series and was consigned by Norddeutsche Landesbank.

The series evolved from Koons's desire to represent a child's ecstatic enjoyment of the world. His forms recall Constantin Brancusi's streamlined sculptures as well as children's toys. Koons has explained that, '[The 'Celebration' series] is about a calendar year and how we perceive different things within the course of a year. You can look at [...] the *Tulips* sculpture and maybe it will make you think of spring. You can look at *Hanging Heart* and think of Valentine's Day, or *Cracked Egg* and you think of Easter. If you look at *Party Hat*, you might think of a birthday. There are different forms of celebration within a cycle of time.' *Balloon Dog (Orange)* (1994–2013), from the same series, was sold for $58,405,000 (£36,270,000) in November 2013, and remains the highest price paid at auction for a living artist. It is now situated at the Wynn casino in Las Vegas.

Tulips looks shiny and weightless, but in reality it weighs more than three tons. 'I started to work with polished steel in 1986,' Koons has said. 'Polishing the metal lends it a desirous surface, but one that also gives affirmation to the viewer. It's about telling him, "You exist!" When you move, it moves.' The work was originally installed outside the Norddeutsche Landesbank in Hanover, Germany, over a reflective surface that enhanced the sculpture's flawless sheen. When it came to Christie's New York, this presentation was emulated by displaying *Tulips* on a purpose-built water-filled plinth located in the Rockefeller Plaza, where it became a much-admired temporary feature.

Jeff Koons in front of *Tulips*
at Christie's New York in 2012.

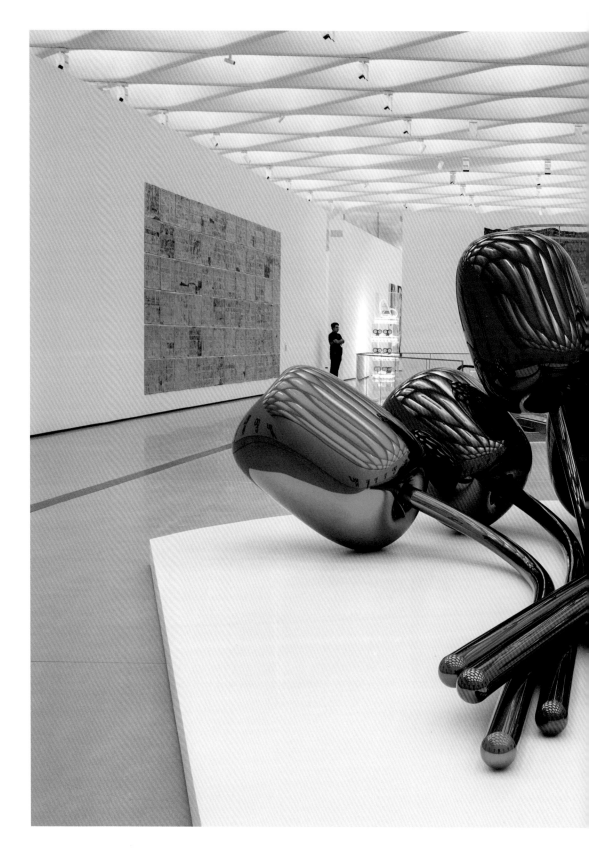

GOING ONCE

HEAVEN
IN A WILD FLOWER

Georgia O'Keeffe (1887–
1986), *Calla Lilies with
Red Anemone*, 1928,
oil on gessoed masonite,
122 x 75 cm (48 x 29½ in)

SALE
23 May 2001, New York

ESTIMATE
$2.5m–3.5m/£1.7m–2.4m

SOLD
$6,166,000/£4,287,835

At the start of her long career, Georgia O'Keeffe created a unique style
of painting that synthesized abstraction and her personal observation
of the natural world. Her large-scale paintings of flowers, which
she began in the early 1920s, are close-up images that are at once
monumental and extremely intimate. When they were first exhibited
they caused a sensation, but most of the criticism – both positive and
negative – missed the point. Her critics spoke of her work in terms of
sexuality, a reading that O'Keeffe herself always denied. Her intention
was to get people to look at things they normally would not notice.
She remarked: 'In a way, nobody sees a flower, we haven't the time …
so I said to myself I'll paint it big and they will be surprised into taking
time to look at it – I will make even busy New Yorkers take time to see
what I see of flowers.'

Painted in 1928, *Calla Lilies with Red Anemone* is one of a series
of calla lilies, the flower with which O'Keeffe is most closely associated.
Explaining that it was her habit to work with an idea for a long time,
she said: 'It's like getting acquainted with a person, and I don't get
acquainted easily.' Each painting in the series is strikingly individual,
with the white lilies arranged in various ways and set against
different colours.

Calla Lilies with Red Anemone, which is larger than most,
introduces another flower as a vibrant contrast in texture and shape
as well as colour. O'Keeffe designed its frame herself, and she put
her star motif and signature on the back – something she very rarely
did, believing her works were so clearly identifiable that they did not
need to be signed. When the painting was sold at Christie's in 2001,
it fetched over $6m, then a world record for O'Keeffe, and the record
price at auction for any work by a woman artist at that time.

Georgia O'Keeffe
photographed by
Alfred Stieglitz in 1920.

THE CLOCK
IN THE ATTIC

Étienne Le Noir (1675–1739),
Louis XV chinoiserie clock,
1735–40, ormolu-mounted
Chantilly porcelain dial: white
enamel; movement: brass
and steel, 49.5 × 24 × 12 cm
(19½ × 9½ × 5 in)

SALE
28 March 1966, London

ESTIMATE
Not published

SOLD
£29,400/$82,000

EQUIVALENT TODAY
£489,000/$689,000

When Jo Floyd – then head of the furniture department, and who in 1974 would become chairman of Christie's – visited Lady Margaret Fortescue at her home in Devon, he thought he was going to make a routine valuation. It was only when he was exploring the attic, and looked inside a cardboard box, that the day took an unexpected turn. In the box was something quite extraordinary: a Louis XV porcelain chinoiserie cartel clock. No such clock in this type of case had ever been recorded.

The wall-mounted cartel clock Floyd carefully inspected was designed by Étienne Le Noir, and made in the Chantilly porcelain factory between 1735 and 1740. Its elaborate frame of partly gilded bronze and soft-paste Chantilly porcelain flowers is dominated by three chinoiserie figures, the one at the apex of the clock holding a globe on his lap. The dial is white enamel, and the movement is of brass and steel.

Le Noir was the patriarch of a dynasty of French clockmakers, whose lavishly decorated cases were much sought after by royal and aristocratic figures. He worked in collaboration with the porcelain factory at Chantilly, France, which was established by the Prince de Condé at his chateau. The prince was one of several European aristocrats who established such factories, intent on finding the elusive 'recipe' for Oriental porcelain. Chantilly's wares were in the Japanese style, using an opaque tin glaze to produce a lustrous background for painted enamel decoration.

The American collectors and philanthropists Jack and Belle Linsky – who had made their fortune manufacturing office supplies – acquired the clock at the sale in March 1966, paying £29,400. In 1982, two years after Jack's death, his wife donated their magnificent collection of European art, which comprised some 380 items, to the Metropolitan Museum of Art in New York. The clock is now on display in the museum's Jack and Belle Linsky galleries.

WATERLILY WORLD

Claude Monet (1840–1926),
*Le bassin aux nymphéas
(Waterlilies)*, 1919 (overleaf),
oil on canvas, 100 x 201 cm
(39½ x 79 in)

SALE
24 June 2008, London

ESTIMATE
£18m–24m/$35.4m–47.1m

SOLD
£40,921,250/$80,379,590

Le bassin aux nymphéas is part of Claude Monet's celebrated waterlily series, which culminated in the 'grandes décorations' he designed for the Musée de l'Orangerie in Paris (1914–26). In 2008 the oil painting broke the world auction record for a Monet, prompting those who packed the King Street saleroom to break into spontaneous applause.

Monet re-landscaped the grounds of his house in Giverny, west of Paris, to create a water garden filled with exotic flowers. He then devoted the later part of his life to painting waterlilies. Playing with reflections and the effects of light on water, he made a series of immersive paintings that exerted a lasting influence on other artists, in particular the Abstract Expressionists.

What made *Le bassin aux nymphéas* so unusual and so coveted by collectors in 2008 was that this late painting, produced at the height of Monet's creative powers, was signed and dated. Monet regarded his waterlily paintings as a work in progress, and guarded them jealously. He signed only five and sold four (one of which now hangs in the Metropolitan Museum of Art, New York).

When *Le bassin aux nymphéas* was offered for auction in London, it had not been seen in public for eighty years, having been in the private collection of the American industrialist J. Irwin Miller and his wife, Xenia. The record price reflected an understanding that this rarest of paintings, made at a critical moment in the artist's long career, might never be seen in a saleroom again.

Claude Monet in his studio
in Giverny, c.1919.

Claude Monet's *Le bassin aux nymphéas (Waterlilies)*, 1919.

THE MAN OF EIGHT GREAT MOUNTAINS

Bada Shanren (b. Zhu Da) (1626–1705), *Landscapes, Flowers, Birds and Rocks*, 1698, album of 17 leaves, ink on paper, each leaf, 29.5 x 22 cm (11½ x 8½ in)

SALE
2 December 2008, Hong Kong

ESTIMATE
Not published

SOLD
HK$34,260,000/
£2,974,115/$4,419,845

Zhu Da was a prince of the Ming imperial line, brought up in a cultured family. Accustomed to wealth, he nevertheless retreated to a monastic life in the countryside to avoid persecution after the Manchu conquest in 1644. Badly affected by depression, he found solace in painting, an occupation frequently cultivated by monks and long associated with the Chan (Zen) order in particular. Any solace it brought him seems to have been equivocal, for he appeared to hover on the verge of madness, but the energetic, even outlandish, nature of his unorthodox painting, characterized by bold brushwork and plentiful ink wash, earned him a reputation and commercial gain.

Zhu rejoined the world in the 1670s, and in 1684, he adopted the sobriquet Bada Shanren ('Man of Eight Great Mountains'). However, by the time he painted this album of 17 leaves, he was again a recluse. Nobility and humility, wealth and poverty, profundity and simplicity – there are so many contradictions in the biography

of this Ming loyalist that some commentators have even questioned the genuineness of his mental instability.

Zhang Hongxing, curator of Chinese paintings at the Victoria and Albert Museum in London, has drawn attention to Bada's love of metaphor and the autobiographical content of his work. Much Zen painting was characterized by the paradox of the profound intent concealed within apparently unassuming subject matter and minimalist brushwork. Bada's outlandishness was seen in his choice of inconsequential subjects (if his predilection for the favourite Buddhist emblem, the lotus, be discounted): birds, fish, plants, rocks and cats were among his favourites, although he is also famed for landscapes and human figures. The leaves of this album contain sixteen paintings of landscapes, birds, plants and rocks, and one piece of calligraphy in a wild, cursive script. They were seemingly dashed off with little concern for composition or technique in his typically exaggerated, expressionistic style.

Bada Shanren is counted among China's greatest artists, breaking the artistic barriers of his time with as much impact as Pablo Picasso did more than two centuries later. Yet, successful as he was in his own day, Bada's fame has peaked in modern times, as was reflected in a particularly good year at auction in 2008. Zen painting was always favoured in Japan, and this album was in several illustrious Japanese collections and published as early as 1916 before coming up for sale at Christie's.

FIRST LIGHT
ON THE MOUNTAIN

J.M.W. Turner (1775–1851),
*The Blue Rigi, Lake of
Lucerne, Sunrise,* 1842,
watercolour, bodycolour,
pen and brown ink,
heightened with white
chalk, on paper,
29.5 x 45 cm (11½ x 17½ in)

SALE
5 June 2006, London

ESTIMATE
Not published

SOLD
£5,832,000/$10,955,965

J.M.W. Turner's *The Blue Rigi*, acclaimed by many as the finest
watercolour he ever painted, was sold in June 2006 for nearly £6m,
a record for a British work on paper. It was the fourth time the work,
which had been owned by a small number of private collectors, had
appeared at Christie's (it had previously passed through the salerooms
in 1863, 1912 and 1942).

A lifelong fascination with the effect of light on his subjects
culminated in Turner's extraordinary series of watercolours painted
in Switzerland in 1841–2. The artist became obsessed with the view
of Mount Rigi from Lake Lucerne, and revisited the spot annually
between 1841 and 1844, making a series of studies and sketches.
He created three breathtaking watercolours that focus on the
transformative effect of light on the mountain. *The Blue Rigi*, which
is considered to be the finest of the set, is a study of first light over
the mountain. It uses subtly modulated tones of blue to create a sense

of early-morning stillness. Delicate, ethereal mist swirls around the mountain, and the lake is serene and calm, apart from two dogs chasing waterfowl in the foreground.

Immediately after the sale in 2006, the British government placed *The Blue Rigi* under a temporary export ban to allow funds to be raised to keep it in Britain in perpetuity. The Art Fund and Tate launched a public appeal, and in just over five weeks an unprecedented £550,000 (just over $1m) was raised, including international donations. A major grant from the National Heritage Memorial Fund as well as funds from the Trustees of Tate ensured that *The Blue Rigi* joined Tate's collection. In March 2007, the watercolour was reunited with *The Dark Rigi* (1842) and *The Red Rigi* (1842) in a dedicated exhibition at Tate Britain in London.

RUSSIAN RECORD FOR A FROSTY DAY

47

Ivan Konstantinovich
Aivazovsky (1817–1900),
St Isaac's on a Frosty Day,
1891, oil on canvas,
111 x 144 cm (44 x 57 in)

SALE
30 November 2004, London

ESTIMATE
£1m–1.5m/$1.9m–2.9m

SOLD
£1,125,250/$2,145,750

Born on the shores of the Black Sea and revered in his homeland, Ivan Aivazovsky was considered the greatest *marinist*, or maritime painter, of his day. In his youth, he was the official artist of the Imperial Navy, and his grand depictions of crashing waves and storm-tossed riggers are one of the glories of Russian Romanticism. One contemporary said of Aivazovsky that 'he kept a secret in the pocket of his coat: how to make water appear wet on canvas'. J.M.W. Turner encountered Aivazovsky's *Bay of Naples on a Moonlit Night* (1842) in Rome, and was so impressed that he wrote a poem in praise of the artist.

This view of St Isaac's Cathedral in St Petersburg, *St Isaac's on a Frosty Day* (overleaf), is unusual for Aivazovsky owing to its dominant architectural subject. But it also demonstrates that the artist was, like Turner, a masterly portrayer of light as well as of water. He captures the blue-grey quality of the northern capital's short winter days, in which the hoarfrost-encrusted trees tinkle like bells with the slightest breath of wind. There is a serenity about the picture; even the dynamism of the hurrying horse-drawn troika in the foreground serves only to highlight the chilly stillness of the mountainous church behind.

The painting came up for auction in 2004, at a time when London was emerging as a magnet for Russians who had prospered in the buoyant post-Yeltsin economy. For passionate collectors,

it was almost an act of patriotism to re-acquire exemplars of Russian heritage that had found their way abroad during the country's turbulent twentieth century.

The interest in this particular picture was probably boosted by the fact that St Petersburg had just celebrated its 300th anniversary with much pomp and civic pride. *St Isaac's on a Frosty Day* became the first nineteenth-century Russian painting to sell for a seven-figure sum.

48

SKI FEVER IN ST MORITZ

Carl Moos (1878–1959),
St Moritz, 1929, colour
lithograph, printed by
Fretz Bros Ltd, Zurich,
102 x 64 cm (40 x 25 in)

SALE
22 January 2015, London

ESTIMATE
£18,000–22,000/
$27,000–33,000

SOLD
£30,000/$45,140

Christie's annual Ski Sale is the only one of its kind, a unique celebration of the golden age of travel when posters promised glamour and excitement in the first half of the twentieth century. It has become a popular event, and the graphic representations of stunning scenery, chic outfits and old-school sophistication have proved a draw for serious collectors and ski enthusiasts alike.

In 2015, the seventeenth Ski Sale coincided with the 150th anniversary of winter tourism in Switzerland – the country responsible for producing the largest number of classic ski posters. Naturally, posters of Swiss resorts were represented heavily in the sale, alongside popular and rare examples from France, Italy, Austria, Germany and Norway, as well as further afield: Australia, America and Canada. This

GOING ONCE

dynamic poster from 1929 for one of the most famous destinations, St Moritz, which nestles in the dramatic Engadin valley, came from the pen of the Swiss artist Carl Moos (1878–1959), whose poster *Athletics* won a silver medal in the arts competition of the 1928 Olympic Games in Amsterdam. Identified as a masterpiece of design, Moos's *St Moritz* easily beat its estimate and sold for £30,000.

As advertisements, the images created for the posters needed to be instantly eye-catching, while also reflecting graphic trends. With so many ski resorts on offer, competition was fierce for lucrative custom. With the services of the finest artists in the field, Switzerland's posters remain the most sought-after in the category.

Also offered in the sale were twenty-five lots of vintage travel luggage and accessories, among them a Gucci saddle and a pair of monogrammed Louis Vuitton desk trunks, which enabled travellers to keep up with their correspondence on the move.

THE PAINTER
OF MODERN LIFE

Henri de Toulouse-Lautrec (1864–1901), *Danseuse assise aux bas roses*, 1890, *peinture à l'essence* and pastel on board, 57 x 46.5 cm (22½ x 18 in)

SALE
12 May 1997, New York

ESTIMATE
$8m–$10m/£4.9m–6.2m

SOLD
$14,522,500/£8,945,860

EQUIVALENT TODAY
$21,400,000/£14,825,500

Often considered to be the quintessential chronicler of Belle Époque Paris, Henri de Toulouse-Lautrec was not simply a man of his time. He was keenly alert to the complex possibilities of avant-garde art, as well as being a candid and astute observer of human behaviour.

Toulouse-Lautrec's subject matter derived from the clandestine world of dance halls, theatres, brothels and the circus of the area in which he lived, Montmartre in Paris. *Danseuse assise aux bas roses* (*Seated Dancer with Pink Stockings*) is one of the occasional images of dancers that he made, and was drawn and painted in a combination of *peinture à l'essence* (oil mixed with turpentine) and pastel. It portrays a young girl dressed in a tutu and pink stockings, who may have been a circus or cabaret performer rather than a ballet dancer, and who is shown resting backstage.

Danseuse assise aux bas roses was first seen by the collectors John and Frances Loeb at a dealer's gallery in New York in 1963. John Loeb fell in love with the painting, but felt it was beyond his reach at $250,000 (£89,286; equivalent to $2.5m/£1.7m today). Unbeknown to him, his wife bought it and later gave it to him as a Christmas present.

The couple's significant collection of Impressionist and Post-Impressionist paintings was sold at Christie's New York in 1997 for a total of $92.7m (£57.1m; equivalent to $134.1m/£92.8m today) – at the time the second-highest result for a single-owner sale in auction history. Bidding was particularly intense for *Danseuse assise aux bas roses*, with competition coming from four telephone bidders and two people in the saleroom. It eventually sold for just over $14.5m, a record for the artist.

THE MOST FAMOUS LITTLE DANCER IN THE WORLD

Edgar Degas (1834–1917),
Petite danseuse de quatorze ans, 1879–81 (cast 1921),
polychromed bronze with
muslin skirt, satin hair
ribbon and wooden base,
98 x 35 cm (38½ in x 13½ in),
excluding base

SALE
14 November 1988, New York

ESTIMATE
$8m–10m/£4.5m–5.6m

SOLD
$10,175,000/£5,716,300

EQUIVALENT TODAY
$20,400,000/£14,130,000

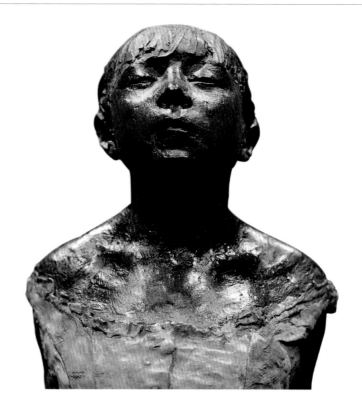

When the wax *Petite danseuse de quatorze ans* (*Little Dancer aged Fourteen*) by Edgar Degas was first exhibited, at the sixth Impressionist exhibition in 1881, it scandalized visitors. The sculpture, a portrait of the plucky young dancer Marie van Goethem, was considered so drab and lifelike that one critic described it as a 'rat from the opera learning her craft with all of her evil instincts and vicious inclinations'. Today, posthumous bronze casts of this sculpture reside in the National Gallery of Art, Washington, DC, and Tate Modern, London, and it has become one of the most famous artworks in the world.

Degas loved the ballet. He haunted the Paris Opéra, studying performances and sketching the dancers backstage, and on one occasion declaring that his soul was like a worn pink-satin ballet shoe. However, by 1880, he was going blind, and so he took to sculpting the dancers in wax rather than painting them.

After the artist's death in 1917, a collection of his wax sculptures was found in his studio, including the little dancer. His family made bronze casts of the originals, and these have been in great demand ever since. In 1988, this early copy was auctioned as part of the collection of film producer William Goetz and his wife Edith, the daughter of movie mogul Louis B. Mayer. Edith had bought the work in the late 1940s for her neo-Georgian home near Hollywood. It sold for over $10m, a record price at the time for any piece of sculpture.

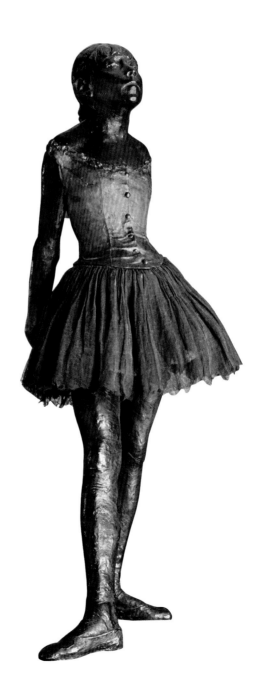

Drawing by Edgar Degas of a standing dancer seen from behind, from 1872–3.

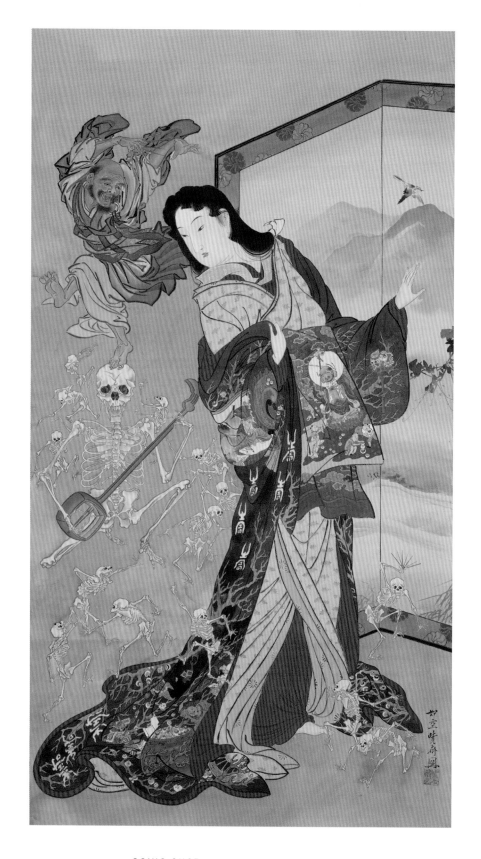

DANSE MACABRE

Kawanabe Kyōsai
(1831–1889), *Jigoku Dayu*,
after 1885, hanging scroll,
colour and gold on silk,
128 x 70 cm (50½ x 27½ in)

SALE
15 October 2013, London

ESTIMATE
£300,000–500,000/
$480,000–800,000

SOLD
£578,000/$923,970

This scroll painting by Kawanabe Kyōsai is based on a nineteenth-century Japanese play about a fifteenth-century Buddhist monk, Ikkyu Sojun. In the drama Ikkyu visits a brothel, where he meets a courtesan called Jigoku. Her name means 'Hell', but this is an ironic inversion, since she is very alluring. The monk proceeds to dance with the other courtesans, and as he does so Jigoku has a vision in which the girls are transformed into gurning skeletons. *Jigoku Dayu* (*Hell Courtesan*) depicts this scene; it is a comical memento mori, a cartoon tableau of impermanence.

The scroll was once part of a collection belonging to Josiah Conder (1852–1920), a British architect who worked in Tokyo and a close friend of Kyōsai. Conder had provided the artist with a Western book on anatomy, which Kyōsai studied so as to portray the skeletons accurately. Conder died in Japan in 1920, and in 1942 *Jigoku Dayu* came up for auction in Copenhagen. (His daughter had married a Dane, which probably explains how it came to be there.) The hanging scroll was sold – and promptly disappeared from view. At the time of the British Museum's exhibition on Kyōsai in 1993, its whereabouts were unknown.

The scroll suddenly resurfaced twenty years after the exhibition, following the death of the collector who had bought it in Denmark. His family, who found the work tucked away in a drawer, did not know that their father possessed such a treasure, and at first had no idea of its significance. But the reappearance of the scroll painting allowed experts to confirm the British Museum's opinion (previously based on two black-and-white photographs) that this was Kyōsai's best treatment of the 'Hell Courtesan' theme. That view was confirmed in 2013, when it sold for £578,000 – a new world record for the artist.

THE CULT
OF CELEBRITY

A pair of pale-pink ballet
slippers worn by Rudolf
Nureyev (1938–1993),
size 7EEE

SALE
20–21 November 1995, London

ESTIMATE
£300–500/$475–800

SOLD
£12,075/$19,075

EQUIVALENT TODAY
£20,700/$29,800

Rudolf Nureyev was arguably the most celebrated ballet dancer of the twentieth century, a passionate, complex perfectionist who – following his defection to the West from Russia in 1961 – captivated audiences all over the world. After his untimely death in 1993, Nureyev's estate, which included an impressive collection of art, decorative art, carpets and antique textiles, was dispersed in two auctions, in New York and London, which realized a total of more than £6.5m ($10.3m; equivalent to £11.2m/$16.1m today).

Both sales were extraordinary: they were the first curated celebrity sales of many that would follow. An enormous variety of items were put on display in room sets. The initial auction took place on 12 January 1995 in New York, where Nureyev had owned an apartment in the Dakota building. More than a thousand people queued to view lots that included English and Flemish Old Masters,

Rudolf Nureyev at the Coliseum in London in June 1977, with his ballet shoes arranged on the table next to his make-up in his dressing room.

an Elizabethan bed, a Venetian glass chandelier and paintings by Joshua Reynolds, Thomas Lawrence and Henry Fuseli, as well as ballet costumes, slippers and memorabilia.

The London sale, which took place ten months later, offered the contents of Nureyev's Paris apartment, which had been sumptuously decorated in a romantic nineteenth-century style. Again, the auction crossed the spectrum of Nureyev's life and passions, from Old Masters, grand antiques and textiles to costumes, battered paperback books and personal effects, including a pair of his worn ballet slippers, which realized £12,075, more than twenty times the high estimate.

Nureyev dancing with Margot Fonteyn in the ballet *Pelléas et Mélisande* in London, May 1960.

ARABIAN NIGHTS

Léon Bakst (1866–1924),
The Yellow Sultana, 1916,
charcoal, watercolour and
gouache, heightened with
gold on two joined sheets
of paper, 46.5 x 68 cm
(18½ x 27 in)

SALE
28 May 2012, London

ESTIMATE
£350,000–450,000/
$550,000–705,000

SOLD
£937,250/$1,470,000

In Russian this work on paper is called the *Zholtaya Sultansha*,
and those sibilants seem to suit the sitter's unabashed sensuality.
The work represents one man's erotic vision of an imaginary East:
Léon Bakst's *The Yellow Sultana* is a pin-up girl of Orientalism,
a nineteenth-century craze that continued to fascinate Europe
well into the twentieth century.

Ida Rubinstein as Zobeide
in Serge Diaghilev's ballet
Scheherazade, c.1910.
Her costume is designed
by Léon Bakst.

The vogue for all things Ottoman and Persian was inspired by the French translation of *The Thousand and One Nights* (also known as the *Arabian Nights*), a collection of Middle Eastern and Indian stories published in 1900. Serge Diaghilev's ballet *Scheherazade*, which caused a sensation when it was first performed in 1910, was one retelling of those Arabian tales. Bakst designed the set and costumes, and the gaudy pageant he created on stage was one of the truly thrilling things about the ballet. 'In every colour there are shades that can express sincerity or chastity, voluptuosity or brutality, pride or despair,' he wrote. 'This can be communicated to an audience, and that is exactly what I attempted to do in *Scheherazade*. I put a mournful green on top of a blue that is full of misery. There are solemn reds, and reds that kill. There is a blue that is the colour of Mary Magdalene, and then there is the blue of Messalina. An artist who knows how to use this is like the conductor of an orchestra, and he can evoke whatever surge of emotion he desires.'

In *The Yellow Sultana*, Bakst re-imagined his ideas for *Scheherazade* a few years after the original production. On paper, the Sultana is poised artistically halfway between Édouard Manet's painting *Olympia* (1863) and Aubrey Beardsley's drawings for *Salomé* (1894), her attire more risqué than it could ever have been on stage. Nevertheless, Bakst's works are perhaps as close as we can come to experiencing the curtain rise on the original Ballets Russes, with their synaesthetic feast of music, colour and movement.

THE SEDUCTION
OF A CITY

Pierre-Auguste Renoir (1841–
1919), *Femme nue couchée,
Gabrielle*, 1903, oil on canvas,
65.5 x 155.5 cm (26 x 61 in)

SALE
16 May 1977, New York

ESTIMATE
Not published

SOLD
$660,000/£377,000

EQUIVALENT TODAY
$2,950,000/£2,090,000

Gabrielle, the governess for Pierre-Auguste Renoir's family and his
most painted model, lies idly in a loosely painted rustic interior in
Femme nue couchée, Gabrielle (*Reclining Female Nude, Gabrielle*).
This was Renoir's first reclining nude, and one of his finest late nudes.

In the early twentieth century, in failing health, Renoir defiantly
renewed his impressive appetite for tenderness and sensuality and
applied his brush to voluptuous reclining women. He admired the past
masters of the reclining nude, above all Titian (active *c*.1506–1576) for
what Renoir described as his 'mystery and depth'. But it is Gabrielle's
earthiness, and the simplicity of the composition, that makes his own
Femme nue couchée so successful, combined with immediacy, which
he achieved by moving his easel very close to his model.

This painting was among about sixty Impressionist and Post-Impressionist works selected for the inaugural auction at Christie's New York saleroom, when it opened in May 1977. Everything about the painting – all five foot of Gabrielle's translucent loveliness – is an invitation to be seduced: surely this would entice new buyers in the art capital of the world?

In the event, she did not cast the spell Christie's might have been hoping for. Estimated to be worth up to $1m (£580,600) before the sale, the painting was a steal at $660,000. 'I'm very happy. And I'm very, very lucky,' the buyer, Raymond Klein, told the Associated Press when he secured the painting, admitting that he would have paid up to $1m for it.

Although Christie's had hosted successful sales in North America before, this was the first to be held at its own dedicated showroom in the Hotel Delmonico on Park Avenue. The auction house was, by its own admission, late to arrive in New York. It was not immediately popular with prospective bidders either, chiefly because of its imposition of a ten per cent buyer's fee, unheard of in America at the time. Although some early buyers were reluctant, the tide soon turned and within six years Christie's smaller Park Avenue operation was frequently outselling the main salerooms in London.

Femme nue couchée, Gabrielle became one of the highlights in Raymond and Miriam Klein's esteemed collection, which Christie's eventually sold in May 2010. On that occasion *Gabrielle* was the star lot, fetching $10,162,500 (£6,717,400).

Photograph of governess and model Gabrielle in Renoir's studio in Paris, c.1912.

DIANA'S REVENGE

Titian (active c.1506–1576),
The Death of Actaeon,
c.1559–75, oil on canvas,
178.5 x 198 cm (70½ x 78 in)

SALE
25 June 1971, London

ESTIMATE
Not published

SOLD
£1,680,000/$4,099,200

EQUIVALENT TODAY
£21,200,000/$30,590,400

Titian's tragic late painting *The Death of Actaeon* is one of a series
of mythological pictures, or *poesie*, commissioned by Philip II, King
of Spain. In common with the other works in the series, it takes its
subject from Ovid's *Metamorphoses*, in which Actaeon's punishment
for accidently glimpsing the naked Diana is graphically and all too
memorably described: the outraged goddess of the chase transforms the
mortal hunter into a stag, whereupon he is set on and devoured by his
own dogs. In visualizing this scene, Titian adds a new element, Diana
herself, who delivers the *coup de grâce* from her bow, while daring
the viewer to share in Actaeon's fate by revealing her right breast. Her
body is the clearest part of the painting; everything else more or less
dissolves in slashing brushstrokes and a frantic confusion of colour.

This great painting was first sold by Christie's in 1820. Its owner
was the painter Benjamin West (1738–1820), second president of the
Royal Academy of Arts in London, and it was auctioned at his death
for 1,700 guineas (£1,785/$8,068, equivalent to £127,000/$183,000
today). By the time it came up for sale again in 1971, *The Death of
Actaeon* belonged to the 7th Earl of Harewood, who had loaned it
to the National Gallery in London.

On 25 June, Titian's masterpiece sold to Julius Weitzner, an art
dealer, who then sold it to the J. Paul Getty Museum in California
two days later. The export license was delayed, however, and the
National Gallery launched a public appeal to try to ensure that
the painting stayed in Britain (it had been on display at the National
Gallery for nearly a decade prior to the sale). The necessary funds
were raised in time and the gallery went on to purchase the painting
the following year.

DRESSED TO KILL

Peter Paul Rubens
(1577–1640), *Portrait of a
Commander, Three-quarter-
length, Being Dressed for
Battle*, c.1612–14, oil on
panel, 123 x 98 cm
(48½ x 38½ in)

SALE
6 July 2010, London

ESTIMATE
£8m–12m/$12m–18m

SOLD
£9,001,250/$13,631,650

Peter Paul Rubens completed *Portrait of a Commander, Three-quarter-
length, Being Dressed for Battle* at the height of his powers as an artist.
A Flemish painter of stupendous energy and force, Rubens garnered
public attention for two great triptychs in Antwerp Cathedral,
securing himself a reputation as the greatest northern painter of the
Counter-Reformation.

Yet *Portrait of a Commander* was unattributed to Rubens
until 1947. It was thought to be by the School of Rubens, and then
the School of Frans Pourbus. Why it languished for so long in the
backwaters of art history is something of a mystery, although it may
have something to do with the ambivalence with which Rubens's
work was viewed in Britain in the nineteenth century. When the
aristocratic Spencer family bought the painting in 1802, Rubens
was considered in Europe to be the prince of painters, but in Britain
his sensuous colour and theatrical Baroque style were viewed with
puritanical suspicion. The Victorian art critic John Ruskin wrote in
Modern Painters of an 'unfortunate want of seriousness and incapability
of true passion'.

However, this psychologically complex work proves that not
to be the case. *Portrait of a Commander* depicts a heroic but battle-
weary military man preparing for combat. His unyielding gaze suggests
a hard-won understanding of the ravages of war, yet his hand rests
tenderly on his page in a quietly affectionate manner.

For 200 years, the painting hung by a doorway at Althorp,
the Spencer family's seat in Northamptonshire. It sold to the German
dealer Konrad Bernheimer for more than £9m in 2010, and is now
in the Metropolitan Museum of Art, New York.

Rubens's *Portrait of a
Commander* in the Yellow
Drawing Room at Althorp,
Northamptonshire, in 2004.

YOUR CARRIAGE AWAITS

Barker & Co (est. 1710),
Spencer State Chariot,
c.1825–50, George IV black-
japanned and livery-painted
carriage with half-glazed
doors, lined with Padua
red silk and hammer cloth,
iron-rimmed spoked wooden
wheels, 221 x 189 x 420 cm
(87 x 74 x 165 in) without pole

SALE
7 July 2010, London

ESTIMATE
£50,000–80,000/
$76,000–121,000

SOLD
£133,250/$202,200

In July 2010, Christie's held two related sales: the Althorp Attic Sale (7 July) and the Spencer House Sale (8 July). These were effectively house clearances on the most magnificent scale, and yielded a treasure trove of forgotten possessions, family heirlooms and notable works of art.

Althorp in Northamptonshire is the ancestral seat of Earl Spencer, the brother of Diana, Princess of Wales, and Spencer House in St James's is the London home, although it has mostly been let out since 1895 (it was Christie's temporary premises between 1947 and 1953, after the King Street saleroom was bombed in 1941). Paintings from the Spencer collection were auctioned on 6 July, and included a portrait by Peter Paul Rubens (see previous page), and a work by Giovanni Francesco Barbieri (1591–1666), known as Il Guercino, which broke the record for the artist at auction when it sold for over £5m ($7.9m).

However, the sale of objects stored in the commodious attics at Althorp was perhaps more fascinating. There were 500 lots, ranging from the mundane and practical to the exotic and rare. Objects included assorted livery, snuffboxes, jelly moulds, wine coolers, children's rattles, hunting crops, army uniforms, fine porcelain and silver. Perhaps most extraordinary was the collection of thirteen nineteenth-century Spencer carriages, said to be the most important group of horse-drawn family vehicles in existence. The Spencer State Chariot, a resplendent two-seater, fetched £133,250. Other carriages included a park barouche (for elegant excursions to Hyde Park), ladies' phaetons and a children's horse-drawn sleigh. The Spencers were a family that seemingly never threw anything away. The accumulated possessions of numerous Spencer generations briefly coalesced in the salerooms, bringing a lost world of aristocratic elegance back to life.

FIT FOR ROYALTY

Bugatti (est. 1909), Type 41
Royale Sports Coupé, 1931,
right-hand drive, eight-
cylinder engine, three-
speed gearbox, four-wheel
mechanical brakes, 640 cm
(252 in) long

SALE
19 November 1987, London

ESTIMATE
Not published

SOLD
£5,500,000/$9,020,000

EQUIVALENT TODAY
£13,800,000/$19,200,000

The Bugatti Royale is sleek and black. Its enormous body, over 6 metres (20 feet) long, is slightly tapered, like the barrel of an enormous fountain pen. The roof of the car arches forwards and the curve of the wheel-guards rises into the perfect wave.

Only six production cars and a prototype were ever made. They were designed to outperform Rolls-Royce in every department; the car was to be the ultimate in comfort, power and (above all) style. Ettore Bugatti (1881–1947) hoped that all the Royales would be bought by royalty – although, in the event, every Royale that sold went to the merely super-rich. This particular Royale, with coach-built coupé bodywork by Kellner, stayed in the Bugatti family, and when war broke out it was bricked up behind a false wall in a French coach house, so that no grasping Nazi general could drive it away. The Royale came out of hiding once the war ended, but did not leave its shelter until 1951, when Briggs Cunningham, an American racing driver and yachtsman, bought it from Ettore's daughter L'Ebé Bugatti. He installed it as the centrepiece of his own museum in California, where it remained for thirty-six years.

Consequently, when it came to auction in 1987, this Royale had clocked up only one careful owner beyond the Bugatti family. It was one of ten car lots to go under the hammer in front of 4,000 enthusiasts in a brief but spectacular sale at the Royal Albert Hall in London. The Royale was the last and easily the most expensive item in the catalogue: it sold for £5.5m – a world record at the time.

TIME FOR
A LITTLE DEATH

Andy Warhol (1928–1987),
*Green Car Crash (Green
Burning Car I)*, 1963, synthetic
polymer, silkscreen ink and
acrylic on linen,
228.5 x 203 cm (90 x 80 in)

SALE
16 May 2007, New York

ESTIMATE
$25m–35m/£12.7m–17.7m

SOLD
$71,720,000/£36,218,600

In June 1962, the American curator Henry Geldzahler met Andy
Warhol for lunch, taking along a copy of the *New York Mirror* to show
the artist. The headline on the front page read: '129 Die'. Warhol was
painting Coca-Cola bottles, soup cans and other consumer objects at
the time, and Geldzahler allegedly told him: 'It's enough life, it's time
for a little death.'

Warhol had a lifelong, almost paranoid obsession with
mortality, and duly obliged, going on to make some of his greatest
works. Warhol's Marilyns, which were made in the aftermath
of the star's suicide that same summer, were, of course, pictures
that were concerned with death as much as with fame and glamour.
Nevertheless, the work that is the purest and darkest fulfilment
of Geldzahler's proposition would be Warhol's chilling series of
'Death and Disaster' pictures.

Of these, *Green Car Crash (Green Burning Car I)* is among the
most nightmarish. The source image was taken from a photo story in
Newsweek on 3 June 1963 that captured the violent denouement of
a car chase involving a local fisherman, Richard J. Hubbard, and police
officers investigating a hit-and-run incident in Seattle. Hubbard's car
hit a pylon and he was propelled into the air before being impaled
on a climbing spike on the pylon. The photograph, taken by John
Whitehead, captures the burning vehicle and Hubbard's seemingly
lifeless, dangling body. Warhol repeatedly silkscreened this photograph
on to a single canvas, and the resulting composition seems to direct
our eye away from the burning car and corpse and towards the
suburban backdrop and the man across the street – a voyeur who
watches with apparent nonchalance.

In his book *America* (1985), Warhol wrote of the illusion of the
'regular humdrum life' led by most American people, which concealed
a dark underbelly. 'Nobody in America has a normal life,' he concluded.
In repeating a suburban scene of unimaginable horror in *Green Car
Crash*, Warhol reinforces this point while also alluding to our ability
to absorb passively the disturbing news we confront every day, with
the images becoming part of that humdrum world. 'When you see
a gruesome image over and over again,' Warhol said, 'it really doesn't
have any effect.'

Yet *Green Car Crash* – the only work using this image that employs
a coloured ground – still has the power to make us shudder. Like
so many of the 'Death and Disaster' paintings, it has a terrible beauty.
No wonder, then, that this key work smashed its upper estimate
so comprehensively in 2007, selling for nearly $72m, a record price
for Warhol at the time.

THE HOME
OF THE BRAVE

Jasper Johns (b. 1930),
Flags I, 1973, screenprint in
colours, numbered 55/65,
70 x 90 cm (27½ x 35 in)

SALE
10 May 1995, New York

ESTIMATE
$80,000–100,000/
£50,600–63,200

SOLD
$101,200/£64,050

EQUIVALENT TODAY
$157,000/£110,000

Flags I by American artist Jasper Johns is widely regarded to be one of his greatest prints. It depicts two star-spangled banners side by side, reversed and rotated ninety degrees, so that if they were the right way up the stars would be top right rather than top left.

As with so many of his best works, it is Johns's unorthodox technique that makes *Flags I* stand out when compared to screenprints by other artists. Andy Warhol had introduced Johns to this process in 1960, but the latter was slow to see how it would suit his work: the flat expanses of colour produced in screenprints suited Warhol, but not the intense mark-making that Johns had made into his signature style.

Johns recalled how he made this screenprint alongside master printer Hiroshi Kawanishi at Simca Artist Prints Inc., one of the legendary New York print studios of the 1970s. 'By adding a rather large number of screens, and having the stencil openings follow the shapes of brushstrokes, I have tried to achieve a different type of complexity,' Johns said at the time. 'One in which the eye no longer focuses on the flatness of the colours and the sharpness of the edges. Of course, this may constitute an abuse of the medium, of its true nature.'

The American flag has become the image most associated with Jasper Johns. In a New York art scene dominated by Abstract Expressionism, with its emphasis on ineffable, sublime themes and maximum emotion, to depict something as humdrum as a flag was a radical gesture. Part of a deliberate tactic by Johns to look at things 'the mind already knows', it allowed him to focus on the experimental use of materials. 'One night I dreamed that I painted a large American flag,' Johns said of his painting *Flag* (1954–5), now in the Museum of Modern Art in New York. 'The next morning I got up and I went out and bought the materials to begin it.'

In reworking the image time and time again, Johns found that he could rejuvenate it: 'With a slight re-emphasis of elements, one finds that one can behave very differently toward [an image], see it in a different way.' He was able to do just that in this print, working from a photograph of his own painting *Two Flags* (1973), and bringing a genuinely unique energy and intensity to a medium known for cool flatness. It sold for $101,200 in 1995; an impression of *Flags I* sold at Christie's for nearly $1.45m (almost £1m) in November 2015, showing that the market for Johns's prints has risen significantly in recent years.

THE DREAM COLLECTION

Pablo Picasso (1881–1973),
Le rêve, 1932, oil on canvas,
130 x 97 cm (51 x 38 in)

SALE
10 November 1997, New York

ESTIMATE
Not published

SOLD
$48,402,500/£28,654,280

EQUIVALENT TODAY
$71,500,000/£49,525,500

Over the course of fifty years, Victor and Sally Ganz assembled one of America's greatest collections of modern twentieth-century art. This low-key Manhattan couple focused on five artists: Pablo Picasso, Jasper Johns, Robert Rauschenberg, Frank Stella and Eva Hesse. Most discerningly, they 'never bought to be comprehensive,' wrote the Picasso scholar Michael FitzGerald. 'They bought because they remained fascinated by an individual work of art.' In 1941, the couple made their first major purchase, for $7,000 (about £1,700; equivalent to $109,000/£75,200 today): Picasso's *Le rêve* (*The Dream*), a portrait of the artist's young lover Marie-Thérèse Walter. Sally likened acquiring this seductive, erotically charged work to 'falling in love'. Twenty-six years later, in 1967, the last Picasso to enter the Ganz collection was *Femme assise dans un fauteuil* (1913), one of the great Cubist paintings.

Le rêve is one of the Spanish artist's most popular and enduring images. It shows Marie-Thérèse napping in an armchair and is celebrated for the brilliant intensity of the pigments, its clean contours and its erotic content (a phallic outline is visible on the upper side of Walter's face). In 1932, the year in which it was painted, it featured in Picasso's first major mid-career retrospective at the Galerie Georges Petit in Paris.

The insightful taste with which the Ganzes had built their collection – that included Hesse's *Vinculum I* (1969) as well as Stella's *Turkish Mambo* (1959) – coupled with the allure of so many modern and post-war masterpieces, generated huge interest in what was to be one of Christie's most important single-owner sales. *The New York Times* reported that from the moment Christopher Burge, then chairman of Christie's America and the evening's auctioneer, opened bidding at the fifty-eight-lot sale, 'the salesroom became a sea of bobbing paddles and waving agents taking calls from telephone bidders'.

Hesse's *Vinculum I* fetched $1.2m (£708,000), while *Le rêve* sold for $48.4m, setting an auction record for Picasso. Another major Picasso also came under the hammer that evening: *Les femmes d'Alger (Version 'O')* (1955). It was bought for $31.9m (£18.8m), more than twice its high estimate of $12m (£7m). In May 2015 the painting set a record for the most expensive work ever sold at auction, when it achieved $179.3m (£115m) at Christie's New York (see pp.380–3).

STRUMMING
HIS OWN TUNE

Rufino Tamayo (1899–1991),
Trovador, also known as
The Troubadour, 1945,
oil on canvas, 153.5 x 127 cm
(60½ x 50 in)

SALE
28 May 2008, New York

ESTIMATE
$2m–3m/£1m–1.5m

SOLD
$7,209,000/£3,650,640

Rufino Tamayo's paintings are a powerful mix of Latin American tradition and European figurative modernism. Tamayo, who defined himself in opposition to the muralists who dominated the Mexican art scene in the twentieth century – Diego Rivera, David Alfaro Siqueiros and José Clemente Orozco, the so-called Tres Grandes (Big Three) – was initially called 'El Cuarto Grande' (the fourth great) of Mexican painting. He rejected the epithet, claiming instead that he was 'the first in a new modality of Mexican painting that attempts a universal voice,' rather than adopting 'that chauvinistic painting' exemplified in the work of the Big Three. The muralists' 'obsession' with a Mexican form of painting forced them, he said, 'to neglect the real plastic problems and to fall into the trap of the picturesque'.

Two years after *Trovador* (1945) was completed, a critic wrote that Tamayo was as much indebted to Georges Braque, Henri Matisse and Pablo Picasso as he was to his Mexican compatriots. The painter balanced a terrific sense of colour with imagery that spoke simply of existential questions about man's place in a world that was tearing itself apart. Just as America was about to enter the Second World War, Tamayo painted the extraordinary *Animals in New York* (1941), an anxiety-laden image of vicious dogs, bare bones at their feet, that nods to Picasso's *Guernica* (1937) and now hangs in the Museum of Modern Art in New York.

Trovador speaks more directly of the condition of man at the end of the Second World War. A figure faces an uncertain world, and the exuberant colour belies a troubling tone. 'Art must belong to its time: it should not be concerned with memories but with what is happening now,' Tamayo said. 'The artist is an antenna. He cannot be passive or content merely to dream. Art is fundamentally a message, a means of communication; it involves a message.'

The Latin American market changed significantly in the first decade of the twenty-first century, and *Trovador* still represents a pinnacle of interest in this field, setting the record for a Latin American work of art at auction when it sold for more than $7m in 2008. It had previously been in the possession of the legendary American collector Stephen C. Clark, an heir of the Singer sewing-machine empire.

EYES WIDE OPEN

Frida Kahlo (1907–1954),
*Self-Portrait with Loose
Hair*, 1947, oil on masonite,
61 x 45 cm (24 x 18 in)

SALE
15 May 1991, New York

ESTIMATE
$1.5m–2m/£0.8m–1.1m

SOLD
$1,650,000/£943,965

EQUIVALENT TODAY
$2,580,000/£1,790,000

The first Latin American work of art to exceed $1m at auction was
a small painting by the Mexican artist Frida Kahlo. The record sale was
surprising because it occurred during the financial recession in 1991,
yet there were good reasons for the price. Kahlo created relatively few
paintings in her short life, and Mexico's policy of national patrimony
(applied to Kahlo's works since 1984) meant that her paintings could
no longer be exported. This resulted in there being very few works
by the artist on the open market.

Kahlo began painting in 1925 while convalescing from a near-fatal
bus crash that resulted in her spine being broken in three places. The
self-portraits she made over the next thirty years captured the tortured
spirit of a woman who was in continuous physical pain. 'She lived
dying,' said Leo Eloesser, her doctor and close friend.

Kahlo died in 1954, but the demand for her paintings continued
to escalate, particularly in the 1980s, when identity politics became
a potent theme in the art world. Feminists saw Kahlo as an icon
for her taboo-breaking subject matter; she had rejected traditional
perceptions of beauty by depicting herself with a thick unibrow and
downy moustache. Added to this was her famously tumultuous
marriage to the Mexican muralist Diego Rivera (1896–1957), a union
that fascinated many.

Self-Portrait with Loose Hair was painted in 1947, a year in which
Kahlo had undergone a series of gruelling operations. She was forty
years old, though the painting's inscription states her age as thirty-
seven. Unlike many of her portraits, in which her long hair is braided
or tied back, in this work it is left loose, alluding to the vulnerability
of her emotional and physical state. Her ability to deal with the frailty
of the body, with life and death and with female suffering has long
fascinated collectors, and is a major reason why competition to secure
her work remains fierce to this day.

Frida Kahlo photographed
by Imogen Cunningham
in San Francisco in 1930.

Aqui me pinté yo, Frida Kahlo, con la imágen del espejo. Tengo 37 años, y es el mes de Julio de mil novecientos cuarenta y siete. En Coyoacán, México, lugar donde nací.

A WOMAN
IN A MAN'S WORLD

64

Mary Cassatt (1844–1926),
In the Box, c.1879,
oil on canvas, 44 x 62 cm
(17 x 24½ in)

SALE
23 May 1996, New York

ESTIMATE
$800,000–1,200,000/
£529,000–793,000

SOLD
$4,072,500/£2,610,600

EQUIVALENT TODAY
$6,170,000/£4,380,000

It seems fitting that Helen Hope Montgomery Scott, the heiress on whom the character Tracy Lord was based in the high-society caper *The Philadelphia Story* (1940), should have owned Mary Cassatt's *In the Box*. The painting's illustrious provenance is also one of the reasons that it fetched $4m when it was sold at auction in 1996.

In the Box is all about the *beau monde*, the kind vividly portrayed by Edith Wharton in *The Age of Innocence* (1920). It was a world Mary Cassatt knew intimately, being the daughter of a wealthy Pennsylvanian family. Yet she was also a rebel. In 1866 she moved to Paris to become a painter, and embraced the new radical innovations of the avant-garde. She was rewarded with an invitation to exhibit at the fourth Impressionist exhibition in 1879, but she hit upon a problem. The new style of painting depicted modern Parisian life, sketched *en plein air* as it raced by. Pierre-Auguste Renoir, Claude Monet and Edgar Degas

Katharine Hepburn in
The Philadelphia Story (1940)
as Tracy Lord, a character
based on the society heiress
Helen Hope Montgomery
Scott, who once owned the
Cassatt painting.

painted dance halls, cafés and street scenes, places that women like
Cassatt were unable to visit alone. Cassatt needed a space where she
could observe and sketch without attracting attention.

Nowhere encapsulated modern Paris better than the opera house,
the Palais Garnier, which opened in 1875. It was where the newly
wealthy came to see and to be seen, and Cassatt was able to sketch
there. *In the Box* depicts two girls looking at the audience through
an opera glass, rather than observing the performance on the stage.

Cassatt exhibited this painting in the fourth Impressionist
exhibition, and the critic Georges Lafenestre praised it in the magazine
Revue des deux mondes. *In the Box* was bought by the art dealer Paul
Durand-Ruel, who sold it to Helen Hope Montgomery Scott's family
in 1883. When it came up at auction in 1996, it fetched more than three
times its high estimate.

65

THE LADY'S
NOT FOR TURNING

Aquascutum (est. 1851),
royal blue suit, 1989, wool
crêpe with gilt buttons and
white pique modesty panel,
UK size 14

SALE
15 December 2015, London

ESTIMATE
£2,000–3,000/$3,000–4,500

SOLD
£27,500/$41,380

On 15 December 2015, Christie's auctioned a collection of the
possessions of Britain's first female prime minister, Margaret Thatcher
(1925–2013). The sale attracted huge interest, with bidders from forty
countries and five continents competing to acquire a piece of the
Thatcher legacy.

Thatcher was a master of the art of power dressing and favoured
bright colours, sharp lines and clean tailoring, accessorizing her outfits
with pearls and handbags. Her handbags are now part of British
political mythology: the *Oxford English Dictionary* added the word
'handbagging' in the 1980s, denoting a ruthless dressing-down,
something that many of her colleagues experienced during her eleven
years as prime minister.

Thatcher's blue Aquascutum suit, which sold for £27,500, was
one of many iconic outfits in the auction in 2015. Smartly tailored
in Conservative royal blue, it was worn by her at many key political
moments. The most notable was her famous speech at the House
of Commons on 30 October 1990, when her response to increased
European economic and monetary union, which she felt was eroding

British sovereignty, was an emphatic 'No, no, no.' This precipitated the resignation of Geoffrey Howe, her deputy prime minister and the last remaining member of her original cabinet of 1979, two weeks later, and Thatcher's own exit from 10 Downing Street soon after.

The King Street auction room was packed for the live sale, which far exceeded expectations by realizing a total of £3.2m ($4.8m), while the online sale, which ran over a week, raised over £1m ($1.5m) more. The two most notable lots auctioned in the saleroom were Thatcher's red prime-ministerial despatch box, which sold for £242,500 ($365,000), and a model of an American bald eagle, a gift from Ronald Reagan, which fetched £266,500 ($400,000). Other items included the typescript of her famous inaugural speech – 'Where there is discord, may we bring harmony' – which sold for £37,500 ($56,500), and her midnight-blue velvet wedding dress (£25,000/$37,600). The sale featured not just clothes, accessories and jewellery, but also books, trinkets, ornaments, photographs and even the young Margaret Thatcher's school prizes.

Top: Margaret Thatcher at the 1989 Conservative Party conference, wearing the royal blue wool crêpe suit (above) by Aquascutum.

HAPPY BIRTHDAY MR PRESIDENT

Jean Louis (1907–1997),
'Happy Birthday
Mr President' dress, 1962,
nude silk and rhinestones,
floor-length gown

SALE
27 October 1999, New York

ESTIMATE
Not published

SOLD
$1,267,500/£769,370

EQUIVALENT TODAY
$1,731,500/£1,190,000

Undoubtedly the most famous rendition of 'Happy Birthday' ever performed was that by Marilyn Monroe on 19 May 1962 at a birthday tribute for President (and alleged lover) John F. Kennedy. It is now seen as especially poignant because it was one of the film star's last public appearances before her tragic death, less than three months later.

Held at New York's Madison Square Garden, the Democratic Party's fundraising gala of 1962 was attended by some 15,000 guests

and filmed by the CBS television network. Monroe was keen to make an impact, and contacted the Hollywood costume designer Jean Louis, saying: 'I want you to design a truly historical dress, a dazzling dress that's one of a kind.' Louis created a stunning piece from layers of flesh-coloured silk soufflé gauze, covered in rhinestones.

Louis decided to play on Monroe's sense of daring. 'Marilyn had a totally charming way of boldly displaying her body and remaining elegant,' he explained later. The delicate fabric was ordered from France and cut by Louis's couture staff, many of whom had been trained in Paris. Some 200 tiny panels were stitched with 6,000 crystal beads to provide a semblance of modesty. To ensure that it fitted like a second skin, Monroe was zipped into the dress without underwear, and extra stitching was added on the night. The effort was worthwhile judging by the gasps that were audible when she took to the stage.

For four decades after Monroe's death, the dress – along with the rest of her private possessions – was kept out of sight and untouched, cared for by the family of Monroe's acting coach Lee Strasberg, to whom she had left her belongings, ranging from the contents of her library to a baby grand piano.

When this lot was auctioned, all the lights in the saleroom went out. Suddenly Marilyn's voice could be heard, singing 'Happy Birthday'. The dress was then spotlit and bidding opened. The dress went on to set a world record for a woman's costume, and set the third highest price ever paid for an item of celebrity memorabilia. When the gavel came down at over $1.2m the winning bidder – and Marilyn – were given a standing ovation.

67

MAPPING AMERICA'S HISTORY

This version of the Buell Map, the best preserved of only seven known copies, is the most expensive map ever sold at auction. It marks a significant moment in American history: the first map to record the new borders of post-revolutionary America and the first to depict – in the title cartouche – the stars and stripes of the American flag.

The story behind the four-sheet map begins with its colourful maker Abel Buell, a practising silversmith and engraver. In 1764, at the age of twenty-two, he was convicted of currency counterfeiting and sentenced to imprisonment, ear-cropping and branding. By 1770, he had served his time and moved to New Haven, Connecticut,

Abel Buell (1742–1822),
*A New and Correct Map of
the United States of North
America*, 1784, hand-coloured
engraved map on four joined
sheets, image 109 x 123 cm
(43 x 48 in)

SALE
3 December 2010, New York

ESTIMATE
$500,000–$700,000/
£318,000–445,000

SOLD
$2,098,500/£1,334,855

where he established a business as a leading copper-plate engraver. A restless and inventive man, he was also a typographer, and invented a machine for grinding and polishing precious stones as well as one for processing cotton.

Buell was a bold self-promoter who advertised his map, which he completed in 1784, as 'the first ever compiled, engraved, and finished by one man, and an American'. This is an exaggerated claim, although Buell's map was certainly the first that showed the new borders of the thirteen states, agreed and ratified by the Paris peace treaty earlier that year. Buell had the advantage of being a printer, and was therefore able to publish his map expeditiously, beating the competition. His great skill lay in synthesizing and drawing upon the work of other cartographers, and he was not averse to taking patriotic liberties: the prime meridian was 'moved' from London to Philadelphia. State borders were still confused at the time, and Buell ambitiously showed the borders of his own home state, Connecticut, reaching as far west as the Mississippi.

THE RIGHT
TO BE HEARD

George Washington
(1732–1799), annotated copy
of the American Constitution
and Bill of Rights, 1789,
53 leaves, specially bound
for the President, 30.5 x 19cm
(12 x 7½ in)

SALE
22 June 2012, New York

ESTIMATE
$2m–3m/£1.3m–1.9m

SOLD
$9,826,500/£6,307,630

George Washington's personal copy of the US Constitution and Bill of Rights, dating to 1789, came under the hammer in 2012, and set a new record for an American book or historic document at auction.

The first president's gold-embossed, leather-bound volume runs to 106 pages, carries his personal signature and features his family coat of arms on the front endpaper alongside his motto, *'exitus acta probat'* (The end justifies the deed). It is a record of an extraordinary period in which the United States was born and its Constitution and much-debated Bill of Rights adopted. But it is also a vivid testimony to Washington's own journey, from commander-in-chief of the continental army in the American Revolution to the country's first president. Washington's own handwritten marginal notes highlight key passages concerning the responsibilities of the president, emphasizing his desire to adhere to the Constitution. He once wrote: 'The Constitution is our guide, which I will never abandon.'

The original Constitution, which had been written in Philadelphia in 1787, emphasized the machinery of effective federal government, rather than individual rights. The amendments that make up the Bill of Rights – establishing fundamental liberties such as the rights to free speech, press, assembly and religion – were a concession that secured the Constitution's hard-won ratification.

Washington was the only president to win unanimous approval by the electoral college, and he did it twice. On his retirement from the presidency in 1797 he brought the book home to Mount Vernon, his plantation estate 24 kilometres (15 miles) south of Washington, DC, where it stayed in the hands of the Washington family until 1876. It then passed into private ownership, and for a time was in the collection of the newspaper baron William Randolph Hearst. It was sold in 2012 by the estate of the businessman and philanthropist, Richard Dietrich, and purchased by the Mount Vernon Ladies Association, which maintains the Mount Vernon estate. A foundation document in American history and the treasured possession of one of the nation's founding fathers, it has finally returned to its original home.

Opposite, far right: portrait
of George Washington by
Gilbert Stuart, c.1796.

G Washington

A C T S

PASSED AT A

C O N G R E S S

OF THE

UNITED STATES

OF

A M E R I C A,

BEGUN AND HELD AT THE CITY OF NEW-YORK,

ON *WEDNESDAY* THE *FOURTH* OF *MARCH,*

IN THE YEAR M,DCC,LXXXIX.

AND OF THE

𝕴𝖓𝖉𝖊𝖕𝖊𝖓𝖉𝖊𝖓𝖈𝖊 of the 𝖀𝖓𝖎𝖙𝖊𝖉 𝖘𝖙𝖆𝖙𝖊𝖘,

THE THIRTEENTH.

BEING THE ACTS PASSED AT THE FIRST SESSION OF THE FIRST CONGRESS OF THE UNITED STATES,
TO WIT, NEW-HAMPSHIRE, MASSACHUSETTS, CONNECTICUT, NEW-YORK, NEW-JERSEY, PENNSYLVANIA,
DELAWARE, MARYLAND, VIRGINIA, SOUTH-CAROLINA, AND GEORGIA; WHICH ELEVEN STATES
RESPECTIVELY RATIFIED THE CONSTITUTION OF GOVERNMENT FOR THE UNITED STATES,
PROPOSED BY THE FEDERAL CONVENTION, HELD IN PHILADELPHIA, ON THE SEVEN-
TEENTH OF SEPTEMBER, ONE THOUSAND SEVEN HUNDRED AND EIGHTY-SEVEN.

THE WEIGHT
OF THE WORLD

Adriaen de Vries (1556–1626),
*A Bacchic Figure Supporting
the Globe*, 1626, bronze,
109 cm (43 in) high

SALE
11 December 2014, New York

ESTIMATE
$15m–25m/£9.5m–15.9m

SOLD
$27,885,000/£17,748,800

In 2010, a little luck and a lot of detective work led to the discovery
of an object that would change the entire market for early European
sculpture. William Lorimer, from Christie's Estates, Appraisals and
Valuations, was at an Austrian castle, the Schloss Sankt Martin,
for a routine valuation. What he discovered was anything but routine:
a major work by one of the most original sculptors of the early
European period. This seventeenth-century masterpiece would break
global auction records and revolutionize the prices paid for sculpture
of that era.

The bronze had stood unrecognized, atop a column in a courtyard,
for more than 300 years. Having climbed a ladder to inspect it,
Lorimer noticed that it was dated and signed, and so decided to send
photographs back to Christie's International Head of Sculpture
in London, Donald Johnston. Immediately recognizing the potential
significance of the sculpture, Johnston quickly made arrangements
to travel to Austria to inspect it for himself.

The name on the edge of the plinth was Adriaen de Vries, a Dutch
master of Mannerist sculpture who, in the early seventeenth century,
was considered the most important sculptor working in bronze in
Europe. The date on the work was 1626, the year of de Vries's death,
making this possibly his last fully autograph work. Johnston knew
that no record of such a work existed in the literature on the artist,
but careful research showed that the bronze had close stylistic
similarities with the last important commission executed by de Vries:
a series of bronzes on classical subjects, now housed at Drottningholm
Palace in Sweden.

It is likely that the bronze made its way from Prague – where
it was almost certainly created – to Austria as part of the dowry
of Margarethe, Gräfn Colonna von Fels in the late seventeenth century.
The first known reference to it is in the form of an engraving dating
from about 1700, where it is clearly visible on the column upon which
it was found in 2010.

In 2014 the bronze became the most valuable piece of early
European sculpture ever sold at auction. It was bought by the
Rijksmuseum in the Netherlands, and became the first free-standing
sculpture by this important, Hague-born sculptor to enter a Dutch
public collection.

Adriaen de Vries in an
engraving by Hendrik
Hondius the Elder, c.1610.

THE BEAUTY
OF THE GRAND TOUR

Roman marble statue of
Venus, c.late 1st–mid-2nd
century AD, Parian marble,
162 cm (64 in) high

SALE
13 June 2002, London

ESTIMATE
Not published

SOLD
£7,926,650/$11,660,100

When the 'Jenkins Venus' sold for just over £7.9m on 13 June 2002, there were audible cries of disbelief. Also known as the Barberini Venus, the sculpture set a new world-record price for an antiquity sold at auction.

The piece was originally acquired by William Weddell (1736–1792), an English gentleman who inherited Newby Hall in Yorkshire when he was just twenty-five. The following year he embarked on the Grand Tour, an extensive period of travel through Europe to appreciate art and antiquities, and a trip that was considered at the time to be an indispensable part of a gentleman's education. By the mid-eighteenth century, the craze for classical art and sculpture had swept through England and much of Europe, and Rome became a Mecca for connoisseurs and collectors. A number of English intermediaries took up residence in the Eternal City and acted as agents for potential buyers seeking objects from the collections of the great Roman families.

Thomas Jenkins (1722–1798) was one such agent, an immensely wealthy dealer and banker in Rome who enjoyed the patronage of Pope Clement XIV. When Weddell arrived in the city in 1764, he carried letters of introduction to Jenkins. Weddell would acquire nineteen chests of antiquities during his stay in Rome, but the Barberini Venus (so-called because it was part of the collection at the Palazzo Barberini in Rome) was the highlight of his collection. It was acquired from Jenkins for an undisclosed sum, thought to be in excess of £1,000/$4,550 (equivalent to over £120,000/$173,000 today).

The statue, made of Parian marble, is a Roman copy of a Hellenistic original from the fourth century BC, traditionally associated with the Cnidian Aphrodite by Praxiteles. The voluptuous figure was substantially restored in Rome, possibly by the notable sculptor Bartolomeo Cavaceppi (c.1716–1799). As part of the restoration programme the body was fitted with an ancient head from a different statue, and the remaining lost elements were replaced. This statue is therefore an extraordinary amalgam of classical and eighteenth-century worlds.

The Jenkins Venus was universally admired, and judged by many to be the most beautiful antiquity brought back to England at the time. Weddell commissioned Robert Adam to design a neoclassical sculpture gallery at Newby Hall to house his new collection, and the Venus took pride of place in the central rotunda. In 2002, this flawless statue was sold to help pay for much-needed restoration work at Newby Hall.

William Weddell, as painted
by Pompeo Batoni in Rome
in 1765–6 around the
time Weddell acquired
the statue of Venus.

THE ESSENCE OF FORM

The enigmatic marble figures produced by sculptors of the Cycladic civilization in the 3rd millennium BC are believed to have been devotional objects, since most have been found at human burial sites. Beyond that little is known about their history, other than that they were carved by hand using an extremely hard abrasive such as emery, and are the product of countless laborious hours.

This pregnant female figure is incredibly rare, the only surviving unbroken work by an unknown sculptor known as the Schuster Master. The figure is in pristine condition and shows the painstaking care taken in carving her aquiline nose, pointed breasts, curling feet and lyre-shaped head, which tapers backwards. The marble still has a thin white layer of calcareous encrustation, indicating that it has never been over-cleaned.

When the work was sold in 2010, achieving the pre-sale low estimate of $3m would have represented a world record for a Bronze Age figure. In the event it more than tripled the pre-sale high estimate, when the piece sold for nearly $17m after a long battle between two anonymous phone bidders.

The clean lines and elegant simplicity of the human figures produced by the pre-Greek civilization living in the Cycladic islands have inspired many twentieth-century artists. Pablo Picasso once remarked that the Cycladic figure he owned was 'stronger than Brancusi', while Constantin Brancusi himself made a series of sculptures after seeing a Cycladic head in the Louvre. He in turn introduced the Cycladic sculptures to his friend Amedeo Modigliani, who became fascinated by the way Cycladic artists had used line to suggest volume and sensuality.

The contemporary demand for Cycladic figures stems from modernism's quest for the essence of form in figuration. Collectors favour works from the Early Cycladic II period (2500–2200 BC) that typically show the female form pared down, idealized and stylized. At times they appear more animated, and this can be used to identify certain figures as being by the hand of a 'master'.

THE NUDEST OF NUDES

Amedeo Modigliani (1884–1920), *Nu couché*, 1917–18 (overleaf), oil on canvas, 60 x 92 cm (23½ x 36 in)

SALE
9 November 2015, New York

ESTIMATE
Not published

SOLD
$170,405,000/£112,671,780

Amedeo Modigliani's *Nu couché* (*Reclining Nude*) is one of the finest, best-known and most admired paintings of a female nude, a work that in many ways marks the culmination of his tragically brief career. The art critic and curator James Thrall Soby described the impact of *Nu couché* thus: 'Modigliani's most ambitious paintings are his nudes – those images of women lying naked, aggressive and pleased … They are in fact the nudest of nudes … They are (let us be candid) erotic nudes … Modigliani's women are not the grown-up cherubs of which the eighteenth century was fond. They are adult, sinuous, carnal and real.'

Blatantly erotic, *Nu couché* is a work that was painted in impoverished circumstances, in a small room in Paris. It is daringly cropped so that the naked sensuality of Modigliani's beautiful, young, Italian model's body becomes the sole, inescapable subject of the picture. The painting is a very modern take on the timeless and distinctly mediterranean theme of the classical reclining nude. It is so modern, in fact, that when one of this series of nudes appeared in the window of a Paris gallery in 1917, at the only solo show of Modigliani's work held during his lifetime, the police demanded that the exhibition be closed on the grounds that it was pornography.

Modigliani was an Italian bohemian who spent much of his life in France, addled on absinthe and high on drugs. He captured the Parisian milieu of the 1910s inimitably, depicting such figures as the sculptor Jacques Lipchitz and his wife, the Russian poet Berthe Kitrosser, the writer Jean Cocteau and the poet Max Jacob. He knew all the important artists, including Pablo Picasso, Henri Matisse and Constantin Brancusi.

Aged just thirty-five, Modigliani died of tuberculosis, little more than a year after the creation of this great painting and just at the point that his pictures were beginning to gain critical and commercial success. His wife, pregnant with their second child, threw herself to her death from her parents' apartment window two days later.

His short life and relatively small output meant that when *Nu couché* came up at auction it attracted enormous interest. It achieved the second highest price ever paid for a work of art at auction when it sold in November 2015 for over $170m to Chinese collector Liu Yiqian. This was also $100m more than had ever been reached for a work by the artist – a fitting record for a painting described as Modigliani's masterpiece.

Amedeo Modigliani in his studio in Paris, c.1915, photographed by the art dealer Paul Guillaume.

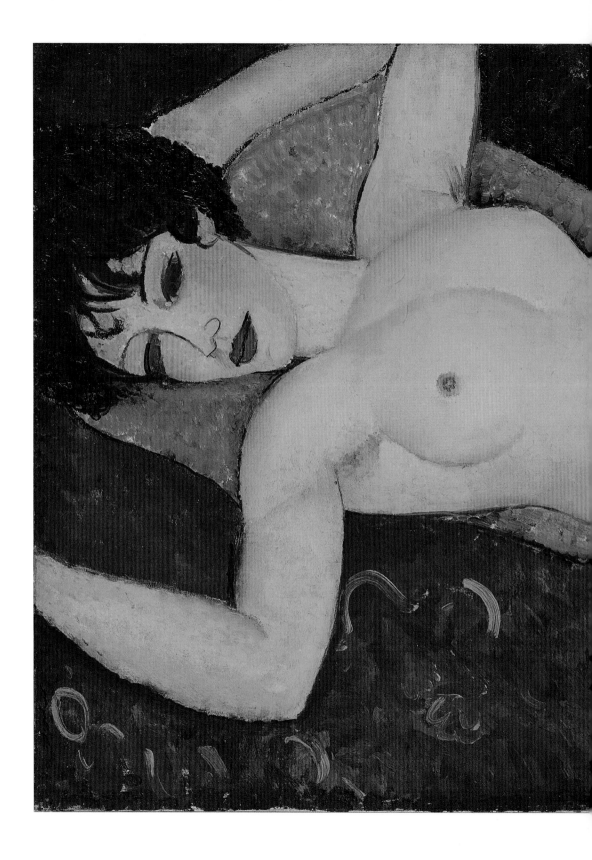

GOING ONCE

PAINTER TO POTTER

Pablo Picasso (1881–1973),
Gros oiseau visage noir,
1951, partially glazed
ceramic vase, edition of 25,
56 cm (22 in) high

SALE
25–26 June 2012, London

ESTIMATE
£30,000–50,000/
$46,000–78,000

SOLD
£289,250/$449,900

In 2012, this ceramic vase in the form of an owl by Pablo Picasso sold for £289,250. It had been made at the Madoura pottery workshop in Vallauris in the South of France, a place Picasso had first visited in 1946 and where he discovered the endlessly inventive ways clay could be manipulated. For the next twenty-four years, he collaborated with the studio, run by the Ramié family, creating over 600 editions including plates, bowls and vases.

The workshop is also where Picasso met his second wife, Jacqueline Roque, a twenty-seven-year-old sales girl whom he wooed by chalking a white dove on her house and sending her a single red rose. They went on to have a very happy marriage, so much so that Picasso's biographer Patrick O'Brian suggested that Picasso had found in Jacqueline 'the devotion of a lifetime'.

Since the millennium, the market for Picasso ceramics has grown steadily, and in June 2012, the Madoura workshop put up 543 ceramics from the studio for auction at Christie's. Thanks to the fine provenance of the collection, nearly 500 clients registered for the two-day sale and all the lots sold. Total sales amounted to over £8m (nearly $12.5m), four times the expectation. (Such sales are known as 'white glove' sales, when every single lot sells.)

The popularity of Picasso's ceramics has much to do with their relative affordability when compared to his paintings (see, for example, pp.122–3 and 380–3), and Picasso's genius is just as evident in clay as it is in paint. Among the wittiest pieces are his owl ceramics, which embody both the shape of the bird and the form of a vase at the same time. Owls were a motif to which Picasso often returned, perhaps drawn by their classical associations as the sacred bird of Athena, goddess of wisdom, or their position as the totemic emblem of Antibes, the fashionable seaside resort close to the Madoura workshop. Picasso loved birds and even owned an owl at one time, when one was found injured in a room of the Musée d'Antibes. He nursed it back to full health and kept it in his kitchen when he returned to Paris.

Pablo Picasso (left) with Marc Chagall in 1948 at the Madoura pottery workshop in Vallauris in the South of France. Unpainted 'owl' vases can be seen on the table behind Picasso.

ODE TO A SHATTERED MASTERPIECE

The Portland Vase (also known as the Barberini Vase), c.AD 1–25, amphora in translucent dark cobalt blue and opaque white cameo glass, 24.5 x 17.5 cm (9½ x 7 in) in diameter

SALE
2 May 1929, London

ESTIMATE
Not published

SOLD
Failed to meet reserve

When questioned by police, William Mulcahy had no explanation for his actions on the afternoon of 7 February 1845. In a gallery of the British Museum, the Irish student had picked up a piece of ancient basalt from a display, pushed through a small crowd and thrown it at the blue vase that they were admiring. It was an act of senseless vandalism that destroyed perhaps the finest example of ancient cameo glass in the world and one of the most exquisite and celebrated objects in the museum.

Owned by the Duke of Portland and entrusted to the museum in 1810, the Portland Vase was well known to the British public. In 1783 the diplomat-collector Sir William Hamilton – husband of the infamous Lady Hamilton of Lord Nelson's affections (see pp.40–1) – had brought it to England from Italy, where it had been in the Barberini family for generations. Believed to date from the first century AD and said to have contained the ashes of the Roman emperor Alexander Severus, the Portland Vase became an icon of classical perfection. It was sketched

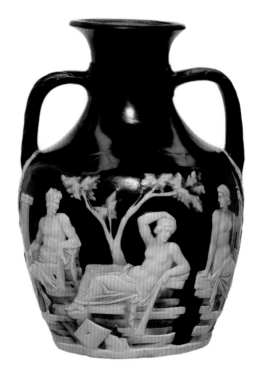

by William Blake (1791) and inspired odes by Erasmus Darwin (1791) and John Keats (1820), and the delicacy and finesse of its glasswork and bas-relief meant that Josiah Wedgwood took nearly four years to re-create it in jasperware (a type of porcelain) in the 1770s.

Wedgwood's first successful copies appeared for sale in 1789–90. They were masterpieces in their own right, and Wedgwood believed his reproductions to be the crowning achievement of his career. They were so meticulous a record of the Portland Vase that when the original was shattered, the Wedgwood version enabled the British Museum's conservator John Doubleday painstakingly to restore it.

On 2 May 1929, another crowd surrounded the Portland Vase. This time the scene was at Christie's and the crowd was considerably larger. The vase was the only lot in the auction, and its sale was the most anticipated event of the year. The room was so full that many people were unable to gain admittance, and photographers lined the walls.

Above the murmur of the excited audience, bidding was heard to start at £10,000 ($48,600). Four or five names and bids were called, but when the hammer fell at 29,000 guineas (£30,450/$147,987), no one in the audience knew who had triumphed. A woman's voice was heard demanding that the name of the purchaser should be given 'in the interest of the British Public'. However, the auctioneer, Terence McKenna, had slipped from the room and there was no reply. In fact, the vase had failed to meet its reserve. The disappointed Duke of Portland renewed his loan with the British Museum and, in the straitened times following the Second World War, the museum was able to purchase the vase for a mere £5,000 (about $15,000).

The packed saleroom at Christie's King Street on 2 May 1929 as the Portland Vase, on display inside a glass case, went under the hammer.

STOLEN JEWELS
AND THE GUILLOTINE

The Madame du Barry
(1743–1793)
collection of jewels

SALE
19 February 1795, London

ESTIMATE
Not published

SOLD
£8,791 4s 9d/$39,825

EQUIVALENT TODAY
£811,000/$1,175,100

The story of the jewellery collection of Madame du Barry, sold at Christie's in 1795, is intricately linked to the tumultuous history of the French Revolution. A courtesan from the age of fifteen, Jeanne du Barry (née Bécu) exploited her great beauty and seductive charm at the court of Versailles in France, capturing the attention of the ageing King Louis XV and becoming his mistress. Her extraordinary collection of jewellery – comprising gifts from the king and many other admirers – represented her capital, a form of wealth that she could bequeath to her heirs.

After the king's death, du Barry retired from Court to her country estate at Louveciennes, and in December 1791, while she was away in Paris, much of her jewellery was stolen. Her notices in the newspapers described, among other items, 'a pair of shoe-buckles containing diamonds weighing 78 carats,' and 'a pair of sprigs composed of large brilliants, valued at 120,000 livres'. Such notices must have done much to incite revolutionary fervour. Du Barry made several trips to England during the French Revolution (1789–99) to recover stolen jewellery that had been seized in London. But her journeys brought her to the attention of the French authorities, and she was arrested and sentenced to death in 1793. Her hysterical fear on the scaffold, and her last plea – *'Encore un moment, monsieur le bourreau, un petit moment'* ('Just a moment, executioner, just a brief moment') – reportedly caused a sensation among the crowd that had gathered to watch her die.

In London, du Barry's many creditors were turning their attention to the legendary collection of diamonds, pearls, emeralds and sapphires. The Chancery Court ordered that the assets of her estate – the jewels – should be realized. The sale took place on 19 February 1795. James Christie was the auctioneer, and his introductory remarks describe the jewels as 'a display of the most peculiar selection, in the superlative stile [*sic*], that was ever offered to the public'. The catalogue lists a total of sixty-five lots, ranging from 'one capital single-stone spread brilliant of the first water, highest quality' to the more modest final lot, 'a pair of sleeve buttons (one of the coloured stones wanting) and sundry settings'.

The main purchasers of the du Barry collection were London jewellers. The largest buyer was Nathaniel Jefferys of Dover Street, the court jeweller, who purchased some 733 individual items in 47 lots,

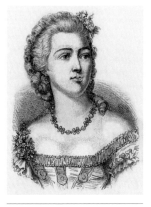

Madame du Barry, in an engraving published in Henri Martin's seven-volume *L'histoire de France populaire*, 1878–85.

the most expensive being an 'oval white brilliant' at £910 ($4,100; about £84,000/$121,750 today). Other London jewellers purchased substantial quantities of diamonds and pearls, while a Mr Parker of Princes Street acquired 'a cameo head in onyx set with diamonds, a head of Louis XV, a Bacchanalian antique, and three more rings'.

The sale made £8,791 4s 9d, but this record-breaking figure was substantially less than the original estimation of the jewellery's value. Many of the stones had been removed from their settings by the thieves, reducing their value, and many other wealthy French émigrés – escapees from Revolutionary France – were flooding the London market with their own valuables. Christie's catalogues frequently bore provenances such as 'An Emigrant of Distinction' (15 January 1795) and 'An Emigrant of Fashion' (20 February 1795). As a result, London became the centre of the art trade, and James Christie's famous sale of Madame du Barry's magnificent jewels secured his reputation.

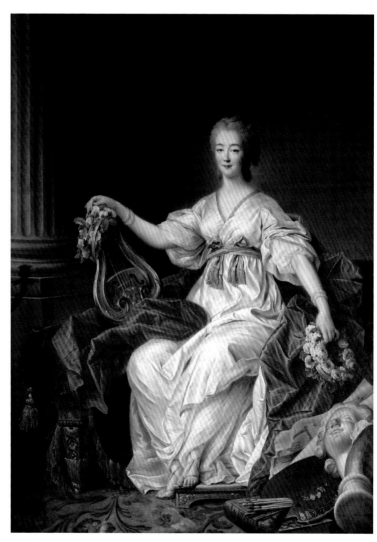

Portrait of Madame du Barry as a muse by François-Hubert Drouais, 1771.

THE GIRL WHO
HAD EVERYTHING

Cartier, La Peregrina, 1972,
natural pearl, diamond
and ruby necklace,
78 cm (30½ in) necklace
and drop

SALE
13 December 2011, New York

ESTIMATE
$2m–3m/£1.3m–1.9m

SOLD
$11,842,500/£7,626,570

The legendary jewellery collection of the actress Elizabeth Taylor
(1932–2011) broke many auction records when it was sold in 2011,
netting over $140m (£90m) from a gala evening sale, a day session
and an online sale. It was the largest sum ever reached for a collection
of private jewels sold at auction. The sale was eagerly anticipated and
attracted crowds of celebrities, buyers and spectators for whom Taylor
exercised an ongoing fascination.

Taylor's screen career took off when she was just ten years old,
when she starred as the horse-mad Velvet Brown in *National Velvet*
(1944). She developed from charming child actress to voluptuous
screen royalty, with memorable appearances in *A Place in the Sun*
(1951), *Cleopatra* (1963) and *Who's Afraid of Virginia Woolf?* (1966).
The camera loved her alluring violet eyes and symmetrical features,
and for much of her career her considerable acting ability was eclipsed
by her striking beauty. Sultry and seductive, she was every inch the
screen goddess: pursued by paparazzi, denounced by the Vatican and
living the jet-set dream of a Hollywood celebrity. Her private life
and loves became a source of fascination. She was married eight times
(twice to the charismatic Welsh actor Richard Burton), and it was her
husbands, in particular Burton, who bought her much of the fabulous
jewellery she so adored. Taylor also spent lavishly on jewellery herself,
designing her own pieces in partnership with her favourite jewellery
houses: Cartier, Bulgari and Van Cleef & Arpels. She had an expert eye
for craftsmanship, rarity and quality.

Many of the most famous jewels in Taylor's collection chart
her personal history. She quipped that three diamond rings bought
for her by Burton were 'my prize for beating Richard at ping pong'.
The Burton ruby-and-diamond ring was a Christmas present in
1968, and when he tucked the small box into her Christmas stocking,
she overlooked it at first. When Taylor received an Oscar for Best
Actress in 1967, she wore a magnificent Bulgari necklace mounted
with octagonal emeralds and pear-shaped diamonds – a wedding gift
from Burton.

The headline lot in the posthumous sale of Taylor's jewellery was
La Peregrina, a rare and beautiful sixteenth-century natural pearl that
Burton had bought at auction in 1969. La Peregrina was discovered
in the Gulf of Panama in 1579 and became part of the Spanish crown

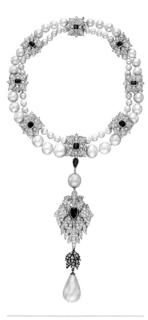

Elizabeth Taylor worked
with Cartier to include
La Peregrina as the dramatic
drop on a new diamond
necklace design.

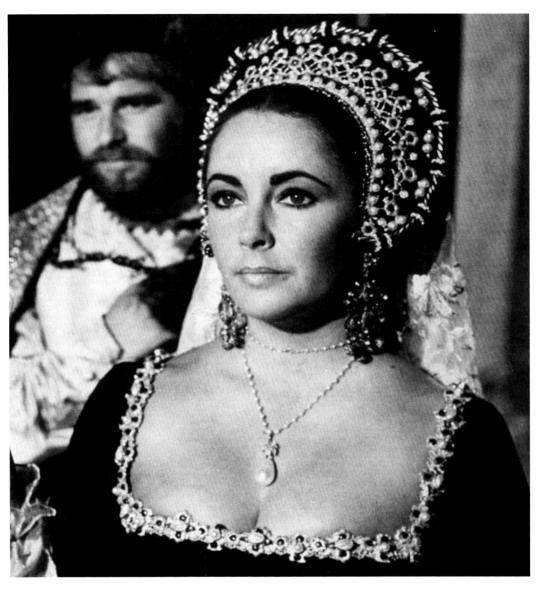

jewels. In the nineteenth century, it entered the collection of James Hamilton, Marquess of Abercorn and the Hamilton family owned the pearl until 1969. After Burton bought the pearl, Taylor worked with Cartier to present it as a dramatic drop on a dazzling diamond necklace.

The Elizabeth Taylor jewellery collection was exhibited in London, Moscow, Los Angeles, Dubai, Geneva, Paris and Hong Kong before the auction, and seen by an unprecedented number of people. At the sale buyers bought in person, over the phone and – for the first time in Christie's history – online, with a website auction running parallel to the live sale. Twenty-four of the eighty jewels fetched over $1m (£644,000) and six jewels over $5m (£3.2m), establishing seven new world auction records, including the price paid for a pearl jewel and the price per carat for a colourless diamond at the time of the sale.

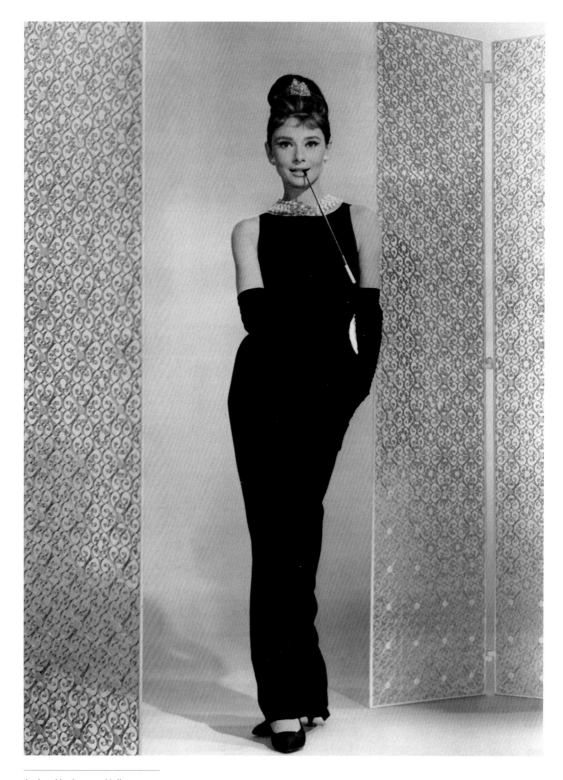

Audrey Hepburn as Holly
Golightly in *Breakfast at
Tiffany's* (1961).

THE ULTIMATE
LITTLE BLACK DRESS

Hubert de Givenchy (b. 1927),
evening gown for Audrey
Hepburn in *Breakfast at
Tiffany's*, 1961, black satin,
floor-length dress

SALE
5 December 2006, London

ESTIMATE
£50,000–70,000/
$98,700–138,000

SOLD
£467,200/$922,250

In the opening moments of the film *Breakfast at Tiffany's* (1961),
Audrey Hepburn steps out of a yellow New York taxi in the early
light of dawn and, standing on a deserted Fifth Avenue, nibbles
on a croissant while gazing at the gems in Tiffany's window display.
As breakfasts go it is a rather frugal and lonely affair, but one thing
above all else makes the scene memorable, and that is Hepburn's
elegant black dress.

This lot was one of the most important prototype dresses made for
the film by Hepburn's friend the French couturier Hubert de Givenchy.
It was surely the finest example of their artist-and-muse relationship:
a sleeveless, floor-length gown with a broad semicircular decolleté at
the back, slit to the thigh and gathered slightly at the waist. Givenchy
himself gave this version of the dress to the India-based charity of the
writer Dominique Lapierre, so that it could be sold to raise funds.

The estimate for the dress was conservatively low, perhaps because
it was not the one that Hepburn wore on screen (the final film version
was redesigned to be more demure by the costume designer Edith
Head). Nobody in the saleroom seemed to mind; it mattered only
that this was how Givenchy imagined Hepburn in the role of Holly
Golightly, and that it was the black satin expression of a special creative
bond. 'She gave a life to clothes,' Givenchy once said of Hepburn. 'She
had a way of installing herself in them that I have seen in no one else
since. Something magic happened.'

And something magic happened when the bidding started. Three
rival bidders rapidly pushed the price up past the estimate and then
beyond the previous world record for a movie costume (Judy Garland's
gingham outfit from *The Wizard of Oz*). A telephone bidder joined the
race at £360,000, and it was this anonymous newcomer who secured
the dress for just under half a million pounds. There were loud cheers
and gasps of amazement when the hammer fell, and no one was more
pleased and astonished than Lapierre. 'There are tears in my eyes,'
he said at the time. 'I am absolutely dumbfounded to believe that
a piece of cloth will now enable me to buy bricks and cement to put
the most destitute children in the world into schools.'

Edith Head's watercolour-
and-pencil costume sketch
for the gown.

ROYAL ILLUMINATIONS

Balthasar Friedrich Behrens
(1701–1760), designed by
William Kent (1686–1748),
the Givenchy Royal Hanover
Chandelier, 1736,
117 cm (46 in) high,
gross weight 52 kg

SALE
4 December 1993,
Monte Carlo

ESTIMATE
Not published

SOLD
FRF19,980,000/
£2,271,745/$3,236,880

EQUIVALENT TODAY
£4,611,000/$6,570,000

The Givenchy Royal Hanover Chandelier, an eight-light silver
chandelier, was commissioned by King George II for his palace
in Hanover. The design, by the royal architect William Kent,
was realized in silver by the goldsmith Balthasar Friedrich Behrens
in 1736. It is an extravagant confection of acanthus leaves, floral
garlands, sphinx and cornucopia, with a centrepiece that features
the prancing horse of Hanover and two naked putti, surmounted
by the royal crown.

 This chandelier once hung over the desk of the couturier Hubert
de Givenchy (b. 1927), who founded his eponymous couture house
in 1952. He went on to exhibit his refined sense of line and proportion
in a series of elegant designs for some of the world's most beautiful
women, including Audrey Hepburn, Grace Kelly and Jackie Kennedy.
Givenchy spent many years decorating his own home, and when
a selection of his furniture, silver and works of art were offered for
sale at Christie's, the beauty and history of these pieces, coupled with
Givenchy's famously impeccable taste and sophistication, attracted
a discerning audience to the saleroom in Monte Carlo.

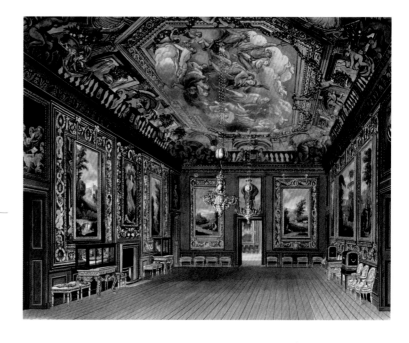

Illustration showing the
Queen's Drawing Room
at Windsor Castle (published
1816–19), with two Hanover
chandeliers that had
been temporarily housed
at Windsor during the
Napoleonic Wars.

On 4 December 1993 the chandelier was purchased by
H.E. Mohamed Mahdi Al-Tajir, formerly London ambassador for
the United Arab Emirates. The price, FRF 19,980,000, was then
a world auction record for a work in silver. The magnificent
chandelier reappeared in the 'Exceptional Sale' in London on
7 July 2011, when it sold for £5,753,250 ($9,188,000). The sale
of the Givenchy collection was a landmark sale, and set a record
for a single owner auction of decorative arts, at the time.

FIT FOR A PRINCESS

Garrard (est. 1735), the
Poltimore tiara, c.1870,
cushion-shaped and old-cut
diamond clusters alternating
with diamond-set scroll
motifs, each surmounted
by old-cut diamond
terminals, mounted in
silver and gold, maximum
diameter 19.5 cm (7½ in)

SALE
13 June 2006, London

ESTIMATE
£150,000–200,000/
$276,000–368,000

SOLD
£926,400/$1,704,330

On 13 June 2006, an auction of the jewellery and other possessions
of the late Princess Margaret attracted huge crowds to Christie's King
Street saleroom. Many were there not to buy but simply to revel in the
mystique and glamour of the Queen's younger sister. For others it was
a chance to acquire a piece of royal history, be it a set of three umbrellas
(£2,400/$4,420) or the Poltimore tiara (£926,400).

The four auction rooms were packed with more than 1,000 bidders
from as far afield as America, China, Japan, France and Russia. Lots sold
rapidly as collectors were confronted with an array of treasures: an art
deco pearl-and-diamond necklace – an eighteenth-birthday gift from
the Queen – sold for £276,800 ($510,000); a Fabergé clock, a gift
from Queen Mary, fetched £1,240,000 ($2,281,600); and an antique
diamond rivière necklace, dating from about 1900, sold for £993,600
($1,828,225).

One of the most eagerly awaited lots was the Poltimore tiara.
This neoclassical piece, made by Garrard in the 1870s, features scrolls,
leaves and flower clusters set on a row of diamond collets. It was made
for Florence, the wife of the 2nd Baron Poltimore, and was acquired
for Princess Margaret at auction in 1959 for £5,500/$15,455
(equivalent to £114,300/$162,500 today). It was finally sold to an
Asian buyer, whose daughter had become hugely enamoured of it.

The Poltimore tiara is particularly memorable because it was worn
by the Princess on her wedding day, on 6 May 1960 – the first televised
royal wedding service, which attracted more than 300 million viewers
worldwide. The tiara was a striking complement to Princess Margaret's
silk organza dress, designed by Norman Hartnell, and her matching veil.

Princess Margaret on her
wedding day, 6 May 1960,
wearing the Poltimore tiara.

A SYMBOLIC GIFT
OF ROYAL GRATITUDE

Unknown English maker and Nicholas Hilliard (1542–1619) (miniature), Armada Jewel (also known as the Heneage Jewel), c.1595, gold locket enamelled and set with diamonds, rubies and rock crystal and containing a miniature of Elizabeth I, 7 x 5 cm (2¾ x 2 in)

SALE
24 June 1935, London

ESTIMATE
Not published

SOLD
2,700 guineas/£2,835/$13,890

EQUIVALENT TODAY
£176,000/$253,900

When the Armada Jewel, an enamelled and bejewelled gold locket presented by Queen Elizabeth I (r. 1558–1603) to her courtier Sir Thomas Heneage (1532–1595), was sold on 24 June 1935, there was great anticipation and excitement in the crowded auction room. Would this precious object return to private hands, or would it be purchased for the nation by the National Art Collections Fund (NACF, now the Art Fund), an arts charity that supported the public acquisition and display of works of art of national importance?

Bidding opened with an offer of 500 guineas (£525/$2,570) before Dr Nicolaas Beets, an Amsterdam dealer, started bidding against the auctioneer, who was representing the NACF. Beets threw in his hand when the bidding reached 2,700 guineas. After hearing of the charity's bold move to acquire the Armada Jewel for the nation, Lord Wakefield – the founder of the Castrol lubricants company and Lord Mayor of London – reimbursed the charity for the full amount. The jewel was donated to the Victoria and Albert Museum in London, where it remains.

The Armada Jewel, also known as the Heneage Jewel, was made in about 1595. On the front is a profile bust of Elizabeth I modelled in gold relief on an enamelled plaque. The locket opens to reveal a miniature portrait of the queen, painted by Nicholas Hilliard, and on the reverse is a picture of an ark in a stormy sea, symbolic of the Protestant Church guided safely by Elizabeth during difficult times. The jewel was once part of the famous Pierpont Morgan collection of miniatures.

A MANSION FOR THE
QUEEN OF THE FAIRIES

James Hicks & Sons
(est. 1894), Titania's Palace,
1907–22, mahogany,
scale 1:12, 294 x 221 x 76 cm
(116 x 90 x 30 in)

SALE
10 January 1978, London

ESTIMATE
Not published

SOLD
£148,500/$285,120

EQUIVALENT TODAY
£761,000/$1,097,600

There can be few doll's houses to match the scale and intricacy of Titania's Palace, which was sold in London in January 1978 for £148,500. The buyer was Legoland in Denmark, who embarked on an ambitious programme of cataloguing and photographing every object the palace contained before putting it on public display in a special exhibition hall in 1980.

Titania's Palace was created by Sir Neville Wilkinson for his young daughter Guendolen (she was eighteen by the time the fifteen-year project was complete). Using detailed drawings made by Sir Neville, James Hicks of Dublin started work on the palace in 1907, employing the services of a number of skilled artists and craftsmen. The fairy-tale palace was richly endowed with art and antiquities – Sir Neville collected miniature works of art, some dating from the sixteenth century, and commissioned many others.

Titania's Palace was built on a scale of 1:12 in mahogany and constructed in eight parts. It was lit, the windows fitted with stained glass and the floors inlaid or mosaic. Tiles, embroidered samplers, paintings and exquisite miniature furniture in lacquer and wood adorned the palace's many rooms, which included a 'Hall of the Fairy Kiss', 'Hall of the Guilds', a boudoir, a day nursery, a royal bedchamber, a morning room, a bathroom and a chapel.

The extraordinary and intricately decorated palace was finally 'opened' by Queen Mary on 6 July 1922, whereupon it was displayed in London and in many other British cities to raise money for children's charities, before going on tour to the United States, Canada, South America, Australia, New Zealand and the Netherlands. In 1967, it was sold to Olive Hodgkinson, who displayed it at Wookey Hole, a tourist attraction in Somerset. When she moved to Jersey, it was exhibited at Fort Regent, St Helier. Following Hodgkinson's death, it returned to the saleroom in 1978.

Princesses Elizabeth and Margaret (right, with Sir Neville Wilkinson) visited Titania's Palace on 22 July 1938.

THE BEAUTIFUL GAME

Pelé's number 10 yellow Brazil shirt from the 1970 World Cup Final, short-sleeved with crew-neck collar and embroidered cloth badge

SALE
26 March 2002, London

ESTIMATE
£30,000–50,000/
$42,800–71,400

SOLD
£157,750/$225,100

In March 2000, a pair of used size eight Adidas Predator football boots sold at auction for £13,800 ($21,700). A year later the hammer fell at £91,750 ($132,300) for an old red shirt with a white number '10' on the reverse.

For those who love the beautiful game, a pair of old boots or a simple red shirt can be imbued with all the historical importance of a hat worn at the Battle of Trafalgar or a painting by Francis Bacon. The Predators were once worn by a young striker called David Beckham during his seminal 1997–8 season; the red shirt was the one Geoff Hurst sported when he scored his hat-trick against Germany during England's World Cup victory in 1966. It is the enduring power of all relics – whether sporting, religious, historical or artistic – that they allow us to touch a near-mythical moment in the past and share in its greatness, a power that turns everyday objects into priceless artefacts.

In 2002 the all-time record price for a football shirt was set by the yellow jersey worn by the Brazilian maestro Pelé during the World Cup Final in 1970. Tripling its estimate, the shirt reached an extraordinary £157,750, a belated consolation prize for its seller, the former Italian defender Roberto Rosata, who had exchanged his own shirt with Pelé after Italy's crushing 4-1 defeat in the final. However, the world record price for football memorabilia belongs to the sale of the FA Challenger Cup (1896–1910). This Holy Grail of football relics was sold at Christie's South Kensington on 19 May 2005 for £479,400 ($880,180).

Pelé held aloft by Jairzinho in the Estadio Azteca, Mexico City, after Brazil won the World Cup on 21 June 1970.

BRAZIL AT ITS BEST

Tarsila do Amaral
(1886–1973), *Abaporu*, 1928,
oil on canvas, 84 x 73 cm
(33½ x 28 in)

SALE
20 November 1995, New York

ESTIMATE
Not published

SOLD
$1,432,500/£923,965

EQUIVALENT TODAY
$2,293,500/£1,590,000

Abaporu by Tarsila do Amaral is the most emblematic painting of Brazilian modernism. Yet when it was auctioned in 1995 and sold for a staggering $1.4m, it went not to a Brazilian collector but to an Argentine. For those who expected such an iconic national work to remain in Brazil, this was a huge shock, and the painting is still considered by many to be the one that got away.

The bidder who successfully fought off all competition was the businessman and philanthropist Eduardo Costantini, who was in the process of amassing one of the world's largest and most valuable collections of modern and contemporary Latin American art. In 2001 he created the Museo de Arte Latinoamericano de Buenos Aires (MALBA), in the Argentine capital. Today *Abaporu* hangs there on permanent display.

Tarsila do Amaral – known simply as Tarsila – wrote that *Abaporu* depicts 'a monstrous solitary figure' that is emblematic of Brazilian national identity. The work was named *Abaporu* by Tarsila's second husband, the poet Oswald de Andrade; the word translates as 'man who eats', or cannibal, and it inspired Andrade to write the *Anthropophagite Manifesto* the same year, a clarion call for rebellion against the Brazilian sociocultural status quo and a rejection of the Brazilian assimilation of European culture. The manifesto would become one of the most radical philosophical documents of modernism in the Americas.

At the time of the sale in 1995, it was rare for Latin American art to exceed the million-dollar mark. Since 2000, however, the market has become far more aggressive, and should this iconic Brazilian masterpiece be put up for auction today the minimum estimate would probably be $15m (£10.3m), given the bidding war that would surely ensue to return it to home turf. As Virgilio Garza, Christie's Head of Latin American Art, says: '*Abaporu* not only represents the pinnacle of Brazilian modernism and its intellectual underpinnings, but also its iconic significance is akin to a national symbol. Much like samba, bossa nova or soccer, *Abaporu* is Brazil at its best.'

FIGURE
FOR A FESTIVAL

Henry Moore (1898–1986),
Reclining Figure: Festival,
1951, bronze with dark brown
patina, 244.5 cm (96 in) long

SALE
7 February 2012, London

ESTIMATE
£3.5m–5.5m/$5.6m–8.7m

SOLD
£19,081,250/$30,316,570

In 1949, the Arts Council commissioned Henry Moore, Britain's leading sculptor, to make a work for the Festival of Britain, which was to be held two years later on London's South Bank. Ignoring the Council's suggestion that he carve a family group, symbolizing the theme of 'Discovery', he chose instead to make a large reclining figure in bronze that would resist allegorical interpretation.

Moore had been inspired to explore the sculptural form of the reclining figure after seeing an ancient Mexican Toltec-Maya figure in Paris in 1925, and it became an increasingly dominant feature of his work. He pointed out that a reclining figure, unlike a standing or sitting figure, can rest on any surface: 'It is free and stable at the same time

[and] fits in with my belief that sculpture should be permanent, should last for eternity.' As do his other recumbent forms, *Reclining Figure: Festival* (1951) evokes aspects of landscape: mountains and valleys, cliffs, caves, slopes and undulating hills.

During the process of making *Reclining Figure: Festival*, Moore employed a new approach, one that became his standard procedure for working in bronze. He began by making modelling-clay maquettes (three-dimensional 'sketches') based on preliminary drawings, before progressing to a small working model. This was then scaled up to a full-size plaster version from which the final bronze sculpture was cast.

The finished work was positioned at the Festival of Britain outside a pavilion that addressed Britain's agricultural history and the relationship between the people and the land. It was placed on a plinth at waist height so that visitors could look through the sculpture and into its interior. As Moore explained, 'If the figure is looked at lengthways from the head end through to the foot end, the arms, body, legs, elbows etc. are seen as forms inhabiting a tunnel, in recession.'

Left: Henry Moore's *Reclining Figure: Festival* on a plinth marking the entrance to 'The Natural Scene' pavilion at the Festival of Britain in London, 1951.

Reclining Figure: Festival was a pivotal work for Moore and had a powerful impact on his subsequent sculpture. It was eventually cast in an edition of five, plus one artist's proof. In 2012, Christie's sold this cast for £19m – a world-record price at auction for Moore, and indeed for a sculpture by any British artist, that stills stands to this date.

CURVACEOUS ALLURE

Marc Newson (b. 1963),
Lockheed Lounge, 1990,
blind-riveted sheet
aluminium with fibreglass
core, number four
in an edition of ten,
90 x 63.5 x 165 cm
(35 x 25 x 65 in)

SALE
17 December 2015, New York

ESTIMATE
$1.5m–2m/£1m–1.4m

SOLD
$1,745,000/£1,172,600

The Australian-born industrial designer Marc Newson created the
prototype for his now iconic aluminium-clad chaise, the Lockheed
Lounge, in 1985, only a year after graduating from Sydney College
of the Arts. Produced in an edition of ten in 1990, it is created
from a complex mosaic of thin aluminium panels blind-riveted
to a hand-sculpted fibreglass substructure. This extraordinary homage
to machine-age American aircraft manufacturing was among Newson's
first commercial successes. Selling at the time for about $1,000 (£560),
it proved to be the starting point of an extraordinary career. Over the
following twenty-five years, Newson would become widely regarded
as one of the great designers of his generation. He has worked in
numerous fields, from aircraft interiors to jewellery, and collaborated
with brands as diverse as the Italian kitchenware company Alessi
and the Japanese camera giant Pentax.

In September 2014, Newson joined forces with Apple. His
inimitable talent can be seen in the first generation of Apple Watch,
released in April 2015, which sold millions of units all over the world.
By contrast, there are only fifteen examples of Lockheed Lounge
in existence (an edition of ten, a prototype and four artist's proofs).
As a result, it has become one of the most sought-after and expensive
pieces of furniture by a living designer.

The Lockheed Lounge offered in December 2015 was numbered
four from the edition of ten. It formed the centrepiece for Christie's
'Design Masterworks' sale in New York, and sold for $1,745,000.
Now a design classic, it first came to wider public attention in the video
for Madonna's single 'Rain' (1993).

A MODERN TAKE
ON THE FEMALE NUDE

Lucian Freud (1922–2011),
Benefits Supervisor Sleeping,
1995 (overleaf), oil on canvas,
151.5 x 219 cm (59½ x 86 in)

SALE
13 May 2008, New York

ESTIMATE
$25m–35m/£12.8m–18m

SOLD
$33,641,000/£17,224,200

As the 1990s dawned, Lucian Freud had been a significant figure in British art for four decades, and yet it was at this point that he made what are arguably some of his best paintings. Ushering in this extraordinary phase of Freud's work was the series of vast canvases featuring the remarkable bulk and physical presence of the performance artist Leigh Bowery. It was through Bowery that Freud came to meet Sue Tilley, who worked in an employment office by day and by night could occasionally be found on the door of the outrageous nights Bowery ran at the Taboo nightclub in London. If Freud had achieved an almost classical grandeur in the portraits of Bowery, he scaled new heights in the portraits of Tilley, of which there are four, all on a heroic scale that suggested the artist had, at last, acquired the self-confidence to take on the Old Masters.

Tilley has provided a wealth of fascinating detail about the sittings, talking of how Freud would sometimes regale her with stories of his life, or recite poetry, or on other occasions work in silence; how he refused to paint her after she returned from holiday with a tan, and waited a year until it had disappeared entirely before he allowed her to sit for him again; how he was uncomfortable with her tattoos because of his insistence on the fleshiness of the body, with which he said the colours of tattoos interfered.

Benefits Supervisor Sleeping is Tilley's personal favourite of the four paintings Freud produced of her. It is fiercely uncompromising in its depiction of Tilley's body, and yet also tender; the paint raw and expressionistic at times, delicate at others. It is a painting that shows Freud at the height of his powers.

Inevitably, the artist's mastery of paint was reflected in the saleroom in 2008, when the work set the record price not just for a work by Freud but also for one by any living artist at auction. The collaboration between Tilley and Freud proved alluring to collectors again in 2015, when *Benefits Supervisor Resting* (1994), another portrait from the series, fetched $56,165,000 (£35,660,000) in the same New York saleroom, setting a new record for the artist at auction.

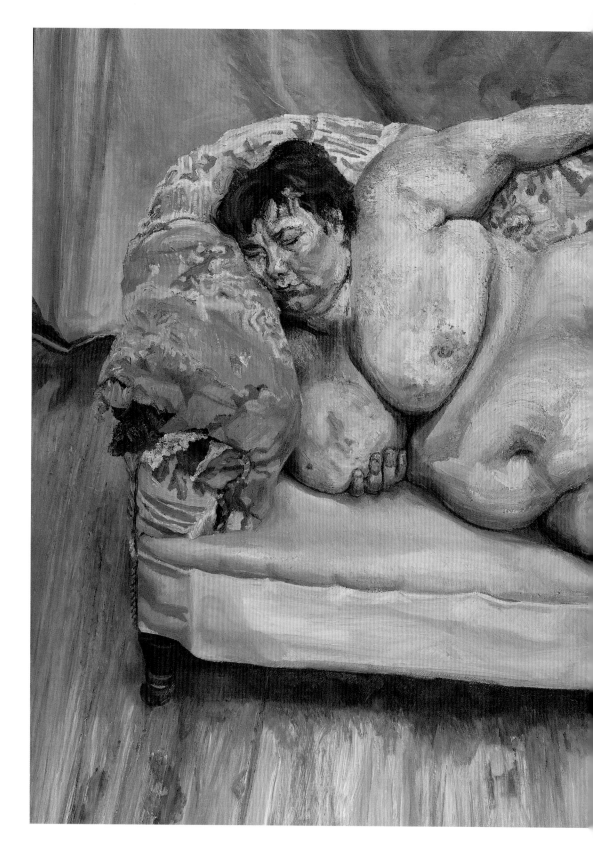

GOING ONCE

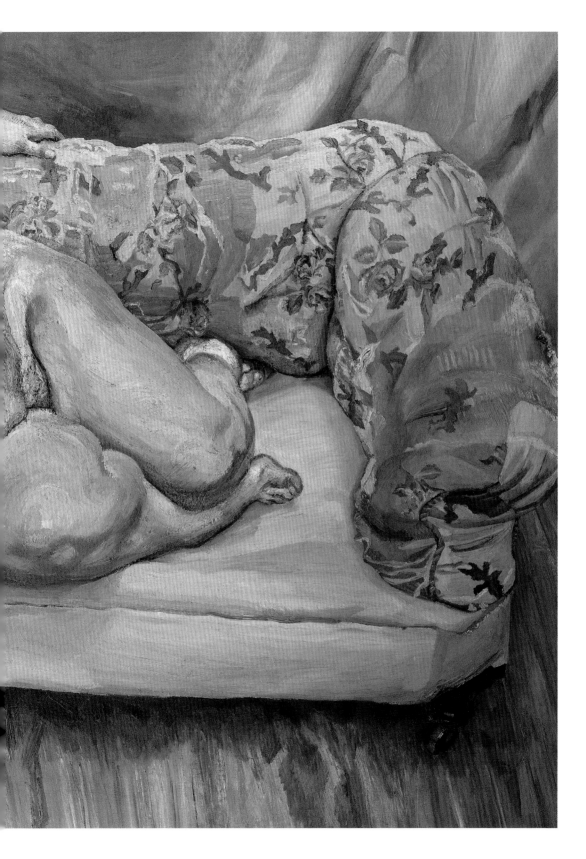

THE HIGH PRICE
OF FRIENDSHIP

Francis Bacon (1909–1992),
Three Studies of Lucian Freud,
1969, oil on canvas, triptych,
each 198 x 147.5 cm
(78 x 58 in)

SALE
12 November 2013, New York

ESTIMATE
Not published

SOLD
$142,405,000/£89,473,060

Francis Bacon and Lucian Freud (1922–2011) were introduced to each other by the painter Graham Sutherland in 1945, and were near-inseparable companions for many years before their relationship cooled in the 1970s. Both stalwarts of the drinking scene at Wheeler's and the Colony Room in Soho, London, they were also keen gamblers and acerbic gossips. They were friends, foils, confidants and rivals who painted each other and pushed each other to greater levels of excellence in the field of figurative painting.

The best-known portrait of Bacon by Freud was in the Tate collection before it was stolen from an exhibition in Berlin in 1988; it has never been recovered. Bacon made three separate triptychs of Freud (one triptych has been split up), as well as other works. The triptych that appeared at auction in 2013, executed in 1969, was the last of the three, and marks the epic culmination of the two men's relationship. It features three seated, full-length portraits of Freud in an altarpiece-style arrangement whereby the two outer portraits

face inwards to the central painting. The images were based on photographs of Freud sitting on a bed taken by another familiar face on the Soho scene, John Deakin. Bacon, unlike Freud, preferred working from photographs rather than life, since he felt that the model inhibited his ability to capture the reality of the subject.

In the paintings, Bacon kept the bedstead from the Deakin photographs but removed the bed itself. Instead, he sits Freud on a chair like the one in his own studio. He then surrounds Freud in 'space frames', as the critic David Sylvester called them. The tension in the portraits lies in the contrast between the precision in the frame, the flat, almost golden background and the extraordinary vigour in the depiction of Freud's face. The art historian Michael Peppiatt wrote: 'A contorted Freud hovers from panel to panel like a coiled spring about to shoot out of the flat, airless picture plane.'

Remarkably, the three panels of the work were separated for about fifteen years of their history. The complete work was exhibited first in 1970 at Galleria Galatea in Turin, later in the now renowned retrospective at the Grand Palais, Paris, and subsequently at Kunsthalle Düsseldorf in 1971–2. Somehow divided in the mid-1970s – one of them was even exhibited alone at the Tate Gallery in 1985 – the three works were, thankfully, reassembled as Bacon had intended them to be viewed in the late 1980s.

Great painterly friendships can often be perceived only through the exchange of letters, yet Freud and Bacon's was immortalized on canvas. It is little wonder, then, that when this triptych evoking the extraordinary empathy between two greats of post-war painting came up for sale, ten bidders fought to acquire it before it reached the highest price in history for a work of art at auction at the time.

Francis Bacon (left) and Lucian Freud in Dean Street, Soho, in 1974, photographed by Harry Diamond.

THREE FACES
OF MAJESTY

Anthony van Dyck
(1599–1641), *Charles I
in Three Positions*, 1635–6,
oil on canvas,
84.5 x 99.5 cm (33 x 39 in)

SALE
12 May 1804, London

ESTIMATE
Not published

SOLD
Failed to meet reserve

In the early nineteenth century, Christie's offered for sale one of the most significant portraits of a British monarch ever painted: *Charles I in Three Positions* by Anthony van Dyck.

The conception and provenance of the painting are as fascinating as the portrait itself. Pope Urban VIII commissioned Gian Lorenzo Bernini (1598–1680) to make a bust of Charles I as part of a plan to entice England back into the Roman Catholic fold (he intended to present the sculpture to the Catholic Henrietta Maria, Charles I's consort). Bernini did not visit England, so the king commissioned his favourite painter, Van Dyck, to make a portrait of him for Bernini to work from, showing his features from three different angles.

Documentation from the Royal Collection acknowledges that Van Dyck was presumably influenced by Lorenzo Lotto's *Portrait of a Goldsmith in Three Positions* (now in the Kunsthistorisches Museum in Vienna), which was in Charles I's collection at the time. It also notes that the heads are 'drawn and modelled with a care and restraint unusual in Van Dyck,' who demonstrated his mastery in the fine, gently wrought depictions of the different lace collars and blue Garter ribbons.

The painting was sent to Bernini in 1636 and the bust made in the summer of that year; it was presented to the English king and queen on 17 July 1637, and Bernini was given a diamond ring as recompense. Sadly, the bust perished in a fire at Whitehall Palace in 1698. The

Lorenzo Lotto's *Portrait of a Goldsmith in Three Positions*, 1525–35, thought to have influenced Anthony van Dyck's painting of Charles I.

painting remained with Bernini's heir, and was at the Palazzo Bernini
in Rome until 1802, when an agent of the British art dealer William
Buchanan bought the portrait.

In all likelihood, Buchanan himself consigned the work to
auction in 1804. According to the sale catalogue, it was accompanied
by a fascinating letter of authenticity: 'This picture was deposited
by the Chevalier Bernini in the Bernini Palace of Rome, and the
complimentary letter from Queen Henrietta Maria to Bernini, bound
up in the Book of Records of that Family,' the entry states. 'When
this picture was sold out of the Bernini Palace, the Queen's original
Letter was torn out of the Book of Records above alluded to, and now
accompanies it.'

The work did not sell in 1804, and was 'bought in' by Christie's
at 490 guineas (£515/$2,343; equivalent to £40,500/$58,400 today).
The painting was subsequently in the collections of Mr Irvine, Walsh
Porter and Mr Wells before being purchased by King George IV in 1822
for 1,000 guineas (£1,050/$5,230; equivalent to £85,500/$123,300
today). It is now in the Queen's Drawing Room at Windsor Castle.

REMBRANDT RUMPUS

Rembrandt van Rijn
(1606–1669), *Portrait of
the Artist's Son Titus*, c.1655,
oil on canvas, 65 x 56 cm
(24½ x 20½ in)

SALE
19 March 1965, London

ESTIMATE
Not published

SOLD
760,000 guineas/
£798,000/$2,234,400

EQUIVALENT TODAY
£13,800,000/$19,905,000

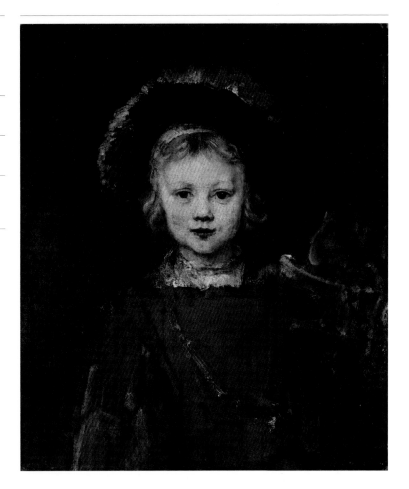

Part of the Cook Collection, this touching portrait of Rembrandt's son
dating from about 1655 made the cover of *Time* magazine when it was
sold in 1965 for 760,000 guineas, setting a new record for a London
auction. Its sale is now the stuff of legend, but that has little to do with
the price tag, the impact of which was rather lost in the furore as the
sale unfolded. The auctioneer was the charismatic Peter Chance, then
chairman of Christie's, who described the sale as 'the worst moment'
of his working life.

Before the introduction of the auction paddle, buyers chose
their own bidding signals. Before the sale of the Cook Collection,

the American industrialist and collector Norton Simon sent a letter stipulating his complex bidding orders. 'If he is sitting he is bidding; if he stands he has stopped bidding,' it explained. 'If he sits down again he is not bidding until he raises his finger. Having raised his finger he is bidding until he stands up again.'

As the bidding was drawing to a conclusion, Chance brought the hammer down on the price of 700,000 guineas (£735,000/$2,060,000; equivalent to £12.7m/$18.3m today) for *Portrait of the Artist's Son Titus*, which sold to Marlborough Fine Art in London. However, it transpired that, confused by Simon's sitting, standing and finger-raising gestures, Chance had missed Simon's last bid. The furious collector leaped up and approached the rostrum to read out the letter of agreement. Bidding was reopened and Simon eventually became the owner of the Rembrandt.

Simon said he had made obscure bidding arrangements to avoid press attention, although the tactic failed on this occasion, when headlines were accompanied by a press photograph that captured him scowling madly at Chance. Pathé's news footage, titled 'Rembrandt Rumpus', also ignored the painting to focus on Lady Cook, the glamorous young seller of the painting, who looked ever so discreetly thrilled as she sat in the audience.

The painting subsequently left Britain and is now in the Norton Simon Museum in Pasadena, California. It remained a favourite of Simon's until his death in 1993. It is interesting to note how it entered Britain in the first place: in about 1815, George Barker, a picture restorer, missed his boat home from Holland and spent a night in a farmhouse near The Hague, where he saw and admired the painting. The landlord is said to have thrown it in with the price of his board: one shilling. On his return home Barker presented it to his patron, Lord Spencer, and it stayed in the Spencer Collection at Althorp in Northamptonshire for many years until it was sold.

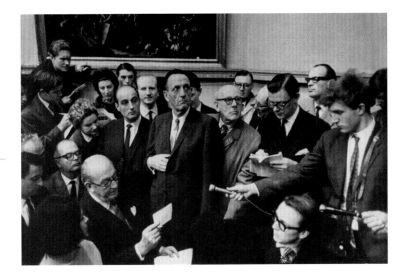

Industrialist Norton Simon, hand on his chest, is surrounded by members of the press and fellow collectors at the auction of Rembrandt's *Portrait of the Artist's Son Titus* at Christie's King Street on 19 March 1965.

A RARE BLUE BEAR

Steiff (est.1880), 'Elliot'
teddy bear, c.1908, mohair,
32 cm (13 in) high

SALE
6 December 1993, London

ESTIMATE
£15,000–20,000/
$22,500–30,000

SOLD
£49,500/$74,250

EQUIVALENT TODAY
£90,100/$130,500

For decades, 'Elliot' – a blue Steiff teddy bear – lay forgotten on a shelf at the company's headquarters in Giengen, Germany. Such stuffed animals are now among the most sought-after toys for collectors, but in 1908, the company – founded twenty-eight years earlier by Margarete Steiff – failed to persuade the London department store Harrods that blue bears would sell.

'Elliot' was the only blue bear in a set of six designed to show what Steiff could achieve through dying the mohair 'fur' different colours. He was almost identical to 'Alfonzo', a red bear commissioned in the same year by the Grand Duke of Russia for his four-year-old daughter, Princess Xenia, cousin of Tsar Nicholas II. 'Alfonzo' became Xenia's lifelong companion, remaining with her until her death in exile in 1965, before entering the record books when he was sold in 1989 for more than £12,000 ($19,680; equivalent to £26,700/$38,700 today).

Teddy bears first appeared on the market in 1902, but it was not until the 1980s, when they started to be sold alongside dolls and other toys, that interest among collectors peaked. Despite the initial rejection from Harrods, 'Elliot' arrived at the world's first auction dedicated to teddy bears in 1993 in 'remarkable condition', according to the sale catalogue.

Predicting high levels of interest, Christie's insisted that clients should register in advance for the auction. On the day, 800 collectors and enthusiasts crowded into the South Kensington saleroom to witness 'Elliot', the star lot, attracting several keen bidders who eventually pushed the price to £49,500, a record at the time.

THERE'S NO PLACE LIKE HOME

Gilbert Adrian (1903–1959),
A pair of 'ruby slippers', 1939,
spool-heeled shoes of red silk
faille, overlaid with hand-
sequinned georgette, flat-
jewelled bows applied to the
toes, stamped 6B E 58 68

SALE
24 May 2000, New York

ESTIMATE
Not published

SOLD
$660,000/£447,500

Hollywood memorabilia is a comparatively new collecting area.
In 1970 MGM held a three-day sale of costumes and film props
dating back to the 1920s. The sale unleashed a wave of enthusiasm
for all things Hollywood, and a collecting mania was born. Speciality
companies and private brokering businesses dealing in memorabilia
sprang up, and prices quickly escalated.

Thirty years later, Christie's New York sale, entitled 'A Century
of Hollywood', realized a total of over $1.6m (£1.1m), providing
resounding confirmation that memorabilia still sells. Record prices
were achieved, including $660,000 for a pair of sparkling red shoes –
the 'ruby slippers' worn by Dorothy Gale, played by Judy Garland,
in *The Wizard of Oz* (1939).

Scarcity increases value, and objects associated with cinematic
'royalty' – Greta Garbo, Judy Garland, Marilyn Monroe, Bette Davis,
James Dean, Charlie Chaplin – continue to be sought after. Eight pairs

of ruby slippers were made for Garland to wear in *The Wizard of Oz*, although only four pairs are known to survive.

In the original book by L. Frank Baum, *The Wonderful Wizard of Oz* (1900), Dorothy's magical slippers are silver, but they were changed to red for the Technicolor film to maximize their cinematic impact. Gilbert Adrian, MGM's chief costume designer, used white silk shoes made by the Innes Shoe Company and dyed them red. Approximately 2,300 crimson sequins were then sewn on to a georgette overlay to make the shoes sparkle under the spotlights.

The ruby slippers appear on Dorothy's feet following the death of the Wicked Witch of the East. When Dorothy clicks the heels together and says 'There's no place like home', she leaves the magical world of Oz and returns to Kansas. According to the Library of Congress, the film is the most watched in American history. For a collector of movie memorabilia, therefore, the slippers are the ultimate acquisition.

In the same sale, the original paw-style shoe of Dorothy's friend, the cowardly lion, realized $25,850 (£17,500). Demand for Hollywood memorabilia continues to rise: in 2011 Judy Garland's *Wizard of Oz* pinafore dress sold for over $1.1m (about £690,000).

Previous page: Judy Garland as Dorothy Gale, with her friends from *The Wizard of Oz* (1939), wearing the ruby slippers.

DOWN AND OUT IN NEW JERSEY

Edward Hopper (1882–1967), *East Wind Over Weehawken*, 1934, oil on canvas, 86.5 x 127.5 cm (34 x 50 in)

SALE
5 December 2013, New York

ESTIMATE
$22m–28m/£13.4m–17.1m

SOLD
$40,485,000/£24,793,000

In the 1930s, Edward Hopper was considered to be the foremost painter of the American Scene. This was the time of the Great Depression; by 1933, nearly half of the country's banks had failed, and about fourteen million Americans were unemployed. Hopper painted *East Wind Over Weehawken* the following year, and the effects of the economic slump are quietly evident in this picture of a desolate New Jersey township. Apart from a group of people in the distance, the only sign of life is the wind blowing through the dead grass in the foreground. The houses, with their blinds half drawn, look vacant. The 'For Sale' sign might almost apply to them all, not just the house we cannot see. As the novelist John Updike wrote, 'Hopper is always on the verge of telling a story,' and although Hopper himself insisted that no obvious anecdote was intended, the narrative suggested in this scene is one of decorous neglect.

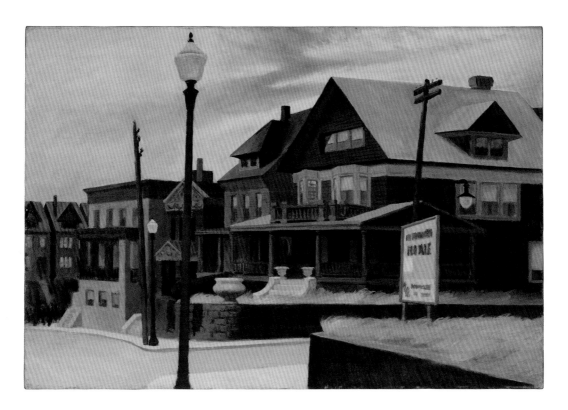

Hopper was fascinated by what he described as 'our native architecture with its hideous beauty, its pseudo-gothic, French Mansard, Colonial, mongrel or what not, shouldering one another along interminable streets'. In *East Wind Over Weehawken* he emphasizes such details as decorative urns, stairways, balustrades and porticos, relics perhaps of thwarted ambition and dreams of grandeur.

The artist regarded *East Wind Over Weehawken* as one of his best pictures. For more than half a century the painting was owned by the Pennsylvania Academy of the Fine Arts, America's oldest art museum and school. It was sold by the institution in order to raise funds to continue its tradition of supporting contemporary art and artists. At the painting's sale at Christie's in 2013 it realized over $40.4m, far exceeding its estimate and making it the most expensive work by Hopper ever auctioned.

WINDS OF CHANGE

Zao Wou-Ki (1920–2013),
Vent du Nord, 1956,
oil on canvas, 97 x 130 cm
(38 x 51 in)

SALE
23 November 2013,
Hong Kong

ESTIMATE
HK$15m–20m/
£1.2m–1.6m/$1.9m–2.6m

SOLD
HK$49,400,000/
£3,928,755/$6,371,645

'Everybody is bound by a tradition. I am bound by two.' So said Zao
Wou-Ki of his artistic career. Zao was a unique figure in twentieth-
century art. Born in China and trained in both Western oil painting
and Chinese ink painting traditions in Hangzhou, he moved to Paris
in the late 1940s, and there, as well as through visits to New York, he
was able to fuse the style he had learned with the more experimental
approaches he encountered in the West. It was not an easy process –
he said 'it was harder than learning English' – but it led to great acclaim
for Zao's work in Europe and America.

Zao was originally inspired by Paul Klee, and used the simplicity
of Klee's language as a bridge to Chinese traditions. He soon grew more
ambitious, and his homeland provided the route to a new language.
He began to look at ancient traditions, and particularly oracle bones –

Zao Wou-Ki (standing, left) and fellow artists (including Georges Mathieu, Jean-Paul Riopelle and Maria Helena Vieira da Silva) with art dealer Pierre Loeb (seated, wearing a sweater) in Paris, c.1950.

pieces of bone or turtle shell used in divination in Bronze Age China, with an elegant language of symbols. *Vent du Nord (North Wind)* is representative of work from Zao's oracle-bone period.

Of this breakthrough in his work, Zao said that 'still life, flowers and animals have disappeared. I use symbols – certain imagined things that fall into a monochromatic background – in an attempt to explore. Later, slowly, the symbols in the painting become shapes, and the background becomes a space. My painting begins to move, to live.' Looking at the painting, this vitality is clear: it seems to shift in space. The marks, like ancient script, separate and reunify to suggest an animal form – perhaps a bird – before dissolving again into a blizzard of calligraphic gestures.

The French poet Henri Michaux, one of a number of European intellectuals whom the Chinese artist befriended, described Zao's canvases of this period as 'a garden of symbols' in which images could be found, 'rich in curiosity, trembling in delight'. He noted that 'a festive atmosphere quietly builds, like a joyous celebration in a Chinese hamlet.' This painting was one of the big successes of a landmark sale in 2013 that achieved HK$935m (£74.8m/$121m).

94 A REVOLUTIONARY LINE

Jackson Pollock (1912–1956), *Number 19, 1948*, 1948, oil and enamel on paper mounted on canvas, 78.5 x 57.5 cm (31 x 22½ in)

SALE
15 May 2013, New York

ESTIMATE
$25m–35m/£16.5m–23m

SOLD
$58,363,750/£38,403,350

The burst of activity that Jackson Pollock embarked upon in 1947 signalled a hugely creative three-year period for the artist. The number of masterpieces he produced during that time is astonishing: *Number 1A, 1948* and *One: Number 31, 1950*, now at the Museum of Modern Art in New York; *Number 1, 1950 (Lavender Mist)* at the National Gallery of Art in Washington, DC; *Summertime: Number 9A* (1948) at Tate Modern in London, to name but a few. The critic and curator Frank O'Hara claimed that Pollock 'had incited in himself, and won, a revolution in three years'. The person who was closest to it all was Pollock's wife, the painter Lee Krasner, who said that her husband's 'assuredness at that time is frightening to me. The confidence, and the way he would do it was unbelievable.'

Film footage of Pollock at work, taken by the photographer Hans Namuth in 1950, reflects this creative outpouring, and the ease with which Pollock moves around the canvas that is stretched out on the floor is spellbinding. The variety of marks and the bodily movements that produce them is extraordinary: delicate dripping, controlled flings,

rhythmic stretches and reaches. Pollock appears to be part ballet dancer, part boxer. Painting for him at this time was something performed not by the hand but by the whole body, and not once did a brush touch the canvas. He knew he was on to something, too, confiding to Krasner that jazz music and the bebop of Dizzy Gillespie and Charlie Parker were the 'only other creative thing happening in this country'.

Number 19, 1948 was singled out for praise by Abstract Expressionism's greatest promoter, the critic Clement Greenberg. In his review of Pollock's show in January 1949 at Betty Parsons, New York, Greenberg wrote: 'The general quality that emerged from such pictures, especially [*Number*] *Nineteen*, seemed more than enough to justify the claim that Pollock is one of the major painters of our time.'

After a tense saleroom battle in 2013, *Number 19, 1948* was sold for over $58m – almost $20m above Pollock's previous auction record – to an anonymous telephone bidder. The work had previously been sold at Christie's twenty years earlier, on 4 May 1993, for $2.4m (£1.6m; equivalent to $4.2m/£2.9m today).

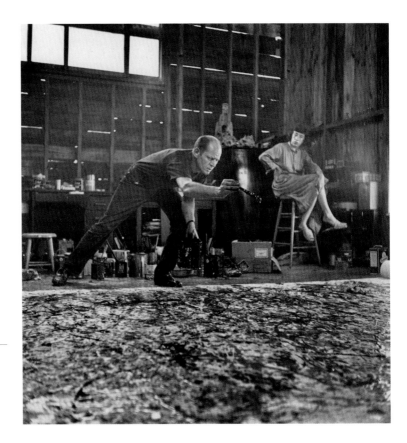

Jackson Pollock at work, watched by the artist Lee Krasner (whom Pollock married in 1945), photographed by Hans Namuth in 1950.

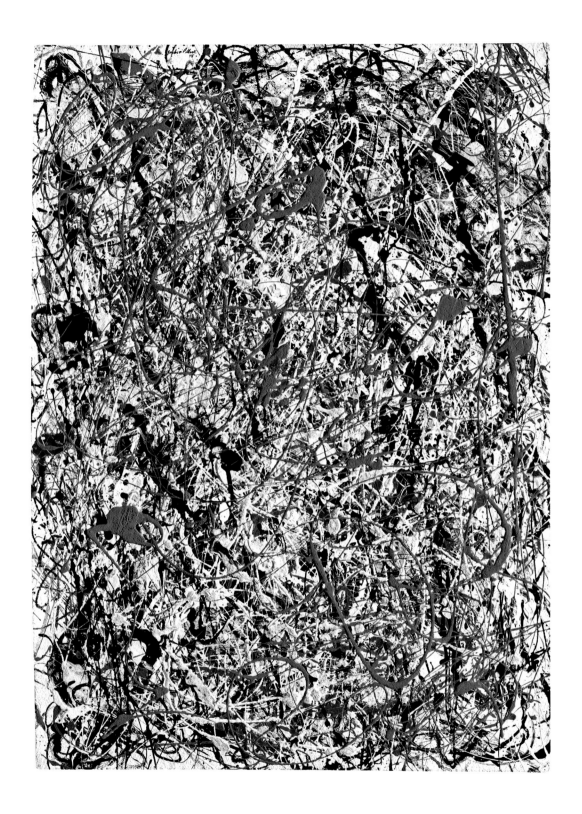

A BIG BANG

Cai Guo-Qiang (b. 1957),
Homeland, 2013, gunpowder
on paper, 240 x 750 cm
(94½ x 295¼ in)

SALE
26 September 2013, Shanghai

ESTIMATE
Not published

SOLD
RMB15,000,000/
£1,530,000/$2,445,000

In his gunpowder drawings and outdoor explosion events, the Chinese multimedia artist Cai Guo-Qiang aims to 'investigate both the destructive and the constructive nature of gunpowder, and to look at how destruction can create something as well'. Born in south-east China, Cai grew up during the tumultuous years of the Cultural Revolution (1966–76). In the 1980s, when he started to become aware of Western contemporary art, he found the cultural climate in China to be too repressive and moved to Japan in search of better opportunities. He began to work with gunpowder in China, then expanded this use in his drawings in Japan and also experimented with explosives on a massive scale. Cai now lives in New York, and works and exhibits internationally.

To create his gunpowder drawings, Cai first sketches a design on sheets of specially made paper placed on the floor. He then scatters gunpowder on top and arranges fuses to form silhouetted designs on the paper's surface. Pieces of cardboard are laid here and there to disperse the patterns that result from the explosion, and bricks are used to weigh everything down and intensify the blast. When the process is complete, Cai ignites the leading fuse with a stick of burning incense. With a series of flashes and loud bangs, the gunpowder rips across the paper, following the line of fuses. When the clouds

Cai Guo-Qiang during the production of his gunpowder drawing *Homeland* at the Union Church, Shanghai, on 25 September 2013 to mark Christie's first auction in mainland China.

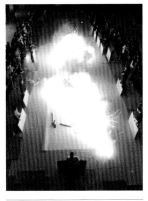

Top: Cai Guo-Qiang tests the gunpowder before creating *Leifeng Pagoda* in Hangzhou City, China, on 20 September 2011.

Above: Cai Guo-Qiang, *Ye Gong Hao Long (Mr Ye Who Loves Dragons)*, 2003. Ignition at Tate Modern, London, 2003.

of smoke disperse, and stray embers have been stamped out, the drawing is hung up for inspection.

This procedure, which Cai calls an 'open production', took place on 25 September 2013 at the Union Church in Shanghai, during the creation of *Homeland*. This vast drawing, which is more than 7 metres (22 feet) long, depicts Cai's home town, the ancient city of Quanzhou, with its pagodas, banyan trees and distant mountains seen against the ghostly outline of Frank Gehry's design for the as yet unbuilt Quanzhou Museum of Contemporary Art (an ambitious project that Cai is overseeing).

Homeland was commissioned to celebrate Christie's first auction in mainland China, which was held the next day. Witnessing the creation of the drawing was an audience of invited guests, many of whom recorded the explosions on their mobile phones. The event, which took Cai, his team and eight student volunteers three hours to prepare, lasted seven seconds and burned through 30 kg (66 lb) of gunpowder. The excitement continued at the auction itself, with over 200 international clients logged in to Christie's LIVE™ to watch proceedings online. The sale achieved RMB154m (£15.7m/$25.1m).

THE EMOTIVE POWER
OF RAW COLOUR

Mark Rothko (1903–1970),
Orange, Red, Yellow, 1961,
oil on canvas, 236 x 206 cm
(93 x 81½ in)

SALE
8 May 2012, New York

ESTIMATE
$35m–$45m/£21.7m–27.9m

SOLD
$86,882,500/£53,780,270

Mark Rothko's fiery canvases, glowing with vermilion, yellow and orange rectangles, were unlike anything that had ever been seen before. The Abstract Expressionist painter used colour to transmit human emotion, and it was this direct, undiluted and unmediated experience of colour that became the dominating force in his work. He once said that he wanted his paintings to establish such a 'presence' that, 'when you turned your back to the painting, you would feel that presence the way you feel the sun on your back.'

In 1967, David Pincus (a menswear magnate and a leading American collector in the second half of the twentieth century) and his wife, Geraldine, took out a loan to buy a Rothko painting from Marlborough Fine Art in London. *Orange, Red, Yellow* became the centre of the couple's burgeoning art collection, which also contained paintings by Jackson Pollock and Willem de Kooning.

Orange, Red, Yellow was sold for over $86m in 2012, the highest price realized at auction at the time for any post-war work. The auctioneer Christopher Burge presided over a seven-minute battle between international bidders, one of the longest ever witnessed in an auction of post-war and contemporary art. The sale eclipsed the previous record set for a Rothko, $72.8m (£36.7m) for *White Center (Yellow, Pink and Lavender on Rose)* (1950) in May 2007.

Rothko – who committed suicide in 1970 – was regarded by many to be the dominant force of Abstract Expressionism in New York. *Orange, Red, Yellow*, which is considered to be among his most powerful paintings, was executed at the height of his career, between the creation of the blood-red Seagram murals (1958, many of which are now at Tate Modern) and the Harvard murals (1962).

Mark Rothko photographed
by his daughter Kate in 1961.

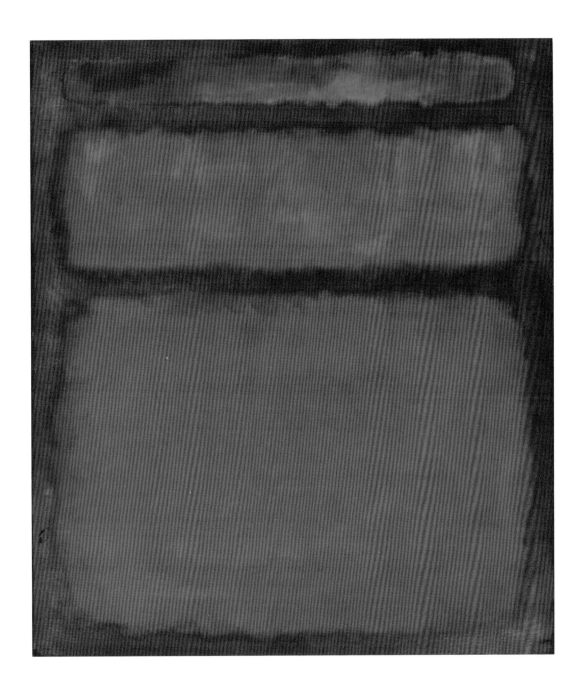

ABSTRACT VALUES

Vasudeo S. Gaitonde
(1924–2001), *Untitled*, 1979,
oil on canvas, 153 x 101.5 cm
(60 x 40 in)

SALE
19 December 2013, Mumbai

ESTIMATE
INR65m–85m/
£650,000–850,000/
$1,040,000–1,360,000

SOLD
INR237,025,000/
£2,323,165/$3,805,975

The prices for works by Vasudeo S. Gaitonde have risen sharply
at auction in recent years. The Indian artist's retrospective at the
Guggenheim in New York in 2014–15 presented his absorbing early
figurative and abstract art to a new international audience. The show,
which was sponsored by Christie's, included forty-five paintings
and works on paper.

This major exhibition was linked to a landmark sale in Mumbai
in December 2013 – Christie's first in the city – when Gaitonde's
Untitled, a shimmering, beguiling golden-yellow painting in oils,
fetched over INR237m, a world record for modern Indian art.

Such pieces rarely come on to the market, so expectations were
high. The sale, held at the Taj Mahal Palace Hotel, drew international
collectors from across Asia, America and Europe, and interest
was so great that an extra room had to be prepared to accommodate
the numbers.

'The saleroom was packed and buyers had to compete hard with
bidders from all over the world, joining online and on the telephone,'
recalled Sonal Singh, the Head of Sale. Gaitonde's *Untitled* was
eventually secured by an American collector, but Singh remarked
that the sale also reflected the huge domestic appetite for works
by Indian artists. The success of subsequent auctions held in Mumbai
has reflected the growth of this market and the burgeoning wealth
of high-net-worth Indian collectors.

Arun Vadehra, a New Delhi-based dealer who represents
Gaitonde's work, said that 'in choosing the abstract form, [the artist]
took the road less travelled, especially by Indian artists of his
generation, and devoted his skill in pursuing the art of painting
as painting in itself.' Gaitonde produced only five or six paintings
annually, and even after his death, his work remains very much
in demand.

THE ORIENTAL MUSEUM

The Oriental Museum of
Major General Charles Stuart,
comprising manuscripts,
sculptures, bronzes, costume,
jewellery, weapons and
natural history

SALE
11 and 14 June 1830, London

ESTIMATE
Not published

SOLD
£1,964/$9,350

EQUIVALENT TODAY
£157,000/$227,600

John Bridge of Wood House, Shepherd's Bush, London, and Major General Charles Stuart, of Wood Street, Chowringhee, Calcutta, had very little in common save the curious coincidence of their addresses. Bridge was a successful partner in a firm of London goldsmiths and had a sizeable estate on the outskirts of London; Stuart was an Anglo-Indian eccentric known as 'Hindoo Stuart' who bathed every morning in the River Ganges. Yet their names will be forever bound by one of the most important collections of Asian antiquities ever amassed.

Charles Stuart arrived in Calcutta from Dublin in 1777, a nineteen-year-old cadet with the army of the East India Company. The country immediately captivated him. He adopted Indian dress, dedicated his life to studying the culture, religions and languages, and was soon advancing the then-revolutionary notion that India's heritage was as rich and important as anything offered by classical antiquity and Christianity. Long after he had ascended to the rank of Major General, his ideas continued to inspire bewilderment among the Anglo-Indian community. One scandalized new arrival wrote: 'There is ... a British general in the Company's service, who observes all the customs of the Hindoos, makes offerings at their temples, carries about their idols with him, and is accompanied by fakirs.' The vast collection of Asian artefacts Stuart accumulated over his lifetime and exhibited at his home in Calcutta became known as his 'Oriental Museum' – an encyclopaedic trove of manuscripts, jewellery, artworks and weaponry, including some of the finest examples of Hindu sculpture ever made.

When Stuart died in 1828, his Oriental Museum was regarded as little more than a collection of heathen curiosities. It was shipped back to England and, at the two-day sale beginning on 11 June 1830, only a handful of people competed for his life's work. Most of the sculpture was acquired by Bridge, who housed Stuart's collection in his own private museum, a faux-Moorish pavilion in the grounds of his estate at Shepherd's Bush. There, priceless works Stuart had devotedly collected were cemented into walls, blackened with boot polish or painted with white numbers.

Interestingly, it was through the Bridge family that Stuart's collection would become known to a wider public. As part of the Bridge Collection bequeathed to the British Museum in 1872, Hindoo Stuart's Oriental Museum formed the original core of the museum's Department of Asia, which is now considered one of the most important collections of Indian sculpture in the world.

Treasures from the Oriental Museum. Left: a 9th-century sandstone figure of Chamunda from Orissa, India. Above: a 13th-century schist relief sculpture of Varaha with Bhu and Gadadevi, also from Orissa.

THE BIRTH OF A NOVEL

E.M. Forster (1879–1970),
A Passage to India, 1913–24,
autographed manuscript,
400 folio leaves, and draft
manuscript, 101 folio sheets,
and 20 quarto sheets of
typescript, each folio
21.5 × 34.5 cm (8½ × 13½ in)

SALE
22 June 1960, London

ESTIMATE
Not published

SOLD
£6,500/$18,300

EQUIVALENT TODAY
£134,000/$192,600

In 1960, the London Library in St James's Square was experiencing severe financial difficulties, as a result of a retrospective demand for rates (made by the Inland Revenue) from which the institution had previously been exempt. Publishers and authors rallied around the venerable institution, which had been founded in 1841, and many books and manuscripts were donated for the London Library Sale, held at Christie's on 22 June that year. Revenue from the sale of catalogues, which cost five shillings, was donated to the library.

Two lots in particular caused the greatest excitement: T.S. Eliot's *The Waste Land* (1922), the author's own fair copy of the manuscript (the original is presumed lost), and draft and autographed manuscripts of E.M. Forster's *A Passage to India*, which Forster confirmed were the only existing manuscripts of his last and greatest novel. Both Forster and Eliot, who was the president of the London Library, were present in the King Street saleroom to witness *The Waste Land* realize £2,800 ($7,900; equivalent to £57,600/$82,800 today). *A Passage to India* broke the world record for a manuscript by a living author, selling for £6,500 to the American bookseller Lew Feldman.

The novel was inspired by an intense friendship and unrequited love. Forster met Syed Ross Masood, a young Indian studying law in England, in 1906, during the highly productive period of five years in which he wrote all his other novels. It was Masood who suggested a novel set in India, and once his friend had finished his legal studies, Forster followed him to the subcontinent. In the six months from October 1912 that he spent in India, the writer travelled extensively. He spent some time with Masood and visited the Barabar Caves, the inspiration for the Marabar Caves in *A Passage to India*, the setting for an ambiguous attack on the Englishwoman Adela Quested.

These manuscripts offer a fascinating insight into the birth of a novel, incorporating a great deal of draft material that reveals Forster's slow and agonizing progress. Some passages exist in up to five different versions, and even the name of Adela Quested causes difficulty; he experiments with Edith, Janet and Violet. What is also clear is how troubled Forster is by the character of Adela, who is more aggressive in earlier versions of the manuscript. In his first drafts, she is subject to a violent physical assault. Forster ultimately rejects this in favour

E.M. Forster with Syed Ross
Masood in 1911.

of an implied attack, which might have been a repressed fantasy – she is, after all, attracted to her supposed assailant, Dr Aziz.

A Passage to India took Forster eleven years to complete, but his efforts certainly paid off. A review in The Guardian on 20 June 1924 congratulated him on the 'tone and temper of his new novel. To speak of its "fairness" would convey the wrong impression, because that suggests a conscious virtue. This is the involuntary fairness of the man who sees.'

DIAMONDS
ARE FOREVER

The Agra diamond,
16th century, unmounted
cushion-cut fancy light pink
diamond, 32.24 carats

SALE
20 June 1990, London

ESTIMATE
Not published

SOLD
£4,070,000/$6,959,700

EQUIVALENT TODAY
£8,262,000/$12,600,000

Portrait miniature of Babur
(1483–1530), founder of the
Mughal dynasty.

The legend of the Agra diamond, a pink cushion-cut diamond of 32.24 carats, spans continents and centuries, conquests and acquisitions. It is said that the Rajah of Gwalior gave the diamond to the Mughal Emperor Babur, who captured the city of Agra in 1526 but spared the lives of the rajah and his family. The gem was worn in the turbans of successive Mughal emperors.

What is clearly documented is the diamond's appearance in the collection of Charles II, Duke of Brunswick, in 1844. The duke was deposed during the revolution of July 1830 in the German Duchy, and consequently spent much of his life in London and Paris. He was one of the nineteenth century's greatest jewellery collectors, and purchased the Agra diamond from the dealers Blogg & Martin in London for the sum of 348,600 French francs (£13,760/$65,000; equivalent to £1.2m/$2.1m today).

The Agra diamond was next acquired by the Paris jeweller Bram Hertz, and was re-cut to 32.24 carats to remove some black inclusions. The London jeweller Edwin Streeter bought the diamond in 1891, and in 1895 it played a starring role in an extraordinary law case, when a young and wealthy man named Joseph Charles Tasker claimed that he had been induced by Streeter to buy jewellery, including the diamond,

at an inflated price when he was drunk and incapable. The jury found for the plaintiff concerning the diamond (although not all the other jewellery), and it was returned to Streeter's.

When Edwin Streeter retired, his stock was taken over by the Parisian firm La Cloche Frères, and Christie's auctioned the diamond on 22 February 1905. It was the highlight of the sale and attracted a large crowd of Indian collectors, but was eventually sold to Max Meyer, a dealer in Hatton Garden, London, for 5,100 guineas (£5,355/$26,100; equivalent to £513,600/$725,000 today).

Louis Winans, the son of an American railway engineer from Baltimore who had made a fortune building the railway from St Petersburg to Moscow, then acquired the diamond. He settled in Brighton, on the south coast of England, and the diamond passed down through his family. It was concealed in an iron casket that was buried in the garden during the Second World War, and was safely preserved before eventually finding its way back to the saleroom in 1990. The purchaser, SIBA Corporation of Hong Kong, set a new record for a pink diamond when they acquired it for £4m. The famous diamond was recut to a modified cushion shape, weighing 28.15 carats, and is now part of the Al-Thani Collection.

101 MUGHAL MASTERPIECE

Mughal flask, first half of 17th century, pale green nephrite jade-panelled flask inset with rubies and emeralds, lined with gold, North India, 24.5 cm (9½ in) high

SALE
27 April 2004, London

ESTIMATE
£0.8m–1.2m/$1.4m–2.2m

SOLD
£2,917,250/$5,227,700

This intricately decorated Mughal flask once belonged to Robert Clive (1725–1774), who established British power in India. He was also known as the First Baron Clive of Plassey, or Clive of India. Covered in jade panels, with bands of emeralds and flowers of rubies set in gold, the flask has an intriguing history.

Clive became a national hero in Britain when, aged thirty-two and at the head of a mixed European-Indian army, he defeated the Nawab of Bengal at the Battle of Plassey in June 1757. It is thought that the flask – originally crafted in the seventeenth century for the Mughal court – was given to Clive by the new Nawab, who opened the doors of his treasury to him. Together with his other treasures, Clive took the intricately decorated flask back to Britain.

Several years after Clive had returned to Britain, his huge personal wealth – which he estimated to be in the region of £400,000 ($1.8m; equivalent to about £50m/$70m today) – prompted a parliamentary inquiry into whether it had been gained through questionable means.

Clive declared: 'Consider the situation in which the victory at Plassey had placed me! ... I walked through vaults which were thrown open to me alone, piled on either hand with gold and jewels. Mr Chairman, at this moment I stand astonished at my moderation.' Clive was exonerated, but died shortly afterwards, possibly having taken his own life.

The flask was auctioned at Christie's in 2004, having been on loan to the Victoria and Albert Museum in London for the previous forty years. It was offered by Robert Clive's direct descendants, and realized just under £3m. Four other Clive treasures were also in the sale, including a fly whisk made from banded agate and inset with rubies that sold for over one hundred times its high estimate at £901,250 ($1.6m).

The drama surrounding the Mughal flask did not end there, however. Before the year was out the British government had placed a temporary export ban on the flask in order to prevent its new owner, the Qatari Minister of Culture, from taking it out of the country, and to offer the chance for the funds to be raised to keep it in Britain. The Clive treasure was, it stated, 'a reflection of eighteenth-century Indian court culture and the way in which the British engaged with it.'

Subsequent negotiations handled directly by the Qatar Museums Authority led to an agreement between the Museum of Islamic Art in Doha and the Victoria and Albert Museum in London. This resulted in the flask being exported for the opening of the Museum of Islamic Art in 2008 but then being returned on long-term loan to the Victoria and Albert Museum.

102

GIFTS FROM
ANOTHER WORLD

Mantegna's *Adoration of the Magi* is extraordinarily intimate, presenting such a close-up view that the onlooker feels included in the event. The painting's small size and the intensity of its spiritual drama suggest that it was intended for personal devotion, to be displayed in a domestic room or private chapel rather than in a place of public worship.

The picture is unusual because all the figures, apart from that of the infant Christ, are half-length, and because the Magi's gifts of gold, frankincense and myrrh are contained in objects not usually seen in Italy at that time. The three kings, or wise men, represent the three parts of the world that were then known: Europe, Asia and Africa. Their exotic presents, however, are not from their own

Andrea Mantegna
(c.1430–1506), *Adoration of the Magi*, c.1500, tempera and oil on linen laid down on canvas, 54.5 x 69 cm (21½ x 27½ in)

SALE
18 April 1985, London

ESTIMATE
Not published

SOLD
£8,100,000/$10,530,000

EQUIVALENT TODAY
£21,900,000/$30,400,000

countries. The European king offers gold in a Chinese blue-and-white porcelain cup that can be dated to the early fifteenth century, while the other kings hold a censer of Turkish tombac ware and a cup and cover of carved agate, probably from Persia. It seems likely that these rare and precious vessels belonged to Mantegna's patrons, the Gonzaga family, whose court at Mantua was one of the most splendid and enlightened in Renaissance Italy.

When it was sold in 1985, Mantegna's *Adoration of the Magi* fetched the highest price ever paid for a painting. It was bought by the J. Paul Getty Museum, whose recent multi-billion-dollar endowment had given it unparalleled purchasing power. Transmitted live to Christie's New York by satellite television, the bidding in the London saleroom started at £2.5m and was all over in three minutes, when the painting sold for more than £8m.

A SPANISH MYSTERY

Neapolitan School, *The Adoration of the Shepherds*, c.1630s, oil on canvas, 228 x 164.5 cm (90 x 65 in)

SALE
13 May 1853, London

ESTIMATE
Not published

SOLD
2,060 guineas/£2,163/$10,580

EQUIVALENT TODAY
£195,000/$278,500

For the last 150 years, this seventeenth-century nativity scene has suffered something of an identity crisis. Bought by the National Gallery in London in 1853 as a 'very celebrated work known as *The Manger* by [Diego] Velázquez [1599–1660]', it was later thought to be by Francisco de Zurbarán (1598–1664), and then attributed by various scholars to an array of lesser-known Spanish artists. It was subsequently ascribed to Bartolomé Esteban Murillo (1617–1682) and eventually reattributed to an 'unknown Neapolitan artist'. The mystery of who painted *The Adoration of the Shepherds*, and when and where it was produced, remains unsolved.

When the National Gallery acquired the painting, the institution had been in existence for less than thirty years, and its collection was still small. But the wars and revolutions of late eighteenth- and early nineteenth-century Europe meant that the market was flooded with works of art. At the sensational Soult sale in Paris in 1852, the National Gallery had hoped to buy Murillo's *Immaculate Conception* (c.1678), the 'star' among the pictures looted in Seville by Marshal Jean-de-Dieu Soult, head of the French army, some forty years earlier. Piqued at losing this picture, which went to the Louvre for the then unheard-of sum of 586,000 livres (£23,400/$114,600; equivalent to £2.3m/$3.3m today), the National Gallery turned its attention to works from King Louis-Philippe's Spanish Gallery collection that were auctioned at Christie's the following year.

The Galerie Espagnole (Spanish Gallery) had been inaugurated at the Louvre in 1838, the same year that London's National Gallery first opened its doors in Trafalgar Square. The collection consisted of more than 400 paintings acquired in Spain by King Louis-Philippe's agents during the chaos of the First Carlist War (1833–9). The Seville-based English collector Frank Hall Standish (1799–1840) had bequeathed 220 Spanish pictures to King Louis-Phillipe, who added them to the Galerie Espagnole. After his deposition in the French Revolution of 1848, the collection followed him to England, and it was sold after his death in 1850. At the six-day sale in 1853, which realized just under £28,000 ($137,000; equivalent to £2.5m/$3.6m today), the National Gallery bought two pictures. One of them was this painting, at the time thought to be by Velázquez, which achieved the sale's highest price of 2,060 guineas.

GOING ONCE

VISION
OF THE SERMON

El Greco (1541–1614), *Christ Driving the Traders from the Temple*, c.1600, oil on canvas, 106.5 x 129.5 cm (42 x 51 in)

SALE
30 June 1877, London

ESTIMATE
Not published

SOLD
24 guineas/£25 4s/$130

EQUIVALENT TODAY
£2,100/$3,000

El Greco's masterful *Christ Driving the Traders from the Temple* was acquired by the connoisseur John Charles Robinson (1824–1913) at Christie's in 1877. Robinson had trained as an artist in Paris and was appointed curator of the Museum of Ornamental Art at Marlborough House, London, in 1852 (it became the South Kensington Museum in 1857 and is now known as the Victoria and Albert Museum). The painting shows Christ lashing out at traders plying their wares in a place of worship, and is full of energetic and exaggerated movement.

Robinson, who maintained reservations about El Greco's style, donated the work to the National Gallery in London in 1895. The painting also made the gallery's curators feel uneasy, and the work was described in less than flattering terms in the gallery's catalogue of 1898: 'There is much energetic action with rather faulty drawing.'

Why did El Greco's approach prove so problematic for British scholars? The art critic Laura Gascoigne considered this in *The Spectator* in 2012: 'To an English late nineteenth-century audience weaned on Murillo this "most eccentric master" – a Cretan-born Byzantine icon painter turned Venetian colourist turned Spanish Mannerist – looked dangerously *outré*.'

As Gascoigne notes, El Greco's reputation and artistic practice have been reassessed over the past century. The artist is now hailed as a prophet of modernism and a forerunner of Expressionism and Cubism. Pablo Picasso was profoundly affected by El Greco's altarpiece painting *The Vision of St John* (1609), which he saw in the studio of a Spanish painter in about 1906; the work is believed to have paved the way for *Les Demoiselles d'Avignon* (1907).

Christ Driving the Traders from the Temple could be seen to refer to the Catholic Church's attempts at purification after the Protestant Reformation. Yet it is far from a straightforward account of either this contemporary religious context or the original biblical narrative. Instead, it appears like a vision, with little attention given to perspective or scale – if St Peter, kneeling on the right in the foreground, were to stand up, he would tower over Christ. This subjectivity of scale both connects to El Greco's training as an icon painter and points the way to the work of the nineteenth-century Post-Impressionists, such as Paul Gauguin and Paul Cézanne.

John Charles Robinson, etching by G. Robinson, completed in the late nineteenth century, some time after his acquisition of El Greco's *Christ Driving the Traders from the Temple* in 1877.

A PICTURE
OF MELANCHOLY

Vincent van Gogh (1853–
1890), *Portrait of Dr Gachet*,
1890, oil on canvas,
66 x 57 cm (26 x 22½ in)

SALE
15 May 1990, New York

ESTIMATE
$40m–50m/£23.9m–29.8m

SOLD
$82,500,000/£49,200,000

EQUIVALENT TODAY
$135,500,000/£94,000,000

In 1990, Vincent van Gogh's powerful portrait of the physician who cared for him in the last few months of his life broke all records to become the most expensive painting ever sold at auction. It was bought for $82.5m by Ryoei Saito, a Japanese paper manufacturer, who purchased it during a two-day spending spree in which he also bought the small version of Renoir's *Bal du Moulin de la Galette* (1876) for $78.1m (£43.9m).

The sale of the *Portrait of Dr Gachet* provided another twist in the story of this melancholy picture. Painted just before Van Gogh committed suicide in 1890, it was described by the artist as 'weary with the heartbroken expression of our time'. It was first sold by the widow of Van Gogh's brother Theo to the ambitious art dealer, Ambroise Vollard, and the painting went on to hang in Frankfurt's Städelsches Kunstinstitut.

Subsequently classified as 'degenerate art' under Nazi cultural policy, the painting was removed from the museum's collection in 1937 and was acquired by Hermann Goering for his personal collection. It was saved from destruction only when Franz Koenigs, a German banker living in Amsterdam, bought the painting from Goering and passed it on to the Jewish philanthropist Siegfried Kramarsky who shipped it to America.

The painting emerged on to the open market at a critical moment in early 1990. Rumours of an impending financial crash were rife and buyers were getting nervous, not least those from Japan, who had dominated the auction houses for the previous few years but were now starting to pull out. Saito's phenomenal bid flew in the face of such widespread pessimism, and when the gavel came down in the auction room, people leapt to their feet and cheered with relief. It seemed – at the time – that the rumours of financial disaster were unfounded. Sato died in 1996 and despite rumours of him having the painting cremated with him at his funeral being retracted, *Portrait of Dr Gachet* has not been seen since the auction. It still stands to this day as the world record price at auction for any work by the artist.

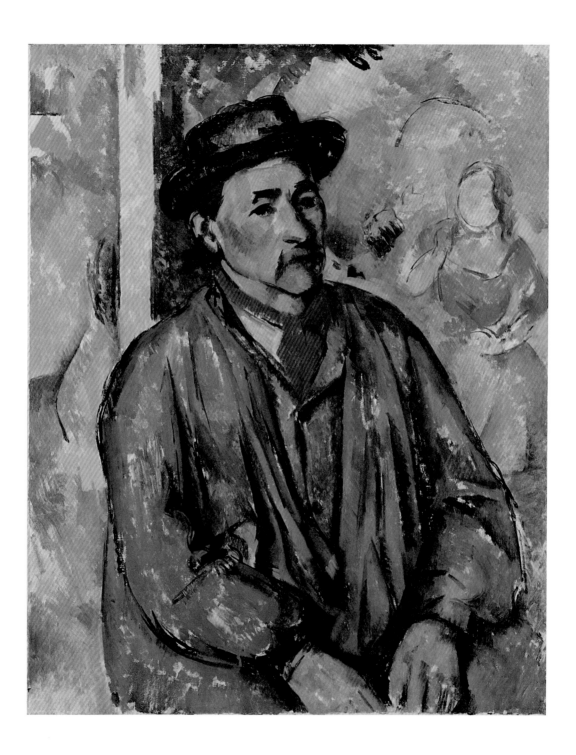

GOING ONCE

MAN OUT OF TIME

Paul Cézanne (1839–1906),
Man in a Blue Smock,
c.1896–7, oil on canvas,
81.5 x 65 cm (32 x 25½ in)

SALE
13 May 1980, New York

ESTIMATE
Not published

SOLD
$3,900,000/£1,673,820

EQUIVALENT TODAY
$9,245,000/£6,410,000

Paul Cézanne was born in Aix-en-Provence in southern France, and his birthplace exercised a powerful influence over the artist for much of his life. He painted Montagne Sainte-Victoire repeatedly, and frequently asked locals to sit for him. Cézanne regarded the area's agricultural workers as steadfast and unchanging, like the mountain, which dominated the town. He said he admired them for 'growing old without breaking with old customs'. The anonymous model for *Man in a Blue Smock* was probably a worker on the Cézanne family estate. The same man appears in the background of two slightly earlier paintings that form part of Cézanne's series of 'Card Players' – some of the most ambitious works of his career.

In this portrait, the dignified labourer sits in front of Cézanne's first known painting, a large six-panel folding screen (c.1859–62), which resembles an eighteenth-century tapestry. The juxtaposition of this early decorative work and a portrait painted some thirty-five years later, when the artist was at the height of his powers, is intentional. The faceless woman with a parasol on the flat screen appears like a ghost behind the sun-baked, wind-blown features of the farmhand, whose enduring presence is solid and sculptural.

If the painting seems to evoke timeless traditions, Cézanne's technique – with its vibrant patchwork of brushstrokes – was radically new. It would become a rich source of inspiration for later avant-garde artists, who regarded him as the father of modern art.

In 1959, *Man in a Blue Smock* was bought for £145,000/$407,450 (equivalent to £3m/$4.3m today) for Henry Ford II, the former chairman of the Ford Motor Company and a lifelong collector and connoisseur of fine paintings. Twenty-one years later, Ford decided to sell the Cézanne and another nine of his most prestigious Impressionist and modern paintings. The 'Ten Important Paintings from the Collection of Henry Ford II' sale was held in New York at the Park Avenue saleroom, which had opened just three years earlier, and helped to establish Christie's reputation in America. The ten paintings realized $18.4m (£8m; equivalent to $53m/£27m today); Cézanne's *Man in a Blue Smock* was sold to a New York dealer and subsequently acquired by the Kimbell Art Museum in Fort Worth, Texas.

The sitter for *Man in a Blue Smock* appears again, standing behind the table, in Cézanne's *The Card Players*, c.1890–2.

HOROLOGY REWRITTEN

Patek Philippe (est. 1839), the Stephen S. Palmer chronograph clock watch, 1898, 18-carat pink-gold open-face 'grand complication' clock watch, 6 cm (2½ in) in diameter

SALE
11 June 2013, New York

ESTIMATE
$1m–1.5m/£0.6m–1m

SOLD
$2,251,750/£1,445,000

Occasionally an auction can rewrite history, and something can appear that changes specialist knowledge in a given field. This clock watch caused just such a recalibration of the historical record when it went under the hammer in New York in 2013. Until it came to auction, the consensus among experts had been that Patek Philippe did not make its first 'grand complication' until 1910. But this piece – never before seen in public – was made twelve years earlier, and was bought by the American industrialist Stephen Palmer in Geneva in 1900.

In horological terms, a complication is a built-in piece of functionality: the use of the second hand as a stopwatch, for example, or a calendar, a dial showing phases of the moon or an alarm. A 'grand complication' is a watch that has numerous complications relating to timing, astronomical data or the striking of the hours. The Palmer split-seconds chronograph clock watch incorporates a perpetual calendar and phases of the moon. It also features a *grande* and *petite sonnerie*: every fifteen minutes, it strikes the number of quarter hours and the number of hours, making it possible for Palmer to know the time without having to take the watch out of his waistcoat pocket.

Palmer could have used the chimes as a cue to show off his watch, because this is not merely a superlative example of *haute horlogerie*; it is also a sumptuous piece of jewellery. Its hefty case is made of 18-carat pink gold; the dials on the white-enamel face are a beautifully executed arrangement of circles, like a stylized picture of the cogs and flywheels within; and the back of the watch bears the engraved Palmer monogram 'SSP'.

Palmer paid 6,000 Swiss Francs (£6/$33; equivalent to £600/$830 today) for this first-of-a-kind watch. More than a century later, with its new-found horological significance, this Patek Philippe sold for $2,251,750.

VENETIAN ATMOSPHERE AND LIGHT

J.M.W. Turner (1775–1851),
*Giudecca, La Donna della
Salute and San Giorgio*, 1841,
oil on canvas, 61 x 91.5 cm
(24 x 36 in)

SALE
6 April 2006, New York

ESTIMATE
Not published

SOLD
$35,856,000/£20,420,000

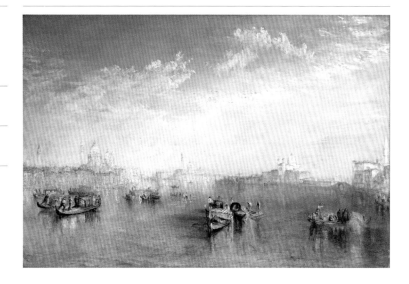

When J.M.W. Turner's panoramic view of Venice, *Giudecca, La Donna della Salute and San Giorgio* came up at auction in 2006, it sold to an anonymous telephone bidder who secured it for $35.8m, setting a new auction record for a British Old Master painting.

Venice, which Turner first visited briefly in 1819, enjoyed special status for British travellers on the Grand Tour. Being a city of unreal beauty, its many canals and marble-clad palazzi formed an atmospheric backdrop for spectacular carnivals and balls. Turner visited the island city on three separate occasions. *Giudecca, La Donna della Salute and San Giorgio* was painted on his return to London from his last visit, in 1840, and exhibited at the Royal Academy of Arts the following year.

The painting is anchored by the gleaming domes of three of the city's most celebrated churches: the Santa Maria della Salute, on the left, beyond which rises the campanile of St Mark's; San Giorgio Maggiore, in the centre, and Le Zitelle on the right. However, it is the watery expanse of the lagoon itself – in which reflections of gondolas, city and sky reverberate – that dominate the composition. Turner's delight in rendering light and atmosphere, and the evident joy he derived from the city's unique combination of light, shimmering stone and water are distilled in this experimental, almost impressionistic, painting.

109

DANCE TO
THE MUSIC OF TIME

Mahmoud Said (1897–1964),
The Whirling Dervishes, 1929,
oil on panel, 97.5 x 70 cm
(38½ x 27½ in)

SALE
26 October 2010, Dubai

ESTIMATE
$300,000–400,000/
£190,000–250,000

SOLD
$2,546,500/£1,605,000

The Sema, or spinning dance, performed by the Sufi mystic Mawlawi (Mevlevi) Order of dervishes is one of the most famous forms of *dhikr* (devotional remembrance of God) in Islam. It gained the order the nickname of the 'whirling dervishes', and is among a number of Islamic rituals immortalized in a striking painting by the Egyptian artist Mahmoud Said.

Although it originated in Turkey, the Mawlawi Order had been in Egypt for four centuries before Said captured the famous ritual on canvas in *The Whirling Dervishes*. He chose to exaggerate the movement of the Sema by taking a high vantage point and narrowing the composition, so that the dervishes fill the panel as they dance in a circle around their sheikh in a traditional Semahane, or ritual hall. At the centre of the image, around the sheikh, a second circle is formed by the dervishes' arms and the folds of their robes, and this is echoed once more by the highlights on the dervishes' tall hats. This is a common trait in Said's work: his paintings did not attempt to create a mimetic representation of a given scene, but simplified the image into a coherent design. The figures are exaggerated – notice the huge hands of the two dervishes in the foreground – as is the dramatic lighting, evident in the extreme highlights on each robe, and especially in the burst of yellow on the left of the sheikh's body.

Said was exposed to new developments in Western painting when he studied for three weeks at the Académie Julian in Paris during the summer of 1921, and subsequently on travels around Europe in the early 1920s. However, his work – from nudes and clothed figures, dancers and musicians, to landscapes and interiors – offers a deeply personal response to the culture of his homeland.

A unique work in terms of subject matter and painterly approach, *The Whirling Dervishes* shows Said at his most dynamic. Its combination of idiosyncratic imagery and bold handling is emblematic of the contribution the artist made to modern Egyptian painting as one of its founding fathers. In 2010, it sold for almost ten times its lower estimate, at more than $2.5m, still the world record for Said's work at auction.

GOING ONCE

FLOWER OF SCOTLAND

Henry Raeburn (1756–1823),
*Portrait of Mrs Robertson
Williamson*, c.1823,
oil on canvas, 239 x 149 cm
(94 x 58½ in)

SALE
19 May 1911, London

ESTIMATE
Not published

SOLD
£23,415/$113,800

EQUIVALENT TODAY
£2,130,000/$3,072,100

'Raeburn's greatest triumph,' wrote his biographer James Greig in
1911, 'was on May 19th of this year when Messrs Duveen paid 22,300
guineas for his splendid *Portrait of Mrs Robertson Williamson*.'
The purchase was a record price for a British painting at Christie's,
following a period of great admiration for the artist's works,
particularly among American and Scottish collectors. Greig
recounted that the broad cheekbones, large, lustrous brown eyes
and parted lips of Mrs Robertson Williamson were the epitome
of Scottish beauty, and that, in the build-up to the sale, it seemed
certain that the painting would top the previous record set for
a Raeburn of 8,700 guineas (£9,135).

The auction was a heated affair, and the two dominant bidders
were so determined to win that Greig, witnessing the event,
was moved to quote Sir Walter Scott's *The Lady of the Lake* (1810):
'Two dogs of black St Hubert's breed,/Unmatched for courage,
breath and speed.'

When the shrewd art dealer Joseph Duveen finally won the day,
it was to loud cheering and applause. Raeburn's status as a great
Scottish artist was assured. Yet not all were happy. Greig wrote
of Raeburn's success that it 'made all forget that it also meant defeat
and loss to Britain of a great picture … there can be little doubt that
the portrait will eventually add to the parade of wealth on the other
side of the Atlantic'.

Duveen was an art dealer with close ties to the great American
industrialists, and had supplied many European masterpieces to furnish
newly built mansions across America. His simple philosophy that
Europe had art and America had money had turned him into a wealthy
man, and contributed towards Americans building some of the finest
art collections in the world. So Greig's fear was well-founded – Duveen
did indeed sell *Mrs Robertson Williamson* to an American collector, and
it is now in the Columbus Museum of Art in Ohio.

THE VICISSITUDES OF FASHION

George Romney (1734–1802),
Portrait of Mrs Davenport,
1782–4, oil on canvas,
76.5 x 64 cm (30 x 25 in)

SALE
28 July 1926, London

ESTIMATE
Not published

SOLD
58,000 guineas/
£60,900/$296,000

EQUIVALENT TODAY
£3,160,000/$4,410,000

This portrait of Mrs Davies Davenport, completed in 1784 by the
English painter George Romney, was commissioned by the sitter's
husband. It depicts a rather serious figure, dressed in fashionable
outdoor clothes, staring in an aloof manner at the viewer. Romney
was a celebrated portrait artist and painted many of London's society
figures, including Lord Nelson's lover Emma Hamilton (see pp.40–1;
as Romney's muse, Hamilton appeared in over sixty of his paintings.)

Romney's popularity, both commercially and critically, grew over
the course of the nineteenth century, and by the early twentieth he was
ranked alongside Joshua Reynolds and Thomas Gainsborough as one
of the great eighteenth-century British artists. When Mrs Davenport's
portrait, which had remained in the family, arrived at Christie's in
1926, the market had finally recovered after the vicissitudes of the
First World War. This is borne out by the fact that the portrait realized
58,000 guineas.

The painting, which was purchased by the British art dealer Joseph
Duveen (see previous page), was to be the most expensive work of art
sold by Christie's between the two world wars. In 1928, the American
industrialist Andrew W. Mellon acquired the painting from Duveen,
and gave it to the National Gallery of Art in Washington, DC, in 1937.

With such commercial success, one might assume that Romney
continued to be greatly admired. Yet even by the time of the sale
in 1926, his stock had fallen markedly with critics, and by the 1930s
prices for his works had begun to slip.

George Romney's favourite
muse was Emma Hamilton,
who became Lord Nelson's
lover (see pp.40–1). This
painting shows Lady Hamilton
as a bacchante, with a crown
of laurel leaves, and dates
to the 1790s.

GRID REFERENCE
FOR GREATNESS

Piet Mondrian (1872–1944),
*Composition with Blue, Red,
Yellow and Black*, 1922,
oil on canvas, 79.5 x 50 cm
(32 x 19½ in)

SALE
23–25 February 2009, Paris

ESTIMATE
€7m–10m/£6.2m–8.9m/
$8.9m–12.8m

SOLD
€21,569,000/£19,193,595/
$27,588,900

The Dutch pioneer of abstract art Piet Mondrian dreamed of establishing a 'universal pictorial language' that applied not just to painting but also to design and architecture. He created an entirely new art, known as Neo-Plasticism, based on the use of primary colours, black and white, straight lines, squares and rectangles. Painted in 1922, *Composition with Blue, Red, Yellow and Black* is an early example of Neo-Plasticism and demonstrates the powerful dynamic possibilities of Mondrian's doctrine.

The painting was owned by Yves Saint Laurent and his partner Pierre Bergé, who amassed a dazzling collection of fine and decorative art over the course of fifty years. They possessed a rare ability to find works from wildly different places, times and cultures that, when grouped together, 'spoke' to one another. The couple bought instinctively and unerringly, but at the start had limited funds. In 1977, following the launch of Yves Saint Laurent's perfume Opium, which became the world's best-selling scent, their purchasing power was dramatically increased and their collection grew to include major works by Pablo Picasso, Constantin Brancusi, Alberto Giacometti, Henri Matisse, Paul Klee

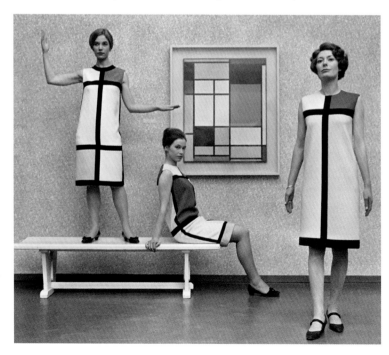

Yves Saint Laurent dresses
inspired by Mondrian's
paintings, modelled at
The Hague Municipal
Museum in January 1966.

and Fernand Léger, as well as Renaissance bronzes, Old Master paintings
and drawings, European silver, African sculpture and art deco furniture
by Jean Dunand and Eileen Gray.

Saint Laurent regularly paid homage to art in his haute couture,
but in the case of Mondrian, whose paintings famously inspired the
designer's collection of 1965, the stimulus came from a reproduction
in a book rather than from a work that he owned. It was not until
1972 that Saint Laurent and Bergé bought their first Mondrian,
although Saint Laurent's iconic, shift-like Mondrian cocktail dresses
bear a resemblance to *Composition with Blue, Red, Yellow and Black*.
They went on to own four more, each of them from key periods
in the artist's career.

When the Yves Saint Laurent–Pierre Bergé Collection was sold
in the historic Grand Palais in Paris in 2009, it was hailed as the 'sale
of the century'. The auction, consisting of 733 lots, was conducted
in six sessions over three days. The sale took place against the backdrop
of the financial crisis, yet it realized €374m (£331m/$476m) – €100m
more than its estimate and a record for a private collection. *Composition
with Blue, Red, Yellow and Black* fetched €21.5m, a record for Mondrian.
It was sold to the Louvre Abu Dhabi, and became the first work in
its collection.

FASHION FADES
BUT STYLE IS ETERNAL

Eileen Gray (1878–1976),
Fauteuil aux Dragons, 1917–19,
lacquered wood and leather,
61 x 91 x 67 cm
(24 x 36 x 27 in)

SALE
23–25 February 2009, Paris

ESTIMATE
€2m–3m/£1.8m–2.6m/
$2.6m–3.8m

SOLD
€21,905,000/£19,492,595/
$28,018,675

Eileen Gray was born into a wealthy family near Enniscorthy, Ireland.
She went to the Slade School of Art in London, before moving in 1902
to Paris, where she enjoyed a free-spirited, bohemian lifestyle. It was
in the French capital that she met Seizo Sugawara, a Japanese lacquer
master, who became her collaborator in the workshop she established,
producing lacquered furniture, screens and decorative panels. In 1922,
she opened a gallery, Jean Désert, on the rue du Faubourg Saint-Honoré,
to sell her creations.

Shy and private, but with a very determined personality, Gray
single-mindedly pursued her own aesthetic path. Her designs
were individualistic and did not conform to the prevalent fashions.
Fortunately she had independent means and was able to pursue her
own ideas free from commercial pressures. While her sales were patchy
and the gallery relatively short-lived, she nonetheless found a few
sophisticated clients who appreciated the inventiveness and quality

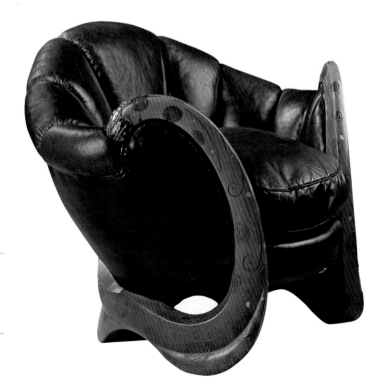

Opposite page, top:
Yves Saint Laurent seated
in his Eileen Gray *Fauteuil
aux Dragons* in his Paris
apartment in 1978.

Opposite page, bottom:
Eileen Gray photographed
by Berenice Abbott in 1926.

of her work. Today her designs, such as the Bibendum chair and the E1027 side table, are considered modernist classics. Gray also became an architect and created her own modernist house near Menton, on the French Riviera.

In 2009, Gray's *Fauteuil aux Dragons* fetched nearly €22m at auction in Paris – more than seven times the high estimate. The diminutive carved and lacquered armchair, its frame formed by intertwined dragons, was created between 1917 and 1919 and is as much a sculpture as a piece of furniture. It was originally bought by Suzanne Talbot, a prominent hat designer and Gray's patron, for whom she decorated an entire apartment. The chair was later bought by the fashion designer Yves Saint Laurent in 1973.

After Yves Saint Laurent's death in 2008, his collection was sold the following year. 'The sale was a homage … to the pioneering vision of Yves Saint Laurent and Pierre Bergé as collectors,' recalls Philippe Garner, deputy chairman at Christie's and a specialist in twentieth-century decorative art and design. 'They were the great tastemakers of their age.' Although it was staged in challenging financial times, the sale broke many records, with highlights including Henri Matisse's *Les Coucous, tapis bleu et rose* (1911; €36m/£31.5m/$45.9m), Constantin Brancusi's *Madame L.R.* (1914–17; €29m/£25.4m/$37m) and Mondrian's *Composition with Blue, Red, Yellow and Black* (1922; €21.6m/£19.2m/$27.6, see previous page).

FASHION FOR
THE MODERN WOMAN

Gabrielle 'Coco' Chanel
(1883–1971), beige tweed
suit bound with braid and
bright pink silk, c.1962,
UK size 6

SALE
2 December 1978, London

ESTIMATE
Not published

SOLD
£2,400/$4,600

EQUIVALENT TODAY
£12,300/$17,500

In December 1978, aristocrats, celebrities, fashion designers and fans
thronged to a champagne reception at Christie's King Street saleroom.
Such was the interest in the pre-sale view of lots from the wardrobe
of the fashion designer Coco Chanel that Christie's staff resorted
to using ropes to create a 'runway' for the models.

Coco Chanel (1883–1971) was a fashion icon. A glamorous, self-
made businesswoman who transformed women's fashion, she managed
to fuse ease with elegance in her clothes. Corsets and formal, structured
pieces were discarded in favour of pleated skirts, sweater dresses,
fitted suits and costume jewellery to create an adaptable day-to-night
wardrobe for the modern woman. In the words of Christian Dior,
'With a black sweater and ten rows of pearls Chanel revolutionized
fashion.' Her simple 'little black dress' was an instant classic, while
her iconic scent, Chanel No. 5, which she launched in the 1920s, was
described as 'the unseen, unforgettable, ultimate accessory of fashion.'

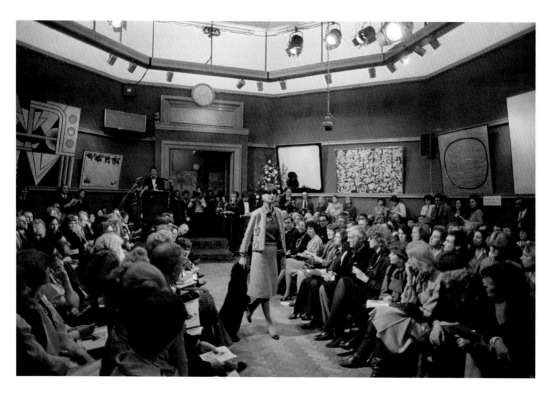

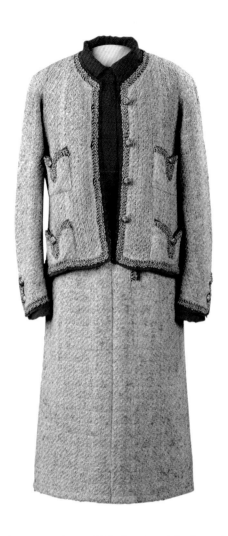

The collection at auction, which dated mainly from the 1960s and consisted of forty pieces from Chanel's own wardrobe (twenty-four suits, five dresses and jackets, seven dresses and four coats), forty-three pieces of costume jewellery and thirty-six other accessories, had been assembled by her close colleague Lilian Grumbach. Before the auction, however, there was speculation that few would be interested in out-of-date, second-hand clothing sold by a company better known for art and antiques. Yet fashionistas flocked to the saleroom, and the auction realized a total of £44,099 ($84,700), equivalent to £226,000 today ($321,500).

The star of the show was Lot 45, a beige tweed two-piece skirt suit bound with braid and bright pink silk, bought for £2,400 by the Oslo Museum. The Victoria and Albert Museum purchased its own piece of fashion history when it bought a black sleeveless dress with coat worn by Chanel at a Luchino Visconti film premiere for £1,200 ($1,720). The famous 'little black dress' was sold for £1,500 ($2,900) to Baroness David de Rothschild.

Left: Coco Chanel's beige tweed suit modelled in the saleroom at Christie's King Street on 2 December 1978.

Above: Coco Chanel in 1938.

THE PEOPLE'S PRINCESS

Victor Edelstein (b. 1945),
a long formal dinner dress,
ink-blue silk velvet

SALE
25 June 1997, New York

ESTIMATE
Not published

SOLD
$222,500/£133,725

EQUIVALENT TODAY
$315,400/£217,000

In 1997, Princess Diana followed the advice of her teenage son Prince William and decided to auction a selection of her dresses for the Aids Crisis Trust, the Royal Marsden Hospital Cancer Fund and other cancer charities. She had been a global celebrity ever since her marriage to Prince Charles in July 1981, and so her decision to hold the auction generated a huge wave of public interest, to such an extent that even the sale catalogue became a collector's item.

The sale took place on 25 June in New York, a decision that played well with her committed American fans and followers. The princess attended previews to promote the sales and wrote notes on each

of the seventy-nine dresses, which she divided into her 'fairy period' and her 'Hollywood period', but she followed the sale from her home, Kensington Palace in London.

The cocktail and evening dresses reflected Diana's trajectory, and recalled the countless glamorous events she attended. A baby-blue-and-pink-ribboned chiffon dress, which she wore in her early twenties, epitomized the early years of her marriage, when her personal style was still girlish and innocent. Her first sophisticated 'column' dress, a one-shoulder design of draped cream silk chiffon by the Japanese designer Hachi, which she wore to a dinner at the National Gallery in Washington, DC, in 1985, sold for $75,100 (£45,100; equivalent to $106,500/£73,300 today). The undoubted star of the show was an off-the-shoulder ink-blue velvet dinner dress, designed by Victor Edelstein and worn by the princess when she danced at the White House with John Travolta. It sold for $222,500, breaking the record for a garment sold at auction.

The sale was one of the great social events of the year and was attended by over 1,100 people, a mix of celebrities, Manhattan socialites, couture collectors and ordinary fans, many of them first-time bidders who just wanted to own a piece of royal stardust. The story behind the dress collection, of a fairy-tale marriage that did not last and a princess who grew in confidence and glamour to become one of the most recognizable faces on the planet, accounted for much of the allure of the pieces being offered. Sadly, two months after the sale, Diana died in a car crash in Paris, on 30 August.

Left: Princess Diana in Hong Kong in 1989 wearing a strapless white silk dress and bolero with silk beading by British designer Catherine Walker. This ensemble was also in the 1997 sale.

Above: Princess Diana dances with John Travolta at the White House in November 1985, wearing the ink-blue silk velvet dress by Victor Edelstein.

Captain Scott's Union Flag,
c.1910, silk, 176 x 365 cm
(69 x 143 in)

SALE
17 September 1999, London

ESTIMATE
£10,000–20,000/
$16,200–32,500

SOLD
£25,300/$41,060

EQUIVALENT TODAY
£39,200/$56,500

When Captain Robert Falcon Scott (1868–1912) travelled to Antarctica
on the *Terra Nova* in 1910 he took with him not one but three
Union Flags: one was left flying at the South Pole, one now hangs
in the ballroom at Sandringham House, and one was sold by Scott's
descendants in 1999 for £25,300.

At the time of the sale, the provenance of the flag was not fully
known. However the polar historian David Yelverton subsequently
revealed that it had been the gift of Arctic explorer Admiral Sir George
Nares to Captain Scott on the day *Discovery* sailed from London
on the first of Scott's Antarctic explorations, in 1901. Nares wrote:
'Hearty wishes for a successful voyage and a safe return Home.'
On that occasion, his wishes came true.

When Scott returned to the Antarctic for the second time, in 1910,
this time aboard the *Terra Nova*, he took the flag with him once more.
One of the most poignant records of its presence on that expedition
is a photograph taken by Herbert Ponting in 1911, in the expedition hut
at Cape Evans. In the depths of the dark Antarctic winter, the expedition
team have gathered for a celebratory dinner for Scott's birthday.
The flag appears as a makeshift tablecloth, a reminder of their home,
their country and their duty. The following year Scott and four of his
companions would die returning from the South Pole.

Captain Scott (at the head
of the table) celebrating his
43rd birthday in Antarctica
on 6 June 1911, during the
Terra Nova Expedition. The
silk Union Flag doubled as
a table runner for the party.

After Scott's death, the flag remained in his family, passing from his widow Kathleen to his son Sir Peter Markham Scott, one of the founders of the World Wide Fund for Nature and founder of the Wildfowl and Wetlands Trust. It then passed to his widow Lady Scott, before it was put up for auction. It sold for well above its high estimate, testament to our enduring fascination with polar exploration, with memento mori and with the man many consider to be the greatest British explorer of all.

117 CROWD CONTROL

L.S. Lowry (1887–1976),
Piccadilly Circus, London,
1960, oil on canvas,
76 x 101.5 cm (30 x 40 in)

SALE
16 November 2011, London

ESTIMATE
£4m–6m/$6.3m–9.5m

SOLD
£5,641,250/$8,893,660

L.S. Lowry is usually thought of exclusively as the painter of industrial and sometimes slightly grey scenes from the north of England, as if he never went anywhere else. So it may come as a surprise to find him painting not merely pictures of London, but ostensibly cheerful scenes of life in the English capital, full of colour and light. He produced two versions of Piccadilly Circus at rush hour, showing it as it was before the Shaftesbury Memorial Fountain with its figure of Eros was moved southwards from its central location in the 1980s.

Piccadilly Circus is the larger and busier picture, and was painted from a higher vantage point. Alongside his collection of gramophone records, live theatre was Lowry's favourite form of entertainment, and the actor Ian McKellen has remarked that perhaps this explains

why 'often Lowry's mid-air viewpoint is like a view from the dress circle, looking down on the scene below.' The drama enacted here is full of incident and humour as figures scurry across the road and through gridlocked traffic with sticks, prams, umbrellas, dogs and other encumbrances. As McKellen says, 'Until Lowry painted his crowds, no other artist had recorded how people (and animals) look and behave en masse.' The illuminated advertisements for which Piccadilly Circus is so famous play a muted second fiddle to the colour and sparkle of the pedestrians and the parade of buses, taxis and vans.

For many years, Lowry's *Piccadilly Circus* was owned by the hotel magnate Lord Forte (1908–2007), who had opened his first 'milk bar' on nearby Regent Street in 1935. He later went on to own the Criterion building and the sporting-goods shop Lillywhites, both of which are just out of sight to the right of the picture, where Eros is now. After Lord Forte's death, his collection of works by Lowry was sold at Christie's in 2011. The highlight of the sale was this painting, which made £5,641,250 – still the record auction price for Lowry, tied with his *The Football Match* (1949), which Christie's had sold earlier that year for exactly the same amount.

L.S. Lowry surrounded by his paintings in his studio, 1964.

ALL ABOARD FOR LONDON

RML Leyland AEC (Associated Equipment Company; 1912–79), London Routemaster bus, 1966, right-hand drive bus (seating 72) with 8.27-litre Cummins C series engine, 914 x 244 x 438 cm (360 x 96 x 172 in)

SALE
3 September 2012, London

ESTIMATE
£20,000–30,000/
$31,800–47,700

SOLD
£67,250/$106,900

Preparing a sale can be similar to curating an exhibition. Choosing objects according to a guiding principle is much like marshalling them under a theme so as to exert the maximum gravitational pull on potential buyers. 'The London Sale' – held at Christie's South Kensington in the same year as the London Olympics and the Queen's Diamond Jubilee – was one such auction. The lots were exhibited throughout the summer, and the public was invited to drop into the saleroom and take a look.

One of the star attractions was a 1960s Routemaster bus. For overseas visitors, London's red double-deckers are iconic. For Londoners, the bus is loved for the libertarian open platform at the back that allows passengers to hop on and off where they please. This particular bus sold for £67,250, and is now parked in a South Korean shopping mall.

An original colour
lithograph poster from 1939,
published by the Ministry
of Information.

Other lots that threw light on diverse aspects of British life included the photographer Terry O'Neill's portraits of the Rolling Stones and the Beatles, young men snapped at a time when they were the epitome of cool; a limited-edition lithograph of Simon Patterson's *The Great Bear* (1992), the Tube map repurposed as a topographic guide to the human imagination, and an original poster from 1939 exhorting London citizens to 'Keep Calm and Carry On' (advice that was never actually dispensed in wartime, since the poster was to be pasted on to walls only in the event of a Nazi invasion). There were also Coronation chairs upholstered in blue velvet, a full-size aluminium replica of the Piccadilly statue of Eros, cast in 1987, and a painted plaster maquette of *Guy the Gorilla* (1982) by William Timym (for thirty years, Guy had been a star resident of London Zoo). The 167 lots amounted to a collage of life in the English capital, a portrait in mixed media of arguably the most vibrant and complex metropolis in the world.

119 CONSTABLE COUNTRY

John Constable (1776–1837),
The Lock, exhibited 1824,
oil on canvas, 142 x 120.5 cm
(56 x 47½ in)

SALE
3 July 2012, London

ESTIMATE
£20m–25m/$31.4m–39.3m

SOLD
£22,441,250/$35,240,655

It was the summer of 2012, and in east London athletes from around the globe were busy breaking records at the Olympic Games. They were not the only ones. Across town, at Christie's King Street, the art world was busy breaking records of its own.

At an evening auction of Old Master and British paintings, one of the biggest draws of the night was *The Lock*, an oil painting by John Constable. It was the fifth in a series of six large landscapes of the Stour Valley that Constable had exhibited at the Royal Academy of Arts in London in successive years from 1819 until 1825 (excluding 1823, when illness prevented him from producing such an ambitious work). In 1824 a critic in the *Morning Post* wrote: 'Mr Constable contributes a landscape composition which for depth, sparkling light, freshness and vigorous effect, exceeds any of his works.'

Constable worked tirelessly to improve the reputation of landscape painting at the Academy, and the scale of his own works ensured that they stood out in the crowded rooms. After the opening in 1824, Constable wrote to his friend and supporter John Fisher, Bishop of Salisbury: 'My picture is liked at the Academy. Indeed it forms a decided feature and its light cannot be put out, because it is the light of nature – the Mother of all that is valuable in poetry, painting, or anything else – where an appeal to the soul is required.' He did,

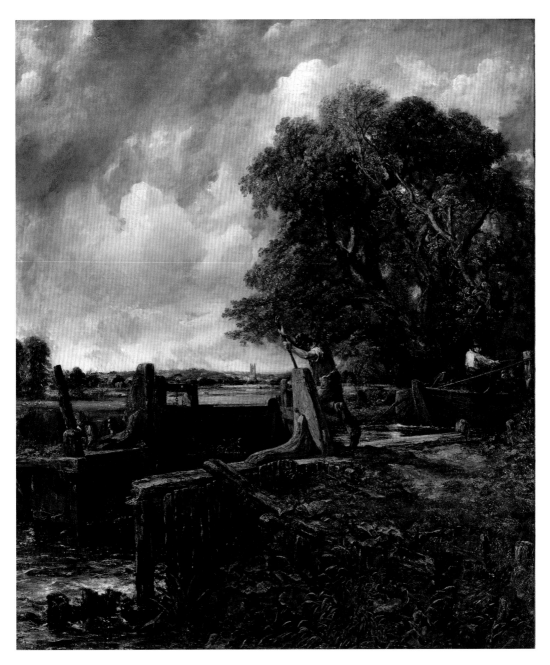

however, concede that other artists were not always enamoured by his execution: 'Perhaps the sacrifices I make for lightness and brightness is too much, but these things are the essence of landscape.'

The Lock was a rare example of a Stour Valley painting to remain in private hands, and when it was offered for sale at Christie's, it fetched more than £22.4m, a world-record auction price for the artist. It was the start of what was to be a record-breaking evening, with the sales of Old Master and British paintings realizing £85m ($133.5m), the highest ever total for the category at auction.

LOCKER-ROOM BRAVADO

Norman Rockwell
(1894–1978), *The Rookie
(Red Sox Locker Room)*, 1957,
oil on canvas, 104 x 99 cm
(41 x 39 in)

SALE
22 May 2014, New York

ESTIMATE
$20m–30m/£11.9m–17.8m

SOLD
$22,565,000/£13,387,815

The great American illustrator Norman Rockwell was a master
storyteller, and, as the filmmaker Steven Spielberg has remarked,
he 'painted the American dream better than anyone'. Rockwell's vision
of America – the America he knew and observed but which he thought
others might not have noticed – appeared on the covers of the *Saturday
Evening Post* over the course of forty-seven years (1916–63).

 The Rookie (Red Sox Locker Room) was painted for the 2 March
1957 edition and, unlike most of his covers, which depict fictionalized
characters, nearly all the models here are well-known baseball players.
The exception is the newly arrived rookie. The impetus for the picture
may have been a rumour that Ted Williams, the star of America's
beloved Boston Red Sox baseball team, was about to retire. Williams
features in the painting, standing at its centre, but the real subject is
the naïve and eager rookie in the pork-pie hat and outgrown jacket,
who effectively upstages the man considered to be the greatest
hitter who ever lived. Rockwell, who was himself unassuming
and self-effacing, instinctively sided with the underdog, and here
it is clear that his sympathy lies with the gawky new boy.

 Rockwell's lengthy and painstaking creative 'system' involved
casting models, finding costumes and props, arranging poses and hiring
photographers to document his tableaux. In the case of *The Rookie*
he used members of the Red Sox team as models, but had to rely on

Two of the men who posed
for Norman Rockwell's *The
Rookie* in 1957 were reunited
with the painting in 2014:
Sherman Safford (left) is the
rookie holding the suitcase;
Frank Sullivan (right) is the
player with number eight on
his shirt.

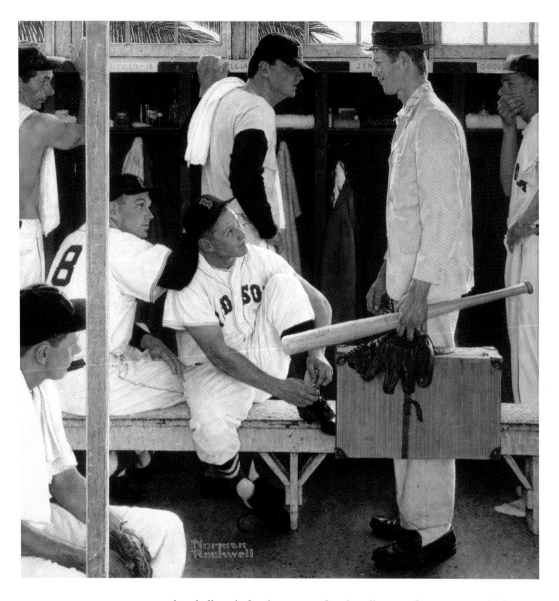

baseball cards for the image of Ted Williams, who was unavailable
to pose. Rockwell also took the trouble of travelling to Florida to
photograph the Red Sox's locker rooms at their spring training
facility, recording everything in great detail – although he edited
out the rubbish and cigarette butts. This almost cinematic process
was bookended by preliminary drawings and subsequent detailed
sketches, before the finished painting was delivered. The published
cover images then found their way into millions of American
homes, enriching lives for a matter of pennies. The original painting
had a quite different fate: when *The Rookie* sold at auction in 2014,
it went to a private buyer for over $22.5m.

121 ANCESTRAL HERO

Biwat ceremonial roof figure,
c.1600–1890, wood, 106 cm
(42 in) high

SALE
19 June 2013, Paris

ESTIMATE
€750,000–1,000,000/
£643,000–856,000/
$1,000,000–1,340,000

SOLD
€2,505,500/£2,145,170/
$3,358,130

This carving, a 1-metre-tall (3-feet) ceremonial roof figure produced by the Biwat people of Papua New Guinea's east Sepik region some time between 1600 and 1890, once decorated the exclusive Savage Club in Melbourne, Australia (est. 1894).

The private members' club, which was named after the eighteenth-century poet Richard Savage, acquired the ceremonial figure in the 1930s before selling it forty-seven years later to raise funds for renovations. The sculpture was then acquired by the American collectors John and Marcia Friede for their 'Jolika' collection of New Guinea artefacts (the collection was named after their three children, John, Lisa and Karen). In 2005, the Friedes donated the 400 works in their pre-eminent collection to the San Francisco Museum of Fine Arts.

When this sculpture eventually came to auction at Christie's, it was described as a once-in-a-generation event. Although the Biwat were known for their fine workmanship, such sculptures had become very rare owing to the tiny population (the Biwat population currently stands at about 4,000), the loss of objects and the fact that most similar works had been bought by institutions. Only a dozen related works of art were still known to experts, with fewer still – in fact only three – of this quality, and they all form part of museum collections. It smashed the world record for a piece of Oceanic art, selling in Paris for over €2.5m.

Most Biwat rituals were never observed by foreigners and many were abandoned by the 1930s, when the region was first explored by outsiders. The figure, with its bulging eyes, glowering mouth and diadem, probably represented an ancestral hero named Bilishoi. The position of the head suggests that the sculpture was probably designed to be seen from below.

RITE OF PASSAGE

A Celtiberian gold warrior
fibula known as the
Braganza Brooch,
c.250–150 BC, gold with
traces of blue enamel,
14 cm (5½ in) long

SALE
25 April 2001, London

ESTIMATE
Not published

SOLD
£1,103,750/$1,588,300

A unique gold fibula dating from the third or second century BC fetched a record price for ancient jewellery when it sold for over £1.1m in April 2001. Belonging to the Chicago collector Thomas Flannery, Jr., and on loan to the British Museum since 1993, it was the first million-pound lot to be sold at Christie's South Kensington.

Known as the Braganza Brooch, it takes its name from the Portuguese royal Braganza dynasty, which owned the piece in the nineteenth century. It was acquired in 2001 by the British Museum for its Iron Age collection, with help from the Art Fund and the Heritage Lottery Fund.

The gold brooch, which was made in Spain, is an important relic of Europe's Iron Age past. The long-footed fibula is finely worked in gold; on the top rests a warrior, nude but for his helmet and a scabbard fixed to his waist, who uses his oval shield to defend himself from a monster. The weaponry is characteristic of the third and second century BC, and constitutes Iberian variations of Roman and Celtic types. Each end of the twisted wire foot of the brooch terminates in a dog's head. The figures are delineated in great detail, and they bear traces of blue enamel, which would have been used for the eyes of the warrior and the animals, as does the arching bow behind the warrior.

The fibula would have secured folds of cloth to the wearer's right shoulder, and would have been fixed with a coiled spring and pin (now missing). This exquisitely worked piece must have belonged to an elite warrior. Some experts believe the brooch may have been presented to mark the rite of passage from youth to manhood, based on the symbolism of the clean-shaven youth confronting a monster.

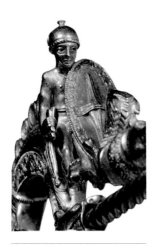

Detail of the warrior
bravely facing the monster
with his shield.

COMIC EFFECT

Albert Uderzo (b. 1927),
Astérix: Le Devin
(*Asterix and the Soothsayer*),
1972, ink on paper,
40 x 46 cm (16 x 18 in)

SALE
5 April 2014, Paris

ESTIMATE
€150,000–170,000/
£124,000–140,500/
$205,500–235,000

SOLD
€193,500/£159,935/$265,140

Bandes dessinées, literally 'drawn strips', or comic strips, have enjoyed a long history in France and Belgium, with much-loved characters such as Tintin, Lucky Luke, the Smurfs and Asterix achieving global fame. Yet, as with American comic art, the auction market for *bandes dessinées* took off only around the turn of the millennium.

It was not until 2014 that Christie's Paris held an auction dedicated to graphic plates and illustrations, featuring contemporary works and classics such as *Tintin* by Hergé (Georges Prosper Remi; 1907–1983) and *Asterix the Gaul* by illustrator Albert Uderzo and writer René Goscinny (1926–1977), who first devised the *Astérix* series in 1959. This is Uderzo's original drawing for the cover of the nineteenth book to be published, *Astérix: Le Devin*, or *Asterix and the Soothsayer* (1972). In the middle of the composition the looming shadow of the supposed fortune-teller terrifying the Gallic warrior's

Albert Uderzo and René
Goscinny with a group
of children at the Childhood
Publishing Prize in Paris,
16 November 1962.

222 uy

1 Jepon - 3 blens de mire en couleur

fellow countrymen is missing; this was added later, along with the colouring. Uderzo retouched this illustration with white gouache and signed it.

Before the auction in 2014, some 900 collectors and connoisseurs viewed the selection of pages and original covers, and many also attended the sale itself. Of the lots on show, seventy-three per cent sold, including online during a record participation on Christie's LIVE™, which accounted for most of the sixty new clients. Altogether, the sale realized €3,889,500 (£2,575,000/$4,670,000) and set twelve artist records. Auctions of comic books and illustrations are now a regular occurrence at Christie's Paris.

B WAS A BAT

Edward Lear (1812–1888),
Nonsense Alphabet, 1857,
autograph manuscript, pen
and ink drawing mounted on
linen with a blue silk border,
folio 26 leaves, 33.5 x 20 cm
(13 x 8 in)

SALE
9 December 1965, London

ESTIMATE
Not published

SOLD
£900/$2,500

EQUIVALENT TODAY
£15,500/$22,500

The much-loved writer and artist Edward Lear disturbed the decorum
of Victorian life and language with his nonsense poetry and rhymes.
The creator of such enduring verse as *The Owl and the Pussycat* (1871),
he first began entertaining children with his funny humorous
poems while staying at Knowsley Hall in Merseyside, the home
of Lord Stanley.

The stifling atmosphere of aristocratic milieux drove the excitable
Lear to distraction, and he wrote in his diary: 'The uniform apathetic
tone assumed by lofty society irks me dreadfully … [there is] nothing
I long for half so much as to giggle heartily and hop on one leg down
the great gallery – but dare not.' Instead he mocked the stuffed shirts
of the upper classes in his poetry and prose, producing a gallery of
characters who stabbed themselves with forks, tore out their hair and
died of despair.

In 1965 an unpublished Lear manuscript came up for sale at
auction. The document was an early version of the artist's *Nonsense
Alphabet*, created for the children of Lear's great friend, the magistrate
Vandeleur B. Crake (1816–1894). It had been carefully bound by the
children's aunt, Mary Ann Crake, a woman Lear described as 'rather silly
rather good' in his diaries. The manuscript was purchased by the Yale
Center for British Art for £900, a reflection of the esteem in which this
deeply troubled yet glorious comic genius was still held.

Edward Lear's satirical
self-portrait from 1864.

A

A were some Ants,
Who never sate still
But made a nice house
On the side of a hill.
A.
Industrious Ants!

B

B. was a Bat
Who slept all the day
And flew all about
When the sun went away.
B!
Beautiful Bat!

125

COMMUNION WITH NATURE

Edwin Henry Landseer
(1802–1873), *Monarch of the
Glen*, 1851, oil on canvas,
162.5 x 167.5 cm (64 x 66 in)

SALE
7 May 1892, London

ESTIMATE
Not published

SOLD
6,900 guineas/
£7,245/$35,285

EQUIVALENT TODAY
£704,000/$1,015,600

Edwin Henry Landseer was the most popular artist of his generation, who achieved global fame through engraved reproductions of his work. Few nineteenth-century pictures became better known than *Monarch of the Glen*, which was exhibited at the Royal Academy of Arts in London in 1851. Landseer elevates animal painting to High Art, imbuing the royal stag with nobility, command of his environment and a sense of destiny. Exhibited concurrently with the Great Exhibition, where Britain displayed its manufacturing prowess to the world, the picture subliminally reflected the confidence of a nation on the cusp of Empire.

Inspired by the Waverley novels of Sir Walter Scott, Landseer spent much of his time in Scotland, hunting and shooting as often as wielding a paintbrush. Witty and urbane, he was a popular guest of both his ducal patrons and the royal family. Since he had spent several months each year on the hills in all weathers, Landseer's vision was carefully considered, and reflective of the exhilaration and sense of communion with nature he found there. His public appreciated such honesty and keen observation.

The picture was intended to hang in the refreshment room of the House of Lords, but when plans for that scheme of decoration altered, it was sold to the first Lord Londesborough. After three appearances at Christie's, in 1884, 1892 and 1916, it entered the collection of Thomas Dewar. In common with other Edwardian manufacturers such as Lord Leverhulme, Dewar used his pictures to promote his eponymous brand – in this case, whisky. The painting hence became even more widely known through the medium of advertising. The picture is currently owned by Diageo, who have placed it on loan to the National Museum of Scotland.

THE LION
THAT ROARED

Islamic bronze lion,
c.11th–12th century AD,
bronze, 73 cm (29 in) high,
81 cm (32 in) long

SALE
19 October 1993, London

ESTIMATE
Not published

SOLD
£2,400,000/$3,600,000

EQUIVALENT TODAY
£4,370,000/$6,200,000

The story of how a bronze lion became the most expensive work of Islamic art to be sold at auction had inauspicious beginnings. In 1992, Christie's expert William Robinson was sent a poor photocopy of a photograph in which the only thing that was clear was the huge size of the animal illustrated in profile. 'I had to answer a single question,' he remembers: 'Might it be worth £30,000?' He thought it just might.

The object he had seen turned out to be a rare bronze lion dating from the eleventh or twelfth century, and which Robinson believed to be from the Western Islamic world, probably Andalusia. How it migrated from Moorish Spain into the hands of an anonymous noble European family – who were now keen to sell – was a mystery, but there were several significant clues as to its original owner. The lion had the same proportions and very similar engravings as the most important known Islamic medieval work of sculpture, a griffin owned by the Museo dell'Opera del Duomo in Pisa. The griffin, which for 500 years graced the eastern gable of Pisa Cathedral, was only removed recently and is now in the cathedral's museum.

There has been much speculation as to what the animals were used for; their ferocity and size were clearly designed to intimidate. They were originally thought to be fountainheads, along the lines of the stone lions in the Alhambra Palace in Granada, but the mouth of the griffin in particular would not serve well as a spout. A careful examination of the lion's interior showed that it had a peculiar vase-shaped element cast in bronze in its interior rump. Subsequent examination of the Pisa griffin showed a similar element, which had not been commented on before. These would be consistent with some form of sounding device, making the animals appear to roar.

The similarity to the stone lions at the Alhambra indicated a Spanish origin. The bronze lion and griffin were thus thought to be part of a group of animals made for the Moorish ruler Abd al-Rahman III (889–961), who built the palace-city of Medina Azahara near Córdoba in 936–40. The palace was destroyed fifty years later, and with it disappeared Abd al-Rahman's bronze menagerie. However, the chronicles of the tenth-century scholar Issa b. al-Rafi survived and describe the fearsome leader seated between animals that roared. At auction this lion tripled the existing world record for any Islamic work of art, achieving £2.4m.

A tenth-century griffin that once adorned Pisa Cathedral shares similar markings with the Islamic bronze lion.

GOING ONCE

THE WALLS OF IRAN

Parviz Tanavoli (b. 1937),
The Wall (Oh, Persepolis),
1975, bronze, 181 x 102 x 23 cm
(71 x 40 x 9 in)

SALE
30 April 2008, Dubai

ESTIMATE
$400,000–600,000/
£203,000–305,000

SOLD
$2,841,000/£1,443,795

Left: Parviz Tanavoli
standing next to *The Wall
(Oh, Persepolis)* in his studio
in Tehran, Iran, in 2010.

Above: Bas-relief on the
walls of the Apadana
Palace, Persepolis, Iran,
founded c.518 BC.

Parviz Tanavoli links Iranian tradition with modern Western art.
He studied in Tehran during the 1950s, when Iranian cultural policy
was opening up to the West while also maintaining ties to Iranian
and Persian history. Tanavoli later studied sculpture in Milan, Italy,
and taught art in Minneapolis, Minnesota, in the 1960s before
returning to his homeland.

Being in America at that moment, Tanavoli was inevitably
exposed to Pop art, and some of his works from that period are clearly
influenced by the exuberant colours and everyday objects of that style.
The Poet and the Beloved of the King (1964–6) is perhaps the best
known of these works, and offers a peculiarly Iranian take on Pop,
drawing on the language of the bazaar, an endlessly mineable source
for Tanavoli. The sculpture was acquired by Tate in London in 2012
and appeared in Tate Modern's exhibition *The World Goes Pop* in 2015.

The Wall (Oh, Persepolis) appears to relate to a different Western
art movement, Minimalism, but it is even more profoundly indebted
to the traditions of the artist's native Iran. Tanavoli founded the
Saqqakhaneh school in Tehran in the 1960s with the express intention
of reappropriating traditional forms and adapting the visual signs
he saw around him in Iran, often drawing on the Persian poetic
tradition. 'I didn't want to follow Westerners, [I] wanted to be more
Persian, so I used all the tools around me: locks, grills,' he said recently.
'Gradually I created my own anatomy; anatomy for an artist of an
Islamic background.'

Tanavoli's ongoing series 'The Walls of Iran' is perhaps the purest
expression of this aim. 'I arrived at the idea that Iran was a wall from
beginning to end,' Tanavoli says. 'Every time an Iranian builds a house
or garden, he surrounds it with a wall; every rug carries a wall-like
border around its periphery. What mystery lay concealed behind these
borders and walls I did not know.' Based on Egyptian and Sumerian
reliefs, it features a grid of symbols that look at first like text, evoking
the florid use of calligraphy in Islamic art. But these pictogram-like
inscriptions do not cohere into a particular script; rather, they form
a new 'universal' poetic language.

The sculpture was auctioned at Christie's fourth sale in Dubai
(the first was in 2006). *The Wall (Oh, Persepolis)* sold for over $2.8m,
a world-record price for any Middle Eastern work of art.

THE WARP AND WEFT
OF PARADISE

Unknown maker from Herat, Iran, The Emperor's Carpet, mid-16th century, silk (warp and weft) and wool (pile, asymmetrically knotted), 751 x 330 cm (296 x 130 in)

SALE
5 July 1928, London

ESTIMATE
Not published

SOLD
22,000 guineas/
£23,100/$112,500

EQUIVALENT TODAY
£1,240,000/$1,768,000

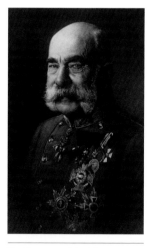

The Emperor of Austria, Franz Joseph (r.1848–1916), one of a long line of Habsburg emperors to have owned the carpet.

The Emperor's Carpet, which is thought to have been woven in the Iranian city of Herat in the mid-sixteenth century, is considered to be one of the finest Persian carpets in the world. It is now in the Metropolitan Museum of Art, although its journey to New York was a long one, taking the carpet from Persia during the time of the Safavid Empire (1501–1722) to Tsarist Russia, Habsburg Austria and on to 1920s London.

The carpet has a purple-red ground decorated by an exquisite and elaborate floral pattern, scrolls and arabesques, and naturalistic animals, including stags, lions, pheasant-like birds and dragons. The exterior borders contain a scrolled vine pattern and various animal heads. The overall effect of the design is to conjure a garden in spring, alluding to the divine Garden of Paradise. These design features can be seen in other works produced during the Safavid Empire, and experts now believe that a centralized workshop was responsible for creating a certain style of imagery. This style was then applied to a profusion of different forms including books, manuscripts, paintings, textiles and carpets.

According to tradition, the carpet was owned by the Russian Tsar Peter the Great. He presented a pair of Safavid-era carpets to Emperor Leopold I of Austria in 1698, and thus the carpet takes its name from the Habsburg emperors. It hung on the wall of the Schönbrunn Palace, the royal summer residence in Vienna, for over 200 years, until the end of the First World War. According to *The Glasgow Herald*, the Austrian government then sold the carpet to London dealers Cardinal and Harford to help fund the restoration and upkeep of the National Art Museum. Victor Behar acquired Cardinal and Harford and therefore the Emperor's Carpet. Behar was from Istanbul and had established a successful business as a carpet manufacturer and importer in Scotland. He owned the carpet between 1925 and 1928, and took it to America, where it was exhibited at the Metropolitan Museum of Art in 1926. However in 1928 *The Glasgow Herald* reported that Behar and his business partner, the Bradford-based Heymann and Alexander, had been ordered to sell the carpet by liquidators after the Bradford firm went bankrupt. Arthur Upham Pope, an archaeologist and historian of Persian art, bought the carpet on behalf of Edith Rockefeller McCormick, paying a then record price of 22,000 guineas. In 1943 the carpet was acquired by the Metropolitan Museum of Art.

GOING ONCE

ONE OF THE WORLD'S GREAT TEXTILE TREASURES

Jiangnan imperial workshops, imperial silk *thangka*, Yongle period (1403–24), *jiang chou* silk with silk and gold thread, 335.5 x 213.5 cm (132 x 84 in)

S A L E
26 November 2014,
Hong Kong

E S T I M A T E
Not published

S O L D
HK$348,440,000/
£28,468,570/$44,938,545

On average, the sale of a lot in a Christie's auction takes about one minute. On Wednesday 26 November 2014, the audience crowded into Christie's Convention Centre saleroom in Hong Kong and listened with rapt attention as two telephone bidders pitted themselves against each other for twenty-two minutes over a single lot. Eventually Lot 3001, an imperial silk *thangka*, went for more than HK$348.4m – a world record for any Chinese work of art sold by an international auction house. The buyer was Liu Yiqian, founder of the Long ('Dragon') Museum in Shanghai, who thus 'brought home' an object that most probably left China as soon as the imperial silk factories of Jiangnan had signed it off some 600 years earlier. It had once belonged to the Chogyal (kings) of Sikkim, India, and was rediscovered in an attic by the widow of a British diplomat to whom it had been given in the 1940s. Its appearance in 2014 was its fourth at a Christie's saleroom, consigned there this time by an American collector.

The great Ming Emperor Yongle (r. 1402–24) showed an interest in the world beyond China's de facto boundaries. This brought him rewards ranging from an African giraffe for his zoo to recognition in Tibet as an incarnation of the deity Manjusri. He was generous in return. Statues and paintings were exchanged between Yongle, who was devoted to Tibetan Buddhism, and Tsongkhapa, the founder of the Gelukpa order in Tibet, and the fifth head of the Karmapa order, Deshin Shekpa.

This huge embroidered silk *thangka*, which is widely believed to have been a gift to the Karmapa, is a unique example. Stitched so densely on heavy fabric in brilliant colours of silk and gold thread that it seems to be painted, it is acclaimed as 'one of the world's great textile treasures' by the textile historian John Vollmer. It bears the Emperor Yongle's presentation mark while the iconography depicts Raktayamari, the red emanation of Manjusri who destroys the blue god of death, Yama. The *thangka* is rich in symbolic detail: both Raktayamari and Yama wear royal crowns of five skulls, and Raktayamari supports his consort Vajravetali in a *yab-yum* embrace while trampling his enemy atop a buffalo. The scene is set against a mandorla of delicate flames and stands on a base of coloured lotus petals. Dancing goddesses offer gifts to the couple from seven pedestals across the bottom of the *thangka*, and the triumphant event is looked down on by a row of seven buddhas and bodhisattvas, and the two Taras, Green and White. This scene is also depicted on a rare gilt-bronze sculpture of the Yongle period, now in the Hermitage Museum, St Petersburg.

CONTEMPLATION
OF THE MOON

Guanyin sculpture,
Yuan dynasty (1279–1368),
wood, 175 cm (69 in) high

SALE
19 December 2012, Paris

ESTIMATE
€200,000–300,000/
£163,000–245,000/
$265,000–398,000

SOLD
€9,025,000/£7,355,000/
$11,960,000

When a rare wooden Guanyin sculpture from the Yuan dynasty
(1279–1368) sold in Paris in 2012 for thirty times its high estimate,
it marked a step change in the market for classical Chinese sculpture.
This sale indicated strongly that the market had now become
interested in wooden artefacts.

This magnificent statue of the Buddhist deity Guanyin, the
bodhisattva of compassion, was carved in northern China at a time
when such wooden figures were common, although – because
of the fragility of the material – few survive today. When it was
made, Guanyin was one of the most popular subjects in Buddhist art,
a beloved figure who could be male or female and was revered
for performing miraculous deeds.

A 13th-century Guanyin carved in fig-tree wood with traces of pigment on a pink gesso ground, now in the Ashmolean Museum, Oxford.

A bodhisattva is a divine being who has achieved enlightenment but has chosen to stay and help sentient beings on their individual paths to Nirvana. Often a pair of bodhisattva sculptures would be placed on either side of a central Buddha.

The depiction of the Guanyin had gone through a variety of stylistic changes in China, developing into the authoritative figure seen in this sculpture. The iconography is drawn from a story of a pilgrim visiting Guanyin and finding the bodhisattva seated on a rock, contemplating the reflection of the moon in water.

Carved in the round, this example is especially large, and many details are still apparent, including the graceful folds of the coat, the ornate necklace and the braids. There are even the remains of the gesso mixture and papier-mâché used for smoothing, and traces of paint and gilding. Only a few comparable large seated Guanyin figures are known, and are found in museums around the world, including the Ashmolean Museum in Oxford (left). Study of these examples tells us that it is likely that this particular statue would originally have been displayed in an important Yuan temple.

131 LOVE AND DEVOTION

The Virgin and Child enthroned, c.1250–80, ivory, 38 cm (15 in) high

SALE
16 November 2011, Paris

ESTIMATE
€1,000,000–2,000,000/
£856,000–1,712,000/
$1,350,000–2,700,000

SOLD
€6,337,000/£5,424,970/
$8,554,265

The Marquet de Vasselot Collection originated with a magistrate named Victor Prosper Martin Le Roy (1842–1918), who bequeathed the works to his son-in-law Jean-Joseph Marquet de Vasselot (1871–1946). Marquet was an art historian, curator at the Louvre and director of the Musée de Cluny in Paris who, in 1906, had published a five-volume *catalogue raisonné* of the collection.

Le Roy's treasures remained largely unknown to the wider public until November 2011, when Christie's Paris auctioned twenty-four medieval works of art from the collection, including a delicately carved ivory figure of the Virgin and Child enthroned. Thought to have been made in Paris between 1250 and 1280, the carved figure sold for more than €6.3m, the highest price ever achieved for a medieval work of art at auction.

This was not the first time that this ivory group had caused a sensation. As part of the De Bligny Collection, it appeared in an exhibition of medieval and Renaissance art in Rouen in 1884, arousing great interest owing to the reinstatement of the infant's head on to its body. At the time the head, which was thought to have been broken off

by French revolutionaries in an iconoclastic attack, had been acquired only recently from the Carrand Collection of medieval art in the Bargello Museum, Florence, enabling the group to become whole once more. Le Roy went on to acquire the devotional object by 1900.

The sale of 2011 brought together a spectacular array of works of art. As well as the record-breaking group of ivories, treasures included a romanesque gilt-bronze corpus figure, a fifteenth-century gilt-copper box for holy oils, a twelfth-century ivory chess piece in the form of a bishop enthroned, and a set of twenty-eight vellum folios from the fifteenth century that featured delicately illuminated notations of liturgical chant.

MOTHER SPIDER

Louise Bourgeois (1911–2010),
Spider, 1997 (overleaf),
bronze, 326.5 x 757 x 706 cm
(128½ x 298 x 278 in)

SALE
10 November 2015, New York

ESTIMATE
Not published

SOLD
$28,165,000/£18,642,415

Standing more than 3 metres (10 feet) tall, *Spider*, Louise Bourgeois's mammoth bronze arachnid, cannot help but conjure the fear stoked by cult American science-fiction films of the late 1950s. However Bourgeois always intended her spiders to have a more ambiguous role, acting as the embodiment of her own turbulent autobiography. They symbolize the artist's mother; indeed, a different version, in which ceramic eggs sit in a pouch beneath the spider's body, is called *Maman* (1999). 'My best friend was my mother and she was [as] deliberate, clever, patient, soothing, reasonable, dainty, subtle, indispensable, neat, and useful as a spider,' Bourgeois recalled.

The French-American artist's formative years remained a constant source of inspiration throughout her seven-decade career. 'My childhood has never lost its magic,' she explained. 'It has never lost its mystery, and it has never lost its drama. All my work of the last fifty years, all my subjects, have found their inspiration in my childhood.' The fact that her mother repaired textiles for a living was significant; Bourgeois identified the spider as a healing creature as much as an aggressor or a symbol of fear.

Bourgeois made her first drawings of a spider in the 1940s, having spent time in the orbit of such exiled Surrealists as André Breton and Joan Miró in New York during the Second World War. She was the link between Surrealism and movements such as Post-Minimalism that appeared in the 1960s, a period when she began to gain long-deserved attention. By straddling the two movements, Bourgeois developed an entirely unique language that made her one of the most influential artists of the late twentieth and early twenty-first centuries. Her work earned great acclaim from the 1980s until her death.

Although *Spider* was made in 1997, it was only after the showing of one of the *Maman* sculptures in Tate Modern's Turbine Hall in London in 2000 that it came to be regarded as one of her greatest works. While Bourgeois spoke about its relationship to her mother, its gothic, threatening and yet simultaneously nurturing presence also reflected her own personality which, she said, went 'from one extreme to the other'. Thus, *Spider* has come to be regarded as an emblem for Bourgeois and her work. In November 2015, it broke the auction record for a sculpture by a woman artist (almost tripling her own previous record) when it sold for more than $28m.

Louise Bourgeois's drypoint engraving *Ode à ma mère* (plate 8), 1995.

Louise Bourgeois, *Spider*, 1997.

GOING ONCE

THE BUILDING BLOCKS
OF LIFE

Francis Harry Compton Crick
(1916–2004), autograph
letter signed ('Daddy')
to his son Michael, outlining
the revolutionary discovery
of the structure and function
of DNA, 19 March 1953,
7 pages on Basildon Bond
blue writing paper, quarto,
each sheet 28 x 23 cm
(11 x 9 in)

SALE
10 April 2013, New York

ESTIMATE
$1m–2m/£0.7m–1.3m

SOLD
$6,059,750/£3,957,620

The sale of the scientist Francis Crick's so-called 'Secret of Life' letter
was record-breaking and momentous. The price realized in 2013 was
over $6m, a record for any letter, outstripping the previous record
held by the sale of an Abraham Lincoln letter for $3m (£1.5m) in 2008.
Crick's letter is valuable and unique because, in it, a truly significant
scientific breakthrough is described with great simplicity and clarity
in an affectionate letter from a father to his twelve-year-old son.

In the early 1950s, Crick, along with his colleague James D. Watson,
was working at the Cavendish Laboratory in Cambridge, England, trying
to unravel the mysteries of the DNA molecule. Understanding the
chemical components of DNA, and the way in which they were joined,
would enable scientists to reach conclusions about its function. Crick
and Watson's article in *Nature*, published in April 1953, describes the
double-helix structure of DNA and the base pair combinations. A month
later, the two men published a second article, which summarized
their ideas on genetic replication. Their work, together with Maurice
Wilkins's at King's College London, helped transform our understanding
of the genetic code and protein synthesis, and would ultimately lead
them to being awarded the Nobel Prize in medicine in 1962.

The discovery was a culmination of intense research and fierce competition with other scientific teams. Watson relates how he felt 'slightly queasy' when an over-excited Crick marched into the Eagle pub in Cambridge, weeks before the publication of the paper, and announced to the assembled company that they had found the secret of life.

The excitement Crick felt is palpable in the letter he wrote to his son, who was confined to his boarding-school sanatorium, recovering from influenza. In just seven pages, Crick outlines his revolutionary discovery and explains how he and his colleague have built a model of the DNA double helix, which reveals how the base pairs could act as a code. 'You can understand we are very excited … When you come home we will show you the model. Lots of love, Daddy.'

Crick and Watson's discovery paved the way for the biotechnology industry, and gene sequencing, genetic engineering, gene therapy and modern forensics are all based on their work. With half of the proceeds of the sale of the letter going to the Salk Institute for Biological Studies in California, it is to be hoped that this significant artefact from the history of science will now fund more groundbreaking scientific research.

Francis Crick in 1962, the year he was awarded the Nobel Prize in medicine with James D. Watson and Maurice Wilkins.

IN THE BEGINNING
WAS THE WORD

Johannes Gutenberg
(d. 1468) and Johann Fust
(c.1400–1466), Biblia Latina,
Volume 1 (Genesis – Psalms),
1455, royal folio, illuminated
by a contemporary artist,
Mainz calf binding

SALE
22 October 1987, New York

ESTIMATE
$1.5m–2m/£0.9m–1.2m

SOLD
$5,390,000/£3,286,585

EQUIVALENT TODAY
$11,912,000/£8,260,000

The Gutenberg Bible marks a milestone in the history of Western civilization. When Johannes Gutenberg invented moveable cast-metal type and developed a wooden printing press, he revolutionized the way in which knowledge was recorded and disseminated. Gutenberg's invention is regularly cited as among the most important of the past millennium.

Bibliographers estimate that he printed about 180 copies of the Bible, the first book ever printed, completed in 1455. Pope Pius II commended the quality of the books, writing that they were 'exceedingly clean and correct in their script, and without error' and could be read without spectacles. Because of careful editing of the sacred text, there are numerous stop-press corrections, and it is likely that no two copies are identical. Some 135 copies were printed on paper, the rest on vellum (calfskin parchment).

Forty-nine whole or partial copies of the Gutenberg Bible survive today, all in various institutions. The last sale of a complete Gutenberg Bible took place at Christie's in 1978, when a price of $2.2m (£1.2m; equivalent to £5.9m/$8.5m today) was realized. The Doheny copy of the first volume sold in 1987 was purchased by the Tokyo booksellers Maruzen, acting on behalf of Keio University. Maruzen was bidding by telephone from Tokyo against Thomas Shuster, a British rare book dealer who was in the saleroom in New York. The Bible remains at Keio University in Tokyo, Japan, and is the only known copy of this historic book to be held outside Europe or North America.

CHRIST CONVERSES
IN COOKHAM

Stanley Spencer (1891–1959),
*Christ Preaching at Cookham
Regatta: Conversation
Between Punts*, 1955,
oil on canvas,
106.5 x 91.5 cm
(42 x 36 in)

SALE
20 November 2013, London

ESTIMATE
£3m–5m/$4.8m–8.1m

SOLD
£6,018,500/$9,719,800

Between 1927 and 1932, Stanley Spencer completed what many would argue to be his masterpiece: the painting cycle based on his experiences of the First World War, housed in the Sandham Memorial Chapel in Burghclere, Hampshire. His plan for Church House, a dedicated building in his home village of Cookham, Berkshire, to be filled with his own religious paintings, was even more ambitious – a true *magnum opus*. It remains one of the great unrealized dreams of British art.

Spencer began the Church House project in the early 1930s, but abandoned it during the war. He worked instead on two important cycles of paintings, the 'Shipbuilding on the Clyde' series (1940–4), an official war commission, and the 'Resurrection: Port Glasgow' series (1945–50), set in the graveyard above Port Glasgow. The Church House idea never left him, though. In the years after the war, when his reputation was again on the rise – he had a major exhibition at the Tate Gallery in London in 1955 – he revisited it, despite there being little possibility of it being realized, since there was no patron to fund it. The scheme was to be set in Cookham in the days following Christ's Resurrection, and Spencer made it even more ambitious by adding a new series to his existing plans. *Christ Preaching at Cookham Regatta: Conversation Between Punts* is one of the few completed works from this new sequence.

This new element was intended to depict Christ preaching from the horse-ferry barge, while Cookham locals and visitors to the regatta watched from punts on the river and from the riverbank. Isolated from the main picture of Christ, *Christ Preaching at Cookham Regatta* becomes one of Spencer's inimitable studies of British life, infused with memories of his own childhood and observations of class distinction. Unable to afford a punt themselves, Spencer and his siblings would later recall watching the regatta from the bank, enviously observing those who could. It is a typically Spencerian image, teeming with incident and animation, pattern and colour, and a superb example of the artist's mastery of complex narrative paintings.

In 2013 the canvas soared above its high estimate to become the most expensive painting sold at a Modern British Art auction, going for over £6m to a private collector.

A RARE SURVIVAL

Michelangelo Buonarroti,
called Michelangelo
(1475–1564), study for *The
Risen Christ*, c.1515, red and
black chalk, pen and brown
ink on paper, 23.5 x 20.5 cm
(9½ x 8 in)

SALE
4 July 2000, London

ESTIMATE
Not published

SOLD
£8,143,750/$12,333,085

This is the only surviving study for Michelangelo's life-size marble figure
of Christ, commissioned in 1514 but only completed and installed in
the Church of Santa Maria sopra Minerva, Rome, at the end of 1521.
The verso of the sheet (though this is probably the side that Michelangelo
worked on first) consists principally of a study of a pair of legs in pen
and ink. Next to this, the other way up, is an outline in pen and ink and
red chalk of the figure of Christ. At some point, probably after he had
begun carving, Michelangelo turned the sheet over and drew the study
of Christ's lower torso. The delicate cross-hatching, showing where the
light falls on the figure's musculature, suggests that he was thinking
about the angle from which the finished sculpture would be viewed.

The studies on this sheet therefore provide not only insight into the artist's technique, but also beautiful depictions of the male form.

The most important Michelangelo drawing to have been sold in the last century, this example has an illustrious provenance, beginning with the distinguished French collector, Jean-Denis Lempereur (1701–1779), who sold it in Paris on 24 May 1773. The next owner was the Englishman William Sharp, before it was acquired by the London stockbroker J.P. Heseltine (1843–1929), who assembled one of the finest collections of his era. Most of Heseltine's Italian drawings were bought by the dealers P&D Colnaghi & Co. in 1912, and they sold the Michelangelo drawing to the London banker, Henry Oppenheimer (1859–1933). The sale of his collection of Old Master drawings took place at Christie's on 10 July 1936. The buyer of the Michelangelo was the youthful Brinsley Ford (1908–1999), supposedly to the consternation of some members of his family. The sum he paid, 3,400 guineas (£3,575/$17,768; equivalent to £216,900/$312,020 today) could, after all, have translated into a substantial house. Sir Brinsley, as he became, was a distinguished connoisseur, and he himself assembled an exceptional collection in which the Michelangelo was his most prized possession. When it came to auction after his death, sixty-four years after its purchase, it more than doubled the record price for an Old Master drawing at that time.

HERCULES
AND THE DUKE

Edward Farrell (active
1813–1845), the Duke of
York's silver candelabrum
centrepiece, 1824,
silver gilt, weighing up
to 28 kg (1,000 oz),
86 cm (34 in) high

SALE
19 March 1827, London

ESTIMATE
Not published

SOLD
£343 5s 6d/$1,695

EQUIVALENT TODAY
£26,500/$38,200

His Royal Highness Prince Frederick, Duke of York (1763–1827),
was the younger brother of King George IV. A successful career in the
army had been curtailed when a scandal involving his mistress forced
him to resign in 1811. The duke was an inveterate collector of silver,
and patronized the antiquarian retailer Kensington Lewis, who
employed Edward Farrell, one of England's most admired silversmiths.
When the duke died in 1827, his financial affairs were in such a state
– he is said to have left debts of between £200,000 and £500,000
($988,000–2,470,000; equivalent to £15.5m–38.7m/$22.3m–55.7m
today) – that the executors took the unusual step of selling his
collection of magnificent silver and silver-gilt plate, a royal collection
no less, at public auction.

The auction attracted enormous interest, and at the pre-sale
viewing, leading members of London society rubbed shoulders with
curious members of the public at Christie's King Street. Indeed, the
crush to get in became so intense that admission was granted only
with the purchase of a catalogue.

One of the outstanding items in the sale was a silver candelabrum
centrepiece made by Farrell in 1824, showing Hercules slaying the
Hydra. Hercules was thought to symbolize the Duke of York's former
position as commander-in-chief of the army, while Hydra represented
England's many enemies.

As auctioneer, James Christie's opening remarks paid tribute to
the duke, who, he said, 'was characterized by a most happy singleness
of heart, urbanity of manners, and kind condescension to all who
approached him'. While these words were warmly applauded, the sale
was to prove a disappointment, and the magnificent silver candelabrum
was knocked down for just 6 shillings an ounce. A murmur of 'How
cheap!' was reported to have spread through the saleroom.

Christie was clearly disappointed, saying he felt grief 'that the
workmanship of the artist is valued so low'. In October 2004, the
Duke of York's silver candelabrum sold for a more robust $791,500
(£438,500) at Christie's New York.

138

A HEAD
FOR HEIGHTS

Attributed to Poupard & Cie,
imperial bicorne campaign
hat, c.1806, black felt,
49.5 cm (19½ in) wide,
15 cm (6 in) high

SALE
9 July 2015, London

ESTIMATE
£300,000–500,000/
$461,000–770,000

SOLD
£386,500/$594,340

It is testament to the enduring mystique of Napoleon Bonaparte (1769–1821) that his trademark hat remains one of the most instantly recognizable pieces of historic clothing. Many generals in Napoleon's lifetime wore similar two-cornered – or bicorne – hats, but such headgear is now most closely associated with the French general and ruler. In what could be argued was a precocious appreciation of the power of branding, Emperor Napoleon made himself instantly identifiable on the battlefield by wearing his sideways, with the two ends over his ears.

The Parisian firm of Poupard & Cie is thought to have made 120 such hats for Napoleon, although few survive today. He would order four a year, and did not like to wear them new. Rather, he had his valets break them in for him. This particular example is lined in olive-brown silk instead of the traditional leather lining to which Napoleon was reputedly allergic. It is believed to have been worn at the Battle of Friedland in June 1807 – in what was then East Prussia and is now in the province of Kaliningrad on the Baltic coast – in which Napoleon was victorious against the Russians.

Only a few years later, in 1814, the hat was acquired by Sir Michael Shaw-Stewart while he was on his Grand Tour of mainland Europe. The baronet wrote in his diary that he paid a sum of 10 thalers for it (£2/$8.50). He acquired it from the keeper of the Palace of Dresden, who had been entrusted with it by a nephew, Napoleon's valet. For the next two centuries, the hat resided at the family seat, Ardgowan House in Renfrewshire, Scotland. It was sold in 2015, the bicentenary of the Battle of Waterloo, along with other Napoleonic memorabilia, including a lock of his horse Marengo's mane.

Jacques-Louis David's
*Napoleon crossing the
Saint Bernard Pass*, 1800.

A NIGHTCAP FOR A KING'S DEATH

Embroidered nightcap, c.1649, small linen cap embroidered in coloured silks and metal threads

SALE
18 October 1983, London

ESTIMATE
Not published

SOLD
£13,000/$19,800

EQUIVALENT TODAY
£39,200/$54,600

'Now they will cut off thy father's head,' said Charles I to his nine-year-old son, Henry, taking leave of the boy shortly before his execution. On that cold January day in 1649, the deposed king wore two shirts, not wanting anyone to see him shiver and think he was afraid. He also donned an embroidered nightcap, partly for warmth, but also to keep the hair from his neck, since it was important that the executioner could see where to strike. When the time came and the blow fell, spectators in the crowd rushed forward to dip their handkerchiefs in the royal blood. Then, as now, people understood the value of a historic souvenir.

Under Oliver Cromwell, the king's collection of paintings was sold off in an auction held at Somerset House. That was before Christie's time, but in 1807 a Mr Innocent consigned Charles I's execution cap for sale at the auction house. It sold for £2 15s ($12; equivalent to £195/$270 today), a low price, although it was said to be 'well authenticated'. Later in the century, in 1889, the cap was shown in an exhibition of Stuart relics at the New Gallery in Regent Street, London; it did not come back to the saleroom until 1983.

Although the article's provenance remained circumstantial, it was good enough to convince most experts. In the British Library there is a print depicting the execution, in which Charles is wearing a cap very like this one, and it is undoubtedly of a type that was fashionable between 1630 and 1650. The linen is embroidered with coloured silks and metal thread, combined to form numerous raised-work Tudor roses as well as honeysuckle and vines adorned with sequins. It is a superb piece of needlework, a cap certainly fit for a king who has lost his crown.

Those who bid for the cap in 1983 were surely hoping not just to acquire the object, but also to connect with its gory history. The successful bidder was George Apter and when asked what he planned to do with the king's death-cap, he said only that he would not be wearing it. It returned to the saleroom again in 2000, when it sold for £23,500 ($35,700).

THE BED OF LIFE

Tracey Emin (b. 1963),
My Bed, 1998, mattress,
linens, pillows and objects,
79 x 211 x 234 cm
(31 x 83 x 92 in)

SALE
1 July 2014, London

ESTIMATE
£0.8m–1.2m/$1.4m–2.1m

SOLD
£2,546,500/$4,365,680

Tracey Emin had shown *My Bed* twice before it made its European debut in the Turner Prize exhibition at Tate Gallery, London, in 1999. It was first exhibited in Tokyo and then in New York, although Japanese customs had attempted to destroy it, not believing it was an artwork. Emin later revealed it was her slippers that the Japanese public found to be particularly risqué. But as soon as the Turner Prize show opened, the story of *My Bed* exploded in the press. Possibly only the furore around Damien Hirst's *The Physical Impossibility of Death in the Mind of Someone Living* (1991), his iconic shark in formaldehyde, rivalled the reception for *My Bed*. They were the two provocative artworks that bookended a decade in which the Young British Artists (YBAs) transformed contemporary art.

My Bed made for a striking entrance to that Turner Prize show in 1999: there it was, in the first room, a ruffled and stained unmade bed, surrounded by detritus that included condoms, a tampon, a vodka bottle and cigarette ends. It was a memorial to four days during which Emin had stayed in bed, heartbroken at the end of a relationship. She

talked of contemplating death while lying there, but says that she chose life, and went to get a drink of water. Initially disgusted by the bed, she returned to it and found it strangely beautiful. It was then that she conceived the idea of transporting it in its entirety to the art gallery. Utterly emblematic of its maker, it is a deeply personal, starkly confessional, expressionist subject married to a tough, post-Duchampian approach to the art object.

My Bed, in becoming a genuine icon, has often been misunderstood and caricatured, with its very real evocation of depression being missed. It was first shown with a noose, which was removed only when it was exhibited at the Tate, and few commentators mention the suitcases bound together with a chain that sit alongside the work: one was the suitcase Emin carried when she left Margate as a teenager; the other a new one she bought when she decided to change her life after the bed episode. Binding them together symbolized the transition Emin made from the past into a new, 'internationalist' future, as she called it.

After the Turner Prize show, *My Bed* was bought by Charles Saatchi. In 2014, he put the work up for auction to benefit the Saatchi Gallery Foundation, and it reached £2.5m, which remains the auction record for a work by Emin. The work was acquired by the Duerckheim Collection and is now on long-term loan to Tate, seventeen years after its first appearance.

141

TO SLEEP, PERCHANCE TO DREAM

Henri Matisse (1869–1954), *Harmonie jaune*, 1928, oil on canvas, 88 x 88 cm (34½ x 34½ in)

SALE
11 November 1992, New York

ESTIMATE
$5m–7m/£3.3m–4.6m

SOLD
$14,520,000/£9,587,555

EQUIVALENT TODAY
$22,000,000/£15,200,000

Mixing exuberance with languor, Matisse's richly patterned *Harmonie jaune* suggests a state between dreaming and waking. The model in the painting appears to sleep, while the viewer's eye is led on a lively visual dance around the image via sweeping arabesques that are punctuated by the staccato dots and dashes of the wallpaper's flowers. The objects on the brass tray, with their play of reflections and shadows, introduce elements of perspective and realism that are at odds with the overall flattened decorative scheme.

The first owners, the Swedish-American couple Philip Sandblom and Grace Schaefer, first saw *Harmonie jaune* when visiting New York on their honeymoon in the early 1930s. Sandblom, a surgeon from Lund in Sweden, and Schaefer, the daughter of a New York banker, met in Stockholm, married in New York and shared a passion for art. *Harmonie jaune* was one of their first acquisitions, bought from the artist through

his son, the dealer Pierre Matisse. The painting remained in the couple's bedroom for almost their entire married life.

Following this purchase, the Sandbloms' collection grew and evolved. They bought widely, often exchanging works in order to acquire others. For instance, they swapped a Modigliani for a Courbet, a Courbet for a Miró and a Derain for a Delacroix. These deals were perhaps motivated by a wish not just to put different works on their own walls, but eventually to fill gaps in Stockholm's museum collections, to which they donated some of their most important works, including Picasso's *La Source* (1921) and Cézanne's portrait *Madame Cézanne Sewing* (c.1877).

In 1992, while *Harmonie jaune* was on show in the hugely popular Matisse retrospective at the Museum of Modern Art in New York, the Sandbloms decided that it was the right moment to part with it. The painting was sold at Christie's New York to an anonymous telephone bidder for just over $14.5m, setting a record for the artist.

DREAM DISCOVERY IN A CHURCH HALL

Samuel Palmer (1805–1881),
*Oak Tree and Beech,
Lullingstone Park*, 1828
(overleaf), pencil, pen and
brown ink and watercolour,
heightened with bodycolour,
on grey paper, 29 x 47 cm
(11½ x 19 in)

SALE
8 June 2000, London

ESTIMATE
£150,000–200,000/
$230,000–305,000

SOLD
£751,750/$1,145,260

All experts hope that, just once in the course of their career, their training and long experience might allow them to spot the diamond in the dust heap, to uncover or rediscover some masterpiece. Most are not that lucky, but James Hastie was.

One day in 1999, Hastie was attending a valuation at a church hall in Essex, in his capacity as a Christie's specialist in nineteenth-century European art. He said that he was not expecting much beyond 'the normal onslaught of chromolithographs, daubs by amateur artists, and museum-shop copies,' but during the course of the morning he was approached by an elderly lady pulling a shopping trolley, from which hung a black refuse sack. Hastie readied himself to deliver his usual practised and polite let-down. But his heart leapt when, as he said, 'from this bin bag she slowly removed one of the most beautiful drawings I had ever seen.'

The woman held a pen-and-ink drawing of a huge knotted oak tree and a flowering beech. The drawing was mostly grey in tone, but beyond the trees, in the middle distance, a yellow ripple of sunlight illuminated a half-glimpsed glade like a horizontal seam of gold. In the foreground, a green wash picked out patches of soft moss around the roots of the oak.

Hastie knew at once that he was looking at an authentic work by Samuel Palmer – son of a bookseller, sometime Baptist minister, and devoted disciple of William Blake. The drawing belonged to the brief period that Palmer spent in Shoreham, Kent, during the 1820s. It was one of a set of drawings known to have been commissioned by his father-in-law, the painter John Linnell. For it to turn up in a bin bag at a church hall was little short of miraculous.

The woman who owned the picture knew very well that it was a significant work of art, and had gone to the trouble of insuring it for £12,000. However, when *Oak Tree and Beech, Lullingstone Park* came up for auction in the inaugural British Art on Paper sale, its estimate stretched to £200,000. It was purchased by the Morgan Library & Museum in New York for almost four times that amount: £751,750, still a world auction record for the artist. 'I feel honoured to have played a part in its history,' said Hastie some years later. 'And if you get the opportunity to go to the Morgan, I strongly recommend you view it. I guarantee it will not disappoint.'

GOING ONCE

REFLECTIONS FROM THE SUBCONSCIOUS

Max Ernst (1891–1976),
The Stolen Mirror, 1941,
oil on canvas, 65 x 81 cm
(25½ x 32 in)

SALE
1 November 2011, New York

ESTIMATE
$4m–6m/£2.5m–3.8m

SOLD
$16,322,500/£10,239,105

The Stolen Mirror was painted during a tumultuous period in Max Ernst's life. He was a German in Paris at the height of the Second World War, a war that forced the Surrealist movement – for so long at the apex of the avant-garde – to disperse and unravel, with Ernst ending up in the US. He was also in the midst of an intense on-off affair with the painter Leonora Carrington.

Yet it was also a hugely fertile and creative period for Ernst. *The Stolen Mirror* conjures a mysterious world, teeming with unsettling imagery, that hints at key moments in Ernst's life. Among those were his visit to the temple complex of Angkor Wat in Cambodia in 1924, and his memory of seeing the Statue of Liberty while he was detained at Ellis Island on arriving in America in 1941.

Few modern paintings are so richly packed with autobiography, world travel, and the storm and stress of contemporary history. The three tall, statuesque figures in the painting may represent the women in his life: the collector Peggy Guggenheim, who helped Ernst escape Europe for America, and whom he later married; his lover, the artist Leonora Carrington; and Gala, the poet Paul Éluard's wife and later Salvador Dalí's muse, with whom Ernst had travelled to the Far East in the 1920s.

The painting was made using a technique called 'decalcomania', in which gouache is used to cover a sheet of paper and pressed into another sheet or surface. The residue left by the pressure evoked vegetal and mineral forms, and Ernst exploited these better than his peers. The process is a form of automatism – its chance results free from conscious thought – and Ernst's use of the technique is definitive Surrealism, his subsequent embellishment of the residual forms giving them a hallucinogenic intensity.

The painting was probably begun in France and completed in Santa Monica, California, where Ernst stayed in 1941. It was first bought by Edward James, the English connoisseur of Surrealism. Subsequently, having been part of the collection of Ernst's son Jimmy, it came to auction in 2011, and after an intense bidding war it was sold for over $16.3m, smashing the previous record for an Ernst of $4.4m. This remains the auction record for a work by Ernst.

WHEN NIGHT
BECOMES DAY

René Magritte (1898–1967),
L'empire des lumières, 1952,
oil on canvas, 100 x 80 cm
(39½ x 31½ in)

SALE
7 May 2002, New York

ESTIMATE
$5m–7m/£3.4m–4.8m

SOLD
$12,659,500/£8,623,650

The Belgian Surrealist René Magritte said he wanted his paintings
to 'show what the mind can say and which was hitherto unknown'.
Magritte employed techniques that recall the characteristics of Freudian
dream interpretation: bizarre juxtapositions, and irrational arrangements
of perspective, lighting and atmosphere. Creating an element of
subversion that so many of the Surrealists propagated, Magritte explored
his subconscious – constantly awakening and reviving dreams.

Magritte would return regularly to the same subjects, as in *L'empire
des lumières* (*Empire of Light*). This uncanny combination of night and
day – darkened trees and buildings, with a glowing street lamp, beneath
a blue sky with fluffy clouds – preoccupied him more than most. Over
a fifteen-year period between the late 1940s and the mid-1960s, he
made seventeen oils and ten gouaches of this image, each with subtle
differences: more buildings, varying formats, less densely clouded skies.

Magritte confessed that he had always felt 'the greatest interest
in night and day, without however having any preference for one
or the other. This great personal interest in night and day is a feeling
of admiration and astonishment.' The subject similarly appealed to
the self-appointed high priest of Surrealism, André Breton, who had
written as early as 1923 in his poem *The Egret*: 'If only the sun were
to come out tonight.' Breton later wrote a catalogue essay on Magritte,
in which he describes the double-take effect on the viewer in *L'empire
des lumières*: 'The violence done to accepted ideas and conventions is
such (I have this from Magritte) that most of those who go by quickly
think they saw the stars in the daytime sky.'

Introduced by Alexander Iolas to many of the Surrealist artists,
including Magritte, Dominique and Jean de Menil acquired a vast
collection of their paintings, sculptures and objects. Reluctant to be
labelled as 'collectors', the de Menils were actively and personally
engaged with their art and emotionally powerful patrons who fostered
the development of many artists. In 1950, they donated the second
completed version of *L'empire des lumières* to the Museum of Modern
Art in New York. It met with great critical and public acclaim, and in
1952 the de Menils commissioned Magritte to paint this work, the fourth
completed version. It was sold in 2002 for over $12.6m, and remained
the artist's record price at auction for the following twelve years. The
new record, at $12.9m (£7.8m), was set in 2014 by *Le beau monde* (1962).

TRANQUIL GLADES
FOR TIRED EYES

Jean-Baptiste-Camille Corot
(1796–1875), *Paluds antiques*,
c.1865–70, oil on canvas,
55.5 x 84 cm (21½ x 33 in)

SALE
30 June 1910, London

ESTIMATE
Not published

SOLD
6,200 guineas/
£6,510/$31,640

EQUIVALENT TODAY
£594,000/$863,300

The French nineteenth-century landscape painter Jean-Baptiste-Camille Corot was revered for his innovative approach to light and colour. His quiet, wooded landscapes, with their soft forms and gentle tones, were admired greatly in England, especially among lawyers, accountants and industrialists. According to a writer in *The Studio* in 1907, such collectors 'find their rest and relaxation in the gathering together of these works, which in some especial way appeal to the artistic side of their nature'.

Paluds antiques (*Ancient Marshlands*) was one of sixty paintings by Corot owned by the accountant Alexander Young. After Young's death, part of his collection of some 700 nineteenth-century Dutch and French paintings was sold over three days in 1910. Billed as the event of the season and featuring forty works by Corot, the auction witnessed fierce competition among bidders, and realized a total of £154,000 ($75,000) – equivalent to about £14m (£20m) today. *Paluds antiques*, sold under a different name (*L'abreuvoir*, or *The Watering Place*), went for what was then the enormous sum of 6,200 guineas (nearly £600,000 today).

In 2010, when the painting next came on the market, it fetched £217,250 ($316,000), nearly £400,000 less than its equivalent value 100 years earlier. The price difference reflected the fact that Corot's popularity at auction has been eclipsed by that of the Impressionists, whom (ironically) he had greatly influenced. Another factor in Corot's devaluation may be the huge number of imitations and forgeries that circulated; such magazines as *L'Amour d'Art* (1936) quoted the art-world joke that Corot had painted 3,000 pictures, of which 10,000 were in America.

PEARLS BEYOND
ALL PRICE

The Red Cross necklace, 1918,
63 graduated pearls with
a diamond clasp, 623 grains

SALE
19 December 1918, London

ESTIMATE
Not published

SOLD
£22,000/$104,720

EQUIVALENT TODAY
£957,000/$1,378,000

During the First World War, while several Christie's directors were on active service, the firm's managing director, Alec Martin, contributed to efforts on the home front by holding a series of charity auctions to benefit the work of the Red Cross. These sales of objects donated by individuals took place every year from 1915 to 1918. Each auction was held over ten to fifteen days, and included items as varied as works of art, wines, spirits, jewellery, postage stamps, porcelain and furs. All kinds of people contributed, from royalty and nobility to artists, craftsmen, writers and other members of the public, and many gave items in memory of soldiers who had lost their lives. Intense public interest meant that good prices were achieved, and the sales

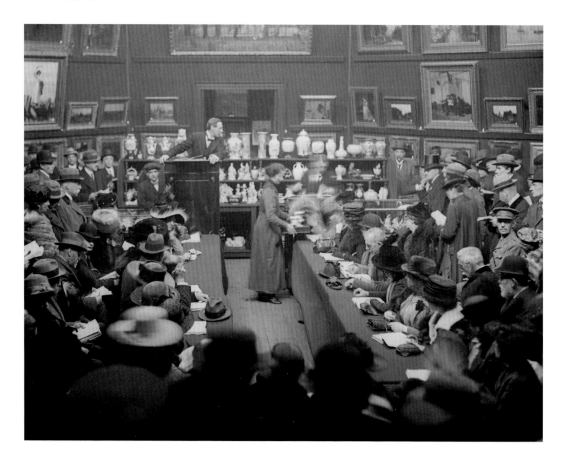

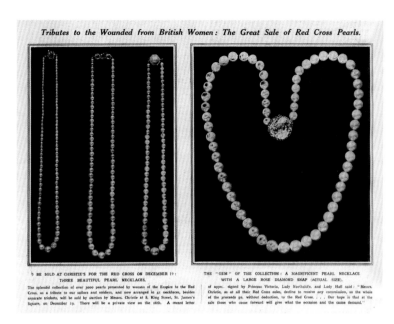

raised a combined total of over £320,000 ($1,523,200; equivalent to £13.9m/$20m today).

The most spectacular of these sales was the Red Cross Pearls sale held in December 1918, shortly after the war had ended. Although the fighting had ceased, there was still an urgent need for funds to support the treatment and aftercare of the wounded. The sale was the result of months of planning by a group of women who came up with the ingenious idea of collecting donated pearls to be formed into a single rope or necklace.

The imaginative project gathered such momentum that by the time the appeal ended, some 3,597 pearls had been given. Many were of historical value, and they came from all strata of British society, from the royal family and aristocrats to less wealthy members of the public. 'If every pearl is a tear, may this one pearl represent only a tear of laughter,' wrote one donor. Another 'sent a pearl in memory of a pearl beyond all price already given – my only son'.

Expert jewellers fashioned the pearls into forty-one necklaces, scarf pins, brooches and rings, and the jewels were displayed at King Street for three days before the auction. People queued round the block to see them, and there was intense speculation about what the star item – a necklace of sixty-three graduated pearls with a rose diamond clasp – would fetch. One viewer expressed the sentiments of many: 'Whatever it fetches will not matter to the buyer. Its value soars above intrinsic value. It is the big Red Cross necklace. It will be as historic as the big jewels of Marie Antoinette; it will be an heirloom more famed than the Hope diamond. Other pearls come from the sea. These pearls come from human hearts, and human tenderness and gratitude will run up their purchase price.'

Left: a Red Cross auction in progress at Christie's.

Above: a report on the 1918 Red Cross sale in the *Illustrated London News*, showing the necklace with large diamond clasp (right) that raised £22,000.

THE NEED FOR SPEED

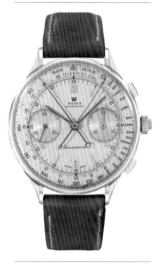

Rolex (est. 1905), oversized
split-seconds chronograph
wristwatch number 4113,
1942, stainless-steel watch
with leather strap, 4.4 cm
(1¾ in) in diameter

SALE
13 May 2013, Geneva

ESTIMATE
CHF700,000–1,200,000/
£478,000–820,000/
$731,000–1,253,000

SOLD
CHF1,107,750/£756,625/
$1,159,920

With watches, as with most other jewellery, the rarity of the item
is as important as the opulence of the materials from which it is
made. This Rolex, reference 4113, is in some ways a modest piece.
The beautifully engineered large case is made from stainless steel
and it was designed to be worn by a man at work – and in this case
the work in question was racing fast cars.

The owner's profession explains the unusually large diameter
of the watch, 44 cm, and the very narrow bezel (the outer metal
rim on the face). The Rolex was designed to be read easily with
the briefest of glances while driving at high speed. The handsome face
is a masterpiece of clarity, considering how much data potential has
been designed into it: outer minute divisions, blue telemeter and black
tachymeter scales, two subsidiary dials for constant seconds, a thirty-
minute register and a split-seconds chronograph.

Only twelve of these Rolex chronographs were made, all of them
in 1942, and with case numbers ranging from 051313 to 051324.
All were given as gifts to famous drivers or team owners; they were
never available on the open market. Eight are known still to exist,
and of these only five have ever come up for auction. That is what
makes the piece so important and desirable: most collectors have never
even seen one, let alone had the opportunity to buy one. Consequently
this watch – case number 051314 – sold for over 1.1m Swiss Francs
in Geneva, the world's capital of horology. It remains one of only a
handful of Rolex watches that have surpassed the $1m mark at auction.

Vickers Supermarine
(est. 1913), Spitfire Mark
IA-P9374, 1940, aluminium
alloy, wing span 11.2 m
(37 ft), length 9 m (30 ft)

SALE
9 July 2015, London

ESTIMATE
£1.5m–2.5m/$2.3m–3.8m

SOLD
£3,106,500/$4,777,025

German soldiers posing
with Peter Cazenove's
downed Spitfire Mark
IA-P9374 in 1940.

On 24 May 1940, Flying Officer Peter Cazenove of 92 Squadron crossed the English Channel in Spitfire IA-P9374 to provide air cover for the British troops retreating towards Dunkirk. His aircraft had rolled off the production line soon after the outbreak of war, and had clocked up a total flying time of less than thirty-two hours. But not even an hour into this mission, the Spitfire was hit by a single bullet from a Dornier 17 bomber aircraft that holed the Spitfire's coolant system, and Cazenove was forced to make a belly-landing on the beach near Calais. From there he walked into town, where he was soon taken prisoner. As for his aircraft, it remained exactly where he had ditched it. The waves and the sand covered it, and it quickly disappeared from view.

Forty years later, the very tides that had buried the plane exposed it once more. The barnacle-encrusted wreckage was ultimately acquired by the American collector Thomas Kaplan, who shipped the corroded pieces to England for restoration. That complex task was entrusted to Historic Flying Ltd, a specialist team based at Duxford airfield in Cambridgeshire. Kaplan insisted that the team rebuild the aircraft

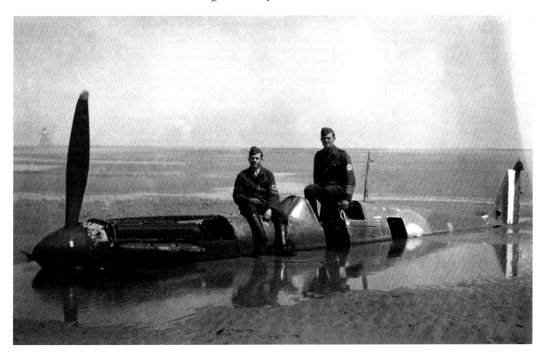

precisely in its original form: as a Mark I, without any of the modifications that were made to later models over the course of the war. That level of authenticity involved extensive research, followed by years of meticulous reconstruction work. But slowly P9374 was brought back to life and to airworthiness, and in 2011 it took to the skies again.

In 2015, Kaplan decided to sell the aircraft to raise money for the Royal Air Force Benevolent Fund and for Panthera, a wildlife conservation charity. The news that Christie's was to auction a Spitfire generated huge interest. This plane offered a link to the 'Few' referenced by the wartime Prime Minister Winston Churchill, the generation of RAF pilots who fought and won the Battle of Britain – very few of whom survived. Kaplan stressed that, in selling his Spitfire, he was making 'concrete gestures of gratitude and remembrance'.

Spitfire P9374 sold for more than £3m, a new auction record for a Spitfire. As for Cazenove, after his capture in 1940 he was sent to the German prisoner-of-war camp Stalag Luft III. He took part in the famous 'Great Escape' from the camp, but was not one of those who managed to make it through the tunnel and away, and he remained a prisoner until the camp was liberated. Late in his life, Cazenove's wife said he had wondered out loud 'what happened to my Spitfire ... [I wonder] if anyone will ever find it.' It was only a few weeks after he died in 1980 that its rounded tailfin emerged at low tide from a flat expanse on a Calais beach.

THE NANKING CARGO

Two blue-and-white butter tubs and shallow domed covers, part of the Nanking Cargo, c.1750, early Qing dynasty (1644–1912), porcelain, 11.5 cm (4½ in) in diameter

SALE
28 April–2 May 1986, Amsterdam

ESTIMATE
NLG1,200–1,600/
£225–300/$330–440

SOLD
NLG37,120/£7,000/$10,250

EQUIVALENT TODAY
€23,600/£18,300/$25,600

Just before Christmas 1751, the Dutch East Indiaman *Geldermalsen* set off from Canton, China, bound for Holland. Its cargo consisted principally of tea, nearly 320,000 kg (700,000 lb) of it. Lining the keel were 147 gold ingots. There were also huge quantities of porcelain, packed inside the tea chests as 'kentledge' – removable and saleable ballast. The china was everyday blue-and-white, designed for European

Hauling the Nanking Cargo, comprised of porcelain and gold from an eighteenth-century wreck, out of the depths of the South China Sea in 1986.

needs: soup tureens, pint mugs, spittoons, chocolate cups, salt cellars. All of it was decorated with modish Chinese motifs: peonies and fish, scholars on bridges, boatmen on still rivers. The crockery was to be auctioned on the quayside as soon as the ship docked in Rotterdam, where the middle-class burghers would snap it up.

But on 3 January 1752, the *Geldermalsen* struck a reef and sank in the South China Sea. The entire cargo was lost, and 80 of the 112 crewmen were drowned. The story of the ship's demise gradually faded from memory, and the wreck lay on the seabed, forgotten, for 233 years.

In 1985, a salvage company located the *Geldermalsen*'s hold and spent months recovering its contents. The porcelain was remarkably well preserved; its glaze was largely unaffected by centuries of seawater, and it was for the most part unchipped – partly because it lay on the seabed in a soft protective mulch of saturated tea leaves. Some 150,000 separate pieces were retrieved, along with 125 of the gold bars, each one marked with the Chinese characters for 'luck' and 'value'.

The third portion of the haul went on view in Amsterdam in 1986, and crowds queued to see the 'Nanking Cargo', as it had been christened. The porcelain was divided into 3,000 lots of varying sizes, making it possible for casual buyers to acquire a small memento of the find – a pair of butter dishes, for example. But in the course of the five-day auction, something extraordinary happened. Even though the porcelain itself was not especially fine or intrinsically valuable, bidding surpassed all estimates, perhaps because of the

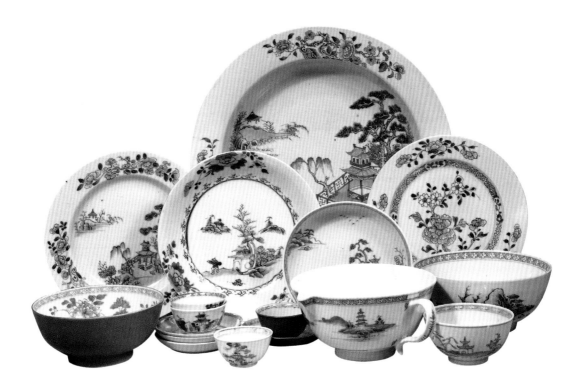

Left: the Nanking Cargo
in Amsterdam, prior to the
auction in 1986.

Above: examples of blue-
and-white porcelain dishes
from the Nanking Cargo.

romance attached to sunken treasure. Lots sold for five, ten or – in
the case of those butter dishes – twenty-two times the expected price.
Restaurants vied to buy stacks of dinner plates; as one newspaper
pointed out, the Qing dynasty tableware was dishwasher safe. The Ritz
hotel invested in a huge service.

Within days, individual items were to be found in shops across
Europe, offered at twice their saleroom price, often with the lot
number still attached as a mark of provenance. As for the sale, it became
part of the history of Chinese ceramics, while 'Nanking Cargo' became
a sub-genre for collectors worldwide. Pieces still appear in salerooms,
like flotsam washed up on a beach.

ALL AT SEA

David Teniers the Younger
(1610–1690), *Judith with the
Head of Holofernes*, 1650s,
oil on copper, 37 x 26.5 cm
(14½ x 10½ in)

SALE
17–18 February 1797, London

ESTIMATE
Not published

SOLD
24 guineas/£25 4s/$112

EQUIVALENT TODAY
£2,300/$3,200

John Trumbull (1756–1843), an American artist, diplomat and friend
of James Christie, was behind one of Christie's most successful early
painting sales. However, probably no auction in the company's history
had such a disastrous beginning.

Known as Colonel Trumbull, he was George Washington's
aide-de-camp, and had fought against the British in the War of

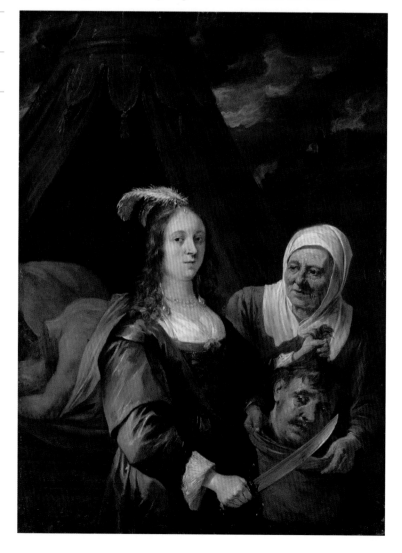

Independence (1775–83). Twenty years later, he found himself in Paris, serving as an emissary of the new American state. France was then in the midst of its own revolution, and Trumbull – an astute dealer as a well as a loyal diplomat – saw the chance to buy up collections of Old Masters at rock-bottom prices. 'In the confusion of the time and the consequent ruin of ancient and opulent families,' he wrote, 'I purchased more than a hundred valuable paintings.'

Trumbull's bargain buys included works by Titian, Peter Paul Rubens, Anthony van Dyck, Nicolas Poussin and Rembrandt van Rijn. He had them all crated up and shipped to England, but, unfortunately for him, they arrived at the docks on a day when the Thames watermen were celebrating the birthday of the Prince of Wales (later King George IV). Everyone was too drunk or distracted to notice when the barge containing Trumbull's collection slipped its chain and sank.

The crated paintings, left bobbing on the river, began to drift seawards on the ebb tide. They were fished out by some more-or-less sober wharfmen, but when Trumbull came to collect his property from customs the next day, he found the canvases dripping like old dishcloths. 'My first impression was to abandon the whole to the underwriters,' he said – but it turned out that he was not insured for this kind of mishap. Instead, 'I passed the remainder of the season in repairing, as well as I could, the damage they had sustained.'

Trumbull managed to salvage ninety-one paintings, and they went to auction in February 1797. The catalogue tactfully made no mention of the accident, stressing instead that this was 'a most superb and distinguished collection ... formed with peculiar taste and judgment.' The pictures all sold well, their dunking notwithstanding; David Teniers the Younger's *Judith with the Head of Holofernes* sold for 24 guineas (it is now in the collection of the Metropolitan Museum of Art in New York). Many of the best works eventually went to the British Royal Collection, while the sale itself raised a handsome £7,996 ($35,500; equivalent to £740,000/$1,030,000 today).

John Trumbull's self-portrait, c.1802.

THE SWORD
AND THE SULTAN

An Italian medieval
broadsword from the
Mamluk Armoury in
Alexandria, known as
the Harriet Dean sword,
dated to '1419', iron and
wood, 90 cm (35½ in) blade

SALE
17 December 2015, London

ESTIMATE
£70,000–100,000/
$104,000–150,000

SOLD
£386,500/$574,805

Top: the sword's owner,
Dr Bashford Dean,
photographed in a suit
of armour in the 1920s.

Above: detail of
the inscription on the
sword's blade.

A Texan restaurant was the unlikely backdrop for one of the greatest
discoveries in arms and armour of recent years – an expertly crafted
medieval broadsword that had been lost for decades, and which the
arms specialist Howard Dixon described as 'a once-in-a-lifetime
discovery'. The sword had been the property of Dr Bashford Dean,
a leading zoologist and arms expert, who in 1912 in New York became
the founding curator of the Metropolitan Museum of Art's arms and
armour department. Dean acquired this piece and others on a tour
of Europe and Turkey in 1919–20, and he bequeathed a similar sword
to the Met in 1928. This example was sold in New York at auction
in 1943 by the estate of Dean's sister, Harriet Dean. It was bought by
Percy Selden Straus, Jr., and disappeared from view.

The whereabouts of the Harriet Dean sword, as it became known,
remained a mystery until 2015, when Dixon was presented with an
unassuming folio of photographs of pieces set for auction while dining
in a restaurant in Texas. On the seventh page, he found a small image
of a piece that set his pulse racing. What piqued his interest in particular
was the two-line inscription in slender Arabic script, which translates
as: 'Abu'l-Nasr Shaikh. Inalienably bequeathed by al-Malik al-Mu'ayyad,
in the magazines of arms, in the Frontier-City of al-Iskandarîya,
in the year 812.'

In the Muslim calendar, Sultan Malik Mu'ayyad Abu'l-Nasr Shaikh
reigned from 815 to 824 AH (AD 1412–21), so experts believe the date
on the inscription is an error and should be 822 AH (AD 1419).
No ordinary weapon of war, this sword was one of a group presented
as a diplomatic gift from the King of Cyprus to the Mamluk Sultanate,
which ruled Egypt and Syria from the thirteenth to the sixteenth
century. 'The poise and balance as it sits in the palm of your hand is
a joy – it is an astonishing piece of the bladesmith's art,' Dixon said
before the sword became the last lot sold by Christie's in 2015. 'I feel
very privileged to have spent so much time with it.'

AN ALLEGORY OF MISATTRIBUTION

Sandro Botticelli
(c.1445–1510), *Venus and
Mars*, c.1485 (overleaf),
tempera and oil on poplar,
69 x 173.5 cm (27 x 68½ in)

SALE
6 June 1874, London

ESTIMATE
Not published

SOLD
£1,050/$5,700

EQUIVALENT TODAY
£87,000/$124,000

Sandro Botticelli painted *Venus and Mars* in about 1485. The painting, in which a sleeping Mars reclines alongside an attentive Venus, suggests that love conquers war, and was probably designed for a bedroom, either as the backboard of a chest or as a bedhead. It is now one of the greatest treasures of the National Gallery in London, yet in 1874, when the gallery acquired the painting for £1,050, it was not the most expensive Botticelli of the day. *An Allegory* (c.1500), also believed at the time to be by Botticelli, was acquired at the same sale for £1,627 10s ($8,820; equivalent to £135,000/$193,000 today), again by the National Gallery.

Botticelli's work was becoming increasingly popular in nineteenth-century England, and the Pre-Raphaelites were greatly influenced by his style. The London sale of the two paintings, which came from the collection of Alexander Barker, the son of a fashionable bootmaker, was therefore of great interest. Prime Minister Benjamin Disraeli decided to investigate the works, his purpose documented in a letter to Lady Bradford, in which he pledged to 'rise early tomorrow and go to Christie's'. Disraeli went on to say: 'If the Barker pictures are as rare and wondrous as I hear, it shall be hard if the nation does not possess them.'

Soon after the sale, doubts were raised about the attribution of *An Allegory*. From 1899 the line of questioning became official, and in 1951 Martin Davies – a curator at the National Gallery, and its director from 1968 – stated that it was 'by some feeble imitator of Botticelli'.

Later scientific examination of the painting backed up Davies's claim, suggesting that it was created in the late fifteenth or possibly early sixteenth century by a follower of Botticelli. *An Allegory* is now attributed to an 'Italian, Florentine' artist, while Botticelli's *Venus and Mars* continues to be admired by visitors to the National Gallery, London.

Sandro Botticelli's *Venus
and Mars*, c.1485.

THE SOLDIER'S TALE

Jacopo Carucci, called
Pontormo (1494–1557),
The Portrait of a Halberdier,
1528–30, oil (or oil and
tempera) on panel
transferred to canvas,
95.5 x 73 cm (37½ x 29 in)

SALE
31 May 1989, New York

ESTIMATE
Not published

SOLD
$35,200,000/£21,463,415

EQUIVALENT TODAY
$61,673,800/£47,700,000

A striking portrait of a swaggering, but poignantly youthful, foot soldier by Jacopo Pontormo broke all records when it sold in May 1989 for $35.2m, more than three times the previous record at auction for an Old Master painting. It was purchased by the J. Paul Getty Museum in California.

A pioneer of Mannerist style, the Florentine artist Pontormo was celebrated for his insightful psychological portraits, which are notable for their stylized elegance and refinement. *The Portrait of a Halberdier* expresses a certain bravado but also alludes to a complex and possibly troubled inner life. The sitter may have been the young nobleman Francesco Guardi, or even Duke Cosimo de' Medici himself.

The painting was part of the collection of the American philanthropist Chauncey D. Stillman, who had loaned it to the Frick Collection in New York in 1970. In 1989, Stillman's collection was auctioned in front of a capacity crowd in Christie's New York saleroom. Among those in attendance was George Goldner, curator of paintings and drawings at the J. Paul Getty Museum. Goldner did not bid, delegating the task to Julian Agnew of the London dealer Agnew & Sons Ltd; Agnew found himself locked in a battle with the New York dealer Jeffrey Deitch and an anonymous telephone bidder. After Agnew clinched the painting at $35.2m for the J. Paul Getty Trust, Goldner commented: 'It is sad for the Frick, but it is important that this painting is not going to an investor or to a Swiss vault.'

THE DEMON BARBER

Peter Paul Rubens
(1577–1640), *Samson and
Delilah*, c.1609, oil on wood,
185 x 205 cm (73 x 81 in)

SALE
11 July 1980, London

ESTIMATE
Not published

SOLD
£2,300,000/$5,360,000

EQUIVALENT TODAY
£8,810,000/$12,500,000

Rubens's dramatic *Samson and Delilah* was painted for his friend
Nicolaas Rockox, a powerful local politician in Antwerp who was also
a scholar, humanist and art collector. The picture was designed to be
the focal point of the 'great chamber' in Rockox's house, where it took
pride of place above the immense fireplace. It depicts the moment
when the beautiful Delilah, having inveigled Samson into revealing the
source of his superhuman strength, deprives him of it by summoning
a barber to cut off his hair. Samson's enemies, the Philistine soldiers
who will capture and blind him, lie in wait behind the door.

Although the Old Testament story of treachery and betrayal
might seem a strange choice for a grand reception room, Bible stories
featuring powerful women were very popular at the time. They
presented the opportunity to display erotic subjects, as well as a moral
lesson for male viewers on the consequences of unbridled passion.

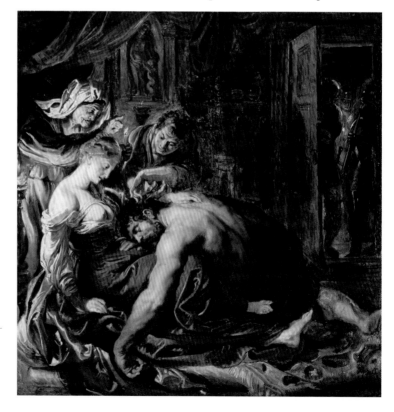

The *modello* (oil sketch)
for Peter Paul Rubens's
Samson and Delilah from
c.1609, identified and sold
at Christie's in 1966.

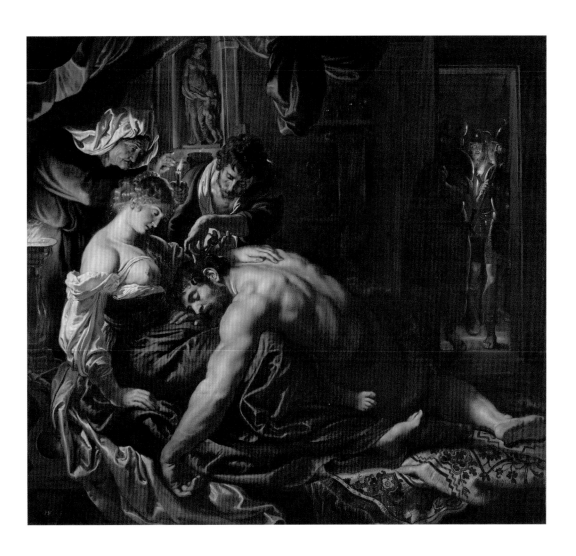

Christie's association with this painting began in the 1960s, when a small work by an unnamed artist was brought in for valuation. Apparently bought for a few shillings in the 1930s because the owner's ancestor liked the frame, the panel was recognized independently by both Brian Sewell and David Carritt as Rubens's *modello*, or preparatory oil sketch, for *Samson and Delilah*. As was the case with many of his commissions, Rubens made the *modello* in order to show Rockox how the finished work would look, and to obtain his approval before embarking on the full-scale painting. The *modello* also allowed Rubens to work out some of the practicalities of light, colour and perspective – crucial considerations, given that the finished painting would hang well above average head height and compete with the flames flickering in the fireplace below.

Following its discovery, the *modello* was sold in 1966 and is now in the Cincinnati Art Museum in Ohio. The full-scale painting, which was sold in 1980 for £2.3m, was acquired by the National Gallery in London. In 2014 the only known preparatory drawing for *Samson and Delilah*, recording Rubens's first thoughts for the composition, was sold in the I.Q. van Regteren Altena Collection sale, also at King Street, for £3,218,500 ($5,513,300), a world-record auction price for a drawing by the artist.

Drawing by Rubens
for *Samson and Delilah*,
c.1609, sold by Christie's
on 10 July 2014.

Nicolas Noël Boutet
(1761–1833), garniture
consisting of flintlock
rifle and pair of pistols,
c.1805, steel, walnut,
silver, gold, horn, mahogany
and velvet, rifle 110.5 cm
(43½ in) long; each pistol
43 cm (17 in) long

SALE
8 July 1970, London

ESTIMATE
Not published

SOLD
£43,050/$103,320

EQUIVALENT TODAY
£595,000/$855,000

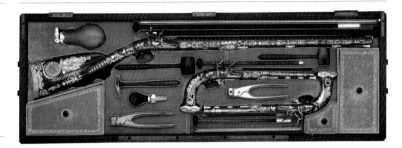

Detail of the trigger
guard, showing a silver
embellishment of Diana,
goddess of the hunt.

Some works of art and design are beautiful because there is nothing otiose or extraneous in them, no detail that is not performing a function or contributing to the whole. This flintlock rifle with matching pistols is not one of those objects. It is beautiful, beyond doubt, but the fascination of the group lies in its extraordinary extravagance, in the opulent decorative scheme that renders it almost unusable for its intended purpose.

All three weapons, now in the Metropolitan Museum of Art in New York, are encrusted with embellishments, like precious barnacles on the hulls of three slender ships. The barrels of the guns are spangled with tiny golden stars, the walnut stocks are piped with silver foliage and there are parrots and harps, stands of flags, scenes of hunting and fishing, winged caryatids and cherubs bearing torches, all rendered in cast and chased silver.

The set was produced by Nicolas Noël Boutet, who ran the Versailles Manufactory. It comes neatly packed in a veneered mahogany case that also contains all the paraphernalia associated with early nineteenth-century firearms: powder horn, ramrods, mallets and the various tools required to disassemble and clean the weapons. It is a presentation piece, a garniture that seems to have been a gift for a foreign dignitary. On the rifle there is a shield bearing the Polish heraldic symbol of the *trzaska* – two broken swords and a crescent moon – along with a later inscription in Russian: Nikolai Pompeyevich Shabelsky. So perhaps the function of this garniture was not to kill (all the signs are that it has never been fired), but to oil the wheels of diplomacy. For that task it seems eminently suited.

OUT WITH THE OLD, IN WITH THE NEW

Giovanni Antonio Canal, known as Canaletto (1697–1768), *The Old Horse Guards, from St James's Park, with Numerous Ladies and Gentlemen and Guards on Parade*, 1749, oil on canvas, 117 x 236 cm (46 x 93 in)

SALE
15 April 1992, London

ESTIMATE
Not published

SOLD
£10,120,000/$17,900,000

EQUIVALENT TODAY
£18,700,000/$25,900,000

In 1992, a painting of London by Canaletto sold at Christie's and caused a sensation when the musical impresario Andrew Lloyd Webber (see also pp.55–7 and 444) joined the proceedings at the last moment, bidding a spectacular £10,120,000 to stop the picture from leaving Britain for America. This late intervention established a new world record for the Venetian master.

The story of *The Old Horse Guards, from St James's Park* begins in 1746, when Canaletto travelled to London. The trip was made out of necessity; the ongoing War of the Austrian Succession (1740–8) meant that wealthy British patrons were wary of travelling on the Continent. Rather than watch his finances dwindle, Canaletto took action. Securing lodgings near Golden Square in London, he put notices in the *Daily Advertiser* inviting gentlemen to visit his studio. There, the 4th Earl of Radnor bought a painting that he thought 'the most capital picture I ever saw by the master'. The painting was *The Old Horse Guards, from St James's Park*, and it depicted the last decaying remnant of old Whitehall before it was demolished in 1750.

Canaletto had arrived in London at a crucial moment. The city was undergoing radical change, and was being transformed into a world-class metropolis. Through the rubble, dust and scaffolding, the artist witnessed the emergence of a wealthier, more self-assured city, and he

painted the new views he observed, from Christopher Wren's St Paul's Cathedral, which had been finished only thirty years previously, to Westminster Bridge, which was completed in 1750.

When the Earl of Radnor died, in 1757, his will bequeathed the painting to a relative, James Harris. It was the Harris family who consigned the painting to auction in 1996, and it has been on loan to various museums in Britain ever since.

<h1>157 A DECADENT DEATH</h1>

Lawrence Alma-Tadema
(1836–1912), *The Roses
of Heliogabalus*, 1888,
oil on canvas, 132.5 x 214.5 cm
(52 x 84½ in)

SALE
11 June 1993, London

ESTIMATE
£0.7m–0.9m/$1m–1.4m

SOLD
£1,651,500/$2,517,530

EQUIVALENT TODAY
£3,000,000/$4,190,000

All genres of art are subject to the ebb and flow of taste, perhaps none more so than Victorian painting and the work of the Victorian artist Lawrence Alma-Tadema. In his lifetime he could command £5,000 ($25,000) for a commission – a staggering sum at the time, equivalent to about £500,000 ($700,000) today. But half a century after his death his work was deemed to be almost worthless: *The Roses of Heliogabalus* changed hands in the 1960s for only £105 ($295; equivalent to £1,800/$2,500 today). Alma-Tadema's style was deemed too sentimental, too cloying, and his subject matter was dismissed as 'Victorians in togas'.

However, the seeds of Alma-Tadema's resurgence in price and popularity had already been sown. His work is often said to have inspired filmmakers such as Cecil B. DeMille (1881–1959), and his recovery was in part thanks to the fact that his portrayals of opulent, sensual excess had obvious cinematic appeal.

The Roses of Heliogabalus is a prime example of Alma-Tadema's visually alluring sensationalism. Heliogabalus, the fey and decadent boy emperor of ancient Rome, looks on as his dinner guests are literally buried alive in rose petals. This is a picture of a sadistic practical joke, a mass murder in progress. But what most viewers see – now as when Alma-Tadema was at the height of his fame – is a cascade of pink petals and a masterful technique. 'No incident could be more happy for the painter to exercise his skill upon,' wrote the *Magazine of Art* when the piece was first exhibited at the Royal Academy of Arts in London in 1888, and certainly Alma-Tadema went to extraordinary lengths to get it right. Every week through the winter of 1887 he had fresh roses sent from the French Riviera so that he could paint them precisely.

Like that of many Victorian artists, Alma-Tadema's currency benefited from the post-war price explosion that the art historian

Christopher Wood has called the 'greatest boom in art history'. In 1973, this painting sold for £20,000 ($49,000; equivalent to £216,000/ $302,000 today). When it next appeared in the saleroom, in 1993, it sold for more than £1.6m. The buyer was the Spanish businessman Juan Antonio Pérez Simón, whose collection of Victorian painting is comparable to that of Andrew Lloyd Webber (see pp.55–7, 296–7 and 444). They share a love of the period, and their rivalry in the saleroom has helped to reverse the fortunes of this genre of British painting.

158

HARBINGERS OF SPRING AND GOOD FORTUNE

The difficult technique of enamelling small, fragile objects (usually glassware) was first adapted for the decoration of porcelain vessels during the Qianlong period (1736–96) in China. Its perfection was linked with Tang Ying, the director of the imperial workshops at Jingdezhen between 1736 and 1756, and the careful preservation of this delicate bowl suggests that it may date from the time of his tenure.

This bowl is a superb example of the fine translucent porcelain produced during Qianlong's long and cultured reign. It is known as

'Swallows bowl', Qianlong
period (1736–96), porcelain
painted in *famille-rose*
enamel, 11.5 cm (4½ in)
in diameter

SALE
28 November 2006,
Hong Kong

ESTIMATE
Not published

SOLD
HK$151,320,000/
£9,991,000/$19,460,500

a *falangcai* ('foreign colours') piece, indicating that it was fired in Jingdezhen but specially enamelled in Beijing. It is painted in overglaze *famille-rose* colours. Pink, yellow, green, brown and black have been used to depict a pair of swallows flying near an apricot tree and an ancient willow. Chinese artists delighted in using rebuses: swallows were harbingers of spring and good fortune, and their association with the apricot anticipated success in the tough examinations on which a scholar's advancement in the civil service depended. On one side of the bowl, a ten-character poem in flowing 'grass' script welcomes the birds.

The 'swallows bowl' came into Western hands when Captain Oswald Liddell was in China (1877–1913). He acquired it for his growing collection of porcelain, the majority of which he purchased from Prince Ching, the last Regent of the Qing dynasty, and from the private secretary and advisor to the politician Li Hongzhang. The bowl was subsequently owned by the heiress Barbara Hutton, from whom Jun Tsei Tai bought it in 1971. In 2006 the collector Robert Chang, who is personally credited with doing much to establish Hong Kong's reputation as a world centre for Chinese art sales, and who bought the bowl in 1985 for HK$1.05m (£109,340/$126,950), celebrated his eightieth birthday by sending twenty treasures from his exceptional collection for auction, 'to pass on these pieces to other collectors who will appreciate them as much as I have'. Among them was the 'swallows bowl'. At the auction it was bought by Chang's own sister Alice Cheng, a company director and philanthropist who had bought a *famille-rose* vase for HK$41.4m (£3.6m/$5.3m) in 2002, which she donated to the Shanghai Museum.

AN ARTIST'S ARTIST

Dante Gabriel Rossetti
(1828–1882), *Pandora*, 1869,
pastel on two joined sheets,
94 x 66 cm (37 x 26 in)

SALE
9 June 2004, London

ESTIMATE
£0.8m–1.2m/$1.5m–2.2m

SOLD
£1,461,250/$2,671,340

One is a twentieth-century painter renowned for depicting urban life
in the industrial north of England; the other is a nineteenth-century
artist famed for being a member of the Pre-Raphaelite Brotherhood.
These two men, L.S. Lowry (1887–1976) and Dante Gabriel Rossetti,
share an unexpected link. Lowry declared that Rossetti was 'the one
man whose work I have ever wanted to possess ... I have always been
fascinated by certain types of the women he painted.'

 Lowry's passion for Rossetti's art led him to collect several of the
Pre-Raphaelite's works, and in 2004 one of the Rossettis he had owned
was put up for auction. It was a pastel, one of two finished studies that
Rossetti made in 1869 for an oil painting of the legendary woman
Pandora. The model for the work was the wife of his friend William
Morris, Jane, with whom Rossetti was deeply in love.

Pandora was sold by Christie's as part of a week-long series
of auctions of British art. The sales realized an overall total of £16.5m
($30.2m) and eight world records were broken, with the Rossetti pastel
fetching nearly £1.5m. It was not the first occasion that it had appeared
in a Christie's saleroom; just four years previously the same drawing
had been sold for £2,643,750 (nearly $4m), making it, at the time, the
most expensive British work on paper ever sold.

So why the significant price drop? When it came onto the market
in 2000, there was huge excitement. There had not been a sale of such
a large, iconic work like it for some time and it was being sold directly
from the estate of L.S. Lowry, who had bought the work in 1968. What
the price difference shows is how direct provenance, and being fresh
to the market, can add lustre to wonderful works of art. What it does
not mean is that the image is any less haunting or beautiful, or that it
could not achieve an even greater price in the future.

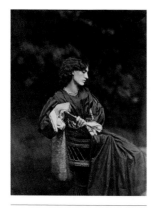

Dante Gabriel Rossetti's
model, Jane Morris,
photographed by John Robert
Parsons, 1865 (copied by
Emery Walker Ltd).

THE INDUSTRY OF SALES

Matthew Boulton (1728–1809), a pair of George III perfume burners, 1771, ormolu, 39 x 13.5 cm (15 x 5 in)

SALE
11 April 1772, London

ESTIMATE
Not published

SOLD
£29 8s/$134

EQUIVALENT TODAY
£3,400/$4,800

James Christie (1730–1803) was friendly with a number of entrepreneurs, including the manufacturer and engineer Matthew Boulton and the potter Josiah Wedgwood (1730–1785), and promoted their products actively through special auctions in his saleroom. He held sales for Boulton in 1770, 1771, 1772 and 1778, and one for Wedgwood in 1781.

In the 1760s, Boulton was expanding the family toy-making business to include decorative objects made from silver plate, Sheffield plate and ormolu, which had previously been a French speciality. Boulton's factory – which he ran in partnership with the merchant John Fothergill (1730–1782) – was in Birmingham, and he lacked a London showroom, so Christie's premises were an ideal place to show his new wares. Not only could people buy the works for sale, but also they might be tempted to commission new pieces inspired by what was on show. The previews were an additional opportunity for Boulton to gauge public reaction to his work and modify it accordingly, as the preface to the catalogue of the sale in 1771 makes clear: 'We have availed ourselves of the remarks and criticisms that were made upon our last year's productions. The colour of the gilding is greatly improved since that time.'

Going to see viewings before a sale was a fashionable pastime: a month after Boulton's first sale, Horace Walpole commented in a letter to the diplomat Horace Mann that the rage to see such exhibitions in London was 'so great that sometimes one cannot pass through the streets where they are'. At first Christie placed advertisements for the sales in the press, but Boulton worried that this would dilute the exclusivity of his products and encourage 'all the dirty journeymen, chasers, silversmiths etc.' to attend. It was subsequently decided that admission should be restricted to those with tickets – effectively the members of the nobility and gentry to whom Christie sent special invitations.

The 1772 sale included pairs of perfume burners designed in the George III 'antique' manner that take the form of sacred urns supported by maenads (female followers of Bacchus; as pictured). One particularly fine pair, which came with the addition of Bacchic pedestals, went to a suitably grand home, being bought by the banker Robert Child for his withdrawing room at Osterley Park House in Middlesex.

In antiquity perfume burners, or 'cassolettes', were associated with banquets and hospitality, so some of Boulton's pieces are appropriately decorated with reliefs of the satyr Silenus and other figures taking part in a Bacchic festival. When Robert Child's perfume burners were sold again, by his descendant, in 1994, they realized £276,500 ($423,045; equivalent to £490,000/$706,500 today) against an estimate of £50,000–80,000 ($76,500–122,400; £88,800/$128,000 today).

Left: A similar pair of George III ormolu perfume burners, c.1779, by Matthew Boulton. These sold for £49,250 ($95,988) at Christie's King Street, London, in 2008.

Right: Portrait detail of the eighteenth-century manufacturer and engineer Matthew Boulton by Carl Frederik von Breda from 1792.

A LADY OF INFLUENCE

Thomas Gainsborough
(1727–1788), *Georgiana,
Duchess of Devonshire*,
c.1787, oil on canvas,
123 x 96.5 cm (59½ x 45 in)

SALE
6 May 1876, London

ESTIMATE
Not published

SOLD
10,100 guineas/
£10,605/$57,480

EQUIVALENT TODAY
£891,000/$1,290,000

Thomas Gainsborough's portrait of Georgiana Spencer, Duchess
of Devonshire, proved a sensation when it went under the hammer
in 1876. The painting shows the voluptuous duchess posing for
the famed society painter, grasping between her thumb and forefinger
a pink rosebud. The flirtatious, suggestive stance reflects, for some,
Georgiana's reputation for sexual immorality. The portrait made
history as it sold for 10,100 guineas, the highest price ever paid
for a painting at auction at that time.

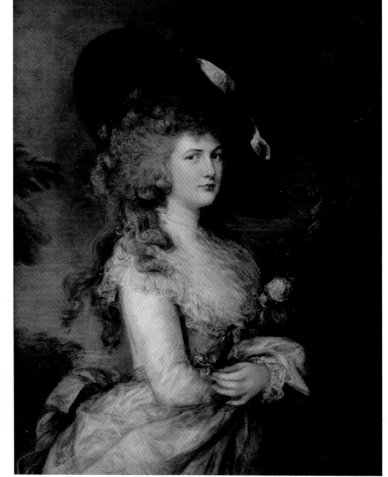

Photograph of Adam Worth,
the 'Napoleon of Crime',
c.1890.

The silk manufacturer Wynn Ellis had been given the painting by his friend John Bentley, a picture restorer, in the 1850s. The feverish clamour to see the notorious picture, which went on display when Ellis's collection was sold at the King Street saleroom, was reported by *The Times* on 8 May 1876: 'All the world had come to see a beautiful Duchess created by Gainsborough, and, so far as we could observe, they all came, saw, and were conquered by the fascinating beauty.' This delirium was hardly surprising, since, as the art historian Gerald Reitlinger pointed out in *The Economics of Taste* (1961–70), from the 1850s to the 1930s British eighteenth-century portraits were the most sought-after and expensive paintings in the world.

The sale itself was an art-market landmark, with *The Times* reporting that 'a burst of applause showed the universal admiration of the picture' when it was placed before the crowded audience. The frenzied bidding war was as exciting as it was suspenseful, the newspaper continued: 'Still the fight went on briskly with 500s, till there was a shout of applause at 10,000 guineas, and then a serious pause for breath between the combatants, when Mr [William] Agnew [a London art dealer] was the first to challenge "any further advance" with his 10,100 guineas, and won the battle in this extraordinary contest.' The report evokes the heady atmosphere of the sale: 'The whole affair was, of its kind, one of the most exciting ever witnessed; the audience, densely packed on raised seats round the room and on the floor of the house, stamped, clapped and bravoed.'

But the drama did not end there. Just a few days later, on 25 May, the portrait was cut from its frame at Agnew's by Adam Worth, known as the 'Napoleon of Crime'. For twenty-five years, the criminal mastermind kept the painting for his private delectation, hidden in a false-bottomed trunk.

In March 1901 Worth – having confessed to his various crimes – handed over the painting to Charles Morland Agnew, William Agnew's son, at the Auditorium Hotel in Chicago. He is reported to have said: 'The Lady must go home.' The painting was then sold to the American millionaire John Pierpont Morgan for a reported $150,000 (£30,800; equivalent to $4.3m/£2.95m today), and it stayed in the family collection until it was sold again in 1994. At the behest of the Duke of Devonshire, it was purchased by the Chatsworth House Trust, the charity that administers his country estate. The portrait is now at Chatsworth House in Derbyshire.

Both sides of a hand-tinted carte-de-visite, published in 1876, announcing a reward for the recovery of the stolen Gainsborough portrait of the Duchess of Devonshire.

THE ART
OF PROVOCATION

Edwin Long (1829–1891),
The Babylonian Marriage Market, 1875, oil on canvas,
172.5 x 304.5 cm (66 x 120 in)

SALE
13 May 1882, London

ESTIMATE
Not published

SOLD
6,300 guineas/
£6,615/$32,215

EQUIVALENT TODAY
£595,000/$858,500

In May 1881, a mysterious buyer, known simply as 'Mr Thomas', made his first appearance at Christie's, paying a record-breaking 6,500 guineas (£6,825; equivalent to £615,000/$888,000) for Edwin Landseer's *Man Proposes, God Disposes* (1864). It was the beginning of a two-year spending spree for this purchaser, who stunned the market twelve months later by securing Edwin Long's *The Babylonian Marriage Market* for 6,300 guineas, then a record for a living English painter. The art critic George Redford reported in *The Times* that 'the greatest curiosity prevailed and many questions were asked about this new purchaser in the field, and whether the name were not simply a *nom de guerre* for an American buyer.' In fact, the newcomer was a gentleman called George Martin, buying on behalf of his brother-in-law Thomas Holloway, a successful businessman and philanthropist who founded Royal Holloway in London, one of the first women's colleges in Britain.

Holloway was building an art collection for his nascent institution, and wanted artworks that would engender debate about female emancipation. Long's painting was inspired by a passage from the *Histories* by Herodotus (fifth century BC), and described a marriage

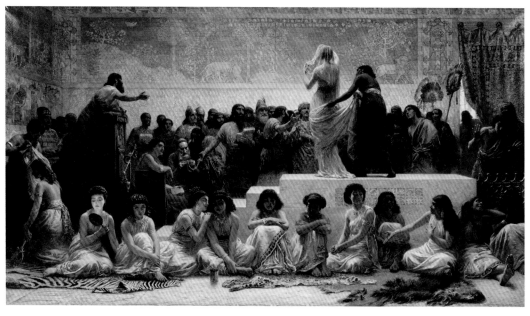

auction in which women were sold in order according to their relative beauty. The painting was an interesting choice to provoke debate, its subject squarely at odds with the ideology of the newly founded women's college.

George Martin – or 'Mr Thomas' – successfully outbid all his competitors to secure the painting, and the purchase was greeted with such a stamping of feet that it drowned out the auctioneer's voice. It remains one of the finest works in the Royal Holloway collection.

163

A SATIRE
ON HIGH SOCIETY

William Hogarth (1697–1764),
Marriage À-la-Mode, c.1743,
oil on canvas, 70 x 91 cm
(27½ x 35½ in)

SALE
10 February 1797, London

ESTIMATE
Not published

SOLD
1,000 guineas/£1,050/$4,660

EQUIVALENT TODAY
£98,070/$138,765

William Hogarth's satirical
engraving *Gin Lane*,
published in 1751.

Today William Hogarth's *Marriage À-la-Mode*, a satirical tale of greed and social-climbing spread over six canvases, hangs in the National Gallery in London. However, when Hogarth attempted to sell the series in 1751, he struggled. The fault was, in part, the artist's own. The printing press had allowed Hogarth to produce engraved copies of his paintings and he had exploited the medium fully, meaning that *Marriage À-la-Mode* could be obtained relatively inexpensively.

An artist of the coffee house, Hogarth was a keen observer who created works that could be understood by everyone. He told rabid stories of modern life in a London that was crime-ridden, flamboyant and filthy, and in which no inhabitant was too grand or too moral to escape his scathing satire. If his popular print *Gin Lane* (1751) was where he sought to depict the deranged hell of poverty, *Marriage À-la-Mode* was an attack on the dissolute aristocracy.

The six pictures tell the grotesque narrative of a brokered marriage between a rich merchant's daughter and the son of a bankrupt earl. The ill-advised union, built on snobbery and greed, is a disaster and ends sensationally with murder, a hanging and a suicide.

When Hogarth completed the paintings in about 1743 he hung them in Christopher Cock's auction rooms in Covent Garden. He had intended to sell them as soon as the engravings for the prints had been completed, at a moment when interest was high. But his dissatisfaction with the proceeds from earlier auctions caused him to postpone the sale until 1751. Perhaps it was a missed opportunity, because when *Marriage À-la-Mode* finally came on to the market there were only three bidders. Hogarth's friend John Lane bought the entire set for 126 guineas (£132/$600; equivalent to £18,700/$26,450 today), 'a sum too contemptible to be named,' wrote John Pye, the author of *Patronage of British Art* (1845).

After Lane died, the family sold the paintings at Christie's in 1797, when they were bought by the businessman John Julius Angerstein (1735–1823), for a substantial 1,000 guineas (£1,050/$4,660; equivalent to £98,070/$138,765 today). The British government subsequently acquired thirty-eight works from Angerstein's collection in a sale brokered by Christie's in April 1824. These works, that included Hogarth's *Marriage À-la-Mode*, were to form the original core of the National Gallery collection.

Hogarth's *The Tête à Tête*, the second painting in *Marriage À-la-Mode*, c.1743.

A TREASURE TROVE OF CHIPPENDALE

Thomas Chippendale
(1718–1779), the Dumfries
bookcase, 1759, parcel-gilt
padauk and gilded limewood,
230 x 172.5 x 61 cm
(90½ x 68 x 24 in)

SALE
Private treaty sale in June
2007 prior to a proposed
sale on 4 July 2007

ESTIMATE
For the Dumfries collection:
£2m–4m/$3.9m–7.9m

SOLD
Dumfries house, contents
and estate: £45m/$88.9m

Dumfries House in Ayrshire was built between 1754 and 1760 for the
5th Earl of Dumfries (1699–1768), and is widely considered the finest
architectural commission undertaken by the architect brothers John,
Robert and James Adam in the early years of their partnership.

The earl, who was widowed in 1755, spent lavishly on his home,
perhaps in the hope of attracting a new wife. But although he married
again, in 1762, the union failed to produce the hoped-for heir. The
house was filled with an exceptional range of furniture, specially
designed to complement the rococo interiors, including more than
fifty pieces by Thomas Chippendale (see pp.311, 430–1) made during
the period in which he published his *The Gentleman and Cabinet
Maker's Director* (1754), as well as pieces by the Edinburgh furniture-
makers Alexander Peter, William Mathie and Francis Brodie.

Chippendale supplied many of the objects that a grand house
might require. His account books reveal that he delivered a bed,
elbow chairs, settees, a library table, girandoles, pier glasses, lanterns,
a breakfast table, a clothes press, a shaving table and wine coolers to
Dumfries House. The most exceptional item was a breakfront bookcase
made of padauk wood, probably commissioned for Lady Dumfries's
bedroom on the first floor. It was a multipurpose piece of furniture,
combining the functions of china cabinet, bureau, dressing table,
clothes press and chest of drawers.

The interior of Dumfries
House, Ayrshire, showing
the 1759 Chippendale
bookcase in situ.

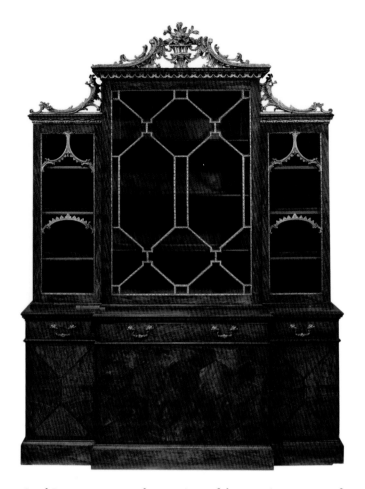

Lord Bute was extremely conscious of the great importance of the house as a unique ensemble and was determined that it should be preserved. Working with Christie's, he offered it to the National Trust for Scotland. However, despite negotiations over a number of years, a satisfactory outcome could not be reached and there was no alternative but to go ahead with a sale in 2007. There was an energetic response from various heritage bodies, pointing out that the dispersal of this unique and largely untouched time capsule dating from the Scottish Enlightenment would be an incalculable loss. While Christie's set about cataloguing and valuing the contents and packing up the furniture, urgent negotiations went on behind the scenes in an attempt to secure the funds to preserve the house intact for the nation.

On 27 June 2007, days before the scheduled sale, it was announced that a consortium of charitable bodies and the Scottish government, led by Charles, Prince of Wales, had managed to raise the £45m required to secure the house, its contents and the estate, and to provide it with an endowment to ensure its future. The furniture, which had been on its way to London for the auction, was put back in place. A comprehensive programme of restoration was started, and the magnificent mansion was opened to the public in 2008.

THE GENTLEMAN AND THE CABINET MAKER

Robert Adam (1728–1792)
and Thomas Chippendale
(1718–1779), Harewood House
library desk, c.1770, oak,
rosewood, satinwood, oak
lining and brass mounts,
85 x 206 x 121 cm
(33½ x 81 x 47½ in)

SALE
1 July 1965, London

ESTIMATE
Not published

SOLD
£43,050/$120,540

EQUIVALENT TODAY
£744,000/$1,054,000

When Edwin Lascelles, 1st Baron Harewood (1713–1795), commissioned Robert Adam to design Harewood House, his magnificent new home near Leeds in Yorkshire, he remarked: 'I would not exceed the limits of expense that I have always set myself. Let us do everything properly and well, *mais pas trop*.' To achieve his goal, Lascelles assembled a team of England's finest designers: the York-born architect John Carr (1723–1807), interior designer Robert Adam, furniture-maker Thomas Chippendale and landscape designer Capability Brown (1716–1783).

The man holding the project together was Adam, a visionary who had returned from his Grand Tour of the Continent in 1758 with a portfolio of drawings of Classical buildings that heralded a new architectural style. It was one that discarded the rococo elaboration and ornamentation of the mid-eighteenth century in favour of neoclassicism: clean lines, elegant proportions, order and discipline.

Adam's enduring partnership with Chippendale resulted in some of the most beautiful furniture of the eighteenth century. Chippendale was born in Otley, Yorkshire, but established a workshop in St Martin's Lane in London, where he employed between forty and fifty artisans. In 1754, he published his first edition of *The Gentleman and Cabinet Maker's Director*, the first work of its kind devoted to furniture and furnishing designs (top left). It was a catalogue from which clients could choose elements that could be incorporated into their own custom-made furniture. Using fashionable and exotic materials, including ebony, satinwood, rosewood, purple-heart and ivory, Chippendale evolved his own, unique interpretation of the neoclassical style pioneered by Adam, James Stuart and William Chambers.

The furniture commission at Harewood House was Chippendale's largest and most lucrative undertaking, amounting to £10,000 (about $45,000; equivalent to £1.2m/$1.7m today). In 1965, Christie's sold this Thomas Chippendale library desk, created for Harewood House, for £43,050, an auction record at the time. Veneered with rosewood and inlaid with designs of satinwood and other stained woods, the desk was bought for the nation with the aid of four anonymous benefactors, as well as support from Blairman & Sons, the Victoria and Albert Museum and the National Art Fund. It is now on display at Temple Newsam House in West Yorkshire, along with objects from the collection of the Chippendale Society.

ALL THE WORLD'S A STAGE

The Chandos Portrait,
possibly William Shakespeare,
c.1600–10, oil on canvas,
55 x 44 cm (22 x 17 in)

SALE
15 August–7 October 1848,
Stowe House,
Buckinghamshire

ESTIMATE
Not published

SOLD
£372 15s/$1,815

EQUIVALENT TODAY
£33,400/$48,100

The sale in 1827 of the Duke of York's art collection was followed in 1848 by the spectacular sale of the Duke of Buckingham's collection at Stowe, in Buckinghamshire. The duke had been forced to leave the country the previous year because of mounting debts, and his London house, on Pall Mall, had been sold, as well as a number of the family estates in England and Ireland.

Stowe was next to go under the hammer. In a sale that lasted forty days, the most valuable paintings from the extensive art collection

(including works by Hans Holbein, Anthony van Dyck and Peter Lely), sculptures, superb pieces of furniture, bottles from the duke's excellent cellar of wines and spirits, and linen from the servants' bedrooms were all dispersed, realizing a total of £75,562 ($368,000; equivalent to £7m/$10m today).

The momentous fall from grace of a noble family received widespread publicity. *The Times* observed the phenomenon with some dismay, reporting that 'the British public has been admitted to a spectacle of painful interest and grave historical import. One of the most splendid abodes of our most regal aristocracy has thrown open its portals to an endless succession of visitors, not to enjoy the hospitality of the Duke, or to congratulate him on his countless treasures of art, but to see an ancient family ruined, their palace marked for destruction, and its contents scattered to the four winds of heaven.' The number of visitors to the house was so large that transport was laid on to take the curious and acquisitive from the railway station to Stowe. The cavalcade, 'in its utter absence of distinction,' reminded *The Times* correspondent of the road to Epsom on Derby Day. 'It was like a picnic,' he lamented, with stalls set up to provide refreshments.

One of the most intriguing paintings offered for sale was this portrait identified as William Shakespeare. According to the catalogue it was 'presumed to be the work of Burbage, the first actor of *Richard III*, who is known to have handled the pencil,' and was the only image of the writer with any claim to have been painted from life. It was bought at the Stowe sale by Lord Ellesmere, who in turn donated it to the National Portrait Gallery on its foundation in 1856. The Gallery's first acquisition, it remains a highlight of the collection.

The Stowe sale had an unexpected and welcome consequence for Christie's. During the preparation for the auction it became obvious that the son of the gamekeeper had an informed interest in the pictures. This young but knowledgeable man was Thomas Woods, who had grown up with the collection. In 1859, he joined George Christie and William Manson as a partner in the firm, which then became known as Christie, Manson & Woods, the name by which it is officially known today.

THE PILGRIMAGE OF THE TALES

Geoffrey Chaucer,
The Canterbury Tales,
first edition, printed at
Westminster by William
Caxton, 1476 or 1477,
370 paper leaves bound
in 18th-century red morocco
leather, tooled in gold,
28 x 19.5 cm (11 x 7½ in)

SALE
27 March–6 April 1776, London

ESTIMATE
Not published

SOLD
£6/$27

EQUIVALENT TODAY
£720/$1,045

If you happened to be strolling through the London district of Rotherhithe in the mid-eighteenth century you might have chanced upon a corpulent middle-aged man shuffling along the street. He would have been dressed in a fine coat with gold buttons and a well-powdered wig, a cane in one hand, a parcel of books in the other. At his heels would have been a pack of chattering children, for he was a favourite local character. This man was John Ratcliffe, whose modest house off Jamaica Road held one of the greatest private libraries in the country.

The mid-eighteenth century was a golden age for book-collecting, when a shared passion transcended class boundaries. Ratcliffe, a Bermondsey-born chandler, came to his passion late, having caught the book-buying bug by studying the old pages in which he packaged his goods. By the 1760s he was holding a small salon every Thursday morning at which he revealed his latest finds – acquired on endless perusals of London's booksellers – to a small coterie of bibliomaniacs, including James West, president of the Royal Society.

It was West who sold Ratcliffe this volume, bound in gold-tooled red morocco leather, whose gilt spine read: 'Chawcer [*sic*] First Edition, Printed by W. Caxton about 1476'. William Caxton's edition of Geoffrey Chaucer's *The Canterbury Tales* was one of the earliest books printed in England. Caxton was England's first printer, having moved his workshop from Bruges to London earlier that same year.

Far left: the red morocco leather spine of John Ratcliffe's first printed edition of Chaucer's *The Canterbury Tales*, produced by William Caxton, 1476 or 1477.

Left: a detail of the printed page.

Above: a portrait of Geoffrey Chaucer from an illuminated version of *The Canterbury Tales* in the British Library, London.

After Ratcliffe's death, the entire 'Bibliotheca Ratcliffiana' was sold by Christie's in 1,675 lots, many of which consisted of tens of volumes. The sale was held over nine evenings in March and April 1776. The Chaucer was acquired for the Marquess of Rockingham at a price of £6 (equivalent to £720 today). It descended through the Marquess's family until July 1998, when Christie's was again charged with its sale. By then, the Rockingham Chaucer was the only Caxton first edition of *The Canterbury Tales* left in private ownership, and so its sale represented the last opportunity for a collector to acquire a copy.

On the evening of 8 July 1998 at Christie's King Street, it became the most expensive printed book ever sold when the American-British philanthropist Sir Paul Getty acquired it for £4,621,500 ($7,575,260). The Rockingham Chaucer is now held in the private Getty library at Wormsley Park in Buckinghamshire, England.

168 LADY IN DISGUISE

Mademoiselle la Chevalière
d'Éon sale

SALE
14 February 1792, London

ESTIMATE
Not published

SOLD
£344 17s 7d/$1,540

EQUIVALENT TODAY
£37,500/$54,000

Charles d'Éon (1728–1810) was a remarkable person by anyone's standards. In the course of a tempestuous life he was a royalist spy, a decorated soldier, a wily diplomat, an expert fencer and a glamorous celebrity. He was also an avaricious collector, a colossal spender of money and a famous transvestite.

D'Éon lived the first half of his life entirely as a man. He distinguished himself as an envoy of the French crown in Russia and England, and earned the rank of *chevalier*, or knight. It was during his time as an embassy secretary in London that d'Éon first ran up unmanageable debts. As part of his information-gathering work, he lavished dinners on such political figures as Horace Walpole, but also spent extravagantly on himself.

He became well known in London society, notoriously so after he precipitated a bitter and very public dispute with his employer, the French ambassador. That scandal so embarrassed the French government that d'Éon was recalled to France. Before leaving England, he took to dressing as a woman – ostensibly as a disguise to help him elude his many enemies. He even announced that he had been a woman all along, and he let it be known that henceforth he should be referred to as *chevalière* – the feminine grammatical form of his title.

D'Éon subsequently spent several quiet years on his estate in Burgundy. In 1785 – now living as a woman – he returned to London

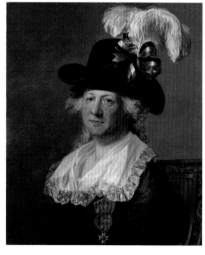

Right: an engraving of Charles d'Éon, c.1762–3, showing him dressed as both a fashionable man and woman.

Far right: a portrait of d'Éon from 1792 by Thomas Stewart, after Jean-Laurent Mosnier.

to clear his debts, but it was a forlorn hope. He continued to be a reckless buyer of beautiful things, and after the French monarchy fell in 1789, his various royal pensions and gratuities were stopped. By 1791, d'Éon was penniless, and decided to sell his library and some of his clothes. Christie's pre-sale pamphlet stated wryly that the lots would include 'wearing apparel, constituting the wardrobe of a captain of dragoons and a French lady' – a rare in-catalogue joke.

The sale was cancelled when the City of London raised £475 ($2,160) for d'Éon (equivalent to £51,000/$73,500 today): the *chevalière* was after all still a popular figure. However, by the following year he was in penury once more, and this time a sale of jewellery and other objects went ahead. It included, among other things, a 'cornelian ring and seal mounted in gold, a cleopatra in a fine hyacinth, a silver pocket compass and dial'. The seventy-four lots raised nearly £345, but this was sadly not enough to solve d'Éon's financial woes. The outcome was always going to be disappointing – a fact that the younger James Christie acknowledged in the catalogue with a doctored quotation from the Roman poet Juvenal: 'A fine thing it is,' read the Latin, 'if an auction should be held of a lady's properties.'



169

MIRROR, MIRROR ON THE WALL



Attributed to John Vardy (1718–1765), pair of early George III pier glasses, c.1760–5, giltwood and glass, 236 x 147 cm (93 x 58 in)

SALE
8 July 1999, London

ESTIMATE
£300,000–500,000/
$470,000–780,000

SOLD
£716,500/$1,115,600

EQUIVALENT TODAY
£1,110,000/$1,566,000

The pair of matching George III giltwood pier glasses sold in July 1999 is a fine example of the cabinetmaking partnership of John and Thomas Vardy.

John Vardy rose from humble beginnings to become a well-known architect and furniture designer in the Palladian style. He was born in Durham, the son of a labourer. By the age of eighteen, he had become Clerk of the Works at the Queen's House in Greenwich. By 1737, he was working with the eminent architect William Kent on the Treasury building in Whitehall. He cited both Kent and Inigo Jones as the two greatest influences on his work, and by the 1750s, had amassed an impressive private clientele, including Lord Montfort, the Earl of Dorchester and the 5th Duke of Bolton, who commissioned these mirrors in about 1760–5.

The upper part of each rounded rectangular mirror is framed by palm leaves, while swagged laurel garlands, held by a pair of fishtailed Triton figures, cross the top of the glass. The scrolled broken pediment centres on an eagle with outspread wings, while beneath the mirror,

a shell is flanked by scrolled acanthus. Designed by John Vardy, the carving was the work of his younger brother Thomas, who was apprenticed in 1740 to James Richards, master carver to George II.

The Duke of Bolton proved a sympathetic patron. He gave John Vardy a free hand at his house at 37 Grosvenor Square, London, and allowed him to emerge from the long shadows cast by other notable architects such as George Gray and James 'Athenian' Stuart. Bolton was a successful career soldier, who rose to the rank of lieutenant general in 1752, and succeeded his father to the dukedom in 1759. He died just six years later, before he was able to enjoy Vardy's work.

THE PHOTOGRAPHER
AT WORK

Jabez Hogg (1817–1899),
Jabez Hogg and Mr Johnson,
1842 or 1843, quarter-plate
daguerreotype, 8 x 11 cm
(3 x 4 in)

SALE
10 March 1977, London

ESTIMATE
Not published

SOLD
£5,800/$10,150

EQUIVALENT TODAY
£32,200/$46,100

As the first ever photograph of a man taking a photograph, this picture has special significance for historians and collectors of photography. It was taken in 1842 or 1843, within three or four years of the invention of the daguerreotype by the French painter Louis-Jacques-Mandé Daguerre in 1839.

Both men in the picture can be identified, and both were involved in the technological process of taking photographs. The young man on the left is Jabez Hogg, one of the pioneers of the daguerreotype in England. The sitter is an American, William S. Johnson, whose son John opened the first photographic portrait studio in New York in March 1840 (in partnership with Alexander S. Wolcott). We see Hogg holding the lens cap of his camera in one hand, while in the other is the stopwatch he is using to time the exposure; Johnson, meanwhile, sits as still as he possibly can – for Hogg as well as for the unseen and unknown photographer behind the lens of the second camera.

The photograph was made at the London studio of Richard Beard, a former coal merchant who was the patentee of the daguerreotype process in England and Wales. (Beard opened the first photographic portrait studio in London, with John Johnson, in March 1841.)

The image was taken to illustrate a book the twenty-six-year-old Hogg was writing – *A Practical Manual of Photography* (1843) – although it necessarily appeared in the book reproduced as a woodcut. Photography did not become Hogg's life's work, but one imagines that his youthful experiments with the artificial eye of the camera may have informed his distinguished career as an ophthalmic surgeon.

The quarter-plate daguerreotype of the photographer at work went under the hammer in 1977 and sold for a record price of £5,800. It was later acquired by the National Museum of Photography, Film and Television (now the National Media Museum) in Bradford, Yorkshire.



171

THROUGH THE LENS OF IRVING PENN



Irving Penn (1917–2009),
*Poppy, Glowing Embers
(New York)*, 1968 (printed
1989), dye-transfer print,
45 x 56 cm (17½ x 22 in)

SALE
14 April 2010, New York

ESTIMATE
$70,000–90,000/
£45,500–58,500

SOLD
$182,500/£118,660

Hailed as one of photography's most respected and influential figures, Irving Penn rose to prominence around 1950 with the austere elegance of his fashion shoots for *Vogue*. He worked for the magazine for seven decades and produced more than 150 covers. His work was almost exclusively studio based and included masterful still life and portraiture.

Penn embarked on a series of flower studies for which he had selected flowers flown in from Europe and delivered to his studio, where he would capture their beauty just as the blooms were starting to wilt. Mortality was a recurrent theme in his work, and poppies – symbols of death and remembrance – were among his most celebrated floral subjects. With such a morbid association this print is perhaps a surprising choice for a Christmas present, but the message on the back of the photograph reads: 'Merry Christmas with love to Pat, 1989.' Patricia McCabe had been Penn's trusted assistant for the previous three decades, 'the rock on which our studio stands,' as Penn said. 'She is the voice of our studio, its spirit and its conscience.'

Poppy, Glowing Embers (New York) was one of sixty-seven photographs Penn gifted to McCabe over the years. These were offered for sale from her estate in 2010, just over six months after Penn's death. Collectively, the photographs reveal the breadth of his work, ranging from his beautiful, intensely coloured flowers to portraits of tribal peoples from different corners of the globe, superbly composed still-life studies and witty and penetrating portraits. Curiously there was no fashion work. The sale was not only testament to the affection a master photographer held for his long-term personal assistant; it was also the most significant group of works by Penn ever to come to auction.

Many works in the sale had rarely appeared at auction, if at all, and it was standing-room only in the Rockefeller Plaza saleroom. A rare 'white glove' sale (meaning that every single lot sold), the auction lasted for more than two hours, with protracted bidding battles for numerous lots. The collection of Patricia McCabe realized $3.8m (£2.5m), and *Poppy, Glowing Embers (New York)* sold for more than double its high estimate.

172 THE THREE GRACES

Almost as soon as Georges Seurat completed his monumental canvas *A Sunday on La Grande Jatte* (1884–6), he embarked on another large-scale figure painting. This was the first, larger version of *Les Poseuses* (1886–8), featuring a trio of nude models who pose in front of the vast *Grande Jatte* painting, which is shown on one wall of Seurat's studio. Although none of the three figures looks at it, it is almost as though they

Georges Seurat (1859–1891),
Les Poseuses (*petite* version),
1886–8, oil on canvas,
35.5 x 49 cm (15½ x 19 in)

SALE
30 June 1970, London

ESTIMATE
Not published

SOLD
£430,500/$1,033,200

EQUIVALENT TODAY
£5,950,000/$8,646,200

have just stepped out of the painting, since the hats, parasols and clothes that are piled all around also appear in the park scene behind them.

The painting reads as an essay on the opposition of nature and artifice, with the relaxed forms of the nude models (*poseuses*) contrasting with the stilted figures of the clothed promenaders. Like *La Grande Jatte*, *Les Poseuses* is executed according to Seurat's theory of 'optical painting', in the style that came to be known as pointillism (although he preferred the term 'divisionism'). In *Les Poseuses*, however, Seurat's technique has evolved, and smaller, stippled dots of colour are intended to blend together in the viewer's eye. Two years later, having completed this vast studio scene, Seurat went on to make a small-scale replica of it.

This second, more intimate version of *Les Poseuses* was bought in 1936 by the Philadelphian Henry McIlhenny, whose family fortune was founded on the invention of the gas meter. Celebrated for his charm and hospitality, McIlhenny was – according to Andy Warhol – 'the only person in Philadelphia with glamour'. Having joined the Philadelphia Museum of Art as an assistant curator in 1933, McIlhenny was associated with the institution – as curator, member of the board of trustees, vice president and finally chairman – until his death in 1986. Most of his collection was bequeathed to the museum, but because the large version of *Les Poseuses* already resided in Philadelphia, in the Barnes Collection, he decided to sell the *petite* version in 1970. The reason, he said, was 'to have plenty of cash for my old age'.

BOHEMIAN BEAUTY

Julia Margaret Cameron
(1815–1879), May Prinsep
('Head of St John'), 1866,
albumen print, 38 x 30.5 cm
(15 x 12 in)

SALE
14 November 2006, London

ESTIMATE
£10,000–15,000/
$18,900–28,400

SOLD
£48,000/$90,930

This bold, penetrating image by Julia Margaret Cameron of her niece May Prinsep in the guise of St John illustrates why the photographer is celebrated as one of the great portraitists in the history of the medium. The Victoria and Albert Museum in London, in the context of its centenary exhibition in 2015 celebrating the photographer's work, rightly called her 'one of the most important and experimental photographers of the nineteenth century'. The subject she chose here also reminds us of the high Victorian context in which it was made.

The allegorical inspiration for this study situates Cameron in an age in which Christian imagery was central to the work of many artists, including those in the Pre-Raphaelite Brotherhood. Yet the simplicity of this photograph, with its tight cropping of the head and soft focus, gives the subject an engaging poetic and mystical quality. It flies in the face of nineteenth-century photography's preoccupation with sharpness and fine detail, which were deemed essential qualities in any successful portrait of that time.

Cameron is known for overriding the conventions of portraiture and photography in pursuit of her artistic ends. Her aim was to evoke the personality of her sitters, rather than merely record their features. She found that a very shallow depth of field and a softening of the focus allowed atmosphere to triumph over what she perceived to be distracting detail. Nor was she troubled by irregularities in the emulsion or other minor imperfections on the negative, provided she felt she had captured the essential character of her subject.

'While some of her images are more elaborate and theatrical, for me, the simpler, the better,' says Philippe Garner, deputy chairman at Christie's and a specialist who has handled the sale of many of Cameron's prints over the last four decades. Garner describes how this Calcutta-born innovator defied the odds in mid-nineteenth-century Britain to make her mark in a nascent medium. 'In this haunting picture we see the key ingredients of her success: a unique vision of harnessing the magic of light and photochemistry to her artistic ends; the readiness to subvert accepted technical standards in the fulfilment of her objectives; and her fearless personality that drew her subjects, including domestic staff, distinguished figures and family, into her project.'

Julia Margaret Cameron
photographed by her
son, Henry Herschel Hay
Cameron, c.1873.

This rich albumen print is mounted on card bearing the blind-stamp of the London gallery P&D Colnaghi & Co., which published her work. Cameron showed exceptional determination, first in the making of her pictures and then in their promotion. As Garner points out, the appeal of this print is enhanced by its provenance. It was consigned by the heirs of the Pre-Raphaelite 'brother' William Michael Rossetti (1829–1919), a reminder of the artistic bohemia in which Cameron made her mark.

LOVE CONQUERS ALL

Edward Coley Burne-Jones (1833–1898), *Love among the Ruins*, exhibited 1873 (overleaf), watercolour, body colour and gum arabic on paper, 96.5 x 152.5 cm (38 x 60 in)

SALE
11 July 2013, London

ESTIMATE
£3m–5m/$4.5m–7.6m

SOLD
£14,845,875/$22,452,925

In 2013, a watercolour by Edward Coley Burne-Jones, *Love among the Ruins*, fetched nearly £15m at auction – three times its high estimate. The sale made the headlines, but there was little mention of the decades of work by Christie's that culminated in this staggering price. For more than twenty years, Christie's Estates and Appraisals, and the Victorian Pictures team had visited the owners of the watercolour to update the valuation of the work. Such a long-standing relationship helped to ensure that, when the time was right, the sale of the painting was held at Christie's.

The picture takes its title from a poem of the same name by Robert Browning (1812–1889), yet what is depicted has only a loose connection to Browning's words. Burne-Jones's *Love among the Ruins* revels in ambiguity: there is no narrative context, no explanation for the setting, no clarity when it comes to the emotions of the two lovers. According to his widow, Burne-Jones 'wanted everyone to see in [his pictures] what they could for themselves'. What many have chosen to see is a portrait of Burne-Jones's lover Maria Zambaco: the head of the young woman is thought to have been modelled on her. Maria was a cousin of Burne-Jones's friends and patrons the Ionides, and the two began a tempestuous affair in the late 1860s. At the time of the sale in 2013, the catalogue stated: 'Although much about the liaison is shrouded in mystery, it seems not unlikely that at some stage the lovers saw themselves as unhappy outcasts, clinging together in a bleak and hostile world.'

While the picture itself remains ambiguous, the reception it received was anything but. *Love among the Ruins* has long been praised as one of the most perfect examples of Burne-Jones's art. Malcolm Bell, the artist's first biographer, declared it to be among 'the most impressive of the painter's works, with its vague hint of an untold tragedy that haunts the memory'. Christie's International Head of British Drawings and Watercolours, Harriet Drummond, recalled taking the painting on tour around the world before it was sold. 'People from every category of the art world – [and] from Hong Kong to New York – were blown away by its haunting beauty,' she said.

GOING ONCE

DR JOHNSON'S LIBRARY

Samuel Johnson (1709–1784),
library of books,
3,000 volumes

SALE
16 February 1785, London

ESTIMATE
Not published

SOLD
£258 9s 6d/$1,175

EQUIVALENT TODAY
£29,200/$42,100

James Christie's auction of the library of Dr Samuel Johnson in 1785 was a real coup, since Sotheby's was then dedicated to book auctions. The sale took place just two months after the death of the great man of letters, and realized £258 9s 6d.

Johnson was a pioneering lexicographer of the English language, as well as an essayist, poet, literary editor and biographer. He is most celebrated for his famous *Dictionary of the English Language* (1755), as well as for his *Lives of the Most Eminent English Poets* (1779–81) and his annotated editions of the plays of William Shakespeare. James Boswell, his travelling companion and biographer, brought Johnson's

Portrait of Samuel Johnson
by Joshua Reynolds, 1775.

Opposite page: Johnson's
eponymous dictionaries.

personality, conversation, witticisms and opinions vividly to life in his *Life of Samuel Johnson*, published in 1791.

Boswell provides a vivid description of his friend's library, which contained 'a number of good books, but very dusty and in great confusion'. As well as literary classics, such as *Robinson Crusoe* (1719), *The Pilgrim's Progress* (1678) and *Don Quixote* (1605), Johnson's library covered a huge range of subject matter, including theology, philosophy, antiquity, history, law, medicine, mathematics and science.

'The Catalogue of the Valuable Library of Books of the late learned Samuel Johnson', produced for the sale, has frustrated modern bibliophiles seeking to understand the works that informed Johnson's mind. They point out that it is full of mistakes, that the books are inadequately described, and that many of the lots contain a number of books that are not described at all. There were 662 lots in the sale, and over the course of four days some 3,000 volumes were sold, including bundles of pamphlets. The amount realized at the sale averaged under ten pence per volume; even then this was considered a very small return for such a library, which contained a number of rare books from the sixteenth century, a copy of Boethius's *De consolatione philosophiae* (1491) and a first folio edition of Shakespeare. This last was catalogued as Lot 427, 'Shakespeare's comedies, histories and tragedies (1623)', and sold for just £1 2s ($5; about £240/$345 today).

Nevertheless, the catalogue has continued to fascinate admirers and students of Dr Johnson, and has been reprinted many times. Subsequent generations, intrigued by the mind of the great man, have combed the catalogue for clues to his eclectic literary taste, and many academic studies of his collection have been published. In the words of the catalogue: 'To say that he, who thus excelled in the art of accumulating human wisdom, and in the talent of widely diffusing it to others, had infirmities, and even imperfections; is only to say, that he was a man: but few men have been freer from frailties, and still fewer from vice.'

RARE JAR TELLS
A STORY OF WAR

Blue-and-white
guan jar, Yuan dynasty
(mid-14th century),
underglaze cobalt blue
on white porcelain body,
33 cm (13 in) in diameter

SALE
12 July 2005, London

ESTIMATE
Not published

SOLD
£15,688,000/$27,844,510

In 2005, a lengthy auction battle took place between six bidders –
both in the saleroom and on the telephone – before this fourteenth-
century blue-and-white *guan* jar was sold to a private buyer for
a world-record sum.

In an age when technology enables auction sales to be conducted
live in front of a global audience and treasures are shipped worldwide,
we might think of an earlier period, when transcontinental commerce
was also creating new habits. The spread of the Mongol empire
under Genghis Khan in the thirteenth century influenced taste
and manufacturing skill in ceramics from the Caucasus to the China
Sea. This jar illustrates this earlier period of cultural transmission.

Yuan dynasty blue-and-white porcelain, fired at the Jingdezhen
kilns and painted with cobalt from western Asia, was exported
in huge quantities as far as Persia and Turkey. It fuelled a growing
international interest in the collecting of Oriental porcelain that

began in Tudor times; this in turn has stimulated and influenced Europe's own ceramics industry since the seventeenth century.

This *guan* was acquired by Baron van Hemert, a Dutch marine captain stationed in Beijing in the early twentieth century. When rediscovered more recently, it was unwittingly being used to store DVDs; traditionally *guan* of this size were used as storage vessels (see also p.360).

Yuan dynasty *guan* are now very rare, and none more so than the eleven surviving 'narrative' jars painted with scenes inspired by woodblock prints found in fourteenth-century literature. This *guan* bears a scene from a fourteenth-century book based on the ancient classic *Zhan Guo Ce*, an anthology of tales about the period of Warring States (481–221 BC) that was especially popular while China laboured under Mongol occupation. Illustrating the war between the states of Yan and Qi, it shows an emissary from Qi consulting the renowned military strategist Wang Yi on how to rescue its own logistics commander – and Wang Yi's follower – Sunzi, who had been captured. Both on the jar and in the woodblock print, Wang Yi is seen in a small carriage drawn by two large cats.

This 'narrative' *guan* was the last to be identified, and is perhaps the finest: evidence suggests that it was made from the highest-quality materials by a master potter and decorated by a first-class artist. The record price at auction in 2005 was paid by the world-renowned dealer in Asian art, Giuseppe Eskenazi.

THE DOVES OF PEACE

Jacob Epstein (1880–1959),
Doves, 1914–15, marble,
65 x 78.5 x 34.5 cm
(25½ x 31 x 13½ in)

SALE
4 December 1973, London

ESTIMATE
£10,000–15,000/
$24,500–36,800

SOLD
£23,100/$56,600

EQUIVALENT TODAY
£249,000/$353,000

'The sale of the century' was how the British press described the sale of Christie's itself in 1973, as the firm floated on the London Stock Exchange and share applications closed after just one minute. But it was another sale held the same year that put a twinkle in the eye of many Christie's specialists after a slow period in the saleroom.

The diamond merchant Sydney J. Lamon's taste was for elegantly understated luxury, and the inventory of his collection reads like a treasure trove of art-historical gems, featuring rare and beautiful examples of Mogul paintings, Renaissance jewellery, Chantilly porcelain, prehistoric Cycladic marble, Continental silverware, French Post-Impressionism, modernist sculpture and French eighteenth-century furniture. Many works from Lamon's collection have ended up in leading international museums and galleries, including this pair of amorous doves seen in a delicate balancing act performing coitus by Jacob Epstein from 1914–15, now in the Tate collection in London.

Epstein has been described by the sculptor Antony Gormley as 'the most radical sculptor working at the beginning of the twentieth century'; Gormley added that, in his view, Epstein 'was solely responsible for the introduction of modernism and direct carving' into the UK. Direct carving is the term used to describe the process of carving intuitively, respecting the integrity of the material as opposed to obeying a pre-designed model. Epstein learned the technique from Constantin Brancusi in Paris, before moving to the Sussex coast in England in 1913. There he produced *Rock Drill* (1913–15), a startlingly new, portentous form of a human figure-cum-drill that seemed to express a deep fear of man's destructive capability. Concurrently, Epstein was contemplating the purity of a flawless block of white Parian marble, into which he carved the doves of peace.

In 1973, the art dealer Anthony d'Offay went to more than twice the lower estimate to acquire the piece for the Tate Gallery. In 2009, he would look back at the acquisition as a turning point that later inspired the donation of his collection to the gallery: 'I was looking at *Doves* with [the deputy keeper of the modern collection]. He said to me: "It's so wonderful; now it belongs to all of us." I thought that was a beautiful thing to say.'

DEATH AND HONOUR

Honkozane nimai do gusoku
(Japanese suit of armour),
early Edo period (1600–1868),
red-and-blue-laced
gold-lacquered armour

SALE
23 October 2009, New York

ESTIMATE
$250,000–300,000/
£150,000–180,000

SOLD
$602,500/£362,285

The elite warrior caste of the samurai was a defining force in Japan
from the twelfth to the late nineteenth century. Bound by the strict
code of *bushidō* ('the samurai's way'), they created a unique culture
that encompassed everything from tea ceremonies to ink paintings and
poetry. The samurai's world view was defined by discipline, diligence,
obedience, duty and – perhaps most importantly – an unshakeable
belief in the importance of dying well.

Bushidō required that a samurai's death should bring only honour
to those he served. He must fight to the end, even if this required
seppuku – ritual suicide – in order to avoid the humiliation of defeat.
Such a ritualized way of life and death engendered an ancillary culture
of Japanese craftsmen and artisans who, over many generations,
crafted and perfected the instruments of the samurai's way of life,
including the arms and armour befitting such warriors. As a result,
the appurtenances of the samurai are regarded as examples of stunning
design: objects that blend efficiency, beauty and poise.

In 1990, Japan suffered an economic downturn that took the
heat out of most of its once-booming markets, including the thriving
international trade in traditional Japanese art and artefacts. By 2007,
some auction houses had even begun to close their Japanese departments.
In 2009, however, with Japan slowly emerging from its economic
doldrums, a rise in Western interest in that country became evident in
New York, with both Christie's and the Metropolitan Museum of Art
organizing events dedicated to the inimitable craftsmanship and visual
splendour of samurai culture.

This red-and-blue-laced gold-lacquered armour formed the
highlight of the sale in 2009. It hailed from the 300-year-old collection
of the Kii Tokugawa family, a branch of the Tokugawa clan whose
power as shoguns (military leaders) allowed them to dominate Japan
during the Edo period. The piece is considered to be a masterpiece
of seventeenth-century *gusoku*, the Japanese armour that came to
define the look of the samurai. Estimated to fetch $250,000–300,000,
it doubled this to sell for $602,500 – proof that the Japanese art
market was on the rise again.

WAR AND PEACE
OFFERINGS

Charles Willson Peale
(1741–1827), *George
Washington at Princeton*,
1779, oil on canvas,
244 x 156 cm (96½ x 61½ in)

SALE
21 January 2006, New York

ESTIMATE
$10m–15m/£5.7m–8.5m

SOLD
$21,296,000/£12,087,610

In the winter of 2006, a full-length oil painting of George Washington standing on the battlefield was sold for over $21m, setting a world auction record for American portraiture. The picture was painted by Charles Willson Peale in 1779, and depicts the master of solemnity leaning against a cannon directly after the Battle of Princeton in January 1777, the turning point of the American Revolution.

When Peale was not working on the sixty or so portraits of Washington that he executed during his lifetime – Washington sat for him on seven occasions – the one-time saddle-maker and clock-repairer led a busy life. After studying painting in England for three years until 1770, he returned to settle in Philadelphia. He raised troops for the American War of Independence, took part in several battles, and later served in the Pennsylvania state assembly.

An interest in natural history led Peale to organize the first US scientific expedition in 1801, and subsequently to establish what became the Philadelphia Museum. This housed a large number of birds, which he stuffed himself, as well as insects, minerals, shells, fish and fossil bones, including the first mastodon to appear in a museum (discovered by Peale in New York State). Peale's three wives bore him sixteen children, whom he named after painters such as Titian, Rembrandt and Rubens. An authority on such diverse subjects as bridge-building, dentistry, taxidermy and optometry, he wrote several books, and also painted Thomas Jefferson and Benjamin Franklin.

This portrait was part of a sequence of eight paintings which Peale had been commissioned to make and which were to be sent as diplomatic gifts to America's allies. *George Washington at Princeton* had been destined for France, but the ship on which it travelled was forced by inclement weather to dock in Spain. The painting arrived in the care of the American diplomat William Carmichael, who sold it for $112 (about £25; equivalent to $4,250/£3,000 today), whereupon it passed into the hands of the Dukes of Pastrana, who bequeathed it to the Catholic order of the Capuchins at Lecároz in northern Spain. How it travelled back from Spain to New York remains a mystery, but in 1919 it was purchased from P.W. French & Co. by Natalie Blair, a great collector of Americana. When the painting came up for auction in 2006, only two of the eight pictures Peale had painted remained in private hands. As a result, the high demand was reflected in the final sale price.

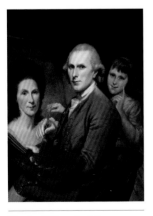

Charles Willson Peale's self-portrait from c.1782–8 with his daughter Angelica and a portrait of his first wife Rachel.

PRIDE OF
NEW ENGLAND

Robert Crosman (1707–1799),
a diminutive William and
Mary chest of drawers, 1729,
pine with original brasses
and paint decoration,
58 x 57 x 32 cm
(23 x 22½ x 12½ in)

SALE
21 January 2006, New York

ESTIMATE
$500,000–800,000/
£284,000–454,000

SOLD
$2,928,000/£1,661,930

The sale in 2006 of the Mrs J. Insley Blair Collection raised the bar for American furniture at auction. Natalie Blair (1887–1951) had been an enthusiastic and pioneering collector and had amassed an outstanding collection of American antiques and decorative arts. A highlight of her collection was a miniature chest of drawers by the cabinetmaker Robert Crosman from Taunton, Massachusetts, bearing his signature and dated 1729. Decorated in green, red and white, with painted chicks, vines and flowers, and standing on ball feet, this diminutive pine chest sold for a substantial $2.9m.

Crosman came from a family of skilled firearms repairers, woodworkers and drum-makers. He served his apprenticeship as a cabinetmaker, and twenty-two chests are now attributed to him. (He went on to become an affluent innkeeper.) His earliest designs are painted with floral sprays; gradually chicks and birds in flight

began to appear on the decoration, while his later chests feature branches, tulips and daisies. These chests were probably made for young women at the time of their marriage, and it is thought the decoration on each was a symbolic reference to the start of a new family.

Natalie Blair was born to an old, established New England family, a proud descendant of the Revolutionary war hero Colonel Thomas Knowlton (1740–1776). An accomplished tennis-player, skier and golfer, she married a banker who was the heir to a railway fortune, and began her collecting career by focusing on European antiques. Increasingly, however, she grew suspicious of fakes, and the authenticity of American furniture held greater appeal, a preference that grew more conspicuous during the First World War, when she became intensely patriotic.

In the early 1920s, Blair formed a close association with the Metropolitan Museum of Art in New York, making substantial gifts that became the cornerstone of the American Wing, and lending much of her collection to the museum. Before she died, she reclaimed her favourite Taunton chest of drawers for her apartment on Fifth Avenue. The chest remained in the family until 2006, when it was sold by her grandson. Reflecting the growing interest in this field among collectors, the Crosman chest broke all records for Americana at auction, and the sale itself is still the record for any sale of American decorative arts.

A REVOLUTION IN TASTE

Sèvres porcelain manufactory
(est. 1740/1756), part
dessert service, 1787–9,
soft paste porcelain,
dimensions variable

SALE
15–17 March 1790, London

ESTIMATE
Not published

SOLD
£110 5s/$500

EQUIVALENT TODAY
£11,800/$17,000

The Prince of Wales (later George IV) was a great Francophile. He adored French works of art and Sèvres porcelain in particular, as did many of his aristocratic friends. In 1787, through his architect Henry Holland, the prince engaged the French *marchand-mercier* Dominique Daguerre to help with the furnishings of his London residence, Carlton House. Daguerre was arguably the most influential 'interior decorator' or 'taste-maker' in Paris at that time, counting the royal families of Europe and leading aristocrats among his customers. Daguerre worked closely with the Sèvres porcelain manufactory and when it ran into financial difficulties he offered Sèvres space in his retail shop in Paris. The following year, he opened a shop in London geared to the same purpose.

These beautiful Sèvres dishes painted with lilac were part of a larger dessert service purchased by the Prince of Wales at Christie's in March 1790 for £110 5s. They were sold anonymously, but the vendor was, in fact, Daguerre, who had shipped the service to England only three months earlier. It seems that Daguerre's London shop was not quite the success he had expected it to be, and he turned to James Christie for help. Daguerre's consignments were sold anonymously in nine sales between 1789 and 1793, and identified as his in March 1791 and May 1792.

The original sale catalogues note 'PW' against the lots purchased by the Prince of Wales. In the March three-day sale alone, he bought

twenty-three of Daguerre's lots. One wonders whether he knew the source of the porcelain, or whether Daguerre concealed his identity but advised his royal client to buy certain lots to fit with the furnishings at Carlton House. An inventory of Carlton House dated January 1793 records the service as comprising sixty-five pieces. Mysteriously, only nine pieces remain in the Royal Collection today, and it is not known how or when the other fifty-six disappeared.

The timing of Daguerre's retail venture in London coincided with the first uncertain years of the French Revolution. From the early 1790s, as French aristocrats frantically tried to leverage family assets, barely a month went by without Christie auctioning a consignment of goods from France. Practically overnight, London became the centre of a vast art and antiques trade, a position it has never relinquished.

182 THE GLASS DETECTIVE

Mamluk jug, Egypt or Syria, second half of 13th century, enamelled glass and gilded clear glass, 18.5 cm (7½ in) high

SALE
14 December 2000, London

ESTIMATE
Not published

SOLD
£3,303,750/$4,843,300

The Mamluk glass jug, first spotted by two Christie's experts among Baroness Batsheva de Rothschild's collection in her home in Tel Aviv, looked too good to be true. Although stylistically it belonged to the thirteenth century, its glass was too clear, its beautifully worked decoration barely worn at all. Surely, the specialists thought, it must be an exquisite copy made centuries later in *fin-de-siècle* Venice or France? The search for provenance was on.

The technique required to copy original Mamluk ware was successfully perfected in the mid-nineteenth century. For the jug to be a genuine thirteenth-century masterpiece, the experts would need to establish its provenance long before the baroness's grandfather, Alphonse James de Rothschild, acquired it at the famous Christie's sale of the contents of Hamilton Palace in 1882. The Duke of Hamilton's family were descendants of the great collector and gothic novelist William Beckford (1760–1844). If evidence existed that the jug was once in Beckford's collection, its provenance could be fixed to a moment long before modern glassmaking had become sophisticated enough to re-create such a piece.

In London, Christie's experts David Llewellyn and William Robinson began to scour every catalogue and inventory pertaining to Beckford's long-destroyed house, Fonthill Abbey in Wiltshire. At first they found nothing, but then, quite by chance, Llewellyn stumbled across something extraordinary: a reproduction of a painting

of 1844 by Willes Maddox that had belonged to Beckford. The object in the foreground was unmistakably the baroness's jug.

The possibility of establishing the jug as one of the most important pieces of thirteenth-century glassware was now tantalizingly close. With the paper trail at an end, however, the only way to prove it beyond doubt was to inflict a risky dating procedure on the piece. A scientist was called in to extract a sample for testing, making the auction-house team so nervous that, when they saw the scientist pick up his hammer and chisel, they had to leave the room.

The result, though, was a triumph of detective work, that demonstrates how twentieth-century science coupled with very thorough archival research managed to enable a masterpiece to be rediscovered. As Robinson explains, 'This was potentially the best, a piece that was very well known in the Islamic art world from the Hamilton Palace sale where it had achieved a record price. Were we to debunk a star or could we support it?' As an exquisite nineteenth-century copy, the jug might have been worth about £30,000 ($43,980). However Christie's had proved it was a thirteenth-century original in unsurpassed condition, with indubitable proof of its authenticity. Consequently the baroness's jug sold for £3,303,750, the second highest price ever achieved at auction for an Islamic work of art.

AN OENOPHILE'S ELYSIUM

Château Pétrus (est. c.1837),
Pétrus vintage 1945,
one dozen bottles

SALE
18–19 September 1997, London

ESTIMATE
£25,000–35,000/
$40,300–56,500
(per dozen bottles)

SOLD
£45,000/$72,600

EQUIVALENT TODAY
£73,100/$101,800

The original 7-hectare (17-acre) vineyard of the Pétrus wine estate in Bordeaux, France, dates back to the late eighteenth century, and until the 1960s – when the Moueix family took a half-share in the property – the reputation of its wines grew steadily. By the time of this landmark sale in 1997, however, Pétrus had become not only one of the pre-eminent Bordeaux wines of the Pomerol appellation, but also a status symbol.

These twelve bottles of Pétrus from the 1945 vintage, considered to be the start of 'the great age of Pétrus', were sold in the highest-grossing wine sale since Christie's resumed its wine sales in 1966. The market had been growing, encouraging many exceptional cellars to come to auction, but this particular single-owner collection was a game-changer. As was noted in the catalogue: 'It is quite simply the best, the most exclusive and the most important private cellar ever to appear at auction.'

Known to the auction house for many years, the businessman who had collected these superlative vintages was a true oenophile, and had not restrained himself from consuming and enjoying many of the wines included in this cellar. Accordingly, its mix of New World and Old, young and mature, suggested a drinker with sophisticated but varied taste.

This particular case had been recorked by the chateau the previous year, and was recorded as being of impeccable appearance. The wines had originally come from the cellars of the Bolivian tycoon Antenor Patiño (1896–1982), and the owner had bought them through Christie's from a descendant of the family. The tasting notes of Michael Broadbent, then chairman of Christie's international wine department, were admirably succinct: 'No comment necessary!'

Detail of the Pétrus label, showing St Peter holding the key of heaven.

AT THE SERVICE OF THE KREMLIN

Imperial Porcelain Factory
(est. 1744), large dinner
and dessert service, part
of the Emperor Nicholas I
banqueting service known
as The Kremlin Service,
c.1837, porcelain,
various dimensions

SALE
21 March 1967, London

ESTIMATE
Not published

SOLD
£8,400/$23,100

EQUIVALENT TODAY
£136,000/$190,000

During a brief mild spell in the Cold War (1947–91), in the years
between the Cuban Missile Crisis and the Prague Spring, Christie's
chairman, Peter Chance, travelled to the Soviet Union as part of
a delegation from the London Chamber of Commerce. Trade with
the West was an important source of hard currency for the USSR,
and from time to time the Soviets brought to market items that
– although precious – were deemed to be ideologically unsound:
religious icons, say, or treasures that the communist state had
inherited from Russia's aristocrats and royals.

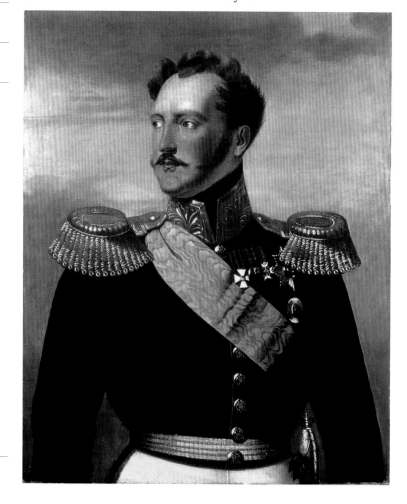

Portrait of Emperor
Nicholas I.

As a result of Chance's visit to Moscow, Christie's was instructed to sell an imperial dinner service consisting of 1,742 pieces. The service had been made for Emperor Nicholas I (1796–1855) around 1837, and was used at coronations, diplomatic soirées and the regular banquets where army cadets received their commissions. Often 200 cadets at a time would attend these feasts, hence the vast quantity of porcelain required. The emperor himself was always present, since he was the only person who could confer a commission.

The various designs on the plates were the work of Fyodor Solntsev (1801–1892), and they drew on motifs from old Muscovy, the medieval Russian state that had thrown off the Tatar yoke and gathered Russians under one all-powerful emperor. The dessert plates bore the double-headed eagle – the Russian imperial cipher – and the inscription: 'Nicholas, Emperor and Autocrat of all the Russias'. As the emperor's young officers celebrated their promotion, the very crockery from which they ate their dinner reminded them where their loyalties lay.

For auction, the Romanov porcelain was split into twenty-eight lots, making dinner services of a more modern and manageable size. Taken together, the lots realized £65,751 ($180,800; equivalent to £1.1m/$1.5m today). A news report at the time pointed out that this amounted to about £38 ($105; about £615/$850 today) per plate.

FLAMENCO
WITH A RUSSIAN BEAT

Natalia Goncharova
(1881–1962), *Espagnole*,
c.1916, oil on canvas,
130.5 x 81.5 cm (51 x 32 in)

SALE
2 February 2010, London

ESTIMATE
£4m–6m/$6.4m–9.6m

SOLD
£6,425,250/$10,247,600

Natalia Goncharova's *Espagnole* is a painting of a Spanish woman
dancing, her fluid movements giving energy to the triangular Cubist
forms, the figure reduced to glimpses of mantilla veil and floral
sweeps of fabric. In the years before the Russian Revolution of 1917,
Goncharova was one of Russia's leading avant-garde artists. She and
her partner, the painter Mikhail Larionov (1881–1964), were early
émigrés from their troubled homeland: they left together in 1914 and
never returned. In 1916 Goncharova went to Spain to meet up with
the touring Ballets Russes; Serge Diaghilev had asked her to travel with
him, to soak up the spirit of the country, with a view to her designing
the set and costumes for two Spanish ballets.

Goncharova had never been to Spain before, and everything about
it amazed her, above all the flamenco dancers she saw in the bars and
taverns of Seville. 'I so love Spain,' she wrote. 'Of all the countries
I have been to, it is the only one that has hidden energies – and in that
regard it is close to Russia.' In the painting, that affinity is expressed
through the floral pattern of the dancer's shawl, strongly reminiscent
of decorative schemes found in Russian folk art (in particular the painted
bowls and spoons of Khokhloma). Elsewhere we can see flashes of the

Natalia Goncharova, seated,
with (left to right) Leonide
Massine, Mikhail Larionov
(standing), Igor Stravinsky
(seated) and Léon Bakst in
Lausanne, Switzerland, 1915.

dancer's costume: the white lace of the mantilla, the long tines
of the wooden comb or *peineta*, and the pleated fan, which is present
in at least three locations, as if it is being swept across the dancer's body
as we watch. The metallic pink cone of the head strikes a troubling
note, although that black visor could be read as a tress of shiny black
hair. Maybe the helmet-like shape is an acknowledgment of the fact that
elsewhere in Europe, a vast, mechanized war was in progress.

Again and again, in various forms and styles, Goncharova returned
to Spanish dance. This picture, an early and outstanding iteration
of the theme, set a new record for a female Russian artist when it sold
in London in 2010 for over £6.4m.

THE ULTIMATE
EASTER EGG

Carl Fabergé (1846–1920),
Rothschild Fabergé Egg, 1902,
jewelled vari-coloured
gold-mounted and
enamelled egg on plinth,
incorporating a clock
and an automaton,
27 cm (10½ in) tall

SALE
28 November 2007, London

ESTIMATE
£6m–9m/$12.4m–18.6m

SOLD
£8,980,500/$18,573,940

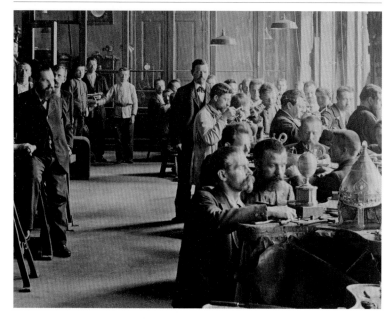

Top: Michael Evamplevitch
Perchin's workshop
in St Petersburg, 1902.
The Rothschild Egg is on
the table in the foreground,
being worked on by two
goldsmiths. Perchin, standing
to the left in the photograph,
was a Fabergé workmaster.

Above: The Winter Egg, 1913,
by Carl Fabergé.

The St Petersburg jeweller Carl Fabergé made about fifty Easter eggs for the Romanov dynasty between 1885 and the start of the Russian Revolution. One example is the egg given by Emperor Nicholas II to his mother at Easter in 1913, which sold at Christie's New York for over $9.5m (£6.5m) in April 2002. Now known as the Winter Egg, it is carved from rock crystal that has been engraved to simulate ice crystals and set with platinum-set rose diamonds. The egg opens to reveal a 'surprise', an intricate platinum basket filled with white-quartz wood anemones, a garnet at the centre of each flower.

Fabergé also made a dozen or so eggs to the same 'imperial' standard for fantastically rich clients. One of these buyers was Béatrice Ephrussi de Rothschild. In 1902, she commissioned an egg for Germaine Halphen, who had just announced her engagement to Béatrice's younger brother, Édouard de Rothschild. Since the egg was a private possession that never left the Rothschild family, it remained unrecorded until it came up for auction in 2007, thirty-two years after Germaine's death.

Like all Fabergé's best work, the Rothschild egg is an exquisite marriage of artistry and ingenuity, of unbridled extravagance and

Detail of the Rothschild Egg,
showing a cockerel
automaton emerging
from the top of the egg.

fine-tooled micro-engineering. The translucent enamel-on-silver surface shimmers like a becalmed pink ocean. The central band – made of seed pearls and stylized gold leaves – is like the ribbon on an opulent wedding cake. As the hour strikes, the top of the egg opens and a stout cockerel emerges. Its plumage is strikingly naturalistic, apart from the fact that it is studded with tiny diamonds. The cockerel flaps its mechanical wings, makes a pecking motion with its clockwork head, then crows out loud.

The Rothschild egg was auctioned at a time when the market for such artefacts was particularly buoyant. An exciting auction-room battle resulted in a price of almost £9m, a three-way record: the highest price for a Russian object (excluding paintings), the highest price for a Fabergé item, and the highest price for a timepiece. The egg resurfaced in Russia in 2014 and was subsequently donated to the Hermitage Museum in St Petersburg. This Fabergé masterpiece had, in a sense, come home.

ROYAL DEITY FOUND
IN A TUCK SHOP

Assyrian bas-relief,
883–859 BC, gypsum,
183 x 117 x 6.5 cm
(72 x 46 x 2½ in)

SALE
6 July 1994, London

ESTIMATE
Not published (reported
as £750,000/$1,148,000)

SOLD
£7,701,500/$11,783,295

EQUIVALENT TODAY
£13,700,000/$19,850,800

The sale of this wall slab, which once adorned the palace of the
Assyrian King Ashurnasirpal II (r. 883–859 BC), was the culmination
of a startling tale of discovery and rediscovery. The story begins in the
1840s with the dashing young archaeologist Henry Layard, whose
excavation of Nimrud in northern Mesopotamia (now Iraq) – 'Nineveh',
as he called it – caused a sensation in Victorian London. People flocked
to see the enormous exotic sculptures of winged bulls that Layard
shipped back from Nimrud, and Layard himself became a celebrity,
the archetype of the adventurer-archaeologist.

His expeditions had been sponsored by the British Museum,
and the majority of his finds were donated to its collection, where
they remain on view today. Layard himself retained a number of the
sculptures he discovered and presented them to John Guest, since
he too had been a material sponsor of his work. The pieces Layard
gave Guest went to his country home, Canford Manor in Dorset, where
they were installed in a specially commissioned building known as

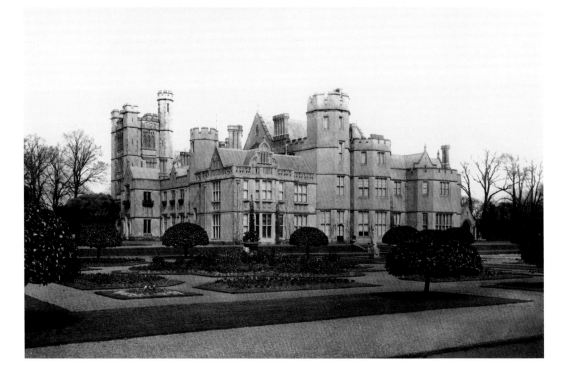

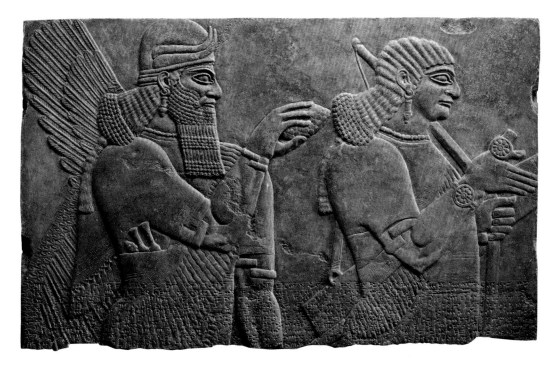

the 'Nineveh Court', in 1851. They did not remain there, however, but were sold: some in 1919 and the remainder in 1959. It was believed at the time that three plaster casts of the original reliefs were all that remained in the court. In the meantime, in 1929, Canford became a private boys' school – and the court its tuck shop. Its interior, including the 'plaster casts', was whitewashed repeatedly, and later painted with vinyl emulsion.

In 1992, a curious American Assyriologist named John Russell paid a visit to Canford. On being shown round the tuck shop he noticed that one cast, depicting an arms-bearer and a royal deity, did not correspond to anything he had seen in a museum. In fact, it looked very much like a piece that was believed to have been lost in the River Tigris while Layard was floating his treasures on barges to Baghdad. A check of the records and a second visit proved Russell's hunch correct: the frieze was indeed a genuine 2,800-year-old relic of Ashurnasirpal's palace.

Once the astonishing truth was known, the school swiftly moved to sell the piece. The frieze was taken down and the layers of paint stripped away. It was found to be in better condition than some of those in the British Museum, although the face of the arms-bearer had sustained a couple of pockmarks from poorly aimed darts meant for a nearby dartboard. As for the sale, it massively exceeded all expectations, fetching far more than had ever been paid at auction for an antiquity. Canford's governors were left with the happy task of spending a £7m windfall. The revenue funded a new sports centre, provided endowments for several 'Assyrian scholarships', and even stretched to a Mars bar for each boy in the school.

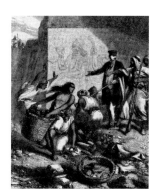

Left: Canford Manor in Dorset, photographed by Francis Frith c.1886, was Layard's home, and the location of the Assyrian bas-relief until 1994.

Above: Henry Layard in Mesopotamia in the 1840s.

SECRETS OF ARCHIMEDES UNCOVERED

Archimedes (c.287–212 BC),
*On the Equilibrium
of Planes, On Floating Bodies,
The Method of Mechanical
Theorems, On Spiral Lines,
On the Sphere and
the Cylinder, On the
Measurement of the
Circle, Stomachion*
(upper text: *Euchologion*,
in Greek, 12th century),
Byzantine Empire, probably
Constantinople, third quarter
of 10th century, palimpsest
manuscript on vellum,
174 leaves, foliated,
19.5 x 15 cm (7½ x 6 in)

SALE
29 October 1998, New York

ESTIMATE
$800,000–1,200,000/
£478,000–716,000

SOLD
$2,202,500/£1,314,275

EQUIVALENT TODAY
$3,200,000/£2,265,000

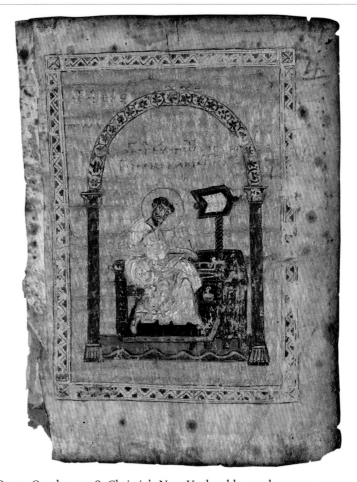

On 29 October 1998, Christie's New York sold a tenth-century
Byzantine manuscript that contained a wealth of hidden information
about the work of the ancient Greek scientist Archimedes (282–212 BC).
The 174-leaf manuscript, bound in the nineteenth century into a
small book, is a palimpsest. The original words of a tenth-century
scribe, probably working in Constantinople, were written on vellum
parchment when the Byzantine Empire was at its peak of power
and prosperity, a centre of religion, culture and learning. Some two
centuries later, the empire had plunged into disarray, culminating
in the sack of Constantinople during the Fourth Crusade (1204).

The manuscript ended up in Jerusalem, where precious writing materials were in short supply, so the original vellum was 'scraped' and a new liturgical text, the *Euchologion*, was superimposed on the original script. This prayer book was held at the monastery of St Sabbas, east of Bethlehem, and latterly in the Metochion of the Holy Sepulchre in Jerusalem. It was at the Metochion that the partially visible underlying text – which nineteenth-century visitors thought to be ancient mathematics – was identified by the world authority on Archimedes, John Ludwig Heiberg, in 1906.

The underlying manuscript is the earliest record of the works of Archimedes by some 400 years. It contains two unique Archimedes treatises, the *Stomachion* and *The Method of Mechanical Theorems*, which are not known to exist anywhere else, as well as diagrammatic illustrations of his theories. In addition, there are a number of treatises recording some of the great thinker's most enduring theories: *On the Equilibrium of Planes*, *On Floating Bodies*, *On Spiral Lines*, *On the Sphere and the Cylinder* and *On the Measurement of the Circle*.

The day before the sale there was a dramatic setback when the Greek government and the Ecumenical Patriarch issued an injunction against Christie's, attempting to stop the sale on the grounds that the manuscript had been stolen. However, the manuscript had been acquired by a French family in the 1920s and so the injunction failed.

At the sale, a rare book dealer from London, Simon Finch, represented the anonymous buyer, who deposited it at the Walters Art Museum in Baltimore. The palimpsest, which has been damaged by mould, is now being subjected to a rigorous programme of conservation, imaging and scholarly study. Mathematicians believe that it will reveal much about the nuances of Archimedes' scientific thought, and it has emerged that the palimpsest also includes other significant Greek texts, including works by the fourth-century BC orator Hyperides, as well as third-century AD commentaries on Aristotle's *Categories*.

RENAISSANCE DRAWING RESURFACES

Andrea d'Angiolo, called Andrea del Sarto (1486–1530), *Head of Saint Joseph Looking Down*, with a subsidiary study of his features (recto); two studies of legs (verso), c.1523, black and red chalk (recto); red chalk (verso) on paper, 37.5 x 22.5 cm (14½ x 8½ in)

SALE
5 July 2005, London

ESTIMATE
Not published

SOLD
£6,504,000/$11,426,180

In today's art market, provenance is of such significance that a work's every move – from owner to owner, gallery to gallery – is meticulously recorded. Apart from incidents of theft, it is very rare for the whereabouts of a major work to become obscured. This has not always been the case. After its disappearance in 1925, the only trace of Andrea del Sarto's beautiful chalk drawing *Head of Saint Joseph Looking Down* was a grainy black-and-white illustration in a monograph. This rare work by a Renaissance master had somehow managed to vanish into thin air.

Head of Saint Joseph Looking Down was made in connection with Del Sarto's *Holy Family* (c.1523), which hangs in the Pitti Palace in Florence. It was one of fewer than 190 autograph sheets to have survived the four-and-a-half centuries since the Florentine artist's death. Even during his lifetime, Del Sarto's drawings had been sought after, to such an extent that Giorgio Vasari (Del Sarto's pupil and the first owner of *Head of Saint Joseph*) reported that the artist's heirs were robbed of many of his works after his death.

By 2005, eighty years after the drawing's disappearance, it seemed unlikely that the little masterpiece would ever resurface. Then, one day, Christie's Swiss office in Zurich received a telephone call from somebody wanting to sell a Renaissance drawing in red and black chalk. Noël Annesley, honorary chairman of Christie's, went to Switzerland to investigate.

The last known whereabouts of the Del Sarto had been the London collection of the art dealer Sir George Donaldson. Annesley found it lying on a bed in Switzerland. 'I felt a little shaky,' he told *The Guardian* newspaper after setting eyes on the long-lost Del Sarto – and in colour, rather than black-and-white.

Head of Saint Joseph is the most important Del Sarto to have come on to the market since the late 1930s. It was bought by a private collector and has since been publicly exhibited, most recently at the Frick Collection in New York in 2015–16.

Andrea del Sarto's *Holy Family*, c.1523, for which the drawing opposite was a study.

ANDREA · DEL · SARTO ·

355

VASARI'S GIFT TO THE FUTURE OF DRAWING

Giorgio Vasari (1511–1574), 'The Vasari Sheet' featuring drawings attributed to Sandro Botticelli, Filippino Lippi and Raffaellino del Garbo, an album page from Vasari's *Libro de' Disegni*, compiled after 1524, with ten drawings on recto and verso in various media with decoration in pen and brown ink, brown and grey wash, on light buff paper, 56.5 x 45.5 cm (22½ x 18 in)

SALE
3 July 1984, London

ESTIMATE
£500,000–700,000/
$670,000–938,000

SOLD
£3,240,000/$4,341,600

EQUIVALENT TODAY
£9,300,000/$13,420,000

This rare and beautiful work is an intact two-sided sheet from the *Libro de' Disegni*, the extensive collection of drawings assembled by the Florentine artist Giorgio Vasari, arranged by him, mounted on pages of uniform size, and bound together in several volumes, perhaps as many as twelve. Next to Raphael's *Head and hand of a young man*, a black chalk study for the *Transfiguration* of 1520, it was the most important (and expensive) lot in the sensational Chatsworth sale of Old Master drawings in 1984.

Consensus has yet to be reached over the authorship of these drawings, which has been variously divided between the Quattrocento master Filippino Lippi (*c.*1457–1504), his master Sandro Botticelli (*c.*1445–1510) and Raffaellino del Garbo (1466–1524). The majority now seem characteristic of Filippino at different stages in his career, but the exquisite *Head of a youth*, on the recto, has been plausibly attributed to Botticelli and dated around 1470.

Vasari was a prolific painter and architect, long in service to the Medici, but he achieved greater renown as a pioneering collector of drawings and as the author of *Lives of the Most Excellent Painters, Sculptors and Architects*, published in 1550. Vasari is often described as the first art historian. He supervised the organization of the sheets in the *Libro*. The ten drawings on this page have been mounted and embellished with characteristic ink borders and an architectural framework to the design. The individual drawings were executed in several techniques, including metalpoint with white heightening, pen and ink, and watercolour and body colour, on different coloured papers. Impressive in size and quality, they captivated the New York collector Ian Woodner, who outbid the Getty Museum to secure 'The Vasari Sheet'. It passed from his estate to the National Gallery of Art, Washington, DC.

The Devonshire collection of drawings at Chatsworth had remained almost intact since its beginnings in the early eighteenth century, and was celebrated as the finest in private hands. The sale of this selection of seventy-one drawings, ranging from the hands of Leonardo, Mantegna and Holbein to Rubens, Van Dyck and Rembrandt, transformed the hitherto rather subdued market for Old Master drawings. The sale fetched £21.6m ($28.9m; equivalent to £62m/$89.5m today) – almost four times the figure at which the Devonshire Trustees had been prepared to sell to the British Museum.

Filippo Lippi Pitt. Fior.

THE PRICE OF ENTHUSIASM

Two Mandarin jars and covers, undated, porcelain, dimensions not available

SALE
6 June–22 July 1885, London

ESTIMATE
Not published

SOLD
£278 5s/$1,350

EQUIVALENT TODAY
£26,800/$38,600

A cautionary tale about the vagaries of taste surrounds this pair of delicately patterned Mandarin jars and covers. The story begins in 1882, when a large selection of objects from the collection of the 10th Duke of Hamilton was sold at Christie's. The sale was prompted by necessity: Hamilton Palace in South Lanarkshire – completed in 1842 – was one of the most spectacular houses in Scotland, but it was expensive to maintain, and by 1882 the 12th Duke had decided to sell a number of objects to raise funds (see also pp.366–7).

The sale lasted for seventeen days and raised £392,562 ($1.9m; equivalent to £35.3m/$50.8m today). Sold alongside these Mandarin jars was furniture created for Marie Antoinette and Louis XVI, large numbers of paintings – eleven of which were purchased by the National Gallery in London – and a pair of Chinese celadon vases, which are now in the Metropolitan Museum of Art in New York.

The sale attracted enormous interest, although nearly a quarter of the Hamilton Palace lots were bought by one collector, Christopher Beckett-Denison, to furnish his house in London. Beckett-Denison, who bid largely by himself but occasionally via an agent, spent prodigious amounts in order to get the objects he coveted – about £100,000 in total by the end of the sale.

The consequences of this audacious auction style were revealed just three years later. After suddenly being taken ill while travelling in Ireland, Beckett-Denison died and his own collection was sold. Many of the Hamilton Palace objects he had bought realized significantly lower sums than those he had paid in 1882. The Mandarin jars and covers, for example, achieved only £278 5s in 1885, in contrast to the £603 15s ($2,900; equivalent to £58,000/$82,000 today) Beckett-Denison had paid for them – an unfortunate example of the importance of works of art being fresh to the market.

UMBRELLA STAND RECOGNIZED AS CHINESE MASTERPIECE

Guan-shaped wine jar, Yuan dynasty (1279–1368), from the kilns at Jingdezhen, Jiangxi province, China, ceramic, dimensions not available

SALE
5 June 1972, London

ESTIMATE
Not published

SOLD
£220,500/$551,250

EQUIVALENT TODAY
£2,600,000/$3,767,400

The art of combining underglaze decoration in blue (cobalt oxide) with red glaze (copper oxide) was first mastered in the kilns at Jingdezhen in China during the Yuan dynasty, and fine examples are very rare. Only four large wine jars in the shape known as *guan* survive: a lidded pair excavated at Baoding, Hebei province, and now in the Beijing Palace Museum; one in the Sir Percival David Collection currently on loan to the British Museum in London; and this fine piece. An attractive floral pattern rings the neck, dotted cloud panels descend from the collar – interspersed with sacred mushroom symbols – and petal panels around the base contain hanging tendril designs. The chief decorative feature is the set of four panels round the body of the vessel, containing quatrefoil patterns. They have been moulded in relief, painted in blue and red and inserted into corresponding spaces cut from the clay body before glazing and firing. They are set within double frames of beaded bracketing.

The jar's modern history is something akin to a fairy tale. When Christie's specialist Anthony du Boulay first recognized its importance in 1970, it was being used as an umbrella stand in a European stately home. The jar was then spotted in the sale catalogue by Sakamoto Gorō, a wealthy self-made Japanese connoisseur and art dealer who flew to London prepared to beggar himself in his determination to acquire the piece. In fact, he paid what was then the highest price ever achieved for an Asian work of art. He later recalled the stomach pains and difficulty in breathing he experienced at the auction, but insisted it was worth it: 'I maintain now, as I did in 1972, that the purchase of the Yuan peony jar contributed to the worldwide boom in Chinese ceramics, coaxing more masterpieces out of hiding.' (see also pp.330–1).

THE FACE
BENEATH THE MAKE-UP

Tōshūsai Sharaku (active 1794–5), *The Actor Ichikawa Yaozo III as Tanabe Bunzo* in 'Hana-ayame Bunroku Soga', 1794, colour woodblock print, 37.5 x 23 cm (15 x 9 in)

SALE
27 May 1969, Tokyo

ESTIMATE
Not published

SOLD
¥1,880,000/£2,200/$5,200

EQUIVALENT TODAY
¥5,120,000/£32,300/$45,200

Little is known about the eighteenth-century Japanese woodblock artist Tōshūsai Sharaku, apart from his name and the fact that in the space of about ten months in 1794–5, he produced an astonishing sequence of 146 woodblock prints. Sharaku was referred to in Japan as the 'enigmatic *ukiyo-e* master,' and his brief appearance and abrupt disappearance have given rise to theories about who he was and what became of him – a Noh actor, perhaps, or a group of people working under one name. The only evidence that remains is the series of extraordinarily vivid portraits of actors, sumo wrestlers and samurai.

The Actor Ichikawa Yaozo III as Tanabe Bunzo is one of the first prints that Sharaku produced, part of a series of twenty-eight half-length portraits of contemporary kabuki actors depicted in their various roles. Tanabe Bunzo was a character in a popular vendetta play, 'Hana-ayame Bunroku Soga'. A loyal retainer of the protagonists' family, he is shown ill and despondent after having been wounded while attempting to defend them. In this print, as in all his theatrical portraits, Sharaku depicted not only the fictional character but also the physiognomy of the real actor beneath the make-up; this realism did not please the actors (particularly the men who played women on stage) or their admirers.

This print was sold in Tokyo in May 1969 in a landmark sale that included Impressionist and Victorian paintings, and Greek and Persian pottery, as well as Asian works of art. It was the first sale ever to be organized in Japan by a foreign auction house, and more than 700 people attended. Closed-circuit television was used for the first time, and there was a special Yen indicator to keep non-Japanese-speaking buyers in touch with the bidding. In deference to Japanese custom, Peter Chance, chairman of Christie's, left his shoes at the door and took the evening auction in his socks – the first time he had ever done such a thing.

TAKING OFF THE MASK

Zeng Fanzhi (b.1964),
Mask Series 1996 No. 6,
1996, oil on canvas, diptych,
200 x 360 cm (79 x 142 in)

SALE
24 May 2008, Hong Kong

ESTIMATE
HK$15m–25m/
£0.9m–1.6m/$1.9m–3.2m

SOLD
HK$75,367,500/
£4,873,480/$9,660,020

In 1993, at the age of twenty-nine, the artist Zeng Fanzhi travelled from Wuhan, the city of his birth, to Beijing. The Chinese capital was experiencing the early stages of its transition to capitalism and the creation of a new social world. Zeng's response was to begin his 'Mask' series, of which *Mask Series 1996 No. 6*, a vast diptych, is perhaps the most striking of all.

 Mask Series 1996 No. 6 features a line of eight figures informally posed as if for a snapshot on a happy occasion. However, while there are smiles on their faces and the background is painted in a breezy yellow, the picture is profoundly disturbing. The masks symbolize personal and political concealment, representing the idea that honest emotions and true character are hidden during social interaction, as well as being oppressed by the state. The neckerchiefs worn by the figures represent membership of the Communist Party, a sign of collective loyalty, although the masks make it impossible to judge the sincerity of this symbol. Despite having strings to fix them to the figures' heads, the masks seem to be part of the group's faces, indicating the permanence of the concealment. The use of a photograph as source

material for this painting is also significant; Zeng has spoken of the 'simulated posture' we all adopt when being captured on camera.

Zeng draws on both Chinese traditional painting and Western art movements in his work, and *Mask Series 1996 No. 6* is a synthesis of the techniques learned in his homeland and the expressionist and existentialist art he saw from the West in reproduction. Francis Bacon's flayed skin and the broad brushwork of German Expressionism, for example, are evoked in his painterly language.

Christie's has sold Chinese art for more than 200 years, but the first decade of the twenty-first century has seen interest reach new heights, with numerous records set for works in multiple disciplines and from various epochs. At the time, the highest total for any series of sales in Asia – HK$2.1b (£1.4m/$2.7m) – was achieved in 2007 when Christie's celebrated twenty-one years of auctions in Hong Kong.

The stage was therefore set for contemporary art to make a splash, and the inaugural evening sale for twentieth-century and contemporary Asian art took place in May 2008, helping to establish Hong Kong as a global centre in the art world. That night, Zeng Fanzhi's painting set a world auction record for the artist and for Chinese contemporary art. The series, which remains his most highly regarded body of work to date, is seen as a key moment in the development of new art in China.

195 FURNITURE À LA MODE

John Mayhew (1736–1811) and William Ince (active c.1758–d.1804), suite of dining-room furniture, c.1770, sideboard table: mahogany with apron of curved pearwood and top veneered with yew and rosewood; two sideboard pedestals and urns: veneered with yew and rosewood, inlaid and mounted with ormolu, sideboard: 84.5 x 144.5 x 61 cm (33 x 57 x 24 in)

By the late 1760s, James Christie had begun selling the contents, and often the leases, of London houses. In 1768, he undertook house sales for the Rt Hon. Lord Cornwallis and the Duchess of Grafton, and just five years later he was approached to sell the estate of a person of royal rank: the Dowager Princess Augusta of Saxe-Coburg, widow of Frederick Louis, Prince of Wales.

Francis Thomas Fitzmaurice, 3rd Earl of Kerry (1740–1818), was an enormously wealthy Irish peer who cheerfully worked his way through his own and his wife's inheritance on what Horace Walpole described as 'the idlest ostentation'. The earl redecorated his houses regularly, equipping them with contemporary furniture in the most up-to-date taste. In 1768, he married Anastasia Daly, a divorcée twenty years his senior, and the couple left South-Hill, their home near Bagshot in Surrey (now Southill Park), to establish themselves in Portman Square in London. The contents of South-Hill were put

SALE
23–31 March 1778, London

ESTIMATE
Not published

SOLD
£55 13s/$255

EQUIVALENT TODAY
£6,330/$9,100

up for sale the following year, and Christie was invited to conduct proceedings, which included 'all the real and neat household furniture, books, and books of prints; A compleat [*sic*] Set of Sulphurs: Fine useful and ornamental China: A large Stock of Wines: Succession, and other Plants: And Live Stock.'

By 1778, when the Kerrys sold more of their 'modern' furniture, the agent who handled the sale appears to have been the furniture-maker William Ince, since he took delivery of £724 18s 6d (nearly $3,300; equivalent to £82,500/$118,750 today) on Lord Kerry's behalf. Indeed, the firm of Mayhew and Ince had most probably provided the furniture for the house, which was described as 'new within eighteen Months'. The sale took place on the premises, and catalogues could be purchased from local inns.

John Mayhew and William Ince were ambitious and innovative. In 1762, they published *The Universal System of Household Furniture*, which featured designs almost entirely in the rococo style, and they later experimented with the 'antique' taste. They were also involved in furnishing the earl's new London home, taking care of all aspects of the interior decoration and dealing with other suppliers. Yet, barely a decade after the 1769 sale, the contents of the Portman Square house were also put up for auction. The catalogue excelled itself in superlatives, describing the furniture as 'elegant' and 'of the first magnitude'. The most fashionable members of society flocked to the saleroom, providing a superb opportunity for Mayhew and Ince to show off their products and attract clients. A sideboard table and a pair of pedestals with urns that had stood in the dining room were recorded as being purchased by 'Hamden', who may have been the 1st Viscount Hampden.

Some time after the sale, the earl and his wife moved to Paris, perhaps forced there by mounting debt. Their departure from England did nothing to curb their extravagance, however, since they went on to furnish their new French home with products from the best Parisian suppliers.

Above: two pages from William Ince and John Mayhew's *The Universal System of Household Furniture*, first published in 1762.

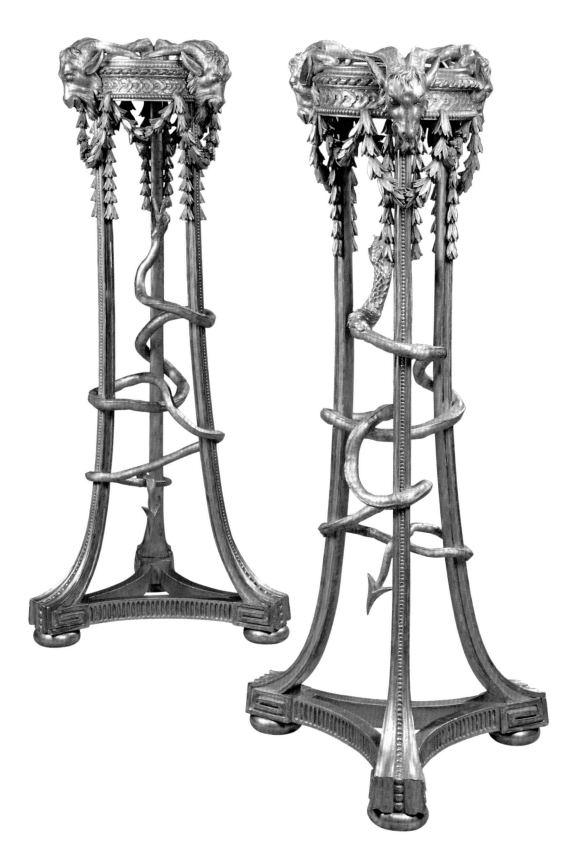

THE RISE AND FALL
OF HAMILTON PALACE

Jean-Henri Riesener
(1734–1806), a Royal
Louis XVI commode, 1778,
ormolu-mounted amaranth,
sycamore, mahogany,
parquetry and marquetry,
95 x 165 x 63 cm
(37 x 65 x 25 in)

SALE
17 June–18 July 1882, London

ESTIMATE
Not published

SOLD
£4,620/$22,500

EQUIVALENT TODAY
£416,000/$600,000

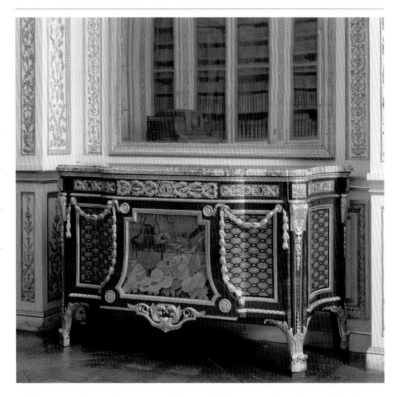

When Hamilton Palace in South Lanarkshire was finally completed
in 1842, it was one of the most impressive houses in Scotland. Work
on the house had begun in 1695, and successive Dukes of Hamilton had
filled it with extremely fine furniture, paintings, ceramics, decorative
objects, books and manuscripts, building a collection that rivalled
those of Europe's royal families. However, the house proved ruinously
expensive to maintain, and in 1882 the 12th Duke approached
Christie's to sell some of its choicest treasures to raise funds.

Although many deplored the dismantling of such an outstanding
collection, the seventeen-day sale aroused enormous interest, drawing
a flood of distinguished visitors and museum directors to the King
Street saleroom in London. After the event, *The Times* newspaper
reported that the sale, which realized £392,562 in total ($1,900,000;
equivalent to £35.3m/$50m today), 'may be considered to be
altogether by far the most important as regards money value that

has ever been known ... The Stowe sale, of forty days, gave a total
of £75,562; the Strawberry Hill Sale of ten days, only realized £40,000;
the Bernal sale – £62,691; so that this Hamilton Sale exceeds these
by more than five times that amount.' (For the Bernal sale, see pp.421–3;
for the Stowe sale, see pp.312–13 and 424–5). Among the highlights
of the sale were the paintings: eleven were acquired by the National
Gallery in London, and four by the National Gallery of Ireland in Dublin.

The furniture created for Marie Antoinette and Louis XVI was
also a great attraction. One of these objects was a superb commode
with a marble top and central still-life panel. Commissioned in 1778
for Louis XVI's *Cabinet de Retraite* at Fontainebleau, it was moved to the
new library at Versailles in 1784. It was sold along with other furniture
from Versailles after the French Revolution (1789–1799), and acquired
by the English connoisseur William Beckford (1760–1844), whose
daughter Susanna married the 10th Duke of Hamilton. Following the
Hamilton Palace sale in 1882, the commode later entered the collection
of Barons Nathaniel and Albert von Rothschild. It was sold in 1999 at
Christie's for a record-breaking £7m ($11m). The French state was able
to acquire this masterpiece with a generous contribution from Madame
François Pinault, and it now stands in the library at Versailles again,
along with other pieces of French eighteenth-century furniture that
originally filled the room.

The fate of the Scottish palace was rather less happy. In 1919,
Christie's organized a further sale of contents from Hamilton Palace,
including the decorations of the seventeenth- and eighteenth-century
rooms. By 1927, the house itself was suffering from serious subsidence
caused by the coalfields running beneath it – coalfields that had once
supplied its income – and it was demolished.

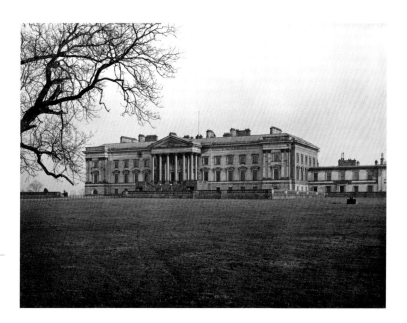

Hamilton Palace in
South Lanarkshire,
Scotland, former home
of the Louis XVI commode.

IN CELEBRATION OF THE SUN KING

Attributed to André-Charles
Boulle (1642–1732), Louis XIV
coffer, 1675–80, oak, pewter,
brass, tortoiseshell, horn,
ebony, ivory, bronze and
snakewood, 86.5 x 53.5 cm
(34 x 21 in)

SALE
8 April 1948, London

ESTIMATE
Not published

SOLD
£262 10s/$1,260

EQUIVALENT TODAY
£8,500/$12,400

Such was the fame of the French craftsman André-Charles Boulle that he gave his name to the technique of veneering furniture with marquetry made from such materials as tortoiseshell, pewter and brass. This has been known ever since as 'boulle work'. From 1672 he achieved the title of cabinetmaker and sculptor to King Louis XIV of France, and expanded his repertoire to include gilt-bronze work (see pp.402–3 and 442–3 for other examples of his work).

This extravagant example of Boulle's work was auctioned by Christie's on 8 April 1948, when it was sold from Harlaxton Manor in Lincolnshire. The symbols in the cabinet's intricate decoration refer to the Sun King's military victories in the Franco-Dutch War of 1672–8, when the Dutch, Spanish and imperial armies were defeated. A panel on the central door shows the cockerel of France standing triumphantly over both the Holy Roman Empire's eagle and the lion of Spain and its possessions in the Netherlands. Two caryatids, figures that act as columns, appear to support the cabinet. They are both taken from Greek mythology: the hero Hercules and Hippolyta, Queen of the Amazons, representatives of strength and bravery in war.

Fleurs-de-lis on the top drawers show that the cabinet was made for Louis XIV, although, since it does not appear in his inventories, the piece may have served as a royal gift. The J. Paul Getty Museum in California, which now owns this cabinet, notes that its pair is in Scotland. Both probably entered Britain in the early nineteenth century, after the French Revolution resulted in the dispersal of many notable French collections.

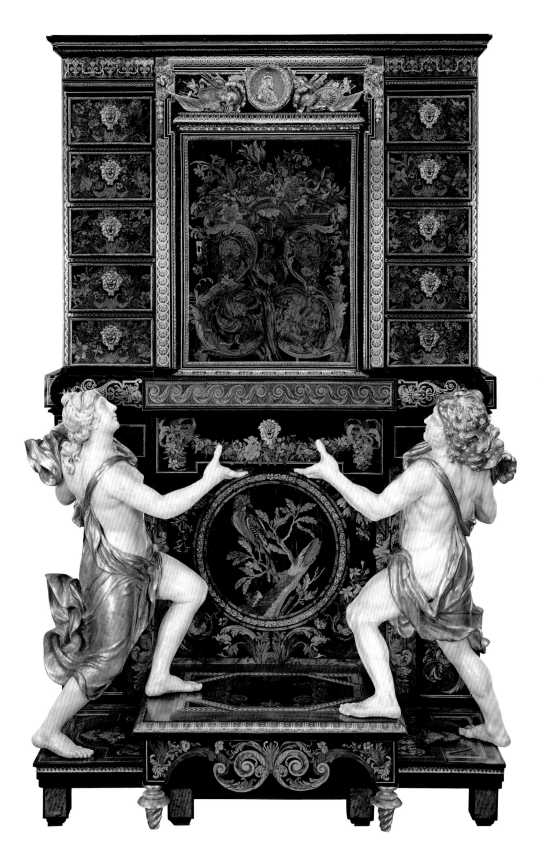

THE LEGEND OF
THE LUBA

Attributed to the Warua
Master, Luba female figure
for a bow stand (second
from left), c.1880, wood,
64.5 cm (25½ in) high

SALE
9 July 2015, London

ESTIMATE
£1.5m–2.5m/$2.3m–3.8m

SOLD
£6,130,500/$9,427,185

Top: six examples
of sculptures by the
Warua Master.

Above: Kazembe VI Cinyanta
Munona, ruler of Luba
and Luanda in West Africa
from 1854 to 1862.

Despite its title today, the 'Luba female figure for a bow stand' was
not an item of war. Nor was it a princely piece of hunting equipment.
Rather, it was the Luba court's equivalent of a crown jewel, carved by
one of the leading craftsmen of the Central African Luba people in the
late nineteenth century.

In Luba mythology, the founders of this aristocratic culture were
great hunters. This detailed ritual object, carved from a single piece
of wood, would have been looked after by a high-ranking female
courtier and brought out for ceremonies, thrust symbolically into
the ground next to the king to hold his bow and arrows. It embodies
the sophistication of the Luba court's visual culture, combining
powerful symbolism from its hunting history with exquisitely
harmonious proportions.

For more than four centuries, the Luba Kingdom grew and thrived
in the marshy grasslands and forests on either side of the Lualaba River,
in what is now the Democratic Republic of the Congo. The Luba court
prized its artists; their creativity was seen as god-like, and each was
honoured with a ceremonial axe to be carried around on the shoulder.

The Warua Master's output was tiny. Just nine pieces of Luba art are thought to be by his hand, perhaps owing to the extreme lengths to which he went in order to achieve perfection in his proportions. As early as 1900, Western art historians were impressed by his style. Much has been made of the Master's rhythmic use of isometric intervals, which give the body a sense of harmony. This bow stand achieved the second highest price ever paid for a work of African art at auction when it sold in July 2015 for just over £6.1m.

199

DRUMMER FROM THE SOUTH SEAS

Hara Shugetsu (active mid-18th century), South Sea Island drummer netsuke, 18th century, ivory, 14.5 cm (5½ in) high

SALE
16 May 1990, London

ESTIMATE
£10,000–15,000/
$17,800–26,700

SOLD
£51,700/$92,000

EQUIVALENT TODAY
£105,000/$148,000

This netsuke made some noise at an auction in 1990 when it sold for more than three times its high estimate. The eighteenth-century piece is described in the sale catalogue as an 'important ivory netsuke ... his hair in tightly coiled ringlets, his chest and abdomen partly covered by a figured cloth held by a coral clasp at the throat'.

It depicts a South Sea Island drummer and is signed by Shugetsu, the Osaka-based artist who flourished between 1764 and 1771 and who, according to the auction catalogue, was awarded the title 'Hogen' Shugetsu for his work as a painter in the Kanō style.

This netsuke came from the collection of Henri Louis Joly (1876–1920), an early twentieth-century scholar of Japanese art. In 1908 Joly published his *Legend in Japanese Art*, at a time when Western collectors were beginning to show an interest in that nation's artistic traditions. His obituary in the *Journal of the Royal Asiatic Society of Great Britain and Ireland* (1920) highlighted his many attributes and concluded: '*Legend in Japanese Art* is too well known to need comment; but perhaps his most important work was in connection with sword furniture.'

The impeccable provenance of the island drummer netsuke was a decisive factor in the price it fetched in 1990. It had previously featured in a landmark exhibition organized by Joly and the dealer Kumasaku Tomita in late 1915. The loan show at the Yamanaka Gallery in London was held in aid of the British Red Cross, and encompassed 2,415 objects including inro, lacquerware and tsuba. The netsuke is described as 'a tall figure of a foreigner, looking skywards', and the figure's gait and features suggest that it is a South Sea Island drummer.

FROM TROPICAL FOLLY
TO ARCHITECTURAL ICON

Jean Prouvé (1901–1984),
La Maison Tropicale,
1950–1, prefabricated metal
aluminium building,
49 x 18 x 10 m (16 x 59 x 33 ft)

SALE
5 June 2007, New York

ESTIMATE
$4m–6m/£2m–3m

SOLD
$4,968,000/£2,491,405

La Maison Tropicale, conceived in the late 1940s, was intended as
the solution to a housing shortage in France's African colonies. The
architect Jean Prouvé set out to design a versatile, mass-producible
building. Its aluminium components were small and light enough to
transport in a cargo plane, and it was easy to construct on site. One
might expect this biscuit-tin building to become unbearably stuffy
under the African sun, but Prouvé built in an ingenious cooling system
whereby air inside was drawn upwards and vented through the
horizontal chimney that runs the length of the roof like a spine. The
porthole windows were made of blue glass to reflect the sun's glare.
These cookie-cutter holes in the metal fabric are a distinctive design
feature – a signature Prouvé touch.

Despite the ingenuity invested in it, La Maison Tropicale did not
take off. Only three prototype houses ever went to Africa: one to
Niger and two to Brazzaville in the Democratic Republic of the Congo.
The Brazzaville houses were never lived in, but were used as offices
by a French business.

In the 1990s, the furniture dealer Eric Touchaleaume went to
enormous lengths to seek out the houses and bring them back to France.
They were in a sorry condition by then – corroded, run-down and war-
damaged. Touchaleaume spent $3m (£2m) restoring the larger of the
two Brazzaville houses, retaining the bullet holes as an authentic part
of the object's history. It was this house that went up for auction in
New York in 2007.

Back in Europe and the United States, the aluminium house took
on all the attributes of an art object, and was hailed as a visionary work
of modernism. Philippe Garner, Christie's deputy chairman and leading
expert in modern design, described it as a 'stunning, industrial-style,
intellectual, twentieth-century "folly"'. La Maison Tropicale was no
longer a cheap prefab, but had become a rare artefact. This one sold
for almost $5m to André Balazs, owner of a portfolio of luxury hotels.
He told the press that he planned to put it 'somewhere hot'.

Architect Jean Prouvé
standing in front of
prototype walls for
La Maison Tropicale, c.1950.

201

AN UNHOLY ROW

Chris Ofili (b. 1968),
The Holy Virgin Mary, 1996,
acrylic, oil, polyester resin,
paper collage, glitter,
map pins and elephant
dung on linen,
253.5 x 182.5 cm (100 x 72 in)

SALE
30 June 2015, London

ESTIMATE
£1.4m–1.8m/$2.2m–2.8m

SOLD
£2,882,500/$4,532,945

Few works of art have been more misunderstood than *The Holy Virgin Mary* by the British artist Chris Ofili. The painting was included in 'Sensation' (1997) at the Royal Academy of Arts in London, the exhibition that featured work by Young British Artists from Charles Saatchi's collection. When the show toured to the Brooklyn Museum in New York, Ofili's painting prompted a fierce debate that led Rudy Giuliani, then mayor of New York, to threaten to withdraw the museum's subsidy and even evict it if the museum did not cancel the entire exhibition (the museum won the lawsuit that followed).

'The idea of having so-called works of art in which people are throwing elephant dung at a picture of the Virgin Mary is sick,' Giuliani exclaimed. Nothing in that statement is accurate, but it set the tone for the debate: reports in leading newspapers claimed the painting was stained, covered, smeared or splattered with excrement. In fact, the dung balls, one of the trademarks of Chris Ofili's early style, had been used sparingly: to prop up the canvas (the words 'Virgin' and 'Mary' are written on the balls using map pins) and, on the canvas itself, as the Virgin's right breast.

Ofili's use of dung was inspired by a trip to Zimbabwe in 1992, as were some of the decorative patterns in his work, which related to cave paintings he saw in that country. Indeed, across twenty-five years of painting Ofili has consistently explored African identity, meaning that his work can be seen in multiple contexts, including the history of British art and that of the African diaspora. For him, the dung has a multitude of meanings, among them fertility, hence its use for the Virgin's breast.

Some writers have speculated that the real problem for those offended by Ofili's painting was that in it Mary is a black woman. Ofili, who was brought up a Catholic, said: 'As an altar boy I was confused by the idea of a holy Virgin Mary giving birth to a young boy. Now when I go to the National Gallery and see paintings of the Virgin Mary, I see how sexually charged they are.' His was a 'hip-hop version,' he said, that explored 'the way black females are talked about in contemporary gangsta rap.' Hence the presence of buttocks cut from porn magazines, equivalents to the putti in Renaissance depictions of the Virgin. 'I wanted to juxtapose the profanity of the porn clips with something that's considered quite sacred,' Ofili said.

With these multiple layers – contemporary black pop culture, historical African influences, and witty and knowing takes on art history – it's no wonder that Ofili was resistant to commenting on the furore. 'The people who are attacking this painting are attacking their own interpretation, not mine,' he said at the time. He later expressed regret at its notoriety because it is, he said, 'a very beautiful painting to look at.'

This combination of notoriety and visual seduction have made the painting one of Ofili's best-known works. It formerly belonged to Charles Saatchi and was later purchased by David Walsh, the Australian collector and founder of the Museum of Old and New Art in Hobart, Tasmania. When the museum sold the work with Christie's in 2015, it established a record price for Ofili's work at auction, selling for nearly £2.9m.

GOING ONCE

THE MELODRAMA
OF VULGARITY

Willem de Kooning
(1904–1997), *Woman*, 1949,
oil, enamel and charcoal
on canvas, 153.5 x 122 cm
(60½ x 48 in)

SALE
20 November 1996, New York

ESTIMATE
Not published

SOLD
$15,622,500/£9,311,010

EQUIVALENT TODAY
$22,500,000/£15,600,000

Willem de Kooning was an Abstract Expressionist painter whose
exuberant, often aggressive works incorporated abstraction and
representation and frequently merged these two fields. One of his
recurring themes was women, or rather a particular type of woman:
voracious and voluptuous. Fascinated by what he called 'the melodrama
of vulgarity,' de Kooning admitted that 'beauty becomes petulant to
me. I like the grotesque. It's more joyous.' He later commented that
his early paintings of women, created in the 1940s and 1950s, were
'vociferous and ferocious'. When they were first shown in 1953, his
'Woman' paintings from the early 1950s caused consternation among
viewers and critics, as de Kooning was accused of betraying abstraction.
Woman (1949), while stylistically distinct, could be seen as a precursor
to this body of work.

Woman was first owned by Boris Leavitt (1905–1996), a pioneer
of direct marketing who had amassed a fortune through his mail-order
business. He bought the painting in 1955 and kept it at his Pennsylvania
farmhouse, where it was seen by Martha Baer, a senior director at
Christie's in New York. Baer remarked in the sale catalogue that
'no illustration can reproduce the intensity of the painting, its bright
colours, its overall impact and beauty'.

After Leavitt's death, the painting was one of twelve works from
his collection to be auctioned at Christie's in a sale that exceeded
all expectations. When *Woman* was sold for just over $15.6m to
an unidentified telephone bidder, all those in the saleroom burst
into applause. The auctioneer Christopher Burge remarked: 'Happy
days are here again … this is the first time in living memory that
a contemporary painting has sold for more than any Impressionist
or modern work.'

A MASTERCLASS IN OLD MASTERS

Rembrandt van Rijn
(1606–1669), *Susanna and
the Elders*, 1647, oil on panel,
76.5 x 92.5 cm (30 x 36½ in)

SALE
13–17 March 1795, London

ESTIMATE
Not published

SOLD
156 guineas/£163 16s/$740

EQUIVALENT TODAY
£15,100/$21,300

In 1795, three years after his death, Christie's sold the contents of the studio belonging to the leading portrait artist Joshua Reynolds (1723–1792). The auction was held over four days, between 13 and 17 March, and 411 pictures from his substantial collection were offered.

The range of Reynolds's collection was remarkable. The catalogue's title page underlines the significance of the sale, describing 'The Capital, Genuine, and Valuable Collection of Pictures, ... Comprising the Undoubted Works of the Greatest Masters of the Roman, Florentine, Bolognese, Venetian, French, Flemish, and Dutch Schools, In the most perfect State of Preservation.'

Reynolds travelled abroad between 1749 and 1752, mainly in Italy, where he made drawings of Old Master works while also developing his own style. He went on to become very popular among politicians, actors and aristocrats, and his perceptive style of portraiture was much in demand. In 1768 he was elected the first president of the Royal Academy of Arts in London.

On occasion, the artist modified and embellished original works, including Rembrandt's *Susanna and the Elders*, which he bought from his friend, the philosopher and political theorist Edmund Burke, in about 1769. Katja Kleinert and Claudia Laurenze-Landsberg of the Gemäldegalerie in Berlin, discovered in 2015 that Reynolds had made 'significant changes' to Rembrandt's painting while it was in his possession. The Rembrandt Database, established in 2012 by the RKD-Netherlands Institute for Art History and the Royal Picture Gallery Mauritshuis, The Hague, gives a credible explanation: 'The reworking cannot have been a repair – Reynolds must have intended to improve it. Perhaps [he] intended to make the painting more "Rembrandtesque" in accordance with the eighteenth-century conception of that term.'

Reynolds had bequeathed *Susanna and the Elders* to his niece Lady Inchiquin, but the artist's impressive collection was sold to pay off Lord Inchiquin's debts. It was purchased in the name of Wilson for 156 guineas.

A NEW ERA
FOR THE ART MARKET

Pablo Picasso (1881–1973),
*Les femmes d'Alger
(Version 'O')*, 1955,
oil on canvas,
114 x 146 cm (45 x 57½ in)

SALE
11 May 2015, New York

ESTIMATE
$140m/£90m

SOLD
$179,365,000/£115,044,710

On 11 May 2015, Picasso's *Les femmes d'Alger (Version 'O')* became the most expensive work of art ever sold at auction, realizing the astonishing price of $179,365,000. The painting heralded the artist's prodigious production of his late period, *l'époque Jacqueline*, which the artist's biographer John Richardson named for Picasso's second wife, the final abiding love of his life and the ultimate muse for his art.

Since before the Second World War, Picasso had been thinking of painting a homage to Eugène Delacroix (1798–1863), taking his *Femmes d'Alger dans leur appartement* (1834) in the Louvre in Paris, as his inspiration. Yet it was not until November 1954 and the death of Henri Matisse, that Picasso finally felt compelled to embark on this project. Matisse had been his long-time rival, and the only artist he esteemed to be his peer. (They became firm friends towards the end of Matisse's life.)

Matisse had brought the Orientalist tradition of the odalisque – a harem concubine – into the realm of modernist painting. Picasso transformed his simmering obsession with Delacroix's *Femmes d'Alger* into an ardent tribute to both Delacroix and Matisse. 'When Matisse died he left his odalisques to me as a legacy,' Picasso declared. 'This is my idea of the Orient though I have never been there.' His series *Les femmes d'Alger*, moreover, celebrated the arrival of Jacqueline in the artist's life. Her presence in *Les femmes d'Alger (Version 'O')* is that of a queen enthroned. Picasso had met Jacqueline at the Madoura Pottery in Vallauris, in the south of France, in 1953, when she was twenty-seven and he seventy-two. They were married in March 1961 (see p.144).

Between 13 December 1954 and 14 February 1955, in his Paris studio, Picasso painted fifteen canvases based on Delacroix's harem painting, titling them from version 'A' to 'O'. The first fourteen versions constitute the prologue to the final work, *Version 'O'*, a painting that remained unsurpassed. Woven into it are strands of Delacroix's lyrical romanticism, Matisse's consummate use of colour, as well as a structural syntax that Picasso derived from his own contribution to Cubism.

Eugène Delacroix's
*Femmes d'Alger dans
leur appartement*, 1834,
inspired Picasso's
own masterpiece.

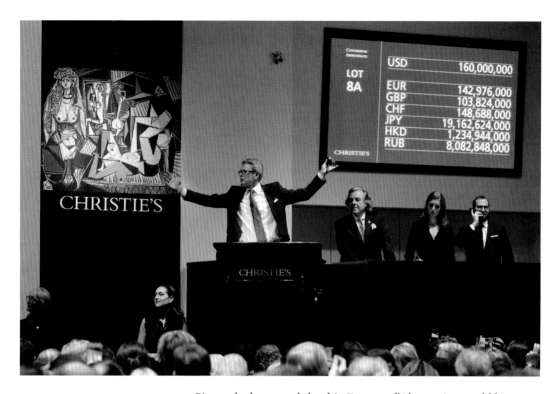

Picasso had assumed that his *Femmes d'Alger* series would be dispersed among various collectors. However, his dealer Daniel-Henry Kahnweiler stipulated that the canvases should be sold as a group, and found an interested buyer in the Manhattan collectors Victor and Sally Ganz. 'The whole harem in one American's house!' Picasso mused. 'These are too many canvases for one man.' The Ganzes paid 80m francs (nearly $213,000) for the entire series in June 1956, but subsequently had to sell ten of the fifteen canvases to other collectors and museums in America. *Version 'O'* remained as the centrepiece of their Picasso collection and it was the highlight of the Ganz sale at Christie's New York on 10 November 1997, when it sold for $31,902,500 (£18,800,000) (see also p.122).

Les femmes d'Alger (Version 'O') reappeared at Christie's in 2015. Olivier Camu, deputy chairman of Impressionist and modern art at Christie's and the person responsible for the consignment of the picture, described it as 'arguably the single most important painting by Picasso still in private hands.' Jussi Pylkkänen began the bidding at $100m, with competing parties signalling at least thirty bids in increments of $1m. After eleven and a half minutes, the work finally went to a telephone bidder for the unprecedented price of $179m. 'We have entered a new era of the art market,' Pylkkänen said afterwards, 'where collectors from all parts of the world compete for the very best across categories, generating record prices at levels we have never seen before.'

Auctioneer Jussi Pylkkänen in action during the sale of Picasso's *Les femmes d'Alger (Version 'O')* at Christie's New York in 2015. It became the most expensive painting ever sold at auction.

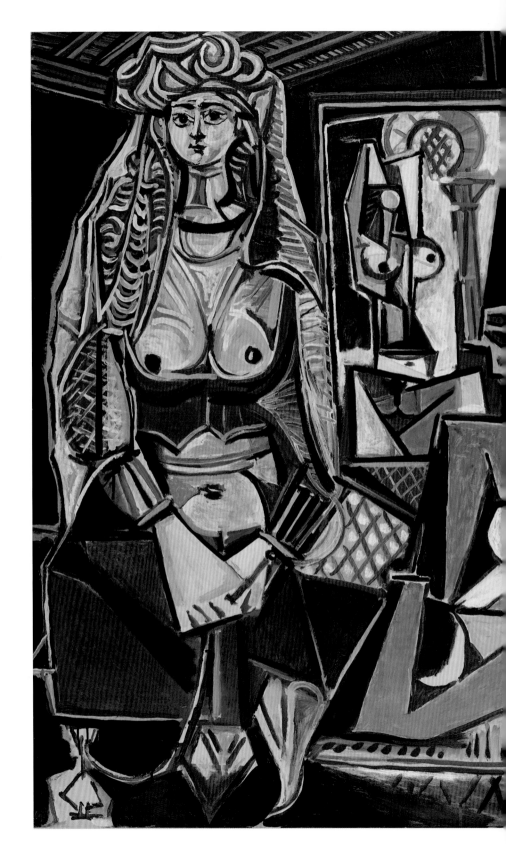

GOING ONCE

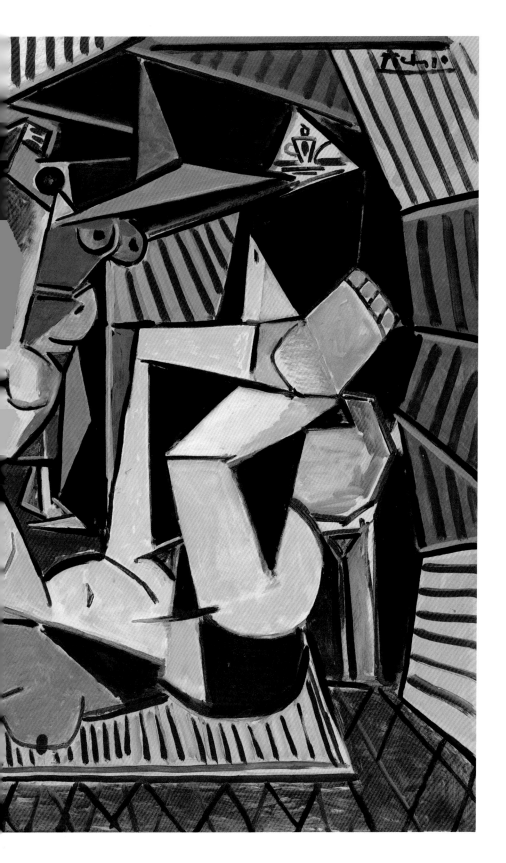

ABSTRACTION
AHEAD OF ITS TIME

Hadley chest with drawers,
c.1715, polychrome oak
and pine, 110.5 x 109 x 47 cm
(43½ x 43 x 18½ in)

SALE
22 January 2016, New York

ESTIMATE
Not published

SOLD
$1,025,000/£716,270

Once in a while an object or artwork comes before a Christie's specialist and changes everything. For Christie's deputy chairman John Hays, that moment came ten years ago, when he was head of the American furniture department in New York.

A local appraiser on the west coast of America had sent Hays and his team a photograph of an elaborately painted chest, asking for assistance in valuing it. For Hays, it was 'one of those "wow" moments'. There was little doubt in his mind that the photograph depicted an example of a rare late seventeenth- or early eighteenth-century New England dowry chest, known as a Hadley chest (named after the town of Hadley, Massachusetts, where the first of these chests was discovered). To see an entirely undocumented example was extraordinary in itself, since these pieces of folk furniture are among the most beautiful examples of New England's unique arts and crafts heritage in existence. However, there was something more: the chest Hays was looking at would make him question his established beliefs concerning the history of art and design.

Example of a carved
unpainted Hadley chest,
made in Massachusetts,
c.1670–1710.

More than 250 Hadley chests survive today. Most are ornamented with beautiful folk carvings, but three, Hays knew, were not. Instead, they were elaborately painted, although over the centuries the delicate paintwork had weathered badly and the true vibrancy of their colours had been lost. However, the paintwork on this Hadley chest – the newly discovered fourth painted chest – had been protected by a layer of varnish. Once restored, it revealed a dazzling multicoloured mêlée of painted flowers and compass decoration that anticipated such modernist painters as Sonia Delaunay and even the colour-field works of 1950s Abstract Expressionism.

'Whenever we look at a piece of painted furniture,' Hays explains, 'we have to look at it two ways. First as a piece of furniture, and then as a painting.' The specialist described the paintwork embellishing the front of the chest as 'a miracle' – a decisive moment in the history of American design. Two hundred years before the advent of modern art, the American folk artists of the upper Connecticut River Valley were now known to have been experimenting with ideas of colour wheels and abstraction.

The newly discovered Hadley chest thus represents a pivotal development in the evolution of American craftsmanship, and in January 2016 it sold at auction in New York for $1,025,000.

OF FAME AND PHARMACEUTICALS

Damien Hirst (b. 1965),
Acetic Anhydride, 1991,
household gloss paint
on canvas, 169 x 200 cm
(66½ x 78½ in)

SALE
8 December 1998, London

ESTIMATE
£20,000–25,000/
$33,000–41,000

SOLD
£122,500/$202,600

EQUIVALENT TODAY
£193,000/$278,400

When Damien Hirst's first spot painting came up for sale in 1996 – the first of his works to reach auction – many commentators and journalists wondered out loud if this was the start of a new era. 'Art market superbrat makes his auction debut this week,' wrote *The Independent*. 'The appearance of a Hirst at Christie's is a first swallow indicating greater confidence in the post-recession contemporary art auction market.'

For once the art-world speculation and newspaper hype proved correct. The previous year, buyers had been playing it relatively safe at auction, buying works by Yves Klein and Robert Rauschenberg. The catalogue for the sale in 1996, however, was populated with young newcomers of whom Hirst was the best known. He was already well-known for his formaldehyde-preserved sharks and cows, which addressed the relationship between art, science and mortality. His 'Pharmaceutical Paintings', comprising immaculate grids of coloured dots, spoke to the same theme: each titled after individual chemical compounds, their molecular structures sought to distil the dialogue between order and chaos that underpins our existence.

Hard on the heels of this first sale came the 'Sensation' exhibition of 120 works from the collection of Charles Saatchi at the Royal Academy of Arts in London in 1997. Then, in 1998, an auction was held of works from that same collection – many of them by the YBAs or 'Young British Artists': Rachel Whiteread, Jenny Saville, Dinos and Jake Chapman, Tracey Emin, Sarah Lucas, Chris Ofili (see pp.264–5, 373–5 and 410–11).

With all this very visible activity, prices for contemporary art began to rocket. In 1996, Hirst's dealer Jay Jopling had declared that he would be happy to see that first-time-on-the-block spot painting make £10,000. Two years later, *Acetic Anhydride* sold for £122,500. A decade after that, Hirst felt able to ask a cool £50m ($100m) for a single work – a platinum skull encrusted with over 8,000 diamonds called *For the Love of God* (2007). It was a grand gesture, as if the price tag were as much a part of the work of art as the object.

FORTUNE FAVOURS
THE BOLD

'Doubly Fortunate'
single-strand jadeite
necklace, late 1940s,
27 jadeite beads and
single-stone diamond
clasp, 47 cm (18½ in) long,
each bead 15–16 mm
(⅝ in) in diameter

SALE
6 November 1997, Hong Kong

ESTIMATE
Not published

SOLD
HK$72,620,000/
£5,519,120/$9,367,980

EQUIVALENT TODAY
HK$101,361,200/
£8,970,000/$12,997,000

The Chinese word for jade – *yu* – covers both nephrite and jadeite.
In colour it ranges from pure white to purple and brown, as well as
the soft greens that are most widely associated with it. The dazzling
colour of this necklace is known as *feicui* (kingfisher) green.

In China, jade artefacts were already being buried with royalty
in the second millennium BC, and in time the rarity and purity of
the stone earned it a reputation for supernatural powers, including a
supposed ability to preserve the human body after death. In the homes
of the wealthy, artefacts made from this beautiful and very hard stone
were collected and treasured, ranging from tiny pieces of jewellery to
large boulders intricately carved with mountain scenes.

Jadeite may have first come to Chinese attention in the eighteenth
century, when the Emperor Qianlong (r. 1736–96) mounted three
costly but unsuccessful invasions of northern Burma. Over the next
century, however, this region became known to Chinese collectors
as their nearest source of jadeite, and merchants began exploiting the
rarity of *feicui* jade.

The Christie's sale in November 1997, during the first Hong Kong
sales season after the former British colony had been returned to
China, provided the first public view of what is now ranked among the
world's most precious pieces of jade jewellery, the 'Doubly Fortunate'
necklace. The necklace was made from a large stone of jadeite, originally
weighing more than 50 kg (110 lb), which had been discovered at
Hpakant in northern Burma some time after the end of the Second
World War. Its name, 'Doubly Fortunate', stemmed from the perceived
increase in value of the raw stone each time it was cut, revealing over
and over again the unparalleled depth of its perfection. What made
the twenty-seven flawless stones of the necklace so special was
their exceptionally consistent appearance and the even distribution
of their 'kingfisher' colour.

The American heiress
Barbara Hutton in 1941,
wearing a similar jadeite
necklace known as the
Hutton-Mdivani necklace.

A DESK TO IMPRESS

Attributed to John Goddard
(1723/4–1785), the Nicholas
Brown desk and bookcase,
1760–70, mahogany,
pine, poplar, chestnut and
cherry wood, 287 x 108 cm
(113 x 4½ in)

SALE
3 June 1989, New York

ESTIMATE
Not published

SOLD
$12,100,000/£7,378,000

EQUIVALENT TODAY
$23,200,000/£16,400,000

John Goddard, the probable maker of this extraordinary piece, was
a hardworking cabinetmaker and father of fifteen children, who was
not above making coffins to help pay his bills. He and his family lived
on the docks of Newport, Rhode Island, strategically positioned so
that he could have first pick of the mahogany logs as they arrived from
the Caribbean.

Next door to his home was his modest shop, the size of a modern
one-car garage. It was there that he built the desk and bookshelf that
– 200 years after his death – would astound experts when it fetched
$12.1m, becoming the most valuable object (excluding paintings) ever
to be sold at auction. (It also eclipsed the $3m decorative arts record –
held by a diamond-encrusted Fabergé egg – four times over.)

Pre-Revolutionary Newport was home to many Quaker
cabinetmaking families, all vying to outdo one another while also
seeking to develop a recognizable local style that would establish the
city as the centre of colonial furniture-making. The Goddard family's
business, which was united by marriage with that of the Townsend
family, is now considered by many to be the best of the best in
colonial cabinetmaking.

This desk first belonged to Nicholas Brown (1729–1791),
a merchant who made his fortune in whale-oil candles and was a
founding father of what would become Brown University. Brown's
biographer, James B. Hedges, described him as 'methodical, patient,
plodding, persevering and thorough'. Such a beautiful 'shell and
block' desk would have been the ultimate status symbol among the
merchant aristocracy, and at nearly 3 metres (10 feet) high, Brown's
was the tallest and grandest of all. It would be passed down through
the Brown family until the sale in 1989.

There are nine so-called shell and block desks by Goddard, four
of which were owned by the Brown brothers. They were masterpieces
distinguished by their elegant, fluted proportions and the sculpted
shapeliness of their details – the distinctive scallop shells are entirely
unique in furniture. This example is now in the collection of Yale
University Art Gallery in New Haven, Connecticut.

BY ROYAL
APPOINTMENT

Ivory settee, c.1770,
sandalwood veneered with
ivory, engraved and inlaid,
with silk seat coverings,
101 x 184 x 82.5 cm
(40 x 72½ x 32½ in)

SALE
6 October 1781

ESTIMATE
Not published

SOLD
£152 5s/$695

EQUIVALENT TODAY
£17,000/$24,600

By the late eighteenth century, James Christie was holding house sales *in situ* as it became impractical to pack up and ship the entire contents of large country homes to the saleroom on Pall Mall. It was on one such occasion, surrounded by the goods and chattels of the late Governor of Madras, Alexander Wynch, at Westhorpe House in Buckinghamshire, that Christie met King George III. The event was reported in the *St James's Chronicle* on Thursday 18 October 1781:

> On Monday, as his Majesty passed by Westhorpe House ...
> Mr Christie requested his most dutiful respects might be
> presented to his Majesty, that he wished to show him some very
> curious ivory chairs and a couch that were to be disposed of.

The king accepted Christie's invitation, and was shown the furniture on the lawn at Westhorpe. He liked what he saw so much that he purchased the settee, the chairs and two bureaux, all in the ivory-veneered sandalwood typical of furniture from Vizagapatam, India, made in the 1760s and 1770s. The king gave the furniture to the

queen as a gift, and it was sent to the royal family's new home, the Queen's Lodge in Windsor.

At the sale of Queen Charlotte's effects at Christie's in May 1819, King George IV (as Prince Regent) purchased the entire set of chairs, settee and bureaux, with other similar pieces collected by the queen, for his newly redesigned Brighton Pavilion. Today, the chairs can be found in the Principal Corridor at Buckingham Palace in London.

A COLLECTION DESTINED FOR AN EMPRESS

210

Carlo Maratta (1625–1713), *Portrait of Pope Clement IX*, 1669, oil on canvas, 153 x 118.5 cm (60 x 46½ in)

SALE
30 May 1778, London

ESTIMATE
Not published

SOLD
£350/$1,600

EQUIVALENT TODAY
£39,800/$57,100

Fedor Stepanovich Rokotov's portrait of Catherine the Great, c.1770. She purchased the Walpole art collection in 1778.

The imposing portrait made in 1669 of the ageing pontiff Pope Clement IX by Carlo Maratta is one of the painter's finest works. It continues the Renaissance tradition of papal portraits established by Raphael and Titian, and invests the sitter – who supported the arts, opened Rome's first public opera house and commissioned the marble angels that decorate the Ponte Sant'Angelo – with an appropriate dignity.

The portrait is one of 204 paintings that were once the crowning glory of Houghton Hall, the Norfolk residence of Britain's first Prime Minister, Sir Robert Walpole (1676–1745). Walpole had refashioned his country home as a Palladian temple to art, filling it with superb furniture and paintings gathered from across Europe, including masterpieces by Anthony van Dyck, Nicolas Poussin, Peter Paul Rubens, Rembrandt van Rijn, Diego Velázquez and Bartolomé Esteban Murillo. Maratta was a particular favourite of Walpole, and he dedicated an entire room to the artist's work.

However, such magnificence did not come cheap, and on his death Sir Robert left huge debts that his heirs struggled to pay. His grandson George Walpole, 3rd Earl of Orford (1730–1791), allowed the house to fall into disrepair, and it gradually became clear that something would have to be done to secure the future of the art collection. In May 1778, James Christie was asked discreetly to value the collection as a whole, and – with the assistance of several experts, including the artist Giovanni Battista Cipriani (1727–1785) – he arrived at a figure of £40,500 ($184,000; equivalent to about £4.6m/$6.6m today).

The MP John Wilkes pleaded with Parliament to make funds available so that the newly founded British Museum might acquire the paintings, arguing that they would inspire British artists to study the excellence of Continental masters. However, Parliament and the

king balked at the sum involved. George Walpole then asked Christie to present his valuation to the Russian Ambassador to the Court of St James. The ambassador despatched a letter to Empress Catherine the Great describing the collection as 'worthy, in the opinion of all connoisseurs, of belonging to one of the great sovereigns'.

Catherine, who was both knowledgeable and insatiable as a collector, was quick to agree to the private sale negotiated by Christie. By the spring of 1779, the paintings, packed into fifty boxes, were sailing to St Petersburg, where they are now a highlight of the Hermitage collection. More than two centuries after the sale, in 2013, Christie's played a supporting role in the temporary return of seventy of Walpole's masterpieces to Houghton Hall when it sponsored the 'Houghton Revisited' exhibition. For five months, the paintings graced the walls of the rooms where they had originally hung, giving the public a chance to appreciate the scale and splendour of this incomparable collection in the setting for which it was intended.

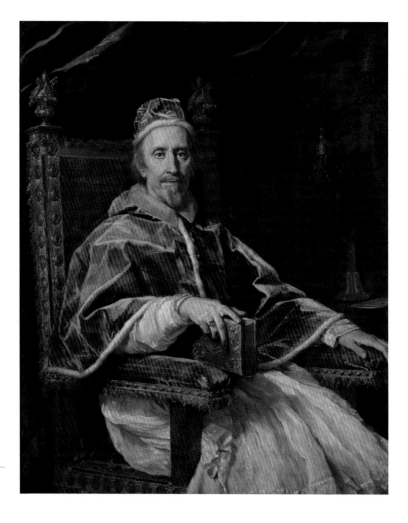

Carlo Maratta's *Portrait of Pope Clement IX*, 1669.

PAPAL POWER

Francis Bacon (1909–1992),
Study for a Pope, 1955,
oil on canvas, 152.5 x 117 cm
(60 x 46 in)

SALE
13 November 1964, London

ESTIMATE
Not published

SOLD
£5,775/$16,110

EQUIVALENT TODAY
£105,000/$151,400

In 1973, Francis Bacon spoke of being 'haunted and obsessed' by the 'perfection' of Diego Velázquez's great portrait *Pope Innocent X* (1650). From his first painting based on the Spaniard's masterpiece in 1949 and in fifty or so further paintings, Bacon set about violating that perfection.

Bacon never saw the original painting. In reality, seeing the Velázquez might have affected his capacity to reinvent the Pope in the

Diego Velázquez's *Pope Innocent X*, 1650, the inspiration behind Francis Bacon's own Pope paintings.

way he could from a reproduction, just as he said he avoided making portraits of people from life, because, as he said, 'if I like them, I don't want to practise before them the injury that I do to them in my work.' Instead, in the chaos of his London studio, he placed an image of Velázquez's painting between photographs of Heinrich Himmler and Joseph Goebbels.

Bacon's pontiffs, often called the 'screaming popes', are, as the art historian Michael Peppiatt writes, 'a centrepiece of the whole of twentieth-century art'; the evidence of a modern master in conversation with a Baroque counterpart. *Study for a Pope* (1955) is unusual in the group in that the figure has left his chair and appears to lunge towards the viewer, escaping the 'space frame' in which Bacon has placed him.

This painting is very probably the first work by Bacon to have been sold by Christie's. It was the only one put up at auction by John Knight, who had acquired it directly from Bacon in the year it was painted. Daniel Farson, the writer and broadcaster who, like Bacon, was a regular of the Soho drinking scene, vividly recalled the circumstances. Bacon had phoned Farson to ask if he knew of a potential buyer for the painting. 'The snag was that he needed the money, £150, that same day,' Farson said, although he never asked Bacon why. Farson had once shared a London flat with Knight, and set about persuading him to buy the picture. 'It almost wrecked his marriage when he agreed,' Farson wrote, 'for his wife, Wendy, grew to dread the purple figure [that] loomed in violent silence at the top of the stairs in their mews cottage.' Farson received £15 ($42) for his role in the deal; the Pope ruled the staircase for nine years before Knight grew 'tired of the Pope's presence,' according to Farson, and sent it to auction in 1964.

The painting was sold again by Christie's in 1989. This time it appeared in a New York saleroom, where it was felt that it would fetch the best price. It realized $5.7m (£3.5m) against an estimate of $1m–1.5m (£609,750–914,630; equivalent to $1.9m–2.9m/ £1.35m–2m today).

THE HAND OF GOD

Maurizio Cattelan (b. 1960),
La Nona Ora, 1999,
wax, clothing, polyester
resin with metallic
powder, volcanic rock,
carpet and glass,
dimensions variable

SALE
17 May 2001, New York

ESTIMATE
$400,000–$600,000/
£281,000–£421,400

SOLD
$886,000/£622,325

When the doors opened on the centenary exhibition at the Zacheta National Gallery of Art in Warsaw in 2000, its star attraction had already achieved worldwide notoriety. Maurizio Cattelan's *La Nona Ora (The Ninth Hour)* – a swathe of ceremonial red carpet upon which a life-size waxwork of Pope John Paul II lies crushed by a meteorite while still clutching his crozier – had become the defining image of the exhibition 'Apocalypse: Beauty and Horror in Contemporary Art', at the Royal Academy of Arts in London a few months earlier.

Poland was the birthplace of *La Nona Ora*'s meteor-struck pontiff, and with the work's iconoclastic reputation preceding it, the country's left-wing president Aleksander Kwaśniewski anticipated a public outcry. Together with two members of the Warsaw clergy, Kwaśniewski publically justified Cattelan's piece as a positive allegory for the spiritual burden placed upon the Pope by God. Nevertheless, on 21 December, two right-wing members of the Polish parliament stormed into the Zacheta, where, making use of their parliamentary immunity to certain Polish laws, they removed the meteorite and tried to stand the Pope on his feet.

It was an absurd affair that seemed almost comically appropriate for a piece by Italy's most famous provocateur. Yet there was little to laugh at; it was the opening move in a nationalistic furore that resulted in the resignation of the gallery's director Anda Rottenberg – a reminder that even in twenty-first-century Europe, the ideas and issues behind art can still produce reactions of this scale.

By May 2001, *La Nona Ora* was at Christie's Rockefeller Plaza saleroom in New York, where, as the controversy surrounding the piece raged, it fetched $886,000. In May 2016, a new world auction record for Cattelan was set at Christie's when the artist's *Him* (2001), a child-size Hitler kneeling in prayer, realized just over $17m (almost £12m).

BEING AND NOTHINGNESS

Alberto Giacometti (1901–1966), *L'homme au doigt*, 1947, bronze with patina and hand-painted by the artist, 177.5 cm (70 in) high

SALE
11 May 2015, New York

ESTIMATE
Not published

SOLD
$141,285,000/£90,620,200

It took Alberto Giacometti an agonizing five years of making and unmaking to achieve the mature style for which he is now revered. At first, he reduced his sculptural figures over and over until they all but disappeared, but after 1945, when he started working on a larger scale, he found that 'only when long and slender were they lifelike'.

L'homme au doigt (Man Pointing) is among the Swiss artist's greatest works, an emblem of post-war humanity of the kind that prompted Jean Genet to write: 'The resemblance of his figures to each other seems to me to represent that precious point at which human beings are confronted with the most irreducible fact: the loneliness of being exactly equivalent to all others.'

This sculpture was made in an extraordinary outpouring of activity between midnight and 9 a.m. one night in October 1947, when Giacometti was preparing works for a show at the gallery of Pierre Matisse (the son of Henri Matisse) the following year. 'I'd already done it, but I demolished it and did it all over again because the men from the foundry were coming to take it away,' Giacometti recalled. 'And when they got here, the plaster was still wet.' He had intended the work to include a second figure, around which the pointing man's left arm would be loosely placed, but the idea was abandoned.

L'homme au doigt was made in an edition of six (others are now in the collections of the Museum of Modern Art in New York and Tate in London), yet this version is the only one that was hand-painted by Giacometti. It was shown in the Pierre Matisse gallery along with one of his *Standing Woman* works and *Walking Man*, another of his seminal pieces. Fewer and fewer of these masterpieces come to auction, because they are often bought by public collections, and consequently do not re-enter the market. On the same May evening in 2015 that Picasso's *Les femmes d'Alger (Version 'O')* became the most expensive work of art ever sold at auction (see pp.380–3), *L'homme au doigt* was bought by a private collector for more than $140m, a world auction record for the artist and for any sculpture.

AN ENGLISHMAN'S REVENGE

214

William Hogarth (1697–1764),
The Gate of Calais (also
known as *O the Roast Beef
of Old England*), 1748,
oil on canvas, 78.5 x 94.5 cm
(31 x 37 in)

SALE
2 May 1874, London

ESTIMATE
Not published

SOLD
£945/$5,120

EQUIVALENT TODAY
£78,400/$112,000

In July 1748, as peace returned to Europe following the end of the War of the Austrian Succession (1740–8), William Hogarth paid a visit to France. Everything he saw there confirmed his virulent hatred of all things French, but nothing more so than an incident that occurred as he was returning home from Paris via Calais. He had stopped to draw the so-called English Gate to the city, and while he sat with his sketchpad on his knee, he was arrested on suspicion of spying. His incarceration was very brief – it lasted only until the wind stood fair for his return passage to England – but Hogarth was already thinking of revenge.

This painting was his retribution, the venting of his Francophobic spleen. In *The Gate of Calais* (also known as *O the Roast Beef of Old England*), he depicts two starving French soldiers who are positively lusting after a side of English beef. It is being delivered to the Lion d'Or, an English inn, and a fat French friar probes the meat with a podgy finger as it passes. In the foreground, a group of haggard women are involved in their own gluttonous blasphemy – pawing a dead skate that bears an alarmingly human countenance. Nearby is an emaciated tartan-clad Scotsman, a veteran of the failed Jacobite rebellion of the previous year.

A carrion crow presides over the scene, atop the gate – but this detail was added only to disguise a rip that the canvas sustained when Hogarth dropped the nearly finished picture. The painter also included a portrait of himself in the composition: away to the left, in the instant before his collar is felt by an officious military *gendarme*.

The Earl of Charlemont bought the painting directly from the artist, and it remained in his family until it entered the saleroom in 1874. It came under the hammer again in 1891, when it made £2,750 ($13,400; equivalent to £268,000/$383,000 today). The *Gate of Calais* now resides in Tate Britain, London, testament to Hogarth's pungent wit, and a monument to a long-standing English tradition of teasing the French.

THE HIGHS AND LOWS OF A SUGAR FORTUNE

Possibly André-Charles Boulle
(1642–1732), Louis XIV
cabinet on stand, c.1690,
ormolu-mounted pewter
and brass-inlaid ebony,
tortoiseshell and marquetry,
216 x 109 x 47 cm
(85 x 43 x 18½ in)

SALE
21 October 1997, New York

ESTIMATE
$300,000–500,000/
£184,000–306,000

SOLD
$398,500/£243,900

EQUIVALENT TODAY
$566,000/£396,000

A ticket from 1822 to the
contents sale of Fonthill
Abbey in Wiltshire, William
Beckford's country home.

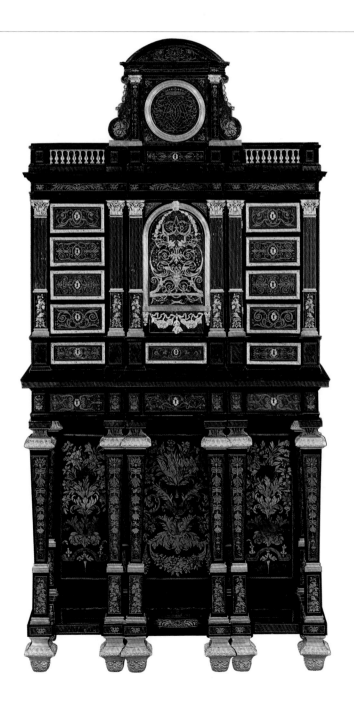

This Louis XIV ormolu-mounted Boulle marquetry cabinet on stand, which sold for $398,500 at Christie's New York in 1997, has had an eventful history with this auctioneer, having previously been sold twice in 1817 and 1825. On both occasions, its appearance at auction was directly connected to the fluctuating sugar market.

Decorated with tortoiseshell and marquetry inlay depicting urns, doves, flowers and foliage, the cabinet bears strong similarities to others designed by André-Charles Boulle, cabinetmaker and sculptor to King Louis XIV (see also pp.368–9 and 442–3), and it arrived at Christie's courtesy of William Beckford (1760–1844), one of the most discerning – and eccentric – celebrities of his day. Beckford inherited a sugar fortune at the age of ten and became what newspapers of the time described as 'the richest commoner in England'. An antiquarian and art collector, he chose to exile himself from society at his country home, Fonthill Abbey in Wiltshire, a gothic fantasy also known as Beckford's Folly and condemned by the critic William Hazlitt as 'a desert of magnificence, in a glittering waste of laborious idleness'. Here, Beckford commanded his own private militia and wrote the first Oriental-Gothic horror novel in English literature, *Vathek* (1786).

Despite his unconventional lifestyle, Beckford was one of the great connoisseurs of the age. His collection included works by Raphael, Diego Velázquez, Giovanni Bellini, J.M.W. Turner and William Blake. However, following the economic depression of 1815–16 and the fall in Jamaican sugar prices, Beckford found himself in straitened circumstances. In May 1817, he was forced to sell part of his impressive library as well as the 'truly elegant' contents of his house at 6 Upper Harley Street, London. In 1822, he put Fonthill and its contents up for sale; Christie's printed more than 70,000 copies of the catalogue and sold them for a guinea apiece. However, the proposed sale did not go ahead. Ever the eccentric, Beckford instead sold Fonthill and a large part of his collection to John Farquhar for £330,000 ($1.6m; equivalent to £27m/$39m today).

At the earlier Beckford sale held on 9 May 1817, this cabinet sold to the celebrated collector George Watson Taylor (1770–1841) for £80 17s ($370; equivalent to £5,300/$7,600 today). Watson Taylor's wealth also originated in the West Indies (he was married to the niece of a wealthy planter in Jamaica), and, like Beckford, he too suffered the financial collapse of his holdings and was forced to sell his beloved collection. On 28 May 1825, Christie's sold the cabinet again from Watson Taylor's house in Cavendish Square. On that occasion it performed less well, realizing 42 guineas (£44/$213; equivalent to £3,200/$4,600 today).

George Romney's portrait of a youthful William Beckford in 1782. The sugar heir was forced to sell the Louis XIV cabinet in 1817.

THE FAITHFUL FRIEND

Diego Velázquez (1599–1660),
Juan de Pareja, 1650,
oil on canvas, 81.5 x 70 cm
(32 x 27½ in)

SALE
27 November 1970, London

ESTIMATE
Not published

SOLD
£2,310,000/$5,544,000

EQUIVALENT TODAY
£31,900,000/$46,190,600

When the painter Diego Velázquez travelled to Italy in 1649, the main purpose of his journey was to buy and commission works of art for his king, Philip IV of Spain. During the two years he spent in Rome, however, Velázquez would achieve something considerably more: he produced some of the greatest portraits of his career.

Besides painting members of the papal court, the artist was also commissioned to produce a portrait of Pope Innocent X – the notoriously wily and unattractive Pope, who deigned to sit for just one day. Perhaps the greatest work to be produced at this time, though, was Velázquez's informal portrait of his own assistant, Juan de Pareja, who accompanied him on his Italian travels. Often referred to as Velázquez's 'slave', de Pareja was painted with immediacy, insight and sympathy, so much so that viewers at the time were astounded by the startling likeness.

Velázquez and de Pareja returned to Spain in 1651, but de Pareja's portrait was sold and remained in Italy. It was acquired by the British ambassador to Italy, Sir William Hamilton, in Naples in 1776. During the Napoleonic Wars the Velázquez, along with other works from Hamilton's collection, was sent to Britain on Nelson's flagship, HMS *Foudroyant*, in 1801. Hamilton, who was heavily in debt, sold his collection in March that year (see pp.40–1). His pictures fetched £6,000 ($26,280; equivalent to £408,200/$591,787 today), with the Velázquez selling for £40 19s ($180; equivalent to £2,785/$4,035 today). Ten years later, it was acquired by the 2nd Earl of Radnor.

The portrait remained in England until 1970, when it was auctioned on behalf of the 8th Earl of Radnor and became the first painting to sell for more than £1m at auction. The art critic Richard Cork, who was at the sale, recalled: 'The atmosphere was extraordinary. The bidding outflew all expectations. It started at £315,000, and took just 130 seconds. It was finally knocked down for a staggering £2,310,000, almost tripling the previous world auction record for a painting. Even the most hardened dealers sitting in the audience breathed gasps of disbelief. Then there was a spontaneous burst of applause. The auctioneer left his rostrum, the painting was hastily removed, and sheer pandemonium broke out.' It is now in the Metropolitan Museum of Art, New York.

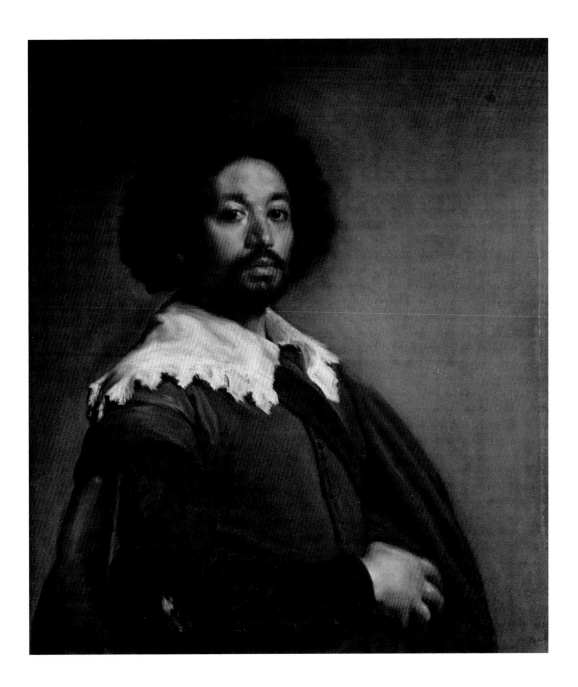

AN AUDIENCE WITH
THE EMPEROR

Jean Barraband
(active 1685–d. 1709) or
his son Jean II Barraband
(d. 1725), *Die Audienz
beim Kaiser von China*,
c.1715, a Berlin chinoiserie
tapestry woven in wools
and silks, 327 x 454 cm
(128½ x 218½ in)

SALE
14 December 2006, London

ESTIMATE
£100,000–150,000/
$197,000-295,000

SOLD
£153,600/$301,885

Die Audienz beim Kaiser von China (*An Audience with the Chinese Emperor*) is a spectacular and colourful tapestry that depicts an audience with the Chinese emperor, who is placed at the centre of the image on a baldachin-covered throne. Sold as part of the collection of furniture and art objects from the Palazzo Carraro Rizzoli, 'Treasures from a Milanese Palazzo', in December 2006, it was one of four striking Berlin chinoiserie tapestries from the 'Emperor of China' series. The original series comprised seven tapestries and had been created in Berlin by Jean Barraband or possibly his son Jean II Barraband.

The German series has its origins in a set of French tapestries designed in 1685–90 by Guy-Louis Vernansal (d. 1729), Jean-Baptiste Belin de Fontenay (d. 1715) and Jean-Baptiste Monnoyer (d. 1699) for the Royal Beauvais Tapestry Manufactory in the north of the country. Barraband was originally from Aubusson, France, but moved to Berlin in 1685; his workshop often based its designs on those from Beauvais that had already proved commercially viable. However, *Die Audienz beim Kaiser von China* is the only one of the Berlin tapestries that is based directly on the original French series; the rest were drawn from local designs.

The initial French series consisted of nine (possibly ten) tapestries that depicted everyday scenes from the life of a Chinese emperor, thought to have been based on Emperor Kangxi (r. 1662–1722), and his empress. The appeal of the tapestries at the time reflected a growing interest in China, encouraged by the opulent Siamese embassies to France in 1664 and 1686, which were entertained by Louis XVI. The court in Berlin was also interested in China, most probably encouraged by the philosopher and political adviser Gottfried Wilhelm Leibniz (1646–1716), who advocated forging links with the Far East, and Queen Sophie Charlotte, who collected Chinese artworks and encouraged theatrical performances inspired by Chinese culture. Indeed, it is thought that Queen Sophie Charlotte may have initiated the first weaving of the series in Berlin.

The tapestry hanging in
La Galleria at the Palazzo
Carraro Rizzoli, Milan.

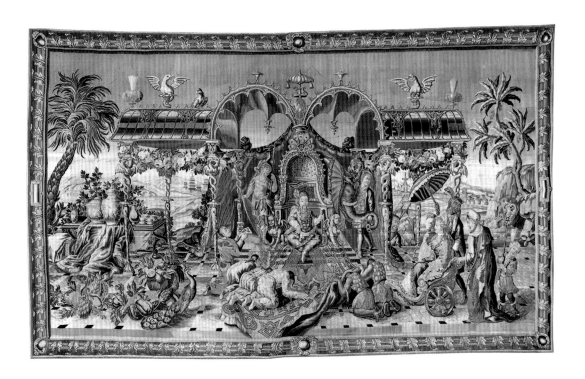

THE SEAT
OF TRADITION

Four Huanghuali horseshoe-
back armchairs, 17th century
(Ming dynasty), yellow
rosewood, 92 x 62 x 44.5 cm
(36 x 24½ x 17½ in)

SALE
17 March 2015, New York

ESTIMATE
$800,000–1,200,000/
£543,000–814,000

SOLD
$9,685,000/£6,568,365

When the 'King of Ming', American dealer Robert Hatfield Ellsworth, died in 2014, his world-class collection of Asian art was sold the following year for $134m (£91m). This series of auctions clearly signalled that Chinese works of art were no longer coveted only by Western collectors; they were now also increasingly sought-after by institutions and private collectors in China, where Ellsworth's name and near-mythical reputation were legendary.

The Ellsworth sales represented the largest private collection of Asian art ever to appear at auction, and were held over several days. One of the highlights was in the very first session, a set of four seventeenth-century Huanghuali armchairs that realized almost $10m, more than eight times the high estimate, setting a world auction

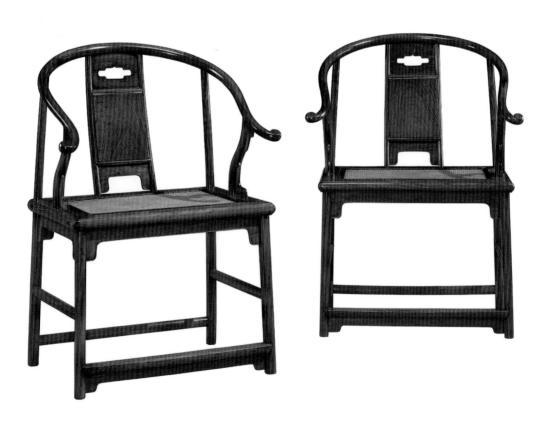

record for this style of furniture. Huanghuali is a yellow rosewood
from Vietnam, and later also sourced from Hainan Island in southern
China, that was historically considered the most precious and luxurious
material from which to make furniture.

The chairs had once been displayed in the centre of Ellsworth's
apartment on Fifth Avenue in New York. He was a true connoisseur-
dealer whose clients included some of the most prominent names
in art collecting, such as John D. Rockefeller III and the financier
Christian Humann.

Ellsworth was made an honorary Chinese citizen, and was named
an honorary consultant and curator of both the Beijing History
Museum and the Museum of Fine Arts in Hefei, near Huangshan.
Just as the Chinese recognized the importance of his work during
his lifetime, so too did they acknowledge the importance of his
acquisitions after his death. The sale of his collection saw four
auction records being set, thanks in no small part to determined
Chinese collectors.

INSIDE OUT

Rachel Whiteread (b. 1963),
Untitled (Square Sink), 1990,
plaster, 107 x 101 x 86.5 cm
(42 x 40 x 34 in)

SALE
8 December 1998, London

ESTIMATE
£40,000–50,000/
$66,200–82,700

SOLD
£133,500/$220,805

EQUIVALENT TODAY
£210,000/$293,400

As the history of the Young British Artists (YBAs) is refracted through retelling over time, Rachel Whiteread's role in the emergence of this talented generation has, arguably, become underplayed. Whiteread, in both her work and her public persona, might now seem remote from some of her peers, but – like that of Damien Hirst – her work appeared in the very first of the Young British Artists exhibitions at the Saatchi Gallery in 1992, a show that gave the group its name.

Untitled (Square Sink) was among the works on view, as well as one of Whiteread's masterpieces, *Ghost* (1990). Both reflect the poetic power of the sculptures that propelled the artist to huge success in the 1990s. *Ghost* was a true breakthrough; a cast from a room in a house on London's Archway Road, much like the one Whiteread grew up in, in which she sought to 'mummify the air in a room'. The result was a Minimalist-inspired sculpture and a lyrical paean to the emotion and memory contained in domestic spaces. The air within and around all manner of other quotidian objects and spaces was also 'mummified', from the space under a bed to the inside of a hot-water bottle. Like her works involving baths, *Untitled (Square Sink)* – a sculpture of the space found underneath a household sink – has an almost funereal, monumental solidity.

Rachel Whiteread in her studio, photographed by Jorge Lewinski in 1995.

Whiteread's *Ghost*, 1990.

Characteristically, this work conjures not just the object but also its wider cultural use. Just as Whiteread's sculptures of beds inevitably prompt thoughts of birth, sex and death, so the cast of the sink becomes a font, a testament to water as a symbol of life, as an element in human ritual. It is also a profoundly strange object, confirming the artist's ability to find the magical in the most humdrum things and places.

The work was one of the top lots in a sale in 1998 of pieces from Charles Saatchi's collection, sold to benefit students and graduates of four London art schools – Chelsea, Goldsmiths, the Royal College of Art and the Slade (see also pp.386–7). Christie's auction raised a total of £1.6m ($2.7m; equivalent to £2.6m/$3.6m today), and, in retrospect, was one of several signifiers of a shift in the London art scene. If the exhibition of Saatchi's collection at the Royal Academy of Arts in London in 1997, 'Sensation', marked the apex of the YBAs' notoriety, the sale, which took place a year later, indicated that Saatchi's interest in them had begun to cool. Other collectors were therefore able to buy early YBA works from Saatchi's collection retrospectively, allowing him to fund his passion for supporting new artists coming through in the YBAs' wake.

A MEDICAL MASTERPIECE

Thomas Eakins (1844–1916),
*Portrait of Dr Samuel D.
Gross (The Gross Clinic)*, 1875,
oil on canvas, 244 x 198 cm
(96 x 79½ in)

SALE
2006 (private treaty)

ESTIMATE
Not published

SOLD
$68,000,000/£35,800,000

In 2006, Thomas Jefferson University in Philadelphia announced that it was to sell a portrait of the eminent nineteenth-century physician Dr Samuel Gross. The painting, which had been hanging in the university's Alumni Hall for the best part of a century, was consigned to Christie's for private treaty sale. In consultation with the university, Christie's proposed to offer the work first to the most active buyer in the field of American art at the time, Alice Walton, the Wal-Mart heiress and founder of the Crystal Bridges Museum of American Art in Bentonville, Arkansas. She was invited to make a bid, with the proviso that the museums of Philadelphia would have the opportunity to make a matching bid in order to keep the painting in Philadelphia. In partnership with the National Gallery of Art, Washington, DC, Walton offered $68m for the masterpiece. After a successful campaign to raise the funds, *The Gross Clinic* was acquired jointly by the Philadelphia Museum of Art and the Pennsylvania Academy of the Fine Arts.

By the mid-nineteenth century, Philadelphia had become a leading innovator in the world of medicine, spearheaded by the world-famous surgeon Dr Gross (1805–1884). In 1875, the artist Thomas Eakins painted a portrait of the great man leading a clinic of doctors in a groundbreaking procedure to treat bone infections. Eakins's *The Gross Clinic* has long been considered one of America's greatest masterpieces.

Eakins had intended the portrait to be exhibited in the art building at the Philadelphia World's Fair in 1876, an event that championed the city's scientific achievements, but it was rejected for being too disturbing. The realism of the painting, in which bloody flesh is lacerated and probed while the clinically detached doctor, scalpel in hand, looks on, was considered too gory for the city's population. Instead it was exhibited in an army field hospital display, before being given two years later to the Jefferson Medical College by the alumni association, where it remained until the university contracted with Christie's to sell it.

The sale prompted an outpouring of civic pride, leading to renewed recognition of the painting and its artist. Over 3,600 individuals donated money to keep the portrait, and now – billed as 'one of the greatest American paintings ever made' – it is displayed on a rotating basis at the Philadelphia Museum of Art and the Pennsylvania Academy of the Fine Arts.

Thomas Eakins photographed
in c.1880.

221

A BLIZZARD OF PAINT

Peter Doig (b. 1959),
Swamped, 1990,
oil on canvas, 197 x 241 cm
(77½ x 95 in)

SALE
11 May 2015, New York

ESTIMATE
Not published

SOLD
$25,925,000/£16,628,295

Many of Peter Doig's greatest paintings were made while he was still an MA student at the Chelsea School of Art in London. The early masterpiece *Swamped*, bought for around £1,000 ($1,780; equivalent to £2,030/$2,930 today) shortly after it was first made, has since made history on two separate occasions. In 2002, it set a new benchmark for Doig's work at auction when it sold for £322,500 ($465,450). Then, in May 2015, it surpassed all previous records for the artist when it sold for nearly $26m at Christie's New York.

Initially, Doig's work seemed incongruous in a London art scene saturated by slick sculpture and installations, where the shadows of Marcel Duchamp, Jeff Koons and Minimalist artists such as Carl Andre loomed large. Doig, by contrast, firmly believed in the continued power of painting: 'it is about working your way across the surface, getting lost in it,' he has said. *Swamped* exemplifies this approach: stand back, and it is a romantic, lyrical scene, but move closer and you are struck by a blizzard of paint – loops, dashes, tremulous lines, mottled dabs. Few contemporary artists are scholars of painting in the way Doig is – he has written and spoken eloquently about the breadth of his artistic heritage. Many of his forbears are evoked in both the techniques and the subject matter of *Swamped*; from Edvard Munch and Vincent van Gogh to Jackson Pollock, Barnett Newman and Gerhard Richter. However, while Doig's references might be multiple, the work remains entirely his own.

Swamped has its origins in Sean Cunningham's 1980 cult slasher film *Friday the 13th*. In a dream scene near the end of the film, the one surviving character drifts in a canoe on a placid lake surrounded by a beautiful forest, before being pounced upon by the masked antagonist, Jason Voorhees. After seeing the film, Doig set about rendering the moment of moonlit calm on several canvases. The artist typically works from a mixture of found imagery and memory, and one of the most apt descriptions of his own work can be found in his characterization of Pierre Bonnard's paintings, which he says capture 'the space that is behind the eyes'. He adds: 'It's as if you were lying in bed trying hard to remember what something looked like. And Bonnard managed to paint that strange state. It is not a photographic space at all. It is a memory space, but one which is based on reality.'

Still from *Friday the 13th* (1980). Peter Doig's *Swamped* was inspired by this scene from the horror film.

Doig's early 1990s works are now among his most sought-after, and many reside in the world's top museum collections. Coinciding with his receipt of the prestigious Whitechapel Artist Prize, which culminated in a solo show at the Whitechapel Art Gallery in London, the works produced during this period constitute the thematic matrix for his subsequent oeuvre. As of February 2016, Christie's has sold Doig's top five lots at auction, four of which stem from these critical early years.

HERALDIC CLUES
FINALLY SOLVED

Hans Holbein the Younger
(1497/8–1543), *Lady with
a Squirrel and a Starling*
(Anne Lovell?), c.1526–8,
oil on oak panel, 56 x 39 cm
(22 x 15 in)

SALE
15 April 1992, London
(private treaty)

ESTIMATE
Not published

SOLD
£10,000,000/$17,700,000

EQUIVALENT TODAY
£18,500,000/26,300,000

Holbein's *Lady with a Squirrel and a Starling* is a picture with a well-kept secret. Painted during Holbein's brief first visit to England, it portrays a modest, self-contained woman who pointedly averts her gaze. The intensely blue background, with its glittering leaves and tendrils, and the animation of the two creatures that accompany her, offer a lively counterpoint to the lady's demure demeanour. As the title implies, little is known about her identity. The suggestion that she is Anne, wife of Sir Francis Lovell of East Harling, Norfolk, is the result of detective work by a stained-glass historian who noticed the heraldic significance of the squirrel and the starling: the animal echoes the crouched, nut-eating squirrels on the Lovell coat of arms, while the image of the bird may be a rebus – a visual pun – on the family's place of residence, which was commonly spelt 'Estharling'.

The subsequent peregrinations of this portrait are circular. The painting left Norfolk in 1658 and spent nearly a century in the Netherlands, before returning to England in 1752. Soon afterwards, it was bought by the 3rd Earl of Cholmondeley, and was kept at his seat in Cheshire for around 150 years. In the 1920s, it was discovered in a back room by Sybil, Countess of Rocksavage, wife of the future 5th Marquess of Cholmondeley. Without knowing the sitter's identity, she took the picture back to Norfolk, to the Cholmondeleys' other home, Houghton Hall (see pp.442–3). This grand Palladian house had become the victim of benign neglect, and Lady Cholmondeley set about restoring it.

After her death, Sybil's grandson the 7th Marquess of Cholmondeley continued her work of restoring Houghton Hall and its estate, and decided to sell the picture by private treaty. Thanks to assistance from the National Heritage Memorial Fund, the Art Fund and the American Friends of the National Gallery, the National Gallery in London was able to secure this important painting for the country in which it originated.

THE MENAGERIE

Meissen porcelain factory
(est. 1710), two herons,
c.1732, hard paste porcelain,
modelled by Johann
Joachim Kändler (1706–1775),
62 cm (22½ in) high and
75.5 cm (30 in) high

SALE
22 June 2005, Paris

ESTIMATE
€2.5m–3m/£1.7m–2m/
$3m–3.6m

SOLD
€5,612,000/£3,732,250/
$6,810,680

In the 2002 sale of furniture, porcelain and silver from Longleat House in Wiltshire, Christie's sold four monumental early Meissen porcelain models of animals, which had originally been made for the Japanese Palace in Dresden. The sale included models of a fox, a turkey and two different types of vulture. The Victoria and Albert Museum bought a vulture for £501,650 ($752,475) and the J. Paul Getty Museum bought the model of fox for just over £1m ($1.7m). When these rare and extraordinary models surface on the market, it always causes international excitement. Three years after the Longleat sale, Christie's sold this majestic pair of herons for a world-record price of €5,612,000. The following year Christie's sold two magnificent models of a lion and lioness in London for the Royal Wettin family, the descendants of the ruler who originally commissioned them. They sold for £2,808,000 ($5,166,720).

The animals had all been made for Augustus the Strong, King of Poland and Elector of Saxony (1670–1733). Augustus ruled from Dresden, one of the great baroque cities of Europe, and he began work on his Japanese Palace on the banks of the River Elbe in 1717. It was to be a courtly, ceremonial temple to porcelain, in particular the porcelain made from the white clay of Saxony at Meissen, created to outdo the imagined displays of the Japanese and Chinese emperors. Thirty-two rooms in the palace housed his Oriental porcelain collection, and some 35,798 original pieces were ordered from the Meissen factory that had been founded by his official decree in 1710. The rooms of the palace and the porcelain they contained were designed to have symbolic significance, representing power, humility, splendour and divinity. There was also a porcelain throne, a porcelain chapel and a porcelain organ.

On the first floor of the palace was a menagerie, conceived as a kind of animal court. An inventory of 1733 lists 296 animals and 297 birds. The commission for the menagerie had been given to the chief modeller at Meissen, Johann Gottlieb Kirchner (c.1706–1738; see pp.421–3). Johann Joachim Kändler was initially employed as his assistant, but two years later Kirchner resigned and Kändler went on to become one of the greatest porcelain modellers of the eighteenth century. His animals are all created with extraordinary naturalism and from close observation, as seen in the herons, in contrast to Kirchner's slightly more stylized and baroque models.

Kändler's herons are outstanding with long, elegant, fluid necks and pointed beaks. One heron twists to preen its feathers, while the other pecks at its feet. Originally the models were decorated in naturalistic 'cold' enamel colours, but because they were too large for a second firing in the kiln to fix the colours, these have worn away over time. The Longleat vulture which was bought by the Victoria and Albert Museum in 2002 still has some of these original colours, but most of the Japanese Palace animals and birds are now uncoloured. The plain white porcelain of the models arguably celebrates the material of porcelain more effectively, drawing attention to the detail and perfection of the modelling.

WHIP CRACK AWAY

George Stubbs (1724–1806),
*Gimcrack on Newmarket
Heath with a Trainer,
a Jockey and a Stable Lad,*
1765, oil on canvas,
102 x 194 cm (40½ x 76½ in)

SALE
11 March 1780, London
10 December 1943, London
20 July 1951, London
5 July 2011, London

ESTIMATE
Not published

Gimcrack on Newmarket Heath with a Trainer, a Jockey and a Stable Lad is a masterpiece in the history of sporting art, and one that has passed through Christie's salerooms four times. It more than doubled the previous record for a work by George Stubbs when it was sold in 2011 for over £22m.

The price is a reflection of the painting's originality. By 1765, Stubbs had completed his celebrated scientific studies of equine anatomy and made his name as a portraitist of horses. *Gimcrack on Newmarket Heath* shows Stubbs displaying his painterly inventiveness as he depicts the plucky character of young Gimcrack, a tiny racehorse that became a sporting celebrity. Standing at only 14.2 hands, and bred by Gideon Elliot in Hampshire – a far cry from the best horse breeders in Yorkshire – Gimcrack won ten races in a row in 1765, the year of this portrait. Lady Sarah Bunbury called Gimcrack 'the sweetest little horse that ever was'.

In this work Stubbs boldly stripped away the conventions of sporting art, employing an expansive narrative format and painting big, open skies above the charged emptiness of Newmarket racecourse. There had been much speculation about certain aspects of the scene. Why, for example, has Stubbs left out the crowd that saw Gimcrack win the race, and why the ambiguous, somewhat melancholy

expression of the jockey? Stubbs uses the device of showing two narratives on one canvas, with Gimcrack and jockey appearing twice, leading the field in the background and standing next to the rubbing-house in the foreground. This bipolar narrative complements Stubbs's realism and his attention to detail, right down to the glimmering buckle on the jockey's riding boots.

The painting was commissioned by one of Stubbs's most important patrons, Frederick St John, 2nd Viscount Bolingbroke, during the short half-year season that the latter owned Gimcrack. It must have been a family favourite: the painting's first buyer at Christie's in 1780 was Bolingbroke's own son and heir, George St John, 3rd Viscount Bolingbroke, who paid 27 guineas for it – a bargain when set against the 1,500 guineas (£1,575/$7,166; equivalent to £192,000/$277,750 today) his father had paid for the horse itself fifteen years earlier. Stubbs made a second version of the picture that was also eventually sold at auction.

225 PORCELAIN PERFECTED

Meissen porcelain factory
(est. 1710), mantel clock
with Arachne and Athena,
1727, hard paste porcelain,
44 x 21 x 13.5 cm
(17½ x 8 x 5½ in)

SALE
5 March–30 April 1855,
London

ESTIMATE
Not published

SOLD
£120/$590

EQUIVALENT TODAY
£10,000/$14,400

The Whig politician Ralph Bernal (1783–1854) was one of a new breed of educated and cultured upper-middle-class collectors. Although he was not extravagantly wealthy, he nonetheless had a substantial income from estates in the West Indies and he used it to amass an outstanding and extensive collection. Bernal was renowned for his remarkable eye; writing later in the century, George Redford (1816–1895), the art and sales correspondent of *The Times*, reported that 'Mr Bernal had such a reputation that whenever he was observed to admire anything it was quite enough to enhance its value in the eyes of the dealers, and thus it required no small amount of diplomacy on his part to obtain the article he wanted at a reasonable price.'

On Bernal's death, the Society of Arts tried to convince the government to buy his collection *in toto*. The government declined, and the objects were subsequently sold in a thirty-two-day sale of over 4,000 lots, which realized a total sum of £62,691 ($306,500; equivalent to £5.2m/$7.6m today). The Museum of Manufactures in London (later renamed the Victoria and Albert Museum) bought 730 lots, and the British Museum acquired many important pieces. The highest prices realized in any one day of the auction were those paid for the ceramics.

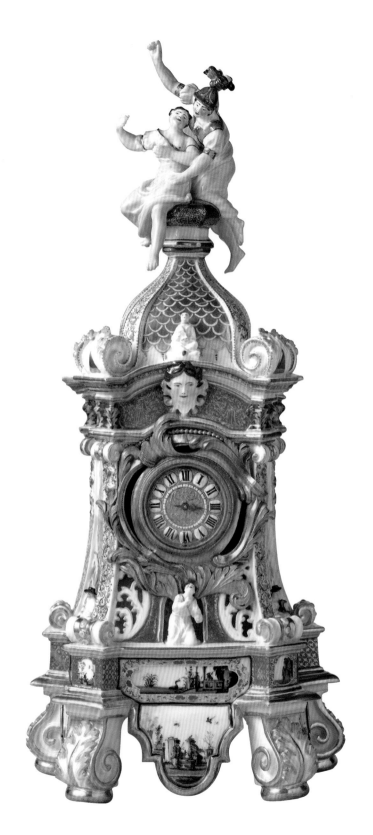

GOING ONCE

Bernal's bold and Baroque Meissen clock case was modelled by Georg Fritzsche (*c*.1697–1756), who probably based it on Johann Gottlieb Graupner's gilt-brass Dresden original, which is now in the Kunstgewerbemuseum in Dresden. The decoration is a curious blend of Baroque forms, mythological figures from antiquity and fantastical chinoiserie scenes that reflected Europe's fascination with the Far East. The intriguing sculptural group at the top of the clock was modelled by Johann Gottlieb Kirchner shortly after his arrival at Meissen in April 1727 (see also pp.418–19). The right-hand figure depicts the goddess Minerva, or Athena, and the other figure may represent Arachne, the skilful weaver who foolishly challenged Minerva to a weaving contest. In Ovid's version of the story, the enraged and jealous Minerva turned Arachne into a spider.

Bernal's clock case sold for £120. It passed through Christie's salerooms again in 1923, when it was acquired by Sir Anthony de Rothschild. It is now in the Rijksmuseum, Amsterdam. A similar version of the clock was commissioned for Augustus the Strong, the king who owned the Meissen factory, and it bears the date of his birthday, 12 May 1727. Augustus had been sent polar bears and arctic foxes by the Russian court a few months earlier, and in return he sent six crates of Meissen porcelain, including his birthday clock, to Princess Elizabeth of Russia (later Tsarina of Russia), who was very happy to receive the gift but said that she would have 'preferred a husband'. Augustus's clock is now in the State Hermitage Museum, St Petersburg.

Left: Meissen mantel clock with Arachne and Athena, 1727.

Right: A Sèvres vase and cover from c.1775, included in the Ralph Bernal sale in April 1855.

THE WRATH OF THE GODS

Auguste-Jean-Marie Carbonneaux (1769–1843), *The Laocoön*, early 19th century, bronze life-size copy modelled from the original marble sculpture, 208 x 163 x 112 cm (82 x 64 x 44 in)

SALE
17 June–18 July 1882, London

ESTIMATE
Not published

SOLD
480 guineas/£504/$2,450

EQUIVALENT TODAY
£45,300/$64,800

In the eighteenth and early nineteenth centuries, it was fashionable for members of British society to complete their education with some foreign travel. Italy was the most popular destination for such a Grand Tour, and the remains of ancient Rome were the main attraction.

For the wealthiest of these tourists, the most sought-after souvenirs from such jaunts were classical marble sculptures that would be shipped back to adorn the galleries of their stately homes. But originals were soon in short supply. Not to be deterred, the wealthy

tourists commissioned copies of their favourite pieces in bronze, marble and terracotta.

Among the most celebrated of ancient sculptures was the *Laocoön* (40–30 BC). The work depicts the death of the priest Laocoön, a figure from Greek mythology who, according to Virgil's *Aeneid* (29–19 BC), was murdered alongside his two sons. After the priest tried to warn the Trojan people about the wooden horse left by the Greeks, the gods sent two giant sea serpents to strangle him and his sons to death. The marble sculpture – which Pliny noted was originally made for Emperor Titus – was excavated in Rome in 1506 and bought by Pope Julius II, who placed it on display in the Statues Courtyard of the Vatican. Its discovery made it an immediate sensation, and a reproduction of the tragic sculpture became one of the most desired objects of the day.

Copies of such marbles were rarely signed, and many were produced, so tracing their provenance is almost impossible. An exception to the rule is a spectacular bronze cast of the *Laocoön* on the same scale as the original, and therefore a particularly opulent record of this passion for ancient sculpture.

It can be traced through three of the great British country-house sales of the nineteenth century: Fonthill Abbey in 1823, Stowe House in 1848 (see pp.312–13) and Hamilton Palace in 1882 (see pp.366–7). The sale catalogue for Fonthill lists the sculpture as being cast by 'Carbonneau[x] of Paris'; the catalogue for the Stowe House sale clearly states that it is 'from Fonthill'; and the catalogue for the Hamilton Palace sale notes that it is 'from Stowe'. The fact that this piece can be traced through three of the most important sales of the nineteenth century, two of them held by Christie's, makes this *Laocoön* one of the most historically significant bronzes in Britain today.

Queen Victoria at Stowe House, Buckinghamshire, in 1845. *The Laocoön* can be seen on the far right of the illustration.

THE BIBLE
IN TRANSLATION

John Eliot (1604–1690),
The Holy Bible translated
into Massachusett, 1661–3,
black morocco leather,
gilt-panelled sides,
fragments of original
silk ties, 19 x 14 cm
(7½ x 5½ in), printed in
Cambridge, Massachusetts
by Samuel Green and
Marmaduke Johnson

SALE
30 June 1958, London

ESTIMATE
Not published

SOLD
£7,200/$20,230

EQUIVALENT TODAY
£150,200/$214,000

In June 1958, Christie's sale of the first Bible printed in America was noteworthy not least because it had been translated into Massachusett, an Algonquian language now extinct (although currently the subject of efforts to revive it in present-day Massachusetts). The Eliot Bible is a testament to the missionary work of early Puritan settlers in New England, and to the zeal with which they spread the Christian message to the native inhabitants they encountered.

This Bible was the brainchild of a pastor named John Eliot, who felt alienated by the perceived corruption of the Church of England during the reign of Charles I (1625–49), and emigrated with fellow Puritans to the New World in 1631. In addition to pastoral work with colonists, Eliot undertook missionary efforts among local Wapanoag people and began to master their language, Massachusett. In 1646, the colonial Massachusetts General Court ordered that 'efforts to promote the diffusion of Christianity among aboriginal inhabitants be made with all diligence', and by October that year Eliot was preaching in Massachusett. He passionately believed that a Bible in their own language was a crucial tool for converting Native Americans. Not only would it advance literacy, but also it would become talismanic owing to the belief among the indigenous peoples that divine power dwelt in physical objects.

Eliot created the first edition of his Bible, or *Mamusse Wunneetupanatamwe Up-Biblum God*, between 1661 and 1663. It retains original proper names, and uses the word 'God' to denote the Christian divinity. He was aided in his endeavour by the London-based Society for the Propagation of the Gospel in New England, and used the services of Samuel Green, the only printer in New England. Eliot's supporters in England also sent out the London printer Marmaduke Johnson with supplies of fonts (extra 'k's, 'oo's and 'q's were required to transliterate Algonquian), paper and a new press.

The New Testament was completed in 1661; the Old Testament two years later. Only about 1,000 copies of the entire Bible were produced. Twenty were sent back to Eliot's supporters in England, one of whom was William Cavendish, 3rd Earl of Devonshire (1617–1684), and a copy remained in the library at Chatsworth House in Derbyshire until the Christie's Chatsworth sale in 1958.

Top: minister John Eliot preaching to Native Americans in the 17th century.

Above: watercolour from 1585–93 by John White showing an Algonquian holding a bow. His body has been painted to mark a special occasion.

MASTER OF
THE PRINTED LINE

Rembrandt van Rijn (1606–1669), *Christ Presented to the People (Ecce Homo)*, 1655, drypoint, 38 x 45 cm (15 x 17½ in)

SALE
5 December 1985, London

ESTIMATE
Not published

SOLD
£561,600/$730,000

EQUIVALENT TODAY
£1,520,000/$2,190,000

Prints have long been a popular way to distribute widely and collect an artist's work for a fraction of the price of a painting. However, over the past thirty years the market for prints has grown exponentially. The extraordinary prices paid today for lithographs, woodcuts, screenprints, aquatints, etchings and drypoints would have been unthinkable in the mid-twentieth century, and the turning point can perhaps be traced to one particular sale in 1985, when a phenomenal collection of Old Master prints came on the market.

The prints, which included some of great rarity by Andrea Mantegna, Lucas van Leyden, Albrecht Dürer and Rembrandt van Rijn, came from Chatsworth House in Derbyshire, the Duke of Devonshire's country residence. Some artists are natural printmakers, ceaselessly innovative and experimental, and what made the 183 works in the Chatsworth collection so special was that many had been created by pioneers of the medium.

The highlight of the sale was *Christ Presented to the People* by Rembrandt van Rijn, one of the artist's largest prints, and one of only seventeen known impressions made before Rembrandt reduced the

size of the copper plate. The superb Chatsworth impression, rich in burr (the inky residue associated with drypoint), was printed on luxurious Japanese paper. As the only example left in private hands, it was expected to fetch around £100,000 ($130,000). On the day, it far outstripped this, selling for a landmark £561,600 to the London art dealer Frederick Mulder, a world expert on Rembrandt prints, making it the most expensive print ever sold at auction at the time.

229 A DISCOVERY RECOVERED

Pietro Lorenzetti (active c.1306–1345), *Christ between Saints Paul and Peter*, c.1320, tempera and gold on gold-ground panel, 32 x 70.5 cm (13 x 28 in)

SALE
3 July 2012, London
(negotiated sale after export stop)

ESTIMATE
£1m–1.5m/$1.6m–2.3m

SOLD
£5,081,250/$7,979,350

Christ between Saints Paul and Peter is a gold-panel painting, the central section of the predella of an altarpiece, by the Sienese master Pietro Lorenzetti, created around the time Dante Alighieri finished his *Divine Comedy*.

In 2012, the panel sold to an overseas buyer for £5,081,250, a world record for a Lorenzetti. This recent discovery, the only known fully autographed work in Britain known to have been painted solely by Lorenzetti (without elements by his assistants) was about to leave the country forever. The National Gallery in London succeeded in temporarily halting the panel's export under the Waverley Criteria – a set of conditions that, if met, prove a work to be of outstanding aesthetic or national importance to Britain. This enables an export to be temporarily halted, allowing time to find a buyer who would keep

the work in Britain. However, with a price of over £5m and amid a climate of rigorous funding cuts, it seemed a nigh-impossible task to find a buyer for this early Renaissance masterpiece.

Almost as soon as the export halt was announced, the National Gallery received a call from the Ferens Art Gallery in Hull. Using its Bradshaw Bequest and with additional support from the Art Fund and the Heritage Lottery Fund, the Ferens managed to raise the funds. It was a triumph for Britain, and for the city of Hull.

Christ between Saints Peter and Paul underwent conservation at the National Gallery in London following the successful completion of the sale. Its new home is currently closed for building work, but in 2017, the year Hull becomes Britain's City of Culture, the painting will be shown in the refurbished Ferens Art Gallery, adding a golden glow to the city's celebrations.

230

THE RISE OF ENGLISH FURNITURE

Attributed to Thomas Chippendale (1718–1779), George III commode, 1762, mahogany with ebony inlay and gilt-lacquered brass carrying-handles, 158 x 59 x 89 cm (62 x 23 x 35 in)

SALE
5 December 1991, London

ESTIMATE
£250,000–350,000/
$443,000–620,000

SOLD
£935,000/$1,655,000

EQUIVALENT TODAY
£1,790,000/$2,526,000

The landmark sale of the Messer collection of English furniture in December 1991 included a George III mahogany commode attributed to Thomas Chippendale, which fetched an impressive £935,000, nearly three times its high estimate.

This Chippendale commode had been sold by Christie's before. On 9–11 April 1785, the contents of Sir Rowland Winn's London town house were auctioned by James Christie, following Sir Rowland's death. The frontispiece of the catalogue boasted a 'Variety of good Mahogany Articles' as well as 'elegant Pier Glasses … Library Bookcases … fine Marble Slabs … Turky [*sic*] and Wilton Carpets, good Kitchen Furniture &c'.

Sir Rowland Winn (1739–1785), whose country seat was Nostell Priory in West Yorkshire, enjoyed a close relationship with Chippendale, who was born in nearby Otley. Sir Rowland had become a wealthy man through coal and textiles, and spent extravagantly, commissioning more than 100 examples of Chippendale furniture for his country house. (Nostell Priory still has one of the finest collections of Chippendale furniture in Britain.)

Sir Rowland acquired a town house at 11 St James's Square, London, and a few years later, in 1774, he commissioned Robert Adam to replace the façade and redesign the interior. This included commissioning new furniture, such as the commode from Chippendale. Adam reported on the work to Sir Rowland:

Robert Adam's design for a new façade for Sir Rowland Winn's London town house at 11 St James's Square in 1774.

'Every creature admires your front & Sir Watkins told me the Square was much obliged to you, as it was a great ornament to the whole inhabitants.'

Chippendale's commode, supplied for Sir Rowland's London bedroom, is boldly decorated with geometric ebony inlay and carved details in the classical style. It features two cupboard doors, six mahogany-lined drawers and two removable racks of alphabetically lettered pigeonholes. It corresponds to the design for 'A French Commode' that Chippendale published in his furniture directory in 1762.

The commode was subsequently acquired by Samuel Messer of Pelsham, Sussex, whose outstanding collection of English furniture – assembled with the advice of the great connoisseur R.W. Symonds, and including a fine group of pieces by Chippendale – came to auction in December 1991. The sale marked a new category of interest in the market for English furniture, that of the glories of English cabinetmaking. It remains one of the most celebrated sales of English furniture ever held, and that year the turnover of the English furniture department was higher than that for Impressionist paintings.

BIBLE STORIES ON A PLATE

Castel Durante ware
(c.1525–75), maiolica
istoriato charger, c.1530–40,
tin-glazed earthenware,
54 cm (21 in) in diameter

SALE
16–19 June 1884, London

ESTIMATE
Not published

SOLD
£378/$1,830

EQUIVALENT TODAY
£35,200/$49,600

The connoisseur and antiquarian Sir Andrew Fountaine (1676–1753)
made two Grand Tours to Italy, in 1702 and 1714, and assembled a truly
spectacular collection of Renaissance decorative art that he kept at his
country house, Narford Hall in Norfolk. When Christie's announced
in 1884 that the collection was to be sold, J.C. Robinson, Her Majesty's
Surveyor of Pictures, wrote an eloquent letter to *The Times*, pleading,
'Let us hope, then, that on this occasion the national purse strings
will be undrawn with a less niggardly hand than heretofore, for
the endowment of the public museums of our country with noble
works of art.'

Despite widespread fears about the collection being broken up, the
British government refused to give individual museums grants to make
purchases. In response, a group of private collectors formed a 'syndicate'
to purchase some of the most spectacular works, hoping that in time
they could be sold on to leading museums. Subscribers to the syndicate
guaranteed sums from £100 to £1,000, with a total of £12,000 being

raised. The syndicate would spend £9,924 14s ($48,135; equivalent to £924,000/$1,303,600 today) on assorted maiolica, Palissy ware and Limoges enamels.

Of the six pieces of maiolica the syndicate bought (out of a total of 270 pieces in the sale), three were acquired by the British Museum the following year. This maiolica dish (c.1530–40) depicting the Conversion of Saul (St Paul) is still on display in the museum, and is an excellent example of the narrative style of decoration known as *istoriato* – meaning 'storied' with mythological, historical or religious subjects. The style was perfected by artists working around Urbino and Castel Durante in Italy in the early sixteenth century, and the elaborate composition on this dish echoes Michelangelo's and Raphael's paintings on the same subject.

The Fountaine sale realized an extremely high price: a total of £91,112 17s ($442,000; equivalent to £8.5m/$12m today) for 565 lots. Many of the most spectacular objects were sold to foreign collectors, a trend that was mourned by *The Times* in a leader article on 20 June 1884: 'England, which a century ago was the sea into which all rivers of art ultimately flowed, is now too rapidly giving back her treasures.'



232

A RACE OF
LIFE AND DEATH



In December 2009, great excitement greeted the sale in Paris of a 'missing' plate, or *tondino*, from the collection of the great Renaissance collector and patron Isabella d'Este, Marchesa of Mantua (1474–1539).

The maiolica plate, attributed to the great master Nicola da Urbino (c.1480–1537/8), was one of two missing pieces from a twenty-four-piece service, the rest of which was already in various museums, including the Metropolitan Museum of Art in New York, the Victoria and Albert Museum in London and the Louvre in Paris. It is not known precisely when the service was made, although a letter dated 1524 appears to confirm the delivery of a maiolica service. It is thought that the service was intended for use at Isabella's private villa, Porto, which was used as a retreat from court life in Mantua, Italy.

The coat of arms is Isabella's, and the plate features her personal devices: a musical scroll, a bundle of lottery tickets and the inscription *'Nec spe nec metu'* ('without hope and without fear'), which was an emblem of indifference to changes brought about by fortune. These act as a unifying design feature on the individual plates. The border of the *tondino* depicts the story of Atalanta and Hippomenes, which

Example of a plate from Isabella d'Este's maiolica dinner service, made by Nicola da Urbino c.1524.

Nicola da Urbino
(c.1480–1537/8),
maiolica *tondino*, c.1524,
tin-glazed earthenware,
27.5 cm (11 in) in diameter

SALE
17 December 2009, Paris

ESTIMATE
€100,000–150,000/
£89,000–134,000/
$145,000–218,000

SOLD
€1,185,000/£1,054,195/
$1,721,130

is recounted in Ovid's *Metamorphoses* of AD 8. Atalanta, proud of her athletic prowess, challenged her lovers to a race in which the losers would be punished by death. Hippomenes entered the race and dropped three golden apples (a gift from Venus) in Atalanta's path; when she stopped to collect them she lost the race. The couple later made love in the Temple of Cybele, depicted in the background.

Nicola da Urbino was a maiolica master known for his brilliant draughtsmanship and his delicate and sophisticated rendering of figures. This plate is now in the Hockemeyer collection of maiolica and glass in Bremen, Germany.

Portrait of a woman,
formerly thought to be
Isabella d'Este, by Giovanni
Francesco Caroto, c.1505–10.

WRITING HISTORY

Martin Carlin (1730–1785),
Louis XVI *bureau plat*, c.1778,
pale tulipwood veneer,
the top lined in black
leather tooled and gilt
with 14 Sèvres porcelain
plaques, ormolu-mounted,
131 x 62 x 76 cm
(51½ x 24½ x 30 in)

SALE
24 June 1971, London

ESTIMATE
Not published

SOLD
165,000 guineas/
£173,250/$422,730

EQUIVALENT TODAY
£2,190,000/$3,087,000

In June 1971, a French eighteenth-century ormolu-mounted *bureau plat* (writing table) became the most expensive piece of furniture in the world when it sold for 165,000 guineas. The work of the great German-born cabinetmaker Martin Carlin, the table was the property of the American collector Anna Thomson Dodge (1871–1970), wife of the automobile pioneer Horace E. Dodge. Widowed in 1920, she was one of the wealthiest women in the world and amassed an impressive collection of fine furniture, works of art and antiques, many of which she bequeathed to the Detroit Institute of Arts and the J. Paul Getty Museum in California.

This writing table is made of oak veneered with tulipwood, and is set with fourteen soft-paste porcelain plaques that are decorated with polychrome enamel. The porcelain was made at the Sèvres porcelain factory near Paris in 1778. The entrepreneur Dominique Daguerre purchased the porcelain plaques from Sèvres with the intention of having them mounted in a new piece of furniture. The table was

commissioned from Carlin, a German who had emigrated to Paris. Carlin lived modestly, and although he was well known for his elegant neoclassical furniture, it was unlikely that his more illustrious clients would have felt comfortable venturing into the Faubourg Saint-Antoine area of the city to visit him. It was the *marchand-mercier*, Daguerre, therefore, who brokered all his commissions.

In May 1782, Daguerre sold the table to Grand Duchess Maria Feodorovna and Grand Duke Paul Petrovich (visiting Paris incognito under the pseudonyms Comte and Comtesse du Nord); the duke later became Emperor of Russia. The table was placed in the duchess's bedroom at the Pavlovsk Palace, near St Petersburg. After the Russian Revolution of 1917, it was acquired by the influential British dealer Joseph Duveen, and eventually found its way into the collection of Anna Dodge in the 1930s.

At the auction in 1971, Habib Sabet, an Iranian oil magnate based in Paris, found himself bidding against the Detroit Institute of Arts, which went as high as 160,000 guineas. Sabet offered an additional 5,000 guineas and secured the table. The table came up for sale again at Christie's on 1 December 1983, when it was purchased for £918,000 ($1.4m) for the J. Paul Getty Museum in California.

234

THE REAL
DA VINCI CODE

The record for a manuscript sold at auction was set on 11 November 1994 when Bill Gates, then chairman of Microsoft, purchased the Codex Hammer, a rare Leonardo 'notebook', for over $30m.

Being a lateral thinker and innovator, Gates is fascinated by Leonardo da Vinci, one of the great creative polymaths of the Renaissance. The Codex Hammer comprises seventy-two loose leaves brought together to form a notebook, written by Leonardo between 1506 and 1510. In it he speculates and discourses on many subjects, from astronomy and meteorology to geology. Everything in the notebook is linked by the theme of water: how it moves and how it can be manipulated. The pages are packed with over 350 of Leonardo's drawings, rendered in chalk and brown ink, as well as his tiny 'mirror' writing, which reads from right to left in reverse.

In 1690, this notebook was discovered among the papers of Guglielmo della Porta, a sixteenth-century Milanese sculptor and student of Leonardo's work. By 1717, it had made its way into the

Opposite page: American industrialist Armand Hammer at Christie's in 1980, with the Leonardo da Vinci manuscript now known as the Codex Hammer.

Leonardo da Vinci
(1452–1519), Codex Hammer,
1506–10, autograph
manuscript of scientific
notes, observations and
experiments, 72 pages,
pen and brown ink,
average page size
23 x 22.5 cm (9 x 9 in)

SALE
11 November 1994, New York

ESTIMATE
Not published

SOLD
$30,802,500/£20,132,355

EQUIVALENT TODAY
$51,800,000/£35,800,000

collection of Thomas Coke, the future Earl of Leicester, and it remained in his library at Holkham Hall in Norfolk, for 263 years, where it was named the Codex Leicester. In 1980, the American industrialist and philanthropist Armand Hammer acquired the manuscript from Christie's for a record-breaking $5.1m (£2.2m; equivalent to $12.1m/£8.4m today) and renamed it Codex Hammer. Just fourteen years later, the manuscript was back on the market.

Before the sale in 1994, the manuscript travelled to Seoul, Tokyo, Milan and Zurich, building anticipation in each city. On the day of the sale, bidding opened at $5.5m (£3.6m) but quickly rose to over $30m. The final, anonymous bid was greeted with a round of applause.

Gates, who later announced himself as the anonymous buyer of the Codex Hammer, said that he found knowledge itself to be 'the most beautiful thing'. He has since had the Codex scanned into digital image files, and a comprehensive CD-ROM was released in 1997. The manuscript continues to travel the world and is put on public display in a different city every year.

Pages from Leonardo
da Vinci's Codex
Hammer, 1506–10.

THE FACE OF HER AGE

Gustav Klimt (1862–1918),
Portrait of Adele Bloch-Bauer 2, 1912, oil on canvas,
190 x 120 cm (75 x 47½ in)

SALE
8 November 2006, New York

ESTIMATE
$40m–60m/£21m–31.5m

SOLD
$87,936,000/£46,359,860

Portrait of Adele Bloch-Bauer 2, painted by the Viennese artist Gustav Klimt in 1912, came on to the market in 2006. The painting, which depicts the wife of a wealthy sugar merchant standing in fashionable outdoor clothes and a wide-brimmed hat, had been hanging in the Belvedere in Vienna before being restored to the Bloch-Bauer family earlier that year, along with four other paintings by Klimt.

The Bloch-Bauers were Jewish patrons of the arts, and Adele was a well-known society hostess in Vienna. She held salons attended by the Austrian intelligentsia, including the composers Richard Strauss and Gustav Mahler, the writer Stefan Zweig and the Socialist Karl Renner. Her slender face and languid air seem to personify the elegant cultural atmosphere of pre-war Vienna, and Klimt completed several paintings of Adele, including a mesmerizing golden portrait of 1907, which took him three years to complete. Adele died from meningitis in 1925.

Following the Austrian Anschluss in 1938, five Klimt paintings owned by the Bloch-Bauers were confiscated by the Nazis, comprising both portraits of *Adele*, *Birch Forest* (1903), *Apple Tree I* (1912) and *Houses at Unterach on the Attersee* (1916). Ferdinand Bloch-Bauer died in exile in Switzerland in 1945.

Fifty-three years later, in 1998, the Austrian government passed a restitution law ruling that property stolen by the Nazis could be returned to its rightful owners. Adele's niece Maria Altmann, who had escaped from Austria during the war and was living in Los Angeles, was now in her eighties. She began a legal battle to regain the five Klimts that belonged to her family, a battle that would last for many years.

Austria vs Altmann was a landmark case for restitution. Monica Dugot, international director of restitution at Christie's, explains: 'It was a turning point because so many claimants had desperately tried over the years to recover their families' collections, but had met with too many obstacles. Maria Altmann's victory gave heart and courage to those families seeking to reclaim not only major artworks, but also personal and more modest lost and unrecovered objects. It marked a time when international restitution efforts were finally reawakening.' (See also pp.48–9, 82–3).

Once Maria Altmann had reclaimed her property in January 2006, Stephen Lash, chairman emeritus of Christie's Americas, introduced her to Ronald S. Lauder, director of the Neue Galerie in New York. The

Adele Bloch-Bauer photographed around the time Klimt completed the portrait of her in 1912.

Neue Galerie bought the golden *Portrait of Adele Bloch-Bauer 1* for $135m (£70.9m), the highest price ever paid for a painting at the time.

In November that year, Altmann's four other Klimt paintings were sold. 'It was one of the most extraordinary sales I have ever been involved in,' the evening's auctioneer Christopher Burge recalls. 'The highlight was the Klimts, which far and away exceeded anything we thought they were going to bring.' The four works realized a combined price of nearly $193m (£101.3m), and the second Adele portrait became the fourth most expensive painting ever sold at auction, going to a telephone bidder for just over $87.9m.

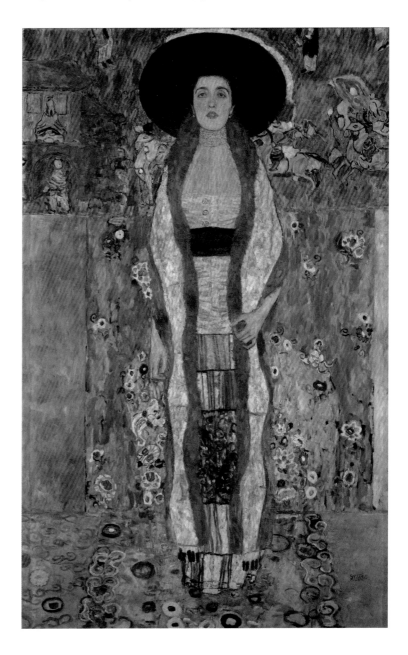

COFFERS SOLD TO SECURE THE FUTURE

André-Charles Boulle
(1642–1732), pair of Louis XIV
coffres de toilette, early
18th century, ebony and
brass and pewter-inlaid
brown tortoiseshell,
71 x 123 x 52 cm
(28 x 48½ x 20½ in)
and 70 x 123 x 52 cm
(27½ x 48½ x 20½ in)

SALE
4–8 December 1994, London

ESTIMATE
£400,000–600,000/
$610,000–920,000

SOLD
£1,541,500/$2,358,500

EQUIVALENT TODAY
£2,580,000/$3,700,000

Christie's long relationship with Houghton Hall in Norfolk dates back to 1778, when James Christie was invited to value Sir Robert Walpole's superlative collection of Old Masters, which were eventually sold to Empress Catherine the Great of Russia (see pp.393–4). There was a further high-profile sale in 1992, when in order to meet the cost of maintenance and pay inheritance tax, the family asked Christie's to sell one of its greatest works of art, Hans Holbein's *Lady with a Squirrel and a Starling* (*c.*1526–8), which had been in the Cholmondeley family since the 1750s (see pp.416–17).

In 1994, David, the 7th Marquess of Cholmondeley, invited Christie's to auction a collection of furniture and works of art with the aim of creating an endowment that would ensure the future of the Hall. Since the intention was to preserve the original spirit of Houghton and its interiors, very little of the furniture that William Kent had made for the house was included. Most of the pieces for sale came from David's grandmother Sybil, Marchioness of Cholmondeley, and her brother Sir Philip Sassoon. Much of it had been housed in their London home at 25 Park Lane, or at Trent Park, Philip's house in north London. There

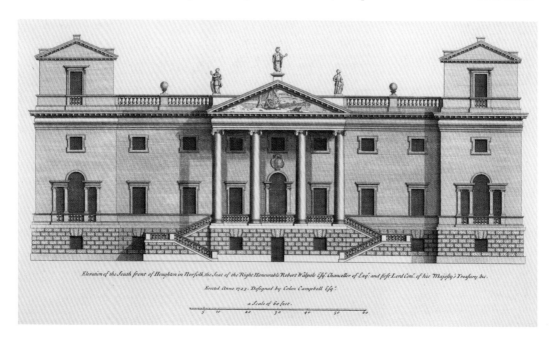

Elevation of the South front of Houghton in Norfolk, the Seat of the Right Honourable Robert Walpole Esq.ʳ Chancellor of Exch.ʳ and first Lord Com.ˢ of his Majesty's Treasury, &c.
Erected Anno 1723. Designed by Colen Campbell Esq.ʳ

a Scale of 60 feet.

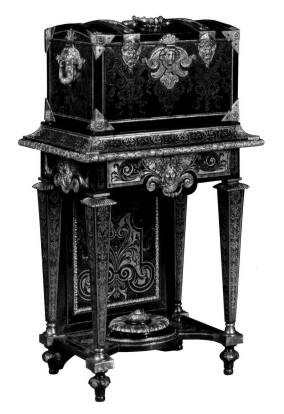

Left: the façade of Houghton Hall in Norfolk, from Colen Campbell's *Vitruvius Britannicus*, 1715–25. Above: the *coffres de toilette* can be seen against the far wall of Philip Sassoon's Park Lane drawing room in John Lavery's *The Red Hat*, 1925.

was a distinctly French flavour to the auction, which offered furniture from the Louis XIV, XV and XVI periods, porcelain, carpets, statuettes of Voltaire and Rousseau, and japanned furniture.

A star lot was a pair of highly ornate Boulle *coffres de toilette* that had decorated the drawing room at the Sassoons' Park Lane house (where they are recorded in the painting *The Red Hat* of 1925 by John Lavery). The cabinetmaker André-Charles Boulle delivered a *coffre* for the Grand Dauphin's *appartements* at the Château de Versailles as early as 1684, and he and his sons continued to make them for more than forty years (see pp.368–9 and 402–3 for other examples of his work). Such coffers might have been used to store night garments, personal effects such as a watch or a wig, or private papers.

Christie's links with Houghton continue to the present day. In 2013, it sponsored the magnificent exhibition 'Houghton Revisited', when seventy masterpieces from Catherine the Great's collection returned to the house, and in 2015, it sponsored James Turrell's *Lightscape*, in which the west façade of the Hall was bathed in a shifting light display.

237 GOLD RUSH

Eugene von Guérard (1811–
1901), *A View of Geelong*,
1856, oil on canvas,
89 x 152.5 cm (35 x 60 in)

SALE
29 April 1996, Melbourne

ESTIMATE
Not published

SOLD
AUS$1,982,500/
£1,560,285/$1,560,285

EQUIVALENT TODAY
AUS$3,374,000/
£1,730,000/$2,434,000

An anonymous art critic, writing in the Australian newspaper *The Age* in 1856, explained eloquently why the Austrian-born Eugene von Guérard's panorama *A View of Geelong* was outstanding. 'The broad expanse of flat country is a masterpiece of perspective,' the critic wrote, 'and nothing can exceed its delicacy, and yet distinctness, with which the objects in the extreme distance are painted.'

Von Guérard's painting offers a sweeping vista of the booming gold-rush township of Geelong, and across to Port Phillip Bay, the You Yang hills and as far as Melbourne and Mount Macedon in the far distance. The artist had travelled to Victoria in Australia in 1852 to try his hand in the goldfields. He settled in Geelong for two years, and the sketches he completed were subsequently developed into picturesque paintings of the area.

The Christie's sale catalogue describes how the artist guides the viewer through the painting: 'In the foreground, one's eye follows the curving road carrying the traffic of commerce – a bullock team heaving its load – until it stops at a lone traveller.' Behind the figure, the eye is drawn towards the blue pool of water in the centre of the painting and out to sea, journeying further into the distance, towards the far purple mountains.

The work was transported to England the year it was painted, having been bought by the wool merchant Frederick Gonnerman Dalgety from Mr Maclachlan's in Collins Street, Melbourne. Dalgety displayed the work at his home, Lockerley Hall in Hampshire, where it remained until its consignment in 1996. *A View of Geelong* was purchased by Andrew Lloyd Webber for AUS$1.9m (see also pp.55–7, 296 and 297–8). He sold it ten years later to the Geelong Gallery for AUS$3.9m (£1.6m/$2.9m) in a private treaty sale brokered by Christie's.

Portrait of Eugene von
Guérard published in the
*Illustrated Australian News
for Home Readers* in 1867.

SOMEWHERE OVER THE RAINBOW

Konstantin Somov (1869–1939), *The Rainbow*, 1927, oil on canvas, 60.5 x 73.5 cm (23 x 29 in)

SALE
13 June 2007, London

ESTIMATE
£400,000–600,000/
$787,000–1,181,000

SOLD
£3,716,000/$7,314,960

Konstantin Somov grew up surrounded by paintings. His father was a distinguished art historian and keeper of the Hermitage collection in St Petersburg. He studied under Ilya Repin (1844–1930), a towering figure in nineteenth-century Russian painting, and by the first decade of the new century Somov was fêted as an illustrator and a portraitist. In pre-revolutionary Russia and following his emigration to Paris, he painted some of Russia's leading cultural figures, including the composer Sergei Rachmaninov (1873–1943), the poet Alexander Blok (1880–1921) and the artist's own father, Andrei Somov (1830–1909).

Konstantin Somov was also a fine landscape painter, as can be seen in *The Rainbow*. In fact, almost the last thing you see in this painting is the rainbow, all but hidden behind the sparse canopy of a silver birch. Three small figures stand by a bank of green trees in a country estate. Stripes of sunlight stretch across the grass while an irregular grey sheet of rain hangs like a ragged curtain across the blue sky. The slender woman in the pink gown, with her tiny turquoise parasol, appears to talk to the blonde girl and young boy, unaware of the colourful rainbow or the impending rain.

The Russian word for rainbow – *raduga* – suggests 'joy', but a rainbow is a universal symbol of transience, of the fleeting nature of things. Perhaps the boy is the artist, a retrospective self-portrait clutching his Pierrot doll, a childhood since vanished.

No Russian could look at the mottled white trunk of the silver birch and not feel a pang of *toska*, the wistful longing for the certainties of the past and the landscapes of home. So perhaps it was sheer nostalgia, real or imaginary, that, in 2007, pushed this painting to sell for more than six times its high estimate, setting a new record for a work of Russian art at auction.

POP HITS THE HEIGHTS

Roy Lichtenstein (1923–1997),
Happy Tears, 1964, magna
on canvas, 96.5 x 96.5 cm
(38 x 38 in)

SALE
13 November 2002, New York

ESTIMATE
$5m–7m/£3.2m–4.4m

SOLD
$7,159,500/£4,504,040

Happy Tears is a classic mid-1960s work by the Pop artist Roy Lichtenstein. His comic-book images are so instantly alluring and apparently celebratory that it is easy to miss the dispassionate delivery that subverts their Pop vividness. His found imagery might have included adrenalin-fuelled *Boy's Own* depictions of war or idealized scenes of cartoon love, but his execution was always cool.

Lichtenstein was avowedly unromantic and deliberately looked to the real world for inspiration, in contrast to the Abstract Expressionists, who preceded Pop artists as the dominant artistic force in post-war America. He admired commercial art because it was 'usable, forceful and vital', and – despite the loaded imagery he played with – he was a great formalist, always emphasizing what he called 'the integrated organization of visual elements' in his works.

Key within this structure are the enlarged Ben-Day dots that Lichtenstein transformed into a fundamental formal tool. At the time, images reproduced in newspapers and cheap comics were created using these dots, and by highlighting them in his paintings Lichtenstein made clear his source material. However, the dots also had a visual role to play on the surface of the paintings, and in *Happy Tears* they create a hypnotic effect.

The market for Lichtenstein's work has grown exponentially since the year 2000. *Happy Tears* took the record for the highest auction price for a Lichtenstein when it sold for more than $7m in 2002, but the record has tumbled numerous times since, reaching over $43m (£27m) with *I Can See the Whole Room! ... and There's Nobody in It!* (1961) in 2011. In 2013, Artprice.com stated that Lichtenstein's price index had increased by 152 per cent in a decade, and that was before it leapt to astonishing heights again, when *Nurse* (1964) was sold for over $95m (£63m) at Christie's New York in November 2015; the same work had fetched $1.7m (£1.1m) at auction just twenty years previously.

Roy Lichtenstein's *Nurse*,
1964, sold for over $95m
in 2015.

449

240

A BLAZE OF LIGHT AND FRESH BREEZE

Claude Monet (1840–1926),
La Terrasse à Sainte-Adresse,
1867, oil on canvas,
98 x 130 cm (38½ x 51 in)

SALE
1 December 1967, London

ESTIMATE
Not published

SOLD
£588,000/$1,423,000

EQUIVALENT TODAY
£9,530,000/$13,223,000

In 1960, Thomas Hoving, curator of medieval art at the Metropolitan Museum of Art, New York, went to meet an eccentric pastor who was buying sculpture for a 'cathedral' built in the grounds of his estate in Pennsylvania. The pastor – the Reverend Theodore Pitcairn – was an avid if erratic collector who, along with stained glass and medieval sculpture, had acquired a fine collection of Impressionist paintings.

In one of the reverend's guest rooms, Hoving discovered a work by Claude Monet, *La Terrasse à Sainte-Adresse*, a bright seaside scene painted, he later wrote, 'like a blaze of light and fresh breeze'. In his autobiography, Hoving recounted that he 'sat down on the bed and stared at it for what must have been an hour. Finally, I pulled myself away and left, but I never forgot that glowing picture.'

Monet painted *La Terrasse à Sainte-Adresse* in 1867 when he was in desperate financial straits and had spent the summer with his family near Le Havre. The year before, the official Paris Salon had accepted a painting of his mistress Camille Doncieux, and he was certain this lively landscape would impress the jury again. It was rejected, however, and Monet became so despondent that he considered suicide: 'I threw myself *en plein air* with body and soul,' he lamented in a letter to the French painter Armand Gautier. 'I was trying to do something that was a dangerous innovation, effects of light and colour and the full outdoors that shocked accepted customs.'

The painting was later acquired by the Reverend Pitcairn from a New York art gallery in 1926. When it came up for sale at Christie's in 1967, Hoving, by then director of the Metropolitan Museum of Art, was determined to buy it for the collection. In four days, he succeeded in raising the money and commandeered the services of the eminent London dealer Geoffrey Agnew to purchase it on the museum's behalf. Their strategy was to sit quiet at first and then enter at a million dollars, since Agnew believed this would unsettle their opponents. The plan worked, and the Met went on to secure the picture for £588,000. It remains one of the highlights of the museum's Impressionist collection.

CAFÉ CULTURE

Edgar Degas (1834–1917),
Dans un café (also known
as *L'absinthe*), 1875–6,
oil on canvas, 92 x 68 cm
(36½ x 26½ in)

SALE
19–20 February 1892, London

ESTIMATE
Not published

SOLD
£180/$875

EQUIVALENT TODAY
£17,500/$25,200

The actress Ellen André,
photographed by Nadar.
She modelled for Edgar
Degas in *Dans un café*.

In 1892, a small painting by Edgar Degas came up for sale at auction in London. The picture would seem fairly innocuous today – a shabby-looking couple seated at a café table – yet when it was presented for sale it was jeered by the Victorian audience. Clearly, the innovations of the Parisian avant-garde were yet to be appreciated by the British public.

Dans un café, or *L'absinthe* as it became known, was already notorious when it arrived at Christie's. When it was exhibited in the third Impressionist exhibition in 1877, Degas was forced to state publicly that the models, the actress Ellen André and the engraver Marcellin Desboutin, were not alcoholics. The Parisian bar in which the couple are painted, identified as the popular bohemian drinking haunt La Nouvelle Athènes in Place Pigalle, had a seedy reputation, and Degas's depiction of the subjects suggested that they were intoxicated. André is seated with a glass of absinthe, a hallucinogenic drink hugely popular in *fin-de-siècle* Paris, while Desboutin's glass contains a brown liquid thought to be a remedy for a hangover from absinthe. With their dull, vacant expressions, the off-kilter composition and the strange way in which the figures are hemmed in by bar tables, the picture seems to sway with the rolling gait of a drunk.

In fact, the odd composition is down to Degas's interest in photography. He wanted the painting to look like a snapshot taken by an observer seated at a corner table. Degas was a painter of everyday life, from dancers backstage to a woman at her toilette. He was fascinated with capturing those quiet, private moments when the real business of living takes place. As a result, his paintings were often thought to embody the societal isolation that was increasingly experienced in Paris during this period of rapid industrial growth. Degas influenced many writers and painters; the novelist Émile Zola, for example, admitted openly to the artist, 'I quite plainly described some of your pictures in more than one place in my pages.' Vincent van Gogh later referred to Degas's paintings as powerful and virile.

Dans un café came to auction from the estate of Henry Hill, Brighton. He knew the sitter Desboutin, was a friend of many of the Impressionists and had bought the painting directly from the third Impressionist exhibition. In 1892, the first Impressionist work to appear in a Christie's auction, it was bought for a modest £180 by the Glasgow art dealer Alexander Reid. The painting is now in the Musée d'Orsay in Paris.

A LEGENDARY VINTAGE

Impériale Château Latour,
1961, 6-litre (10½-pint) bottle

SALE
27 May 2011, Hong Kong

ESTIMATE
HK$600,000–800,000/
£46,800–62,400/
$76,800–102,400

SOLD
HK$1,680,000/
£131,000/$215,000

There is something sculptural and unsettling about a six-litre Impérial bottle. Like one of Claes Oldenburg's outsize shuttlecocks or Ron Mueck's human giants, the somewhat unfamiliar scale of it creates a curious sense of estrangement. But an Impérial of Château Latour is no mere curiosity. Bordeaux wines age very well in larger bottles, and more slowly – so older vintages benefit. The relatively small airspace inside the bottle – known as ullage – allows a wider range of nuances to develop over time: a vintage maturing in a larger bottle may grow to be more complex than the very same wine in a standard one. And the thicker glass of a large bottle gives the wine greater protection from temperature variation. So, for a serious wine collector, the magnums, jeroboams, imperials and salmanazars are a sound and serious investment.

This Impérial from 1961 – eight bottles' worth of the vintage of the century – was one highlight of a spectacular auction in Hong Kong in 2011. Over 300 lots stretching back to 1863 – the year Latour conceived its first labels – had been specially released from the Château Latour cellars by François Pinault, the vineyard's owner. In the sale catalogue, Pinault complimented Chinese wine-lovers for understanding the 'hidden meanings of this legendary wine,' and described the allure of Latour: 'Its aromas unleash perfumes of a crystalline purity and open the doors to the imagination … Its force interrogates the senses, and the memory remains indelible. Majestic wine, Latour is not engaged, it conquers.'

The Asian market had been growing apace since Hong Kong abolished wine taxes in 2008. That, combined with a soaring Asian economy, suddenly made Hong Kong and China the top destination for exports of top-flight Bordeaux. Hammer prices went wild.

The 1961 Impérial went to an anonymous Chinese connoisseur, who paid almost three times the estimate – still a good price for a vintage that Christie's had described as 'a transcendent bottle of perfect wine'.

The grape harvest at Château Latour in 1963.

NECTAR OF THE GODS

Min *fanglei*, ritual *lei* wine jar, late Shang – early Zhou dynasty (11th–10th century BC), bronze, 64 cm (25 in) high (excluding lid)

SALE
20 March 2001, New York

ESTIMATE
Not published

SOLD
$9,246,000/£6,440,765

Ritual *lei* wine containers from the late Shang dynasty (1600–1046 BC), renowned as the greatest era of ancient Chinese bronze production, are rare. This one is the largest and most elaborately decorated example known to have survived. It illustrates the ostentatious expenditure on metal craftsmanship and the ritual connection with alcohol that featured in the Shang court's relationship with its gods.

Two inscriptions, one of six characters inside the neck and one of eight under the lid, reveal that this was a 'sacred' *lei* made by Min on behalf of his father, and modern admirers have popularly dubbed it the 'King of *Leis*'. Details of exactly when and how it was found are uncertain, but it seems to have been unearthed by farmers in Hunan province some time between 1919 and 1922. The lid of the set remained in Hunan, but collectors passed the *lei* around the world until its last foreign owner died in 2014. A consortium of collectors, displaying the cohesive potential of Chinese culture, negotiated through Christie's to buy it by private sale before the planned auction in March 2014 and to donate it to the Hunan Provincial Museum. On 21 June 2014, three months after the private sale, the 'king' regained his 'crown' when the wine vessel was reunited with its lid, an occasion for great celebration.

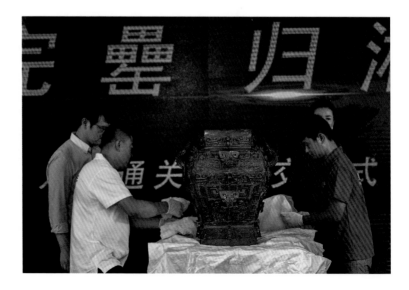

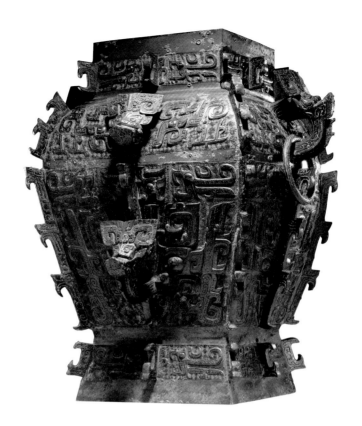

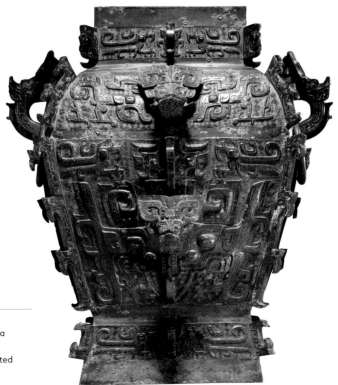

Left: the Min *fanglei* at Changsha airport in China on 21 June 2014, the day the wine vessel was reunited with its lid after nearly a century apart.

The lustrous Min *fanglei* is in superb condition (*fanglei* means 'square *lei*'; square wine vessels are much less common and are therefore more unusual and valuable). It has two handles with attached rings on opposite shoulders and another handle, lower down on a third side, for tipping and pouring out the wine. Horned dragon masks span the top of each handle. The vessel tapers to a low waist before flaring at the base. Pairs of ornamental birds face each other on panels around the neck and the base, and stylized dragons, birds and cicadas adorn the upper sections. Below the shoulders of the jar, the chief decorative feature on each side is a large *taotie* mask. All these elements are moulded to stand out in sharp relief from the body. The pattern continues on to the lid, which is shaped like the hipped roof of a traditional Chinese house.

The price paid for the Min *fanglei* in 2014 is a closely guarded secret. Given that it sold for a world record price for an archaic bronze in 2001, it now seems certain that Hunan Provincial Museum possesses one of the world's most precious bronze artefacts.

244

THE POETIC ALLURE OF LACQUER

Early Ming dynasty bowlstand, c.1403–24, carved cinnabar lacquer on metal, 17.5 cm (6¾ in) in diameter

SALE
3 December 2008, Hong Kong

ESTIMATE
Not published

SOLD
HK$33,140,000/
£2,868,300/$4,275,300

The Emperor Qianlong (r. 1736–96) referred to lacquer carving from the Yongle period (1402–24) no fewer than twenty-four times in his poems, confirming today's view that the art form reached its apogee during the early Ming dynasty in China.

The Ming court valued carved pieces as luxury objects and presented them as gifts for diplomatic and social purposes. A stand like this one, which bears the mark of the Yongle reign, could be used to hold a snugly fitting porcelain or lacquer tea bowl, and would have been highly prized. In time such sets became highly collectible, although the risk of breaking the delicate bowl was ever present.

Qianlong seems to allude to this fragility in the poem he wrote in 1781 for the present stand, on the interior of which it is incised and illuminated with gilt. Once, he said, it held a bowl from the Jiaqing period (1522–66), but 'although it is complete [again] now it could become half again some time in the future.' By the time the collector Sir Percival David acquired it in the twentieth century, the cup had indeed become separated. Sir Percival loaned the stand to the great London Exhibition of Chinese Art in 1935, where it was one of four examples of Yongle carved lacquer on display.

The tray is shaped as six petals, reminiscent of flanges on Tang and Song stands, and the lacquer is deeply laid on a metal base and sharply carved with phoenixes and lotus scrolls. The lacquer expert Sir Harry Garner stressed that the epithet 'imperial' should rightly be reserved exclusively for objects decorated with five-clawed dragons, but the presence here of four phoenixes, one pair on the body and another on the tray, suggests that it was probably made for the empress in the imperial workshops.

The Metropolitan Museum of Art, New York, and the Beijing Palace Museum have matching stands, but neither share Qianlong's poetic addition. When this stand came up for sale in 2008 alongside other important pieces of Chinese lacquer, it achieved a world-record price.

CHINESE CLASSICS
WITH A TWIST

Shang Xia (est. 2008),
Da Tian Di (Sky and Earth),
2014, a pair of 'Bo Luo'
lacquered carbon-fibre
chairs, 49 x 51 x 82 cm
(19 x 20 x 32 in)

SALE
24 October 2014, Shanghai

ESTIMATE
RMB600,000–650,000/
£60,900–66,000/
$98,100–106,300

SOLD
RMB1,110,000/
£112,720/$181,450

For Christie's, the sale of Chinese contemporary design held in Shanghai in October 2014 represented a foray into a new market. The prospect of top-quality traditional Chinese craftsmanship combined with innovative contemporary design attracted new buyers from mainland China and abroad, eager to invest in pieces that blended modernity and tradition in a manner that characterizes the Chinese art market.

The twenty unique pieces of design that featured in the sale were created by the luxury Chinese brand Shang Xia, which was founded in 2008 and whose stores sell a range of homewares, clothes, jewellery, furniture and art. Objects in the sale included a woven gilt bamboo porcelain tea set, a magnificent lacquered *zitan* desk, a four-panel folding screen with silk embroidery and a pair of carbon-fibre chairs finished in red-and-gold lacquerwork.

The ancient and prized technique of sanding and polishing known as pineapple (or rhinoceros hide) lacquerware dates back to the Three Kingdoms period (220–280), and has died out and been rediscovered several times. These 'Bo Luo' lacquered carbon-fibre chairs follow the style of the Ming dynasty (1368–1644), but embody the philosophy of the Shang Xia brand by transforming the 'Made in China' label into a mark of excellence.

Much of China's traditional craft knowledge was put aside during the turmoil of Chinese history. Today, China's sophisticated and wealthy consumers are eager to reconnect with their cultural heritage and to revive ancient skills, hence the appeal to collectors of such contemporary and uniquely Chinese brands as Shang Xia.

AN EYE FOR QUALITY

Robert Adam (1728–1792) and Thomas Chippendale (1718–1779), a set of four George III armchairs and a sofa, 1765, giltwood with silk velvet damask upholstery, seats: 107 x 75.5 x 75 cm (42 x 30 x 29½ in)

SALE
26 April 1934, London

ESTIMATE
Not published

SOLD
360 guineas/£378/$1,900

EQUIVALENT TODAY
£24,000/$34,500

On 26 April 1934, the sale of the property of Lord Zetland (1876–1961) from his house at 19 Arlington Street, London, included Gobelins tapestries and furniture designed by Robert Adam. He had been commissioned in 1763 to furnish and decorate the London house together with Moor Park in Hertfordshire, the town and country homes of Sir Lawrence Dundas, Lord Zetland's ancestor and a great eighteenth-century collector. The Dundas chairs – four giltwood armchairs and a sofa, each made with a padded back, arms and a seat originally covered in crimson silk damask – are fine examples of Thomas Chippendale's work for Adam.

Adam was perhaps the most avant-garde architect of the time. He not only remodelled Sir Lawrence's numerous houses, in 1764 he also designed this sofa and chairs, mixing curvaceous rococo forms with the neoclassical. It is the only known instance of Chippendale executing an Adam design.

The interior of Lord Zetland's house at 19 Arlington Street, London, with Chippendale's armchairs and sofa.

Sir Lawrence Dundas gained a reputation as a distinguished collector and connoisseur. When serving as commissary general of the army in Flanders during the Seven Years' War (1756–63), he was dubbed the 'Nabob of the North'. An astoundingly successful merchant-contractor with contacts all over Europe, he entered politics, becoming a Member of Parliament for the first time in 1747, and was eventually elevated to the baronetcy.

Sir Lawrence and his equally discerning wife, Lady Dundas, spent lavishly on their London home. Robert Adam's attention to detail was legendary, encompassing furniture and carpets to candlesticks and upholstery fabrics.

The Arlington Street address remained in the Dundas family until the sale of 1934, when the four giltwood Chippendale chairs and sofa sold for 360 guineas. On 18 June 2008, a pair of chairs reappeared at Christie's and were bought for £2,281,250 ($4,464,400), and the sofa sold for £2,169,250 ($4,013,112) – a testament to the value placed by collectors on Chippendale furniture.

A CHAIR
FIT FOR A KING

Georges Jacob (1739–1814),
Royal Louis XVI giltwood
fauteuil frame, 1784, carved
beechwood, 97 x 72 cm
(38 x 28 in)

SALE
23 June 1999, London

ESTIMATE
£100,000–150,000/
$150,000–220,000

SOLD
£386,500/$610,115

EQUIVALENT TODAY
£598,200/$866,300

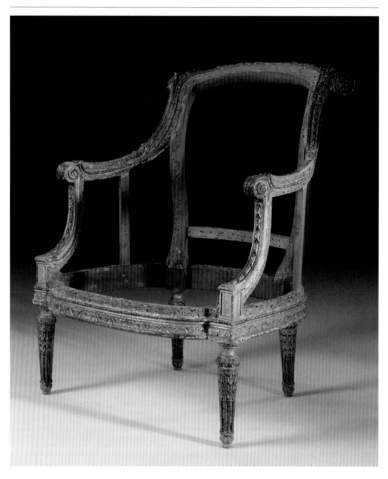

Louis-Michel van Loo's
1770 portrait of the Comte
d'Artois. The comte
commissioned this *fauteuil*
for Louis XVI (his brother)
to use while visiting his
Château de Bagatelle
near Paris in 1784.

This gilt-framed *fauteuil* (armchair) was created for Louis XVI in 1784,
and was for his exclusive use during a visit to the Château de Bagatelle
near Paris. The frame of the chair was carved by Jean-Baptiste Rode,
under the direction of Georges Jacob, probably the foremost French
menuisier or furniture-maker, whose inventive neoclassical carving
was much sought after by the French aristocracy and by the heads
of other European countries. The *fauteuil* demonstrated his skill,
with its decorative scrolling, fluting, ribbon-tied and laurel-wrapped
cornucopia, oak leaves, flower heads and the royal fleur-de-lis. The
fauteuil was commissioned by the Comte d'Artois, brother of the

king, in July 1784, for a party in honour of Louis XVI to be held in the comte's recently completed Château de Bagatelle. The new chateau was the result of a bet between the comte and Marie Antoinette, who wagered that it could not be built in three months. Designed by the architect François-Joseph Bélanger in one night, it was built in just nine weeks. This speedy completion came at a cost, however: over 900 workers were employed in the construction of the small chateau and the planting of the extensive grounds.

What those hundreds of workers created was a mini pleasure-palace, conveniently situated in the Bois de Boulogne (now in the city's sixteenth arrondissement). It comprised a dining room and billiard room, with a circular salon and a glazed cupola. Georges Jacob supplied eight *fauteuils*, sixteen side chairs and a screen.

This chair was commissioned in accordance with the elaborate rules of royal etiquette that prevailed at the Palace of Versailles, which decreed that the royal personage would have exclusive use of his own *fauteuil*. In the presence of the king and queen, no one else – apart from another monarch – was permitted to sit on a *fauteuil*. As a potent symbol of royal privilege, it is perhaps surprising that the chair survived the French Revolution intact, although an explanation might be found in the removal of the royal fleur-de-lis decorations from the panels above the legs. In June 1999 this chair fit for a king was sold at auction for £386,500 ($610,115).

Top: François-Joseph Bélanger's drawing of the Château de Bagatelle, built for the Comte d'Artois in 1777, and where the *fauteuil* was used by Louis XVI.

Right: the stamp of the renowned furniture maker Georges Jacob, who made the *fauteuil*.

A GEM
OF A COLLECTION

248

Seven hundred gems,
cameos and intaglio

SALE
28 June 1875, London

ESTIMATE
£60,000/$85,000

SOLD
35,000 guineas/£36,750/
$205,430

EQUIVALENT TODAY
£3,090,000/$4,432,000

When large collections come to auction, the expectation is that they will be broken up and sold to private collectors, museums and institutions. But the Marlborough Gems, which arrived at Christie's in 1875, was one collection that bucked the trend. An exquisite cache of antique gems, cameos and intaglios amounting to 700 items, it was sold as a single lot, ensuring that the collection stayed together – if only for a brief period.

The Marlborough Gems was the largest and most important eighteenth-century collection of gems in England and was held in the highest regard by international scholars and connoisseurs. It had been assembled by the 4th Duke of Marlborough (1739–1817) at Blenheim Palace, Oxfordshire, and comprised items of both aesthetic and historic significance, including the Renaissance collection of the Gonzaga Dukes of Mantua, acquired by Lord Arundel in the mid-seventeenth century, the eighteenth-century collection of Lord Bessborough, and objects collected by the duke himself, including ancient and neoclassical pieces. Individually, the objects were small enough to be carried around in a pocket, but at Blenheim the collection was displayed in bespoke cabinets, and attracted crowds of visitors.

Offered for sale on 28 June 1875 by the 7th Duke of Marlborough in order to raise funds for maintenance of the estate, the collection was at first valued at £60,000. The duke instructed the auctioneer that he would be prepared to lower the reserve on the collection to 35,000 guineas to allow the nation the opportunity to keep the collection together, whereupon it sold *in toto* to David Bromilow of Bitteswell Hall, Leicestershire, for the reduced price. The news that the collection would stay together was greeted by applause in the saleroom, a testament to the esteem in which the Marlborough Gems were held.

This joy was short-lived, however, and the collection was returned to the market by Bromilow's daughter in 1899. This time it was dispersed internationally, and while there are pieces held by the British Museum and the Victoria and Albert Museum in London and the Metropolitan Museum of Art in New York, the whereabouts of three-quarters of the collection is now unknown. An archive compiled by the late Oxford professor John Beazley contains impressions of almost all the Marlborough Gems commissioned by the 4th Duke, as well as notebooks and catalogues recording details of them. It is held at the Classical Art Research Centre at Oxford University.

KING CANUTE'S GIFT

The Pusey horn, late 10th–
early 11th century (silver-gilt
mounts: early 15th century),
ox horn with silver-gilt
mounts, 65 cm (25 in) long

SALE
14 December 1938, London

ESTIMATE
Not published

SOLD
£1,900/$9,300

EQUIVALENT TODAY
£108,000/$150,000

Horns such as this one, which dates from the late tenth or early eleventh
century, were used in England from Anglo-Saxon times for ceremonial
purposes and displays of power. Often they indicated ancient lineage
and even the transfer of land or property. This example takes its name
from the manor of Pusey in Berkshire, southern England. Legend has it
that William Pusey, an officer in the army of King Canute (c.985–1035),
sneaked into the enemy camp and learned of an impending Danish attack.
In return for informing Canute, he was given the house and land at Pusey.

The horn's inscription, engraved on the later (fifteenth-century)
silver-gilt mounts, supports at least some of this tale. It reads: 'I King
Canute gave William Pecote [Pusey, mistranscribed] this horn to hold by
thy land.' As such it was an heirloom, a term originally used to convey
ownership of a specified object that is indelibly linked to the inheritance
of property. The horn was reputedly delivered with a letter of tenure,
and made legal history when it was successfully presented as evidence
in a court case in 1684.

The horn remained in the possession of the Pusey family until 1935,
when the family was 'allowed' to part with it, 'with the consent of the
Court,' according to the catalogue notes. It was acquired by William
Randolph Hearst (1863–1951), an American newspaper publisher (and the
man who inspired Orson Welles's film *Citizen Kane* of 1941). In 1938, his
businesses suffering during an economic depression, Hearst sold the horn,
among other silver pieces. It was bought by the London art dealer Mallett
and donated anonymously to the Victoria and Albert Museum in London.

REMAINS OF THE DAY

Skeleton of a mammoth,
c.13,000 BC,
4.8 m (16 ft) long,
3.8 m (12½ ft) tall

SALE
16 April 2007, Paris

ESTIMATE
€150,000–180,000/
£102,000–123,000/
$203,000–244,000

SOLD
€260,000/£177,000/
$352,000

The mammoth's skull looks like an octopus sculpted in mahogany, its enormous tusks curving upwards, while the thick femurs have the beautiful deep-brown patina of a Chippendale sideboard. This enormous creature, whose complete skeleton was sold in 2007, lived and died in Siberia during the Quaternary period, about 15,000 years ago.

Before the sale, the mammoth had been nicknamed 'The President' in honour of another Siberian, Boris Yeltsin, the ailing former president of Russia (he died a few days after the sale). It was by no means the oldest thing up for auction that day – there were four-million-year-old trilobite fossils – but the mammoth was the spectacular centrepiece of the sale. A spokesman for Christie's described the mammoth as 'exceptionally large', but that understatement was not quite to the point. The key thing about this skeleton was that it was complete, a more or less perfect specimen of *Mammuthus primigenius*. Its wholeness, as much as its immensity, was what made it compelling for collectors of palaeontological curiosities.

The skeleton set a new world record for this kind of object. Not everyone was pleased to see the mammoth pass into private hands rather than go to a scientific institution. 'It is a pernicious consequence of the Jurassic Park effect,' complained Pascal Tassy, a professor at the Natural History Museum in Paris. Most people merely wondered how the new owner of The President would make room in their house for it.

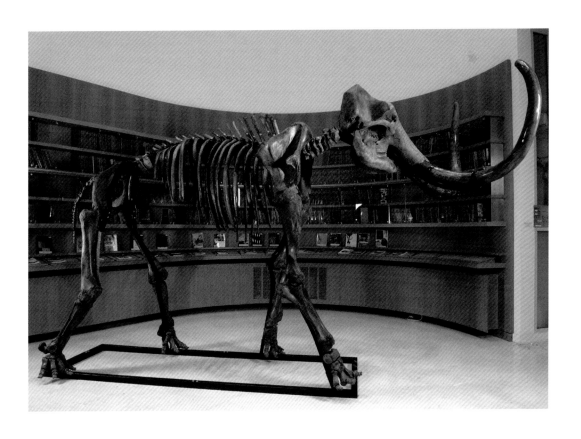

NOTES ON PRICES

The pricing of objects of desire and beauty is a delicate matter, and the values ascribed to those that pass through Christie's are dependent on many factors, some more tangible than others. To make better sense of the values indicated in this book, we have tried to clarify some financial and numerical principles below.

CURRENCY

All prices are listed in pounds sterling and US dollars. If the object was sold through Christie's in London, the sale price is given in sterling first, followed by the price in dollars based on a conversion at the time of the sale.

Conversely, for works purchased in New York, the dollar price is listed first, followed by its contemporary sterling equivalent.

When the item has been auctioned in another currency, contemporary conversions into both sterling and dollars are given.

ESTIMATES

Christie's introduced the publishing of separate estimate lists in 1977. Therefore, many entries will not include one. Even today, certain items may be included in a sale catalogue without a published estimate.

GUINEAS

Christie's conducted all of its sales in guineas until December 1974. A guinea was worth 21 shillings when £1 was worth 20 shillings. A guinea is worth £1.05p today.

EQUIVALENT TODAY

Although the conversion of historic sums of money into present-day equivalents is an inexact and sometimes contentious science, we have attempted to provide an updated figure for all items sold before the year 2000.

Entry number 224 (pp.420–1), for example, George Stubbs's painting *Gimcrack on Newmarket Heath*, has been offered for sale at Christie's four times. It was sold in 1780 for 27 guineas, which we equate to £3,200, or $4,860, in 2016.

This is not to say, of course, that the painting would fetch £3,200 today. Our conversions take only inflation into account – the impact of increased rarity and demand are more difficult to quantify.

In 1943 the work was offered again and sold for 4,200 guineas, equivalent to £177,100/$268,700 in 2016. Its 1951 sale price of 12,000 guineas could be said to equate to around £353,500/$536,300 today. Yet when the painting was sold most recently in 2011, it actually fetched the substantially higher figure of £22,440,000/$34,045,000.

ROUNDING UP AND DOWN

For the sake of simplicity, conversions into alternative currencies have been rounded to the nearest 5. Estimate conversions and 'equivalent today' figures have been rounded to the nearest 100.

1766

James Christie holds his first auction in his permanent saleroom in Pall Mall, London (p.17).

1767

Christie's holds its first auction devoted entirely to paintings.

1771

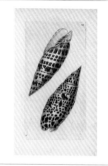

Christie's holds its first natural history sale, of fossils, shells and 'other curious subjects' (p.84).

The invention of the water-powered cotton mill in Britain speeds the development of the Industrial Revolution.

1772

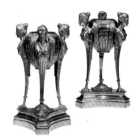

James Christie invites makers such as silversmith Matthew Boulton (pp.302–3) and potter Josiah Wedgwood to produce objects for special auctions in his saleroom.

1789

Outbreak of the French Revolution. Over the next ten years, the exodus of French aristocrats brings many French objects on to the art market in England.

1790

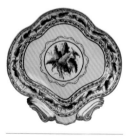

The Prince of Wales buys a collection of Sèvres porcelain brought to London by the French interior designer Dominique Daguerre (pp.340–1).

1794

James Christie 'the younger', Christie's son, conducts his first auction, replacing his father after the latter is wearied by a six-day sale.

1795

Christie's sells the contents of the studio of the artist Joshua Reynolds, including *Susanna and the Elders* by Rembrandt (pp.378–9).

Sale of the jewellery collection of Madame du Barry, King Louis XV's mistress (pp.148–9), after her execution in 1793.

1776

Christie's sells the Rockingham Chaucer for the first time (pp.314–15).

The Declaration of Independence signals American Patriots' intention to split from Britain. The split is formalized at the end of the American Revolution in 1783.

1778

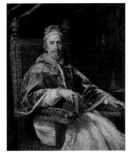

James Christie negotiates the sale of the art collection of Sir Robert Walpole to Catherine the Great of Russia. It is now part of the Hermitage Museum, St Petersburg (pp.393–4).

Thomas Gainsborough paints James Christie's portrait to hang in his saleroom (pp.18–19).

1780

Gimcrack on Newmarket Heath by George Stubbs is sold for the first time at Christie's (pp.420–1).

Approximate start of the Romantic era in European literature and art.

1785

After his death, Christie's sells the library of the renowned writer and antiquarian Dr Samuel Johnson (pp.328–9).

1797

William Hogarth's celebrated series of paintings, *Marriage À-la-Mode*, is sold in February (pp.307–8).

James Christie sells the Old Master paintings in the collection of his friend the American artist John Trumbull (pp.284–5).

1801

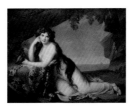

Admiral Lord Nelson arranges the private purchase of a portrait of his mistress Emma Hamilton by Élisabeth Vigée-Le Brun, before it appears in the saleroom (pp.40–1).

1803

James Christie, founder of the firm, dies at his home and saleroom in Pall Mall.

Napoleon Bonaparte becomes Emperor of France.

The United States buys Louisiana from France. The country now stretches from the Atlantic to the Pacific.

1804

Christie's offers for sale one of the most significant portraits of a British monarch ever painted: *Charles I in Three Positions* by Anthony van Dyck (pp.172–3).

The 'Elgin Marbles' arrive in London from Greece and become celebrated works of art. The demand for antique works of this kind increases.

1811

Christie's begins its Day Book, a handwritten record of consignments brought into the auction house.

1815

The Battle of Waterloo ends Napoleon's domination of Europe and signals a gradual lessening of French influence over European politics and culture.

1823

The auction house moves from Pall Mall to 8 King Street, the present London headquarters (pp.20–1).

In the Monroe Doctrine, US President James Monroe rejects European political or military involvement in American affairs.

1824

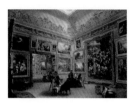

The National Gallery opens in London with a collection based in part on purchases from Christie's.

Christie's issues its first illustrated sales catalogue.

1848

The Stowe House sale of the Duke of Buckingham's collection takes place over forty days and includes a portrait of William Shakespeare (pp.312–13).

Democratic revolutions break out in many European countries.

1853

The Adoration of the Shepherds is sold to the National Gallery in London as a work by Diego Velázquez; but it is later attributed to other artists. The mystery of who painted the work remains unsolved (pp.198–9).

Japan ends its policy of international isolation.

1859

Thomas Woods becomes a director and the firm becomes Christie, Manson & Woods (CMW) – still its official name.

Charles Darwin publishes *On the Origin of Species*, proposing a controversial theory of evolution.

1864

Sale of a remarkable eighteenth-century automaton, the Silver Swan by John Joseph Merlin (pp.67–8).

1827

After the death of the Duke of York, his collection of silver and silver gilt is sold to pay his debts (pp.260–1).

J.M.W. Turner buys his own painting, *Sun Rising through Vapour* (pp.42–3).

1830

The sale of the Oriental Museum of Major General Charles Stuart includes many Hindu artefacts from India (pp.190–1).

The Georgian period comes to an end when King George IV dies and his brother William IV comes to the throne.

1831

James Christie 'the younger' dies.

George Henry Christie J.P. takes over the firm and immediately takes on a partner, William Manson; the company becomes known as Christie and Manson.

1837

Victoria becomes Queen of England, marking the start of the Victorian age.

1870

After his death, Christie's sells the library of Charles Dickens, then the world's most celebrated author.

War breaks out between France and Prussia; a German victory in 1871 helps to complete the unification of Germany.

1874

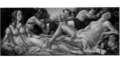

The National Gallery in London buys *Venus and Mars* by Sandro Botticelli (pp.287–9).

The Impressionists hold their first exhibition in Paris.

1875

The sale of the Marlborough Gems – a collection of over 700 gems, intaglios and cameos sold as a single lot – attracts huge public attention (p.466).

1876

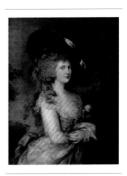

Days after it is sold at Christie's, a celebrated Gainsborough portrait of Georgiana, Duchess of Devonshire, is cut from its frame by a thief and disappears for twenty-five years (pp.304–5).

Britain's Queen Victoria becomes Empress of India.

1877

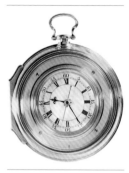

Sale of the H5 marine chronometer by John Harrison, the timepiece that solved the problem of calculating longitude at sea (pp.70–1).

Sale of El Greco's masterpiece *Christ Driving the Traders from the Temple* (pp.200–1).

1882

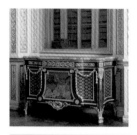

The Hamilton Palace sale, one of the most important house sales of the nineteenth century, takes place over seventeen days (pp.366–7). It includes furniture made for Louis XVI and Marie Antoinette.

1885

A new gallery is opened to the public in King Street, London, with more room to display works of art.

The German inventor Karl Benz invents the Motorwagen, which is seen as the first motor car.

1888

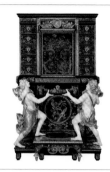

Sale of a marquetry cabinet attributed to André-Charles Boulle for Louis XIV, the Sun King (pp.368–9).

1912

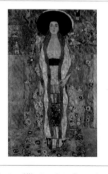

Gustav Klimt paints *Portrait of Adele Bloch-Bauer 2*; the work is confiscated by the Nazis but restituted in 2006 (pp.440–1).

The Armory Show in New York introduces modern art to the United States in 1913.

1914

Egon Schiele's *Herbstsonne* (*Sunflowers*) is painted; it is subsequently thought to have been lost during the Second World War, but is rediscovered by Christie's experts in 2005 (pp.82–3).

1915

Sir Alec Martin, Christie's managing director, oversees the first Christie's Red Cross charity sale to raise money for the war effort. Among the objects sold are a rifle donated by King George V, a Stradivarius violin and autograph manuscripts of Charles Dickens's *Pickwick Papers*.

1918

Sale of 'The Red Cross Pearls', the most valuable of the Red Cross sales. Some 3,597 donated pearls were fashioned into forty-one necklaces, scarf pins, brooches and rings (pp.276–7).

The First World War ends with the armistice between the Allies and Germany.

1889

The firm's last direct connection with the original James Christie comes to an end when James H.B. Christie (son of George Henry and great-grandson of the founder) retires.

The Eiffel Tower in Paris is completed and opens.

1892

Christie's sells its first Impressionist painting, *Dans un café* (also known as *L'absinthe*) by Edgar Degas (pp.452–3).

Sale of *Monarch of the Glen* by Edwin Landseer (pp.236–7).

1901

Queen Victoria dies. Edward VII comes to the British throne, beginning the Edwardian period.

Australia becomes a unified nation.

1910

Sale of nineteenth-century French and Dutch paintings, including forty works by the French artist Jean-Baptiste-Camille Corot (pp.274–5).

The British Empire reaches its greatest extent, covering about a quarter of the globe.

1926

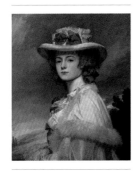

Sale of *Portrait of Mrs Davenport* by George Romney, the most expensive work of art sold at Christie's between the wars (pp.212–13).

1927

Sale of Gainsborough's *Portrait of James Christie* (pp.18–19).

Sale of the Russian State Jewels.

1928

Sale of The Emperor's Carpet, an outstanding Persian rug from the mid-sixteenth century (pp.242–3).

The Holford Sale of seventy-eight Dutch and Flemish pictures raises £364,097 ($1.8m), a world record for a day's sale of paintings at auction.

1929

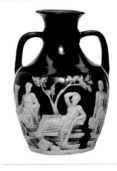

The Portland Vase, which had been smashed in 1845 while on display in the British Museum, goes on sale and is subsequently loaned back to the museum (pp.146–7).

The Wall Street Crash in October signals the onset of the Great Depression.

1932

Pablo Picasso's *Le rêve* is painted and features in the artist's first important mid-career retrospective, in Paris. It goes on to set an auction record for Picasso when it sells at Christie's New York in 1997 for more than $48m (£28.6m; pp.122–3).

1933

Adolf Hitler becomes Chancellor of Germany after the electoral success of his Nazi Party; soon many Jews and other Europeans begin to leave Germany and Central Europe.

Franklin D. Roosevelt becomes US president and launches the 'New Deal'.

1934

Sale of the property of Lord Zetland, including outstanding Chippendale furniture designed in 1764 (pp.462–3).

Mao Zedong leads China's Communists to internal exile in the 'Long March'.

1935

The Armada Jewel, a lavishly decorated gold locket presented by Elizabeth I to Sir Thomas Heneage, is bought by the National Art Collections Fund and donated to the Victoria and Albert Museum in London (p.157).

1951

The Festival of Britain opens on the South Bank of the River Thames in London and features Henry Moore's *Reclining Figure: Festival* (pp.164–5).

1953

The newly rebuilt King Street saleroom is ready for Christie's to return 'home'. A grand dinner to mark the event is attended by the Queen Mother.

Coronation of Queen Elizabeth II.

1954

The first sale of Modern British Paintings takes place; the objects come from the collection of Kenneth Clark.

Vietnam is split into North and South after the defeat of the French colonial rulers.

1958

Sale of the Massachusett Bible (1661–3), translated into the Native American language by John Eliot (pp.426–7).

The Metropolitan Museum of Art, New York, sells part of its collection of arms and armour at Christie's; it is the first time the Met has sent objects to London to be sold.

1937

In the Spanish Civil War, German bombers destroy the town of Guernica, an event that is later commemorated in the large-scale painting by Pablo Picasso.

1939

The film *The Wizard of Oz* is released. Christie's will later sell the sparkling red slippers worn in the film by Judy Garland (p.177).

The Second World War begins when German troops invade Poland. Europeans jews and others flee to Britain and the United States.

1941

Christie's King Street premises is bombed during the Blitz, leaving only the façade and entrance.

With the permission of the Earl of Derby, Christie's holds sales in Derby House.

Japan's attack on Pearl Harbor in Hawaii brings the United States into the war.

1947

Christie's salerooms move to Spencer House in St James's when Earl Spencer gives Sir Alec Martin permission to use the ballroom for auctions.

1960

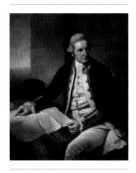

Sale of the logbook and journal of the first and second voyages of Captain James Cook (pp.36–7).

The first dedicated Impressionist and Post-Impressionist sale is held.

1963

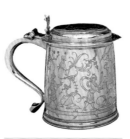

The Derby Day sale of the Brownlow silver collection attracts huge public interest. A pair of silver tankards by John Duck achieves a record price (p.35).

President John F. Kennedy is assassinated in Dallas, Texas.

1964

Christie's sells its first work by Francis Bacon, *Study for a Pope*, 1955 (pp.395–6).

Such is the public interest in a Christie's Old Masters sale that closed-circuit television is installed so that people can watch the auction from adjoining rooms.

1965

The industrialist Norton Simon buys Rembrandt's *Portrait of the Artist's Son Titus* in an auction that is notoriously chaotic thanks to Simon's peculiar bidding arrangements (pp.174–5).

Christie's buys White Brothers Printers in order to print its increasing number of catalogues.

1966

Christie's 1966 bicentenary is celebrated with an exhibition in January 1967; in just under three weeks it is attended by nearly 15,500 people.

The first post-war sale of wine takes place.

1967

Sale of the Kremlin service: 1,742 pieces made for Emperor Nicholas I (pp.344–5).

The first telephone bidding takes place at the King Street saleroom.

First sale of US, Australian, Canadian and South African art.

1968

Christie's first European sale takes place in Geneva.

The first stamp sale since the Second World War takes place in London. A new department of textiles, costumes, dolls and fans is created.

1969

The National Gallery, London, buys a Tiepolo ceiling painting discovered by Christie's experts in a house in Mayfair (pp.32–3).

Christie's holds its first sale in Canada.

The first sale is held in Tokyo, and features Impressionist and Japanese art.

1974

The first sale takes place in Madrid.

The first sale devoted to twentieth-century contemporary art is held.

Discovery of the Terracotta Army in China.

1975

The first sales take place in Amsterdam and Melbourne.

Christie's South Kensington holds its first sale at the Brompton Road saleroom.

1977

First sale in New York on Park Avenue: a two-part Impressionist sale, where Renoir's *Femme nue couchée, Gabrielle* fetched the highest price for a painting at this auction (pp.110–11).

Queen Elizabeth II celebrates her Silver Jubilee.

1978

Sale of Coco Chanel's wardrobe (pp.218–19).

Sale of Titania's Palace, a remarkable doll's house (pp.158–9).

China introduces economic reforms that herald the emergence of capitalism.

1970

Diego Velázquez's portrait of Juan de Pareja becomes the first painting to sell for more than £1m (pp.404–5).

The Villa Miani near Rome is used for the first sale in Italy.

A sale in Houston, Texas, is the first to be held by Christie's in the United States.

1971

The Death of Actaeon by Titian is sold in London, but a public appeal means it is acquired by the National Gallery (pp.112–13).

A Louis XVI writing desk becomes the most expensive piece of furniture in the world (pp.435–6).

Decimalization of British currency.

1972

A Yuan wine jar becomes the most expensive Asian work of art when it is sold in London after being discovered in use as an umbrella stand (p.360).

The first car sale takes place at Beaulieu in Hampshire.

1973

Sale of the collection of Sydney J. Lamon, which includes *Doves* by Jacob Epstein (pp.332–3).

Christie's is floated on the stock exchange.

Oil crises slow the world economy.

1979

Christie's opens a second saleroom in New York, on East 67th Street.

The first sale takes place in Milan.

1980

Paul Cézanne's *Man in a Blue Smock* (pp.204–5) is a highlight of the 'Ten Important Paintings from the Collection of Henry Ford II' sale in New York – an auction that fetches a total of $18.4m (£8m).

Samson and Delilah by Rubens sells for £2.3m ($5.4m; pp.292–4).

1982

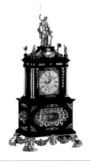

The Mostyn Tompion clock, created to mark the coronation of William III and Mary II in 1689 and one of the greatest English timepieces, is sold in London (pp.68–9).

1983

A complete set of 'One Thousand Pictures of the Ocean' by the Japanese artist Hokusai is sold in New York (pp.78–9).

The embroidered nightcap worn by King Charles I for his execution in 1649 is sold in London (p.263).

1984

Five Old Master drawings from Chatsworth House sell for over £1m ($1.3m) each in a sale of seventy-one drawings from the collection (pp.356–8).

1985

Adoration of the Magi by Mantegna sells for £8.1m ($10.5m) in London, a sale that is transmitted live to New York by satellite (pp.196–7).

The first sale is held in Monaco.

Paddles and paddle numbers are introduced in London.

1986

The Nanking Cargo of Chinese porcelain and gold ingots is sold in Amsterdam for a total of £10.2m ($15m), one of a series of shipwreck sales (pp.281–3).

Christie's Hong Kong holds its inaugural sale at the Mandarin Hotel.

Christie's Education Trust is formed.

1987

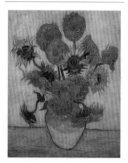

Van Gogh's *Still Life: Vase with Fifteen Sunflowers* becomes the most expensive painting ever sold at auction (pp.80–1).

Sale of a Gutenberg Bible, one of just forty-nine extant worldwide (pp.254–5).

A Bugatti Royale, one of only six made, is sold in a special sale at the Royal Albert Hall in London (p.117).

1992

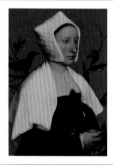

Private treaty sale of Holbein's enigmatic portrait *Lady with a Squirrel and a Starling* (pp.416–17).

The first sale is held of sports memorabilia.

Sale of Canaletto's *The Old Horse Guards* (pp.296–7).

1993

The first exclusive sale of teddy bears (p.176).

The first sale takes place in Athens.

1994

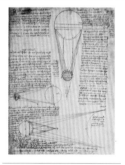

Leonardo da Vinci's notebook is sold in New York (pp.436–9).

The first sale is held in Tel Aviv, Israel.

Sale of a carved Assyrian wall panel found in a Dorset school (pp.350–1).

Works of art from Houghton Hall, home of the Marquess of Cholmondeley, fetch more than £24m (pp.442–3).

1995

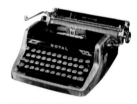

Sale of Ian Fleming's gold typewriter (pp.62–3).

Christie's Great Estates (now Christie's International Real Estate) is formed in New York.

Rudolf Nureyev's estate sells for £6.5m ($10.3m); a single pair of ballet shoes fetches over £12,000 ($19,000; pp.106–7).

1988

Petite danseuse de quatorze ans by Degas is sold for more than $10m (£5.7m), a record price for a sculpture (pp.102–3).

Premier Mikhail Gorbachev introduces reforms in the Soviet Union.

1989

The Portrait of a Halberdier by Pontormo sells for $35.2m (£21.5m) in New York, then the highest price paid for an Old Master painting (pp.290–1).

A saleroom opens in Melbourne.

Communism collapses across Eastern Europe.

Invention of the World Wide Web.

1990

Sale of the Agra diamond, which once belonged to the Mughal emperor Babur (pp.194–5).

Van Gogh's *Portrait of Dr Gachet* becomes the most expensive work of art when it is sold for $82.5m (£49.2m; pp.202–3).

1991

A self-portrait by Frida Kahlo becomes the first Latin American work to exceed $1m at auction (pp.126–7).

First sale is held in Zurich.

Sale of the Messer collection of English furniture (pp.430–1).

1996

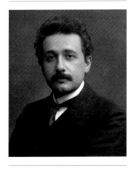

Sale of fifty-four loose pages of notes by Albert Einstein and Michele Besso on the general theory of relativity (pp.30–1).

1997

Diana, Princess of Wales, sells seventy-nine of her dresses for charity in New York (pp.220–1).

The Victor and Sally Ganz sale makes auction history, totalling $206.5m (£122.2m; pp.122–3).

1998

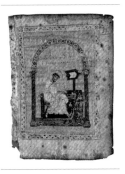

The Archimedes palimpsest sells for $2.2m (£1.3m; pp.352–3).

The Rockingham Chaucer is sold by Christie's some 220 years after its first sale (pp.314–15).

The French billionaire François Pinault buys Christie's.

1999

Sale of possessions of Marilyn Monroe, including the famous Jean Louis gown she wore when singing 'Happy Birthday' to President John F. Kennedy in 1962 (pp.131–2).

2000

'A Century of Hollywood' sale in New York includes a pair of Dorothy's ruby slippers from *The Wizard of Oz* (pp.177–8).

Christie's New York moves from Park Avenue, and the first sale is held at Rockefeller Center.

2001

Sale of James Bond's Aston Martin DB5 from the film *Goldeneye* (pp.64–5).

The first sale takes place at Avenue Matignon, Paris, following the opening up of the French art market.

2002

A Brazilian football shirt worn by Pelé in the World Cup Final of 1970 is included in a London sale of football memorabilia (pp.160–1).

The 'Jenkins Venus' sets a new record for the sale of an antiquity (pp.138–9).

2004

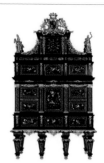

The Badminton Cabinet, made in Florence between 1726 and 1732, sells for the second time at Christie's (pp.50–1).

Sale of *Pandora* by Dante Gabriel Rossetti, once owned by L.S. Lowry (pp.300–1).

2009

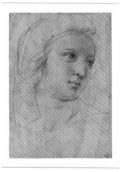

The drawing *Head of a Muse* by Raphael sells for £29m ($48m), a record for a work on paper (pp.52–3).

The highest total ever is achieved for an auction of Old Master paintings in London: £68.4m ($112.4m).

2010

Abel Buell's map of America becomes the most expensive map in history when it is sold in New York (pp.132–3).

Sale of *Portrait of a Commander* by Rubens (pp.114–15).

2011

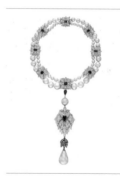

Sale of Elizabeth Taylor's jewellery, the most valuable private collection of jewels ever sold (pp.150–1).

Christie's sets sixteen world auction records in a sale of post-war and contemporary art in New York.

2012

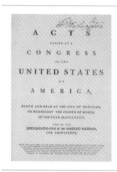

Sale in New York of George Washington's personal copy of the American Constitution and Bill of Rights (pp.134–5).

Christie's holds the most valuable sale of post-war and contemporary art ever: £240.9m ($388.5m).

2005

A world-record price is set by a blue-and-white *guan* jar from the Yuan dynasty (pp.330–1).

Creation of Christies.com. Christie's LIVE™ enables buyers to bid online.

2006

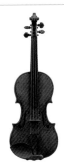

Sale of a Stradivarius violin known as 'The Hammer' for $3.5m (£1.9m), a record for a musical instrument (p.54).

The sale '40 Years of Star Trek: The Collection' includes 1,000 lots of official memorabilia (pp.28–9).

Dubai sales commence.

2007

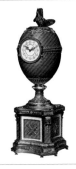

Sale of the Rothschild Fabergé egg, later donated to the Hermitage Museum in St Petersburg (pp.348–9).

Private treaty sale of Dumfries House in Ayrshire, Scotland (pp.309–10).

2008

An evening auction of Impressionist and modern art in London sets a new record for a European art auction: £144.4m ($283.9m). The sale includes *Le bassin aux nymphéas*, one of Monet's famous waterlily paintings (pp.91–3).

2013

Jackson Pollock's *Number 19, 1948* sells for $58.4m (£38.4m) – a world auction record for the artist (pp.181–3).

Christie's first auction in mainland China takes place in Shanghai, totalling RMB154m (£15.2m/$24.7m).

The most valuable auction in history takes place on 12 November in New York: $691.6m (£435.7m).

2014

A unique embroidered silk *thangka* achieves HK$348.4m (£28.5m/$45m) – a world record for a Chinese work of art sold by an international auction house (pp.244–5).

Christie's appoints its first female CEO, Patricia Barbizet.

2015

Christie's sells the two most expensive works of art in history, *Les femmes d'Alger (Version 'O')* by Picasso and *Nu couché* by Modigliani (pp.380–3, 141–3).

Sale of Margaret Thatcher's possessions, including her famous blue suit (pp.129–30).

2016

A painting by Jean-Michel Basquiat (*Untitled*, 1982) sells for $57.3m (£39.2m) in New York, a record price for the artist.

ACKNOWLEDGEMENTS

The fascinatingly diverse works of art and craftsmanship represented in this book reflect the expertise, energy and enthusiasm of the Christie's staff who have come into contact with them over the past 250 years. And while those individuals, whether chairman or specialist, art handler or security guard, may come and go, the unwavering passion and commitment that distinguishes Christie's endures.

We would like to acknowledge and thank the clients of the company – vendors and buyers – for entrusting us over the centuries with the safe passage of precious and historic objects from one country to another, from collector to connoisseur, and from one generation to its successor.

We would also like to thank the following people for their help in assembling this book, beginning with the committee that undertook the daunting task of selecting, from many thousands of possibilities, our final list of 250 objects: Jane Burton, Dan Davies, Eva Dimitriadis, Meredith Etherington-Smith, Vivien Hamley, Catherine Manson, Lynda McLeod, Charlotte Mullins, Jussi Pylkkänen, Orlando Rock and Francis Russell.

Phaidon: Keith Fox, Deborah Aaronson, Kim Scott, Rebecca Price, Julia Hasting and the designers at Atlas, Astrid Stavro, Pablo Martín and Giovanni Cavalleri.

Writers: Jonathan Bastable, Caroline Bugler, Sam Fletcher, Gareth Harris, Beth Jones, Jessica Lack, Helen Luckett, Ben Luke, Chris Mugan, Tim Pozzi, Keith Pratt, Florence Waters, Eliza Williams and Liz Wyse.

Specialists, experts and Christie's team members: Georgiana Aitken, Noël Annesley, Pola Antebi, Nishad Avari, Max Bernheimer, Giovanna Bertazonni, Louise Britain, Peter Brown, Robert Brown, Anthony Browne, Christopher Burge, Andrew Butler Wheelhouse, Anna Campbell, Olivier Camu, Jason Carey, Ben Clark, Charles Cator, Joyce Chan, Eric Chang, Gilles Chwat, Robert Copley, Piers Courtney, Hugh Creasey, Vanessa Cron, Helen Culver Smith, François Curiel, Leila de Vos van Steenwijk, Howard Dixon, Harriet Drummond, Monica Dugot, David Elswood, Antonia Fitzgerald, Nina Foote, Margaret Ford, Pat Frost, Philippe Garner, Virgilio Garza, Zita Gibson, Sharon Goodman, Brett Gorvy, Benjamin Hall, Nicholas Hall, Elizabeth Hammer, Philip Harley, Victor Harris, James Hastie, John Hays, Valerie Hess, Paul Hewitt, Rachel Hidderley, Mark Hinton, Peter Horwood, James Hyslop, Amin Jaffer, Donald Johnston, Kerry Keane, Imogen Kerr, Hala Khayat, Susan Kloman, Ben Kong, Marcello Kwan, Nick Lambourn, Jo Langston, Stephen Lash, Lisa Layfer, Géraldine Lenain, Danqing Li, Pepper Li, Viscount Linley, David Llewellyn, Richard Lloyd, John Lumley, Domoni Mainstone, Sarah Mansfield, Sarah Mao, Nick Martineau, Joy McCall, Nic McElhatton, Piers Morgan, Chris Munro, Mami Nagase, Rupert Neelands, Giulia Omodeo Sale, Jessie Or, Francis Outred, Marcus Radecke, Arabella Radford, John Reardon, William Robinson, Francis Russell, Marc Sands, Catherine Scantlebury, Tim Schmelcher, Rosemary Scott, Vickie Sek, Samantha Sham, Anastasia von Seibold, Dominic Simpson, John Steinert, Mark Stephen, Jonathan Stone, Kay Sutton, Alexis de Tiesenhausen, Nicolette Tomkinson, Chi Fan Tsang, Thomas Venning, Jay Vincze, David Warren, Nick White, Eric Widing, Jodie Wilkie, Harry Williams-Bulkeley, Julian Wilson, Alice Whitehead and Toby Woolley.

Phaidon Press Limited
Regent's Wharf
All Saints Street
London N1 9PA

Phaidon Press Inc.
65 Bleecker Street
New York, NY 10012

phaidon.com

First published 2016
© 2016 Phaidon Press Limited

ISBN 978 0 7148 7202 5

A CIP catalogue record for this book
is available from the British Library and
the Library of Congress.

Printed in China